The World of Physical Culture and Exercise

Within qualitative research in the social sciences, the last decade has witnessed a growing interest in the use of visual methods. *Visual Methods in Physical Culture* is the first book in the field of sport and exercise sciences dedicated to harnessing the potential of using visual methods within qualitative research. Theoretically insightful, and methodologically innovative, this book represents a landmark addition to the field of studies in sport, exercise, the body, and qualitative methods. It covers a wide range of empirical work, theories, and visual image-based research, including photography, drawing, and video. In so doing, the book deepens our understanding of physical culture. It also responds to key questions, such as what are visual methods? Why might they be used? And how might they be applied in the field of sport and exercise sciences?

This volume combines clarity of expression with careful scholarship and originality, making it especially appealing to students and scholars within a variety of fields, including sport sociology, sport and exercise psychology, sociology of the body, physical education, gender studies, gerontology, and qualitative inquiry.

This book was previously published as a special issue in *Qualitative Research in Sport and Exercise*.

Cassandra Phoenix is a lecturer at the University of Exeter, UK. Her research interests include ageing, the body, experiences of physicality across the life course, and visual methods. Cassandra is a member of the editorial board for *Journal of Aging and Physical Activity*, *Journal of Aging Studies*, and *Narrative Works*.

Brett Smith is a senior lecturer at Loughborough University, UK. His research interests include disability, the body, narrative, and qualitative inquiry. Brett is Associate Editor of *Psychology of Sport and Exercise* and the Editor-in-Chief of *Qualitative Research in Sport and Exercise*.

The World of Physical Culture in Sport and Exercise

Visual Methods for Qualitative Research

Edited by

Cassandra Phoenix and Brett Smith

LONDON AND NEW YORK

First published 2011
by Routledge
2 Park Square, Milton Park, Abingdon, Oxon, OX14 4RN

Simultaneously published in the USA and Canada
by Routledge
711 Third Avenue, New York, NY 10017

Routledge is an imprint of the Taylor & Francis Group, an informa business

First issued in paperback 2012

This book is a reproduction of *Qualitative Research in Sport and Exercise*, vol. 2, issue 2. The Publisher requests to those authors who may be citing this book to state, also, the bibliographical details of the special issue on which the book was based.

Typeset in Times New Roman by Taylor & Francis Books

British Library Cataloguing in Publication Data
A catalogue record for this book is available from the British Library

ISBN13: 978-0-415-61555-6 hardback

ISBN13: 978-0-415-66120-1 paperback

Disclaimer
The publisher would like to make readers aware that the chapters in this book are referred to as articles as they had been in the special issue. The publisher accepts responsibility for any inconsistencies that may have arisen in the course of preparing this volume for print.

Erratum
The publisher wishes to make it known that in chapter 1, 'Seeing the world of physical culture: the potential of visual methods for qualitative research in sport and exercise' by Cassandra Phoenix, Phoenix is the sole owner of figures 1, 2, 3 and 6.

Contents

CONTENTS

Notes on Contributors

Jaclyn A. Andrzejczyk received her master's degree in developmental kinesiology, with a specialisation in sport psychology, at Bowling Green State University.

Maureen C. Ashe is an assistant professor in family practice at UBC and an investigator at the Center for Hip Health and Mobility. Her research interests are in physical activity and falls prevention in older adults.

Michael Atkinson is associate professor in the Faculty of Physical Education and Health at the University of Toronto, where he teaches physical cultural studies and research methods. His current research projects include ethnographic analyses of technology and bioethics in sport, transhumanist physical cultures and animal ethics. He is author of seven books, including *Tattooed: The Sociogenesis of a Body Art* (2003, University of Toronto Press) and *Deconstructing Men and Masculinities* (2010, Oxford University Press).

Laura Azzarito, currently at Loughborough University, has published her work widely in peer-reviewed journals in the pedagogy of sport and PE, sociology of sport and curriculum studies. She has also written numerous invited book chapters. Her research explores issues of inequalities among young people in schools by investigating young people's embodiment at the intersection of gender/sex, race and social class. She has recently been awarded fellow status by the American Association of Health, Physical Education, Recreation and Dance for her scholarship.

Jim Cherrington is a PhD researcher at Leeds Metropolitan University in the Carnegie Research Institute.

Karen T. D'Alonzo, Ph.D., RN, APNC, is an assistant professor in the College of Nursing at Rutgers, The State University of New Jersey. Her research interests include promotion of physical activity among diverse groups of women, community-based participatory research and the acculturation processes of immigrant women. Dr D'Alonzo is also certified as an adult nurse practitioner.

Lorraine Friend, PhD, is based at The University of Waikato in the Department of Marketing. Her areas of interest are consumer research, visual methods and social issues in marketing. She has previously published in marketing research journals such as *Advances in Consumer Research, Consumption, Markets and Culture,* and the *Journal of Services.*

Kristy Ganoe is a graduate student of American culture studies and women's studies at Bowling Green State University. Her research interests include feminist ethnography and the body.

Linda Glick, Med, LPC, is based at the University of Colorado at Colorado Springs in the Beth-El College of Nursing and Health Sciences (retired faculty). Her areas of interest are improving methods of teaching communication skills to health care professionals, exploring the experience of becoming a Senior Athlete, and film-making. She has previously published in healthcare education and health promotion journals such as the *Journal of Nursing Education* and *Educational Gerontology*.

Bevan C. Grant, PhD, is based at The University of Waikato in the Department of Sport and Leisure Studies. His areas of interest are exploring the interaction between policy, community initiatives and the day-to-day physical activity and recreation experiences of the older person, and qualitative research methods. He has previously published in gerontology journals, such as *Journal of Aging and Physical Activity, Ageing & Society, Journal of Ageing,* and *Activities, Adaptation and Aging.*

Hannah M. Gravestock is a theatre designer, researcher and figure skater. As a lecturer & workshop leader in scenography, her current work involves training figure skaters through movement and drawing. Hannah's doctoral research examines embodied understanding in costume design created through the physical act of drawing the performing body.

Meridith Griffin's research interests focus upon the lived experiences of the female body, in both the athletic and the aesthetic realms. She is currently conducting a narrative ethnography of a women's-only running group. Her previous work has been published in numerous journals, including *Ageing & Society, Qualitative Health Research* and *Journal of Women and Aging.*

Laura Hurd Clarke is associate professor (Sociology of Aging and Health) and a Michael Smith Foundation for Health Research Career Scholar in the School of Human Kinetics at the University of British Columbia. Her research interests include aging, body image, embodiment, technology and qualitative methods.

Mary Ann Kluge, PhD, is based at the University of Colorado at Colorado Springs in the Department of Health Sciences, Beth-El College of Nursing and Health Sciences. Her areas of interest are exploring older persons' experiences with physical activity, qualitative and visual research methods, and artistic inquiry. She has previously published in gerontology, physical activity, and health promotion journals, such as the *Journal of Aging and Physical Activity, Activities, Adaptations, and Aging,* and the *Journal of Physical Education, Recreation, and Sport.*

Vikki Krane is a professor of sport psychology in the School of Human Movement, Sport, and Leisure Studies at Bowling Green State University. Her research focuses on issues of gender and sexuality in sport.

Teresa Liu-Ambrose's current research focuses on defining the role of exercise to promote healthy aging and prevent cognitive and functional decline among seniors. She is an investigator with the Brain Research Centre and the Centre for Hip Health and Mobility.

Cathryn B. Lucas earned her master's degree in developmental kinesiology, with a specialisation in sport psychology, at Bowling Green State University. Currently, she is a doctoral student in the Department of Health and Sport Studies at the University of Iowa.

Montana Miller is an assistant professor in the Department of Popular Culture at Bowling Green State University. A folklorist and ethnographer, she specialises in youth culture.

John Naslund is currently working on a project through the Centre for Hip Health and Mobility in which he is examining the role of cognition in relation to falls risk among frail older adults. His primary interests are in geriatrics and research surrounding topics related to cognition, aging, neuropsychology, neurology and dementia. John's goal is to pursue a career in geriatric medicine.

Cassandra Phoenix is a lecturer at the University of Exeter, UK. Her research interests include ageing, the body, experiences of physicality across the life course, and visual methods. Cassandra is a member of the editorial board for *Journal of Aging and Physical Activity*, *Journal of Aging Studies*, and *Narrative Works*.

Clive C. Pope is a senior lecturer and chairperson in the Department of Sport and Leisure Studies at the University of Waikato. His research interests include the sport experiences of youth, visual ethnography, photo-elicitation, exploring the sport experience and sport in educational settings.

Sally R. Ross is an assistant professor in sport and leisure management at the University of Memphis. Her research areas include gender and sport opportunity, marketing of female athletes, and sport and social responsibility.

Julie L. Rowse earned an MA in popular culture at Bowling Green State University. She currently teaches AP language and composition and media studies classes at Bellevue West High School in Bellevue, Nebraska.

Manoj Sharma, MBBS, CHES, Ph.D., is a professor in the Health Promotion and Education programme, College of Education, Criminal Justice and Human Services at the University of Cincinnati. Dr Sharma has taught in academia for more than 15 years and has served as a health consultant for many national and international organizations, including the Centers for Disease Control and Prevention (CDC) and the European Union (EU). His research interests are in designing and evaluating theory-based health education and health promotion programs, alternative and complementary systems of health and community-based participatory research.

Joanie Sims-Gould is post-doctoral research fellow in the Department of Family Practice and an investigator with the Centre for Hip Health and Mobility. Her current research focuses on older adults' experiences post-hip fracture. She employs a range of qualitative methodologies to animate the experiences of older adults in research.

Jennifer Sterling is a research associate in the School of Sport, Exercise and Health Sciences at Loughborough University.

Beccy Watson is a principal lecturer at Leeds Metropolitan University in the Carnegie Research Institute.

Foreword

Sarah Pink

The World of Physical Culture in Sport and Exercise: Visual Methods for Qualitative Research offers researchers and students in sports and exercise studies a very welcome and timely range of examples of how and why visual methods and media should be part of qualitative research in this interdisciplinary field of study. 'Visual' methods are becoming increasingly sensory (Pink 2009), digital (see Pink 2007a) and applied (Pink 2007b). All of these issues – as the chapters of this volume demonstrate – are of importance for scholars of sports and exercise studies making attention to how audio-visual media and cultures intersect with research practice all the more pertinent.

Indeed Cassandra Phoenix and Brett Smith's intervention in developing this collection represents an advance that fills a gap in the literature. In the 1990s I was doing the photographic ethnography published in my first book, *Women and Bullfighting* (1997), and writing the first edition of another book, *Doing Visual Ethnography* (2007 [2001]). Little of the then emergent (and growing) literature about visual methods and cultures came from sports and exercise studies. Yet it was already evident that this provided an ideal context for a focus on visual methods and media, as shown by the few studies that were developed at the time. One exception at the time was Diane Hagaman's (1993) article on the photographic representation of defeat in sports journalism. Moreover my own experience of researching the bullfight, which is an embodied practice with its own visual culture and practices, invited the use of visual research methods. It is therefore very welcome to see such a literature emerging now – and particularly at a time when digital media are expanding the range of visual technologies and practices in use. But why have visual methods not become integrated into sports and exercise studies earlier? I believe the answer lies beyond this field of interdisciplinary scholarship itself and in the practices of the mainstream disciplines from which sports and exercise scholars draw. The influence of mainstream sociology offers one example. While the sub-discipline of visual sociology is now thriving, sociologists have traditionally relied on conventional methods to do their research. There have been few bridges between visual and mainstream sociology in the past. Moreover, while many sociologists are now engaging with more innovative methods, the verbal, audio-recorded interview prevails as a staple sociological research method. This has often been the case even in the work of some sociologists who study activities that might be explored through a focus on their embodied and experiential dimensions rather than through what interviewees verbally report.

Given the centrality of the body, 'physical culture', movement and visual and media representations to sports and exercise sciences the use of visual methods and analysis of visual cultures is particularly pertinent to its area of interest. As recent literatures show,

visual methods bring the corporeality of everyday practices (both of the ethnographer and of the participants in the research) to the fore (see MacDougall 2005, Pink 2009) and visual and media production, dissemination and consumption are integral to sports cultures. Working with visual methods and media enables researchers to engage in ways that are empathetic, participatory or aesthetic with other people's embodied experiences. Thus leading to new levels of understanding, and ways of communicating research knowledge to both scholarly and non-academic and public audiences. Visual methods also enable us as researchers to embed the visual practices and visual cultures of the performances we study in our own research practice. Therefore creating new types of correspondences between local and/or culturally specific knowledges and the routes through which these are investigated (see for example Pink 1997).

Interest in the visual is now increasing across the ethnographic disciplines and the growth in visual methods in sports and exercise studies indeed reflects this. The range of different disciplinary and theoretical influences – and the very appropriate set of different methods – represented in the chapters of this book stand as evidence. That visual methods and analysis are being developed across disciplines is good news for an interdisciplinary field, providing, as this book does a 'visual' theme around which research might cohere. Yet there is also a case for caution in assuming that 'visual' approaches will be mutually compatible and theoretically coherent with each other. For example, sociological uses of visual methods based on semiotic-based approaches such as the multimodality paradigm (e.g. Dicks et al 2006) and video analysis methods (e.g. Heath et al 2010) are based on different philosophical principles to those that inform uses of the visual in phenomenological anthropology and anthropological filmmaking (e.g. MacDougall 2005) (see Pink 2011 for a discussion of the relationship between multimodality and sensory ethnography). As an interdisciplinary area of scholarship sports and exercise scholars might be or become attached to any of these paradigms of visual research and representation. Each of these and other approaches offer different and sometimes opposed ways of knowing (about) and understanding embodied experiences of sports and exercise. While plurality within an interdisciplinary field of study is part of its merit, it also invites challenges to researchers seeking to understand the similar phenomena from different perspectives. It likewise demands a reflexive sociology of knowledge about these approaches: just because two sports and exercise scholars are using visual methods this does not mean that they will necessarily be in agreement about the types of knowledge and understanding these methods produce or about the ways in which the audiovisual materials they create should be analyzed.

To end I would urge sports and exercise researchers to take up the initiative presented in this volume; to start to think about sports and exercise as happening in worlds where visual practices, images and cultures are part of the everyday.

References

Hagaman, D. (1993) "'The Joy of Victory, The Agony of Defeat': Stereotypes in Newspaper Sports Feature Photographs Stereotypes in Newspaper Sports Feature Photography" *Visual Sociology*, 8, pp. 48–66. Available online at http://www.diannehagaman.com/articles/articles_joy.html, accessed 26th August 2010.

Marvin, G. (2004) 'Research, Representations and Responsibilities: An Anthropologist in the Contested World of Fox Hunting' in S. Pink (ed) *Applications of Anthropology: professional anthropology in the twenty first century*, Oxford: Berghahn.

Pink, S. (1997) *Women and Bullfighting: gender, sex and the consumption of tradition*, Oxford: Berg.

Pink, S. (2007a) *Doing Visual Ethnography: images, media and representation in research* London: Sage. Revised and expanded 2nd edition. London: Sage.

Pink, S. (2007b) (ed) *Visual Interventions: Applied Visual Anthropology*, Oxford: Berghahn.

Pink, S. (2009) *Doing Sensory Ethnography*, London: Sage.

Pink, S. (2011) 'Multi-modality and Multi-sensoriality and Ethnographic Knowing: or can social semiotics be reconciled with the phenomenology of perception and knowing in practice' *Qualitative Research* 11(1).

Seeing the world of physical culture: the potential of visual methods for qualitative research in sport and exercise

Cassandra Phoenix

Qualitative Research Unit, School of Sport & Health Sciences, University of Exeter, UK

Readers should also refer to the journal's website at http://www.informaworld.com/rqrs and check volume 2, issue 2 to view the visual material in colour.

Adopting visual methods can enhance our understanding of the social world. By encompassing a multitude of forms including photographs, videos, maps, diagrams, symbols and so forth, images can provide specific information about our existence. They can also act as powerful indicators regarding the multiple meanings embedded within our culture. One domain where the use of visual methods has been less well documented is that of physical culture. Physical culture is taken here to mean human physical movement occurring within recognised cultural domains such as sport, dance and, more broadly, outdoor and indoor recreational activities involving expression through physicality. Opening this special edition of *Qualitative Research in Sport and Exercise* on 'Visual Methods in Physical Cultures', I provide some broad responses to the following questions: What are visual methods? Why might they be useful? How can they be utilised? I then outline some ongoing debates within the field surrounding issues of interpretation, representation and ethics. I conclude by positioning this special edition as a resource to assist with the continued use of visual methods in physical culture.

Introduction

The last decade has witnessed a significant growth in the use of visual data within qualitative research. Such growth reflects a rising appreciation of the ubiquity of imagery and visual culture in every day life, as evident by the growing number of texts focusing upon the analysis of visual representations, visual methods or both (e.g. see van Leeuwen and Jewitt 2001, Knowles and Sweetman 2004, Banks 2007, Pink 2007, Rose 2007). Indeed, scholars working within a number of different disciplines have become increasingly aware that adopting visual methods has the potential to further develop our understanding of the social world. One domain where the use of visual methods has been less well documented is that of physical culture. Physical culture is taken here to mean human physical movement occurring within recognised cultural domains such as sport, dance and, more broadly, outdoor and indoor recreational activities involving expression through physicality.

The purpose of this special edition of *Qualitative Research in Sport and Exercise* on 'Visual Methods in Physical Cultures' is to addresses this lacuna. It brings together

a range of qualitative research projects that have employed a variety of visual methods in order to 'see the way' of physical culture. Prior to introducing each of the contributions in the special edition, I offer – as point of departure and painting with broad strokes – brief responses to the following questions: What are visual methods and why might they be useful? How might they be utilised in qualitative research? What cautions accompany the use of these methods?

What are visual methods and why might they be useful?

According to Harrison (2004), 'visual methods' describes any research design, which utilises visual evidence. Cameras and photographic images are drawn upon most widely, although this form of research can also include maps, diagrams, sketches, posters, websites, signs and symbols. Inclusion of different sorts of technologies and the images that they produce renders the world in visual terms, enabling insight into what the eye can physiologically *see* ('vision'), and also how vision is culturally constructed ('visuality'; Rose 2007). For Grady (2004), an image can be extremely objective – a record of what occurred at a given moment – yet its interpretation is entirely subjective. In this sense, 'images usually represent complex subjective processes in an extraordinarily objective form' (Grady 2004, p. 18). They can act as an impetus for asking questions such as: How are we *able* to see? How are we *allowed* to see it? How are we *made* to see? *What* is being seen, and *how* is it socially shaped?

Incorporating visual methods into the field of physical culture is useful for a number of reasons. First, they can offer a different way of 'knowing' the world of physical culture, which goes beyond knowledge constructed and communicated through written and spoken word alone. This is important given Knowles and Sweetman's (2004) suggestion that visuality is a fundamental fact of social existence, and that sighted individuals navigate the social world visually. For these authors, mass culture itself might best be described as 'hyper-visual'. Similarly, Banks (2007) has also noted the importance of taking visuality into account by suggesting that images are ever present within society, and accordingly, the study of society must at some level be attentive to the role of what we see. Second, visual images can act as unique forms of data that have the ability to amass complexly layered meanings in a format, which is both accessible and easily retrievable to researchers, participants and audiences alike. Third, images are powerful in that they can *do* things. Images can evoke a particular kind of response. Thinking, writing, presenting and discussing with images, suggests Grady (2004), can make arguments *more* vivid and *more* lucid than alternative forms of representation. Visual images, therefore, have the ability to construct and convey arguments whilst powerfully indicating the multiple meanings embedded within (physical) culture. None of this, of course, is to say that visual methods can do everything or are a panacea for understanding. They are not. They are, however one valuable way to examine our social world and physical culture. Thus, qualitative researchers might consider harnessing their potential and incorporating them for certain purposes into their methodological 'tool box'.

How might visual methods be utilised within qualitative research in sport and exercise?

The relationship of visual data to the questions or concepts being addressed is one that requires close attention. Indeed, Harrison (2002) urges researchers to consider

whether or not the use of visual methods is appropriate, by asking how they might contribute to an understanding of a said concept in ways that words cannot. That is, can the sociological or psychological ideas that we are exploring be expressed and represented visually? Such questions become salient, she argues, in light of the recent 'anyone can do it' boom that visual methods have undergone within some areas of qualitative research, and indeed people's increased familiarity and engagement with the associated visual technologies.

With increased uptake across a range of social sciences, now more than ever the use of visual data requires researchers to demonstrate knowledge of theoretical and empirical understandings – not only concerning the sociological ideas that are being examined – but also of the visual itself (see van Leewen and Jewitt 2001, Banks 2007, Pink 2007 for further information). For instance, Knowles and Sweetman (2004) suggest that there are, broadly speaking, three key theoretical approaches to visual images within social research: images as *evidence*, images as *constructions* of reality and images as *texts*. Meanwhile, Harrison (2002) distinguishes between *the visual as topic* (i.e. the visual itself as the subject of investigation) and *the visual as resource* (i.e. the visual as a means of accessing data about other topics of investigation). An example of the latter approach within the sport and exercise sciences can be seen in Smith's (2008) work on the meaning of pain amongst professional wrestlers. Locating his research in the tradition of symbolic interactionism, Smith utilises a series of images to provide additional contextual information regarding a pro-wrestling competition environment, and of injuries characteristically sustained during combat.

In terms of how and by whom visual material might be produced, Banks (2007) loosely divides between *the creation of images by the researcher* (i.e. the use of images to study society) and *the collection and study of images produced or consumed by the subjects of the research* (i.e. the sociological study of images). These approaches, however, should not be viewed as mutually exclusive, nor exhaustive of all visual research within the social sciences. Rather, as Banks notes, in either approach – and depending upon the research questions being posed – researchers may find themselves conducting surveys, interviewing participants, collecting life histories and so forth. Prosser and Loxley (2008) elaborate upon this issue further:

> Ultimately, (as well as cumulatively) visual researchers will choose to place their meta-phorical fulcrum either closer to researching 'on' respondents and hence seeing them as the 'other', or closer to collaborating 'with' respondents and seeing them as experts in their own lives. (p. 16)

In what follows, using the template offered by these authors of *researcher-created visual data* and *respondent-generated visual data*, I seek to illustrate how visual methods are, and could be, utilised to gain further insight into the world of physical culture.

Researcher-created (or -found) visual data

Whilst the visual perceptions of researchers can be converted into sketches and diagrams, signs, words, codes and numbers, still and moving photography continues to be the primary means of documenting, representing and analysing within visual sociology and anthropology (Prosser and Loxley 2008). Photographs 'may *not* provide us with unbiased, objective documentation of the social and material world, but they *can* show characteristic attributes of people, objects, and events that often

elude even the most skilled wordsmiths' (*emphasis added,* Prosser and Schwartz 1998, p. 116). These authors suggest that via photographs the researcher is able to explore relationships that may be subtle or easily overlooked. Furthermore, a sense of the emotions evoked by particular activities, environments and interactions might be communicated more effectively and provide an alternative, and at times more tangible way of knowing (see Griffin, this issue). For example, the researcher-created images shown below were produced as part of my own work with mature, natural bodybuilders. They were taken in a commercial gym (Figure 1) and a bodybuilding gym (Figure 2). By *showing* how the same general message was communicated differently within each of these locations, the images offer insight into how the social space of the gym is managed to create and sustain the (gendered) environment of 'soft gym' versus 'hard gym'.

When used as a part of ethnographic fieldwork (see Atkinson, this issue, Pope, this issue), visual methods are likely to be employed in complex field interactions, being undertaken alongside interviews, note-taking and participant observation. Photography in this context can provide the researcher with useful and meaningful visual information. It can also 'potentially construct continuities between the visual culture of an academic discipline and that of the subjects or collaborators in the research' (Pink 2007, p. 66). Such strengths of researcher-created visual data can be found within the work of a small group of ethnographers working within the field of sport and exercise sciences. For example, Hockey and Allen Collinson (2006) weave together photographs and autoethnographic data to offer the reader specific cultural knowledge concerning how distance runners 'see the way'. By including photography in their methods, they provide insight into runner's embodied feelings and experience of momentum along a typical running route. As the reader is led visually and verbally up slopes, through an underpass, across a busy road and along grassy playing fields, Hockey and Allen Collinson offer an effective way of communicating just how

Figure 1. Image produced by Phoenix and Sparkes (2009).

Figure 2. Image produced by Phoenix and Sparkes (2009).

distance runners experience their training terrain. They also show how what we see means different things to different people. For instance, looking at a grassy park area for some might signify open space, leisure time and an opportunity for a 'kick around' with friends. In the sub-culture of running, however, the same scene may be translated into knowledge of: marshy patches, unruly dogs, protruding tree roots and so forth, each holding the potential to induce or aggravate a new, or existing running injury.

Any photograph, it would seem, can hold some form of ethnographic interest, connotation or significance at particular moments in time, for particular people, and for particular reasons. Elaborating upon this point further, Pink (2007) explains:

> The meanings of photographs are arbitrary and subjective; they depend on who is look-
> ing. The same photographic image may have a variety (perhaps conflicting) meanings
> invested in it at different stages of ethnographic research and representation, as it is
> viewed by different eyes and audiences in diverse temporal historical, spatial and
> cultural contexts. Photographs produced as part of an ethnographic project will be given
> different meanings by the subjects of those images, local people in that context, the
> researcher, and other (sometimes critical) audiences. (pp. 67–68)

An example of this situation is offered using the image shown in Figure 3, which is taken from my own research. For an onlooker, this photograph may depict an image of an older man feeding some chickens from behind a wire fence. For the man featured in the image, the photograph might remind him of the time when a young, female researcher from the University of Exeter came to visit. He had been showing her around the local area and they had stopped for a coffee at his local farm shop. She took the photograph as he threw stale bread, which he brought from home, to the farm shop's flock of free-range chickens. For the owner of the farm shop, the image might demonstrate one of the attractions of his business – the interaction that customers can experience with his livestock. Thus, it might be viewed in relation to its potential as a

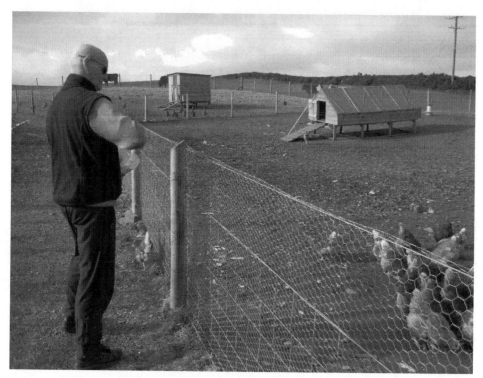

Figure 3. Image produced by Phoenix and Sparkes (2009).

marketing device. Finally, for me, the researcher, this image speaks of ageing, natural bodybuilding and diet.

The man featured in the image is 73-year old Eric Dowey, former Olympia Master's Champion in natural bodybuilding. Central to the discipline of natural body-building is diet, and during the time that I spent with Eric, I gained insight into the prominent role that diet played in his life. I learnt that food *quality* (aside from the stereotypical assumptions regarding bodybuilders and food quantity) was crucially important to Eric. He regularly visited the farm shop to purchase free-range eggs and organic chicken breast. Feeding the chickens had become part of this routine. On a broader level, the meanings behind this image might shed additional light onto how we understand the ageing body – what it can and cannot do, and the heterogeneity within the bodybuilding community. In particular, the meaning behind images such as Figure 3, might call into question the stereotypical assumptions that all bodybuilders possess 'freakish' hypermuscular physiques and engage in behaviours that are detri-mental to their health.

Respondent-generated visual data

Respondent-generated data promotes the use of visual methods in a way that encour-ages greater co-operation with the participants. This might involve the researcher working alongside the participant throughout the project to co-produce (visual) knowl-edge about a particular social issue (see Krane *et al.*, this issue, Kluge *et al.*, this issue). Alternatively, participants may work more independently over a set period of time to

produce their own visual data. For example, the use of video diaries (see Chaplin 2004) and auto-photography projects (Phoenix, forthcoming) involve the power of the camera being turned over to research participants to document the images/footage they choose, and in some instances to story their meanings collaboratively with investigators (see Azzarito and Sterling, this issue, Sims-Gould *et al.*, this issue).

Working *with* respondents in this manner can provide another layer of insight into individual lives by enabling researchers to view the participant's world through their eyes. For this reason, it has been recognised as an especially useful form of data collection for understanding the experiences of marginalised groups (see D'Alonzo and Sharma, this issue). It can also provide respondents with a sense of agency and opportunity to speak for themselves, and subsequently help to erase the traditional power imbalance between researcher and participant (Pink 2007, Packard 2008). Moreover, participants are able to use their bodies and the space around them to *'show'* rather than just *'tell'* about their lives (Riessman 2008). Referring to video diaries in particular, Holliday (2007, p. 61) proposes that their usefulness lies in their potential to persuade audiences to 'bear witness' to the lives that are filmed, whilst also providing them with the means to reflect upon their own (see Cherrington and Watson, this issue). In addition to auto-photography and video-diary projects, graphical-elicitation, creative methods and arts-based research methods (see Gravestock, this issue) can also appear under the umbrella of respondent-generated visual data (Prosser and Loxley 2008).

Westcott (2007) utilised creative methods as a means of documenting her experiences of an unexpected physical trauma to her eye that caused periods of blindness and intense migranes. As an undergraduate student from a sport and exercises science degree programme, and player for the university ladies football team, Westcott's reflexive narrative of the self tells of the inescapable erosion of her previously taken for granted assumptions about a smoothly functioning athletic body. It speaks of the disruption to her sense of body-self unity that resulted from 'two years of investigations comprising of biopsies, steroids, MRI scans, weekly hospital appointments and massive amounts of prodding and manipulation' of her right eye (Westcott 2007, p. 20). At times, however, the sensations and emotions that she encountered during this period were beyond written and spoken word. Instead, she drew the images presented in Figures 4 and 5 in an attempt to *show* her embodiment of excruciating pain, depression and isolation more fully.

Westcott (2007) signalled that more than photographs do, drawings can allow those who are the subjects of the research to shape how they see themselves, and are potentially seen by others. Whilst in some instances of creative methods, there may be a close affinity with photo and graphic elicitation, the participatory principle here is further emphasised by the respondents ownership and agency through the act of creation. Analysis, meanwhile, can focus on *what* is constructed, *how* it is constructed, and the *ways of seeing* the images that are produced relative to context of production and reception (Riessman 2008).

Using visual methods: ongoing debates

Image-based research is a lively domain spanning a variety of disciplines. Accordingly, the presence of ongoing debates and discussions are very much part of its character and appeal (and for some, frustration). In this section, I signal three areas where debate and discussion are rife: the issue of *interpretation*, the issue of *representation* and,

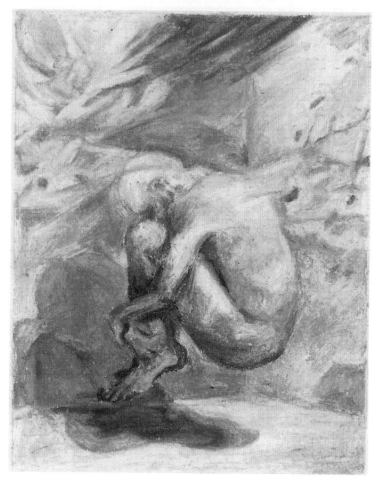

Figure 4. 'Isolation' image produced by Westcott (2007).

briefly, the issue of *ethics*. It should be emphasised that I do not seek to settle any of these debates. My purpose is to draw attention to them so that researchers working within the sport and exercises sciences intending to use visual methods might be in a stronger position to make informed choices about how to conduct, analyse and present their project.

One continual topic of contestation is that of *interpretation*. Undoubtedly, there are diverse approaches employed when collecting and analysing visual data as observed by van Leeuwen and Jewitt (2001). These authors highlight how some methods of analysis are more methodological than others, outlining very precise criteria for analysis and in doing so offer an impression that visual analysis can be followed in much the same 'step-by-step' way as a recipe in a cookbook. Other forms of analysis are far less precise, especially those found within cultural studies, narrative inquiry and ethnomethodology, where analysis is viewed far more as a complex process. The researcher is required to shift between, on the one hand, a careful structural analysis of set parts, whilst, on the other hand, demonstrating an intuitive grasp of the whole. Sorting through evidence with specific questions is combined with

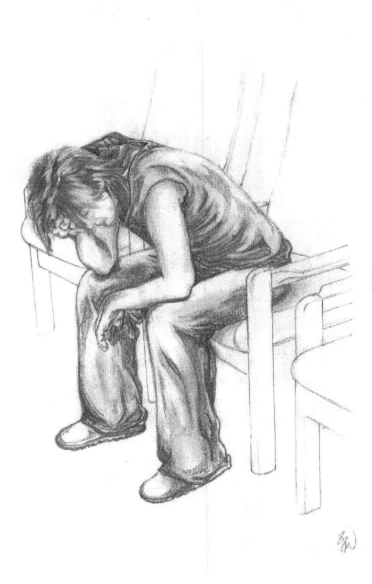

Figure 5. 'Accident & Emergency' image produced by Westcott (2007).

sensitivity to the data's subtleties and overtones. For van Leeuwen and Jewitt, it is the employment of artistic or intuitive creativity that is essential to discovery *alongside* systematic detailed analysis that optimises the usefulness of interpreting visual images. Thus, whilst the variety of approaches to interpret one's visual data can initially feel unnerving, it can also be recognised as an endearing trait. Indeed, Pink (2007) has gone so far as suggesting that the very presence of textbooks offering prescriptive frameworks which encourage distance, objectivity and generalisability detracts from the very strengths, uncertainties and expressivity that can be gleaned from visual methods.

The topic of *representation* is a familiar one within qualitative research, and comprehensively discussed by Andrew Sparkes (2002) in his book, 'Telling Tales in Sport & Physical Activity'. Absent from this publication is a chapter focusing upon imaged-based research. This is perhaps indicative of the traditional tendency to focus on words within qualitative research in sport and exercise sciences. Yet, how best to represent visual research seems to be a contested area within the field of visual studies itself (for different media and modes of visual data representation, see Prosser and Loxley 2008). A critical area of this argument centres on the relationship of images with text.

Referring specifically to photography, Harrison (2004) asks, is it 'possible for photographs to narrate independent of written or oral word?' (p. 113). Should visual data 'speak for itself' and be left to the interpretation of its audience? By inserting written or spoken commentary alongside images, are we defeating the very power and purpose of the visual? Harrison distinguishes between what people *see* in an image, and what people may *say* about it. She proposes – and I am inclined to agree – that it is through some form of verbalisation that we generally have to rely in order to gain understanding of an image, much the same as people communicate the meaning of visual images in everyday life.

> It is not that pictures cannot tell stories in themselves, or that viewers cannot be invited to 'see' images in this way, but rather for the social scientist, we need to know what these stories or readings are … Its [the images] narration will provide us with an understanding of how it is such images do their 'work' as a material part of people's everyday lives. (Harrison 2004, p. 132)

Take, for example, the photograph shown in Figure 6:

What does this say to you?… What meaning is being conveyed here?… If, as we looked on, I said to you 'this picture says so much, doesn't it!', would you (feel pressure to) agree? Why?…Why not? (For those who require some form of 'verbalisation' to glean anything from this image, refer to Note 1).

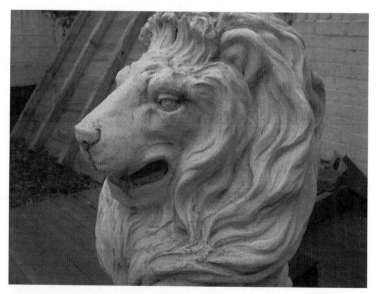

Figure 6. Image provided by Phoenix and Sparkes (2009).

In contrast to Harrison (2004), Rich (2004) argues that 'showing *is* telling'. He bemoans the assumption that images must be translated into words for analysis and discussion to occur, and asserts that doing so reinforces a lack of clarity and cohesion that plagues visual research. Likewise, the suggestion that 'pictures don't say anything, words do' is fiercely challenged by Chalfen (2004). He argues that rather than asking 'what is this image saying/doing?', the question should be 'what do we bring to this image in conjunction with what we are supposed to do with this visual text (if anything)?' (Chalfen 2004, p. 145). Such an approach, Chalfen suggests, take us in a more fruitful direction – a direction where the material and symbolic significance of the image acts as a vehicle of communication, which contributes to the fabric of social relations.

A key issue within this ongoing area of tension concerning the issue of representation appears to be the prioritising and valuing of *verbal* knowledge over *visual* knowledge. Yet, visual studies have also received criticism that sight is regularly foregrounded at the expense of other senses like smell and taste. Researchers should be aware of this when considering the use of visual methods, and be mindful of what other senses can offer as ways of knowing. This has been recently published in *Qualitative Research in Sport and Exercise Sciences* by Sparkes (2009), Hockey and Allen Collinson (2007) and Allen Collinson (2009). These authors have made strong cases for bringing the senses into sport and exercise sciences. Sensorial experiences are important because sensory relationships are essential domains of cultural expression and communication, and are the means by which values are enacted. Prosser and Loxley (2008) note how creative research methods, including sensory (of which vision can claim to be the dominant sense) and arts-based approaches are increasingly emerging as researchers strive to answer more complex questions about (visual) society. To date, more common contributions to this genre include collage as inquiry, installation art-as-research and ethnodrama (see Sparkes 2002, Douglas and Carless 2005).

Visual-based research is dynamic and multidimensional. As an increasing number of qualitative researchers make the 'visual turn', to ensure distinctiveness and robustness of visual studies, we must familiarise ourselves with the lay of the land. We must become articulate in theoretical and conceptual debates. And, as we negotiate new terrains in terms of data collection, interpretation and representation, we must ensure that we do no harm to our informants and work with visual data in moral and ethical ways. It is this topic in particular to which I turn now.

Knowles and Sweetman (2004, p. 12) suggest that there are a number of key difficulties with visual methods, not least considerations that should include, 'the problem of ascribing anonymity or confidentiality to research subjects who have been photographed, equipment costs associated with the use of photography and video, difficulties with dissemination – particularly where images are in a moving form – and issues of copyright where already existing images are employed'. The issue of ethics is also huge, (hugely) complex, and has been comprehensively discussed elsewhere in ways that go beyond the scope of this overview (see Simons and Usher 2000).[2] Suffice to say that like all forms of social research, ethical considerations are relevant to each stage of the visual research process from its initial conception to the final dissemination of the results and beyond.

Pink's (2007) sentiments directed towards visual ethnographers are especially worthy here. She suggests that:

> Ultimately, the decision will be a personal one for each ethnographer has to decide whether his or her research practices and representations are ethical before these are held

up to the scrutiny of others who will then interpret this question for themselves. (Pink 2007, p. 51)

In my work with mature, natural bodybuilders like Pink, I felt obliged to 'protect' my informants by attempting to represent them as health-conscious, relational individuals, and portray their understanding of bodybuilding in a way that suggested that they did not fit the 'drug fuelled, obsessive underworld' that others often associate with bodybuilding per se. A second point worth noting here is Pink's proposal that when using visual methods, consent should be *ongoing*. Obtaining initial informed consent, she argues, should not be considered to give the researcher the moral right to use the image in unrestricted ways over time and within different contexts.

Ethical issues within visual research do indeed constitute what Prosser (2000) terms a 'moral maze'. Careful and ongoing consideration is required by the researcher, who must also be simultaneously receptive of ethical frameworks advocated by other forms of qualitative research (participant observation, interviewing and so forth). Yet the complexity should not become a reason to halt the progression of viable, responsible and potentially enlightening visual method projects. On this issue, Prosser and Loxley (2008) contend that due to the relative newness of visually orientated research – as is especially the case within the field of physical culture – there is limited agreement amongst ethics committees and visual researchers on ethical guidelines and resultant practices. This lack of consensus is particularly prominent here because visual-based research constitutes a range of visual media applied in a number of ways, and does not form a homogeneous collection of technologies, procedures or techniques. Prosser and Loxley express concern at the gatekeeper status often afforded to codes of practices and ethics committees within universities and other institutional settings. They argue that overly restrictive situations can easily arise, protecting institutions and sponsors at the expense of letting participant's stories be heard. The reason being that, 'committees comprise of members from epistemologically dissimilar academic disciplines who would scrutinize proposals differently and may look on minority (visual) methods judgementally' (Prosser and Loxley 2008, p. 48). As qualitative researchers, perhaps this is a familiar scenario to us all.

In this respect, the latest contribution by Denzin (2009) is thought provoking and might stir 'a narrative of passion and commitment' (p. 82) in colleagues who find or have found their (visual) work being judged, graded and perhaps even blocked by positivists and post-positivists operating within science-based research (SBR). As we progress across relatively new terrain – such as the use of visual methods in the study of physical culture – to draw upon Denzin's words, our experiences might resonate with those of an intruder, like an elephant in the SBR movement's living room. Yet, Denzin also offers an alternative interpretation of this scenario and invites qualitative researchers to consider that, maybe, the elephant is in fact located in *our* living room. He explains:

> With notable exceptions, we have tried to ignore this [SBR] presence. Denial has fed codependency. We need the negative presence of the SBR to define who we are. For example, we have not taken up the challenge of better educating policymakers, showing them how qualitative research and our views of practical science, interpretation, performance ethics can positively contribute to projects embodying restorative justice, equity, and better schooling. (Denzin 2009, p. 81)

The time has come, it would seem, to engage policymakers, grant-funding bodies, directors of research and ethics committees in a dialogue about alternative ways of conducting and evaluating quality research within sport, exercise and health sciences. We have not always engaged SBR advocates in these conversations, and nor have they always accepted our invitations for dialogue. Yet, if we are to move forward positively, we must resist the temptation of embedding ourselves within a victim narrative. Though easily recounted when negotiating with committees whose templates seem ill-aligned to our research aspirations, Denzin (2009) argues that we must strive to take some responsibility ourselves, for 'we have allowed the SBR elephant to set the terms of the conversation' (p. 81). For those of us working within the domain of physical culture, perhaps this special edition might equip us with a resource that can assist us as we proceed with this educational and dialogical task.

Introducing the special edition on *visual methods in physical cultures*

I am thrilled to introduce this special edition of *Qualitative Research in Sport and Exercise Science*s on 'Visual Methods in Physical Cultures'. I would like to extend my sincere thanks to all who have *made this happen*; the authors, whose contributions have ensured a varied and exciting additions to the field; the reviewers for a willingness to share their expertise and experience in image-based research; QRSE editors David Gilbourne and Brett Smith – the special edition would not have been possible without their insight, receptiveness and encouragement to pursue qualitative research in sport and exercise; the publishers Taylor and Francis for their continued support in this venture, particularly shown in the construction and management of the journal's website (http://www.informaworld.com/rqrs).

The edition opens with two visual ethnography papers. The first examines the sport of fell running by Canadian-based Michael Atkinson. Drawing upon French post-structural theory, he infographically illustrates the allure of post-sports like fell running to people who wish to immerse themselves in rather novel contexts of desire-producing, personally rewarding and spiritual activity. This is followed by Clive Pope's visual ethnography of New Zealand's major high school rowing competition 'the Maadi Cup'. Pope's analytical focus is concerned with the material culture of the competition, namely the wearing and trading of T-shirts by the competitors. Moving from researcher-*created* data, to researcher-*found* data, the next contribution is from Meridith Griffin who considers the role of visual and material culture within a UK-based women's only running group (the Women's Running Network) to examine how women are *told* and *shown* particular gendered and embodied identities prior to joining the club. Having discussed how the media and running organisation(s) construct visual images to portray the sporting body in a particular way, the fifth paper in this edition by Vikki Krane and colleagues takes a slightly different approach. Joining feminist cultural studies and social psychological theory, these authors examine how a group of US female college athletes *prefer* to be represented by inviting them to direct their own photo shoot. Branching away from photography, Hannah Gravestock brings to the edition an ethnographic study of arts-based research. Focusing on drawings of the performing body, and the sport of figure skating, she discusses the external visualisation of an internal thought process through mark-making and considers the potential it has for the field of image-based research.

The following three papers convincingly illustrate the value of auto-photography studies for understanding informant's experiences of physical culture. Together, they

highlight the suitability of this respondent-led method for including hard-to-reach/ marginalised groups. In doing so, they illustrate the rich insight that can be gained when including all age groups into the research agenda of sport and exercise sciences. Laura Azzarito and colleague Jennifer Sterling begin by exploring the ways in which young people of different ethnicities in two inner-city UK schools engage in physical culture within their everyday lives. Next, Karen D'Alonzo and Manoj Sharma focus upon the influence of *marianismo* beliefs on participation in habitual and incidental physical activity amongst middle-aged immigrant Hispanic women living in the USA. The final auto-photography study featured in this special edition is that of Canadian-based Joanie Sims-Gould and her colleagues, who examine how older women perceive and visualise their physical health and the benefits of engaging in an exercise programme.

Shifting the focus from physical education, health and well-being *back to* competitive-sporting performance, Jim Cherrington and Beccy Watson co-author the first of two contributions that use the medium of film to gather respondent-generated data. Their paper 'Shooting a diary, not just a hoop' illuminates the significance of video diaries as creative visual methods within social science-based research on sport. Members of a UK University men's basketball team were invited to keep video diaries over a period of time as a means to gain insight into the everyday, identity, and the body. Finally, reminding us that athletic performance is not exclusive to the young, the concluding paper by Mary Ann Kluge (in collaboration with colleagues from the USA and New Zealand) outlines the process, problems and possibilities of making a documentary film. The film in question was developed with, and about her friend and colleague, Linda Glick who, at the age of 65, decided to become a masters athlete and compete in the US Colorado State Senior Games.

Clips of the video diaries, film and (colour) images produced by all of the contributors can be found on the journal's website at http://www.informaworld.com/rqrs. All at QRSE along with myself hope that you will find this special edition thought-provoking, exciting and insightful. We also hope that it will act as an impetus for further high quality, high impact (however one chooses to define it) image-based research within the field of physical culture.

Notes

1. This photograph of a lion statue was produced by a mature natural bodybuilder (male) as part of an auto-photography task. He had been asked to show what 'a month in his life' was like through photography. Amongst the many images he produced during this time, a significant proportion depicted the lion; cuddly toys, fridge magnets, paintings, a statue in his garden (as shown), and a bronze sculpture in his house. During the follow up interview, I asked what the significance of the lion was to his life. He replied:

 I'm a Leo I was born in August so therefore I use the symbol of my birthday as a style just to show of my activity, my identity really and that's where the lion comes … Even in my garden there's a lion statue. I've got a lot of soft toys that are lions. A lot of people actually give me gifts of lions because that's what they look at me as being. They say I look like a lion, you know what I mean, I growl like one sometimes as well (laughs) and then there's the hair … But it's a good sign because a lion is strength, power, and a king of the other animals, and respect, so therefore if you come to that, all the good qualities of that like you *carry out your Leo birthright, fight power with power.*

 This further elaboration brings, in my opinion, far richer meaning to what the symbol of the lion signifies in the participants life, than the image does alone.

2. I would also direct readers towards the statement of ethical practice for The British Sociological Association's Visual Sociology Group: http://www.visualsociology.org.uk/about/ethical_statement.php).

References

Allen Collinson, J., 2009. Sporting embodiment: sports studies and (continuing) promise of phenomenology. *Qualitative research in sport and exercise*, 1 (3), 279–296.

Banks, M., 2007. *Using visual data in qualitative research.* London: Sage.

Chalfen, R., 2004. Hearing what is shown and seeing what is said. *In*: M. Bamberg and M. Andrews, eds. *Considering counter-narratives, narrating, resisting, making sense.* Philadelphia: John Benjamins, 143–150.

Chaplin, E., 2004. My visual diary. *In*: C. Knowles and P. Sweetman, eds. *Picturing the social landscape: visual methods and the sociological imagination.* London: Routledge, 35–48.

Denzin, N.K., 2009. *Qualitative research under fire, toward a new paradigm dialogue.* Walnut Creek, CA: Left Coast Press.

Douglas, K. and Carless, D., 2005. Across the Tamar: stories from women in Cornwall. Audio CD. Available from: http://www.acrossthetamar.co.uk/ [Accessed 28 April 2010].

Grady, J., 2004. Working with visible evidence: an invitation and some practical advice. *In*: C. Knowles and P. Sweetman, eds. *Picturing the social landscape: visual methods and the sociological imagination.* London: Routledge, 18–32.

Harrison, B., 2002. Seeing health and illness worlds – using visual methodologies in a sociology of health and illness: a methodological review. *Sociology of health and illness*, 24 (6), 856–872.

Harrison, B., 2004. Photographic visions and narrative inquiry. *In*: M. Bamberg and M. Andrews, eds. *Considering counter-narratives, narrating, resisting, making sense.* Philadelphia: John Benjamins, 113–136.

Hockey, J. and Allen Collinson, J., 2006. Seeing the way: visual sociology and the distance runner's perspective. *Visual studies*, 21 (1), 70–81.

Hockey, J. and Allen Collinson, J., 2007. Grasping the phenomenology of sporting bodies. *International review for the sociology of sport*, 42 (2), 115–131.

Holliday, R., 2007. Performances, confessions, and identities: using video diaries to research sexualities. *In*: G.C. Stanczak, ed. *Visual research methods: image, society, and representation.* London: Sage, 255–281.

Knowles, C. and Sweetman, P., 2004. Introduction. *In*: C. Knowles and P. Sweetman, eds. *Picturing the social landscape: visual methods and the sociological imagination.* London: Routledge, 1–17.

Packard, J., 2008. 'I'm gonna show you what it's really like out here': the power and limitation of participatory visual methods. *Visual studies*, 23 (1), 63–77.

Phoenix, C., forthcoming. Auto-photography in aging studies: exploring issues of identity construction in mature bodybuilders. *Journal of aging studies.*

Phoenix, C. and Sparkes, A.C., 2009. Being Fred: big stories, small stories and the accomplishment of a positive ageing identity. *Qualitative research*, 2 (9), 83–99.

Pink, S., 2007. *Doing visual ethnography.* 2nd ed. London: Sage.

Prosser, J., 2000. The moral maze of ethics. *In*: H. Simons and R. Usher, eds. *Situated ethics in educational research.* London: Routledge, 116–132.

Prosser, J. and Loxley, A., 2008. Introducing visual methods. ESRC National Centre for Research Methods Review Paper. Available from: http://eprints.ncrm.ac.uk/420/ [Accessed October 2009].

Prosser, J. and Schwartz, D., 1998. Photographs within the sociological research process. *In*: J. Prosser, ed. *Image-based research: a sourcebook for qualitative researchers.* London: Falmer Press, 115–130.

Rich, M., 2004. Show is tell. *In*: M. Bamberg and M. Andrews, eds. *Considering counter-narratives: narrating, resisting, making sense.* Philadelphia: John Benjamins, 151–158.

Riessman, C. K., 2008. *Narrative methods for the human sciences.* London: Sage.

Rose, G., 2007. *Visual methodologies: an introduction to the interpretation of visual materials.* London: Sage.

Simons, H. and Usher, R., 2000. *Situated ethics in educational research.* London: Routledge.

Smith, R.T., 2008. Pain in the act: the meaning of pain among professional wrestlers. *Qualitative sociology*, 31, 129–148.

Sparkes, A.C., 2002. *Telling tales in sport and physical activity: a qualitative journey.* Leeds: Human Kinetics.

Sparkes, A.C., 2009. Ethnography and the senses: challenges and possibilities. *Qualitative research in sport and exercise*, 1 (1), 21–35.

van Leeuwen, T. and Jewitt, C., 2001. *Handbook of visual analysis.* London: Sage.

Westcott, E., 2007. Shadow of darkness. Unpublished thesis, University of Exeter, UK.

Fell running in post-sport territories

Michael Atkinson

Faculty of Physical Education and Health, The University of Toronto, 55 Harbord Street, Toronto, Ontario M5S 2W6, Canada

Readers should also refer to the journal's website at http://www.informaworld.com/rqrs and check volume 2, issue 2 to view the visual material in colour.

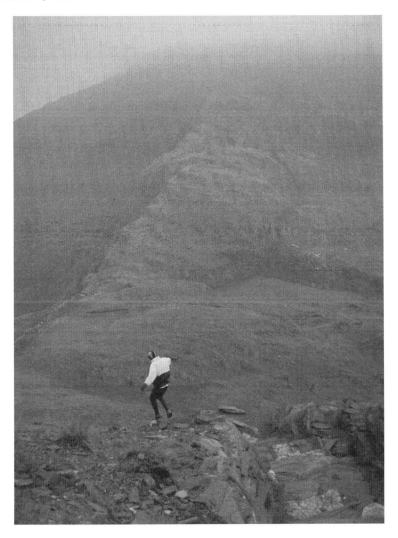

This paper explores the visual, embodied and interactive elements of the post-sport physical culture(s) of fell running. Fell running is textually represented in the paper as a physical cultural practice with many surface level, or 'residual', articulations of mainstream sport, but is deployed by many enthusiasts as a novel praxis of athletic engagement that cultivates communion with the self, others and the environment. By unpacking ethnographic and photo-elicitation data gleaned through a study of fell running in the English midlands, and drawing from several core concepts in French post-structural theory, I infographically illustrate the allure of post-sports like fell running to people who wish to immerse themselves in rather novel contexts of desire-producing, personally rewarding and spiritual activity. The paper represents how increased recognition and promotion of a broad range of post-sport cultures within the global athletic ethnosphere might promote mass, and sustained, involvement in physical activity across a range of groups.

Prologue: running on empty

That's me in 2006 (Figure 1) at the end of a mid-distance duathlon race in Collingwood (Ontario, Canada) – probably in the best aerobic condition of my life. Upright, alert, refreshed and vibrant at the end of the tricky course in the 35°C summer heat. I could run for days without fatiguing and loved punishing myself through long-distance events. I ate it up. I competed in about 40 duathlons, half-marathons and marathons between 2005 and 2007, and my hunger for those sports during that time knew no satiety. Duathlon was new to me then; I had developed a tight friendship network with other duathletes and triathletes, and my sporting success in the Ontario race series in 2006 fit nicely with my construction of sport as a quintessential middle-class zone of meritocracy.

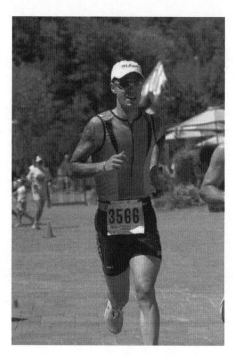

Figure 1.

In the summer of 2007, here I am crossing the finish line at the Powerman Duathlon long-distance championships in Zofingen, Switzerland (Figure 2).

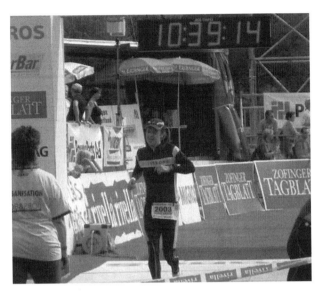

Figure 2. Warning: internal server error.

My crumpling, misshaped finish line pose says it all. I was physically, mentally and emotionally battered throughout the race and it showed (horribly) in the end. I had moved to the UK only a few months prior to the Zofingen championships, and while acclimatising to a new job, British culture and improvising while our household furniture remained in transit for three months (including my race bike!), training time and focus suffered. Within the first 10 minutes of the Zofingen race, I felt utterly drained, disinterested and ready to quit distance sports forever. I spent the first hour of the race trying to find any excuse just to keep going. I trudged onward and tried my best to enjoy the Swiss countryside, ultimately performing slightly beyond my expectations – but something else nagged at me over the entire course. I could not pinpoint the source of my existential discomfort and race day implosion at the time. Just sour grapes over not performing well? Well, no, because I travelled to Zofingen just to absorb as much of the elite duathlon culture there as possible, and to merely 'do the [world famous] du'.

When I look at the picture above, I can recall every phenomenological detail of dragging my sorry carcass across the finish line. I wanted to find my son Eoghan and go back to the hotel to switch off. I did not want to eat or drink, sit down, congratulate fellow participants or check my results. The end mimicked the entire race, as every step up or down the hills, every pedal across the low Alps and every agonising creep felt forced. Friends and family said I had burned out from overtraining and excessive racing over the previous three years. Perhaps. That would certainly explain my mental and physical exhaustion and sporting alienation. But it would not, as I came to reflect upon a month or two after Zofingen, explain my spiritual angst. I realised that I could no longer 'connect' with distance sport; I had 'separated' from the physical practice of racing and its culture. I no longer identified with the activities because after the several year (initial) thrill ride of being involved, I could not imagine what, beyond a

gruelling test of my will against others, I gained or learned from races as a human being. I suffered through races without purpose or reason, passion or desire. It took Zofingen to teach me that lesson and to make me reflect on what I already knew deep down.

I quit competing and scaled training down just to 'keep in shape'. Another child, Finnegan, came along and I had good reason (or maybe self-determined justification) not to miss distance sport. Not so coincidentally, I started two ethnographies around the same time: one in a Parkour culture and the other among Ashtanga yoga enthusiasts. Parkour and Ashtanga were like nothing else I had studied sociologically. Their associated practices, ethics, values and encompassing physical cultural lifestyles are, according to everything I have learned or experienced in athletics, markedly *anti-sport* (Atkinson 2009). Over the course of two years in each setting, my athletic batteries were partly recharged. Through their study I came to investigate the viability of *post-sports* Pronger (1998, 2002) articulated.

The considerable growth in post-sport cultures is a noteworthy, late modern phenomenon. Post-sports, including skateboarding, windsurfing, adventure racing and trials (bike) riding, emerged over the past three decades within a diffuse late modern pattern of boundary crossings and the ongoing de-centring of traditional [sporting] forms (Heaphy 2007). Across the late modern sports ethnosphere, doors have been opened for the exploration of non-mainstream physical cultural forms, identities, lifestyles and practices that do not perfectly emulate or replicate hyper-competitive, hierarchical and patriarchal modernist sports. The destablisation of modernist boundaries has ironically paved the way for a partial eclipsing of traditional modernist physical practices within sport, including their de-institutionalisation, diversification, moralisation and structuring around ideologies of egalitarianism (Atkinson 2009). Late modern life in North American and Western Europe is indeed a fertile social environment for exploring subaltern forms of existential and deontological truth, morality, desire, authenticity and purpose through a variety of non-traditional, boundary crossing physical cultural practices that might loosely be called *post-sport athletics*.

Post-sport athletics challenge modernist physical cultural ideologies and practices, and challenge boundaries demarcating the sacred and profane, the raw and the cooked, the civilised and the primordial through rigorous movement. Whereas modern sports practices contain discipline and enframe physical bodies as spectacular resources to be deployed toward the attainment of competitive, rule-bound and performative outcomes, post-sport athletics mostly eschew the modernist body-as-resource schematic. Post-sport athletics can be moral, reflexive, community-oriented, green, spiritual, anarchic and potentially eros-filled physical cultural practices. They quite often adorn the guise of mainstream sports forms and techniques of play (e.g. swimming, running or cycling) – what Wheaton (2004) describes as 'residual' elements of modernist sport – but their individual or collective experience bears little similarity. Post-sports are thus sinewy and connected athletics that inflect anti-commercial, co-operative ideologies over the competitive. They do not fetishise advanced material technology, are socially inclusionary rather than hierarchical, process-oriented, holistic and internally differentiated in their orientation and engagement.

Very few have written about or explored what existential post-sports might look like, their ethics and practices, or how increased public participation in them might reconfigure sensibilities about popular physical activities and sporting lifestyles (Rinehart and Sydnor 2003, Wheaton 2004). Given the growing disengagement and disillusionment shared among clusters of youth in North America and Europe with

institutionalised sports (Atkinson and Young 2008a, 2008b), there are strong grounds for heightened sociological scrutiny of physical cultural practices which are more inclusive than exclusive, and those fostering an overall sense of personal and collective well-being (i.e. versus well-being measured by a body mass index or a mood state scale). To me, the promise of academic engagement with post-sport athletics lies in the chance for sociologists to learn something that is rather theoretically surprising regarding the cultural logics underpinning non-mainstream physical activities. Post-sports tend to be zones wherein important existential lessons about human spiritual and moral conditions are taught, and these serve as baseline points of social connection for participants. For example, post-sport surfing cultures (Booth 2002) often promote the spiritual transcendence and the existential grounding participants may experience while communing with waves, water, sun and all ocean life. Participants routinely express how their long-term involvement in surfing is not about competitive performance, getting a good workout or deriving external rewards from athletics, but rather how the practice nourishes their minds, bodies and social selves in the process of developing a community *style of life* composed of mutually oriented and supportive peers. In Evans *et al.*'s (2009) terms, they allow for a wide exploration of the 'corporeal device', or the ways in which present 'fleshy' bodies can be experienced as a desiring subject of activity and producer of meaning.

Pronger's (2002) critique of Western sports cultures rings with incredible empirical relevancy in the study of post-sports cultures such as Parkour, Ashtanga, surfing and others. Pronger (2002) weaves together a complex and convincing blend of post-structuralism, Heideggerian existentialism and queer theory with Buddhist thought in order to expose how a majority of Western sports experiences are dominated by external *pouvoir*; or more simply, that one's desire to participate in sport, relationships and positions forged through sport, experiences therein and identities as athletes are indeed pre-shaped by cultural goals and values (i.e. late capitalist logics of dominance, winning, external reward, social distinction through vanquishing others, the cultivation of cultural ideal-type bodies and the maintenance of political-economic social hierarchies) which are not one's 'own'. Bodily energies and desires to move, to express and to find existential joy in athletics are literally *re-sourced* (Heidegger 1954/1977) and channelled into competitive sports practices – be it against a clock, against an opponent or against the natural elements. Post-sports, according to Pronger (2002), may promote a re-centring of the individual as a desire-producing, lustful agent of movement. Athleticism becomes a site of flow between people and 'thing', through the connection of energetic *jouissance* (Deleuze and Guattari 1972, 1980, Pronger 1998). Prout (2000) reminds us that athletes in this sense are made through a complex blend of nature (bodies, flesh, emotions and desire) and culture. As such, energetic interchange between people, animals, material objects and even imagined realities can be explored in a type of connective 'network' fashion as described by Latour (2005). Human desire and flow exploration in post-sport, what Pronger (2002) refers to as the realisation of one's potential or *puissance*, is thus unhinged from the credo and ethics of capitalist, technologically enframed and spiritually limiting mainstream sports.

Three months and 17 days after Zofingen, I re-read Pronger's *Body Fascism* (2002) while languishing on a ridiculously delayed and uncomfortable plane ride to Canada from the UK. Across its pages, I read a perfect summary of me tired, bored, irritated and spent in Zofingen. I connected with his theoretical argument about the enframing of bodily desires and meaning in athletics in a way I had never imagined I could as a

sociologist. I reflected on my own experiences in distance sport and other sports across my life. His critical interpretation of how body flows (desires) are blocked, energies are contained and spiritualism is predominantly excised from mainstream athletic cultures resonated.[1] My body did not want to move or to explore any longer in hyper-*pouvoir saturated* sport settings. I felt disconnected from the physical culture(s) of organised distance sport or potential for my growth/desire there. I reflected on how my socially instilled and demanded desire to place, beat a personal best or conquer others while racing (each of which served to organise my training and racing activities) had been arranged and culturally pre-packaged for me in this modernist sporting *assemblage* (Deleuze and Guattari 1980). Evans *et al.* (2009) might comment that my body, like many of those engaged in modern sport organisations, became an overly discursive 'body without flesh'. My motivations to run and to perform as a modern athlete were hierarchically ordered before I even stepped onto the starting line; the cultural script for duathletes/runners like me had been written, by and large, by an impetus to approach the body as a machine of middle-class distinction through sporting deployment – as a spectacle of modern capitalist achievement in Debord's (1967) sense. In the end, I considered if and how many mainstream sports treat the individual as only a *body with [modernist/discursive] organs.*

Late modernity has drawn, perhaps unintentionally, the pervasive lack of *puissance* in contemporary sports cultures into sharp relief. Theorists of late modernity, including Beck (1992), Bauman (2005) and Giddens (1991), respectively, note how the transitory, de-traditional, impermanent and hyper-reflexive nature of late modern life is anxiety-invoking for people in cultures infiltrated by neoliberal praxis. Why? Because people often encounter the nature of life in late modern *seasonal society* (a society where meanings, identities and notions of reality change or may be exchanged as regularly as the seasons change) as increasingly unappealing – as, one which is organised less by ontological stability, meaning or existentially charged activities designed to democratically tap *puissance*, and more by exclusionary and alienating neoliberal norms of self-reflexivity and improvement, commodity-fetishism, and activities governed by techno-capitalist *pouvoir*. As a strange twist of fate, the collective recognition of imploding state-welfare systems, the implosion of modernist identity categories, and recent backlash against polysemic cultural truth-telling as part of the North American neo-conservative 'recovery movement' (Kincheloe 2008) can actually force public reflection on (late) modernist practices, their enduring ideological baggage and their physical outcomes. Crumbling welfare structures, risk conditions and the return of conservatism could actually be a perfect context from within which to call for socially democratic, liberating and inclusionary (sport) practices.

Consider, for example, the literature on pain and suffering in sport. Reams of sociological evidence documents how athletes experience pain, injury and suffering not on their own terms, but through the victimising ideological lens provided within late capitalist sport cultures for little or no purpose other than for performance-based glory, in-group acceptance or approval from hegemonic authority figures (Malcolm 2006). Brutal forms of self-harm are justified, negated, silenced or seemingly celebrated as markers of true sports[man]ship. As (especially elite) sport is growing in global importance as symbolic markers of social and cultural development and progress for nations, it seems as if the pressure to play while injured or suffer through great personal trauma in the name of sport has never been greater. Sociologists of sport, such as Nixon (1996) and Young (2004), have long questioned the existential logic, or long-term personal benefit, of individual acceptance of pain and injury codes in sport. And, finally, it

seems more athletes, coaches and parents centrally involved in sport are doing the same; if recent court cases against leagues and teams which hegemonically 'convince' athletes to play while injured or in dangerous contexts of play, who refuse to allow dissent from parents or coaches who object to dominant pain practices, or attrition rates in contact sports in countries like Canada and the USA teach us anything (Atkinson and Young 2008a). Contexts and discourses of hyper-reflection, neoliberal choice, 'healthism' and the impetus toward self-monitoring – though rightfully decried by other critical pedagogues including Giroux (2005) and Andrews (2006) as part of corporate culture in the West – may become existential forces that press publics to question what athletic values, beliefs and choices we hold for ourselves in our everyday lives; and most important, to seek new collective alternatives.[2]

Advocates of post-sport are clear about their choices and preferences for socially alternative athletics. Over the first year of my separate ethnographies among Parkour enthusiasts and Ashtanga participants, for example, they indicated to me that the more people see athletic movement and competition/desire outside of the machinations of our self-production, the more personal dissatisfaction follows (Atkinson 2009). We realise that we do not desire because we lack something and wish to procure it, but rather we simply do not express desire in meaningful, sustainable, connective ways that generate existential flow between *machines*, as Deleuze and Guattari (1972, 1980) describe. For Deleuze and Guttari, a machine can be anything animate or inanimate and may be composed of smaller desire-producing machines each of which sits on a [energy] flow and can *interrupt* (connect with) the energies of other machines. Deleuze and Guatarri (1972, 1980) describe the body itself as system of desire-producing, energetic machines. There can be neither a starting point nor an ending point of a flow process between the machines, as the flow is created and transformed through the 'interruption' between many machines over time. If we recognise this property of machines, we understand how there are never isolated molecular or nomadic machines (i.e. people, animals, landscapes, athletic equipment, etc.) but rather many interdependently connected to others in a vast web.

Post-sport practices not only connect machines in desire-producing ways (i.e. bodies, landscapes, wind, sun, animals, athletic equipment and so forth) but also operate under a central ethic of *de-territorialisation* (Deleuze and Guattari 1980), that is the de-territorialisation of athletics flows and desires from modernist sport zones.

> *De-territorialisation:* a physical cultural process of moving away from rigidly hierarchical contexts of interaction which packages people, activities, identities, and desires into discrete categorised units with singularly coded meanings.

De-territorialisation shifts people toward *rhizomatic* (Deleuze and Guattari 1980) zones of multiple flows and fluctuant identities where machine operations connect and interrupt others freely, resulting in a dynamic, constantly changing set of interconnected entities with fuzzy individual boundaries (what Deleuze and Guattari also call, *dissipation*).Various techniques for *de-territorialising* are alluded to by Deleuze and Guattari in *A Thousand Plateaus* (1980). Parkour enthusiasts, yoga practitioners and other post-sport enthusiasts teach us that to de-territorialise athletics from modernist sport cultures, and to 'open up' the expression of energy, desire and movement in athletics, is not a tremendously difficult process. According to Deleuze and Guattari

(1980), the effects of de-territorialisation on the worldview of participants can be profound, as summarised by their descriptions of *lines of flight, de-stratification* and *bodies without organs (BwO).*

Ailleurs commence ici (Virilio 2005, p. 111)

My personal academic 'throwness' (Lyotard 1989) into the post-sport of fell running occurred in the late summer of 2007. Living in Canada for the majority of my life never exposed me to fell running. The physical, mental and emotional fission from my home country and relocation to the east midlands of England allowed me to discover this ancient physical cultural athletic. Fell running is a physically exhausting and mentally trying amalgam of cross-country, trail, mountain and, at times, wilderness running. Picture yourself as a typical road-running enthusiast and conjure up a mental image of running in the 'worst' spatial and climatic conditions possible. That is fell running. Fell running is typically undertaken in expansive, rugged, inclement highland or mountain areas by people from the upper working classes or middle-classes who range in age from 13 to (well over) 60 years old (Figure 3). A typical fell run traverses meadows, crosses rivers or waterfalls, shoots up and down steep hills, staggers across rocky terrain, lumbers through thickets, meanders over bogs and occasionally dodges animal herds. Fell runs vary in format and length, but normally range from 2 miles to (in excess of) 40 or 50 miles. They can be incredibly organised or very disorganised in a traditional sporting sense. Fell runners remain a small lot in the burgeoning global running figuration and as such tend to maintain rather close (sub)cultural ties within local counties. I came to fell running after being introduced to it by a [road] running club mate of mine in Loughborough (Leicestershire) and approached it at first as a training supplement (and then absolute alternative) to road running. After a few months in fell spaces and in reflection of my dissatisfying experiences with long-distance road racing, I radically changed my orientation to running. Like others who have become smitten with practice, it fits nicely into my personal interest for exploring physical activity along existential lines. Since 2007, I have spent several hundred hours running fells with other enthusiasts, participating in local 'races', speaking with fell runners whilst running, socialising in everyday life or simply sat around a table in a pub during a post-run recovery session philosophically scrutinising the virtues of the practice.

Fell running may actually appear like a traditional sport when we sociologically examine its cultural emergence and history. Although the date is somewhat disputed among fell running enthusiasts, the earliest fell race is believed to have run in Braemar, Scotland, between 1040CE and 1060CE with the staging of the Braemar Gathering hill races (Askwith 2004). From there, not much is known about fell running history in the UK until the mid-nineteenth century. By the nineteenth century, feel races were regularly staged across the British highlands during village and town festivals, and alongside other sports competitions, such as wrestling, sprint races or throwing events such as caber or hammer tossing. Competitors raced for both prize money and social accolade in rural communities who recognised and highly prized the competitors' abilities to navigate treacherous terrain. The sport developed both professional and amateur wings in Scotland, England and Wales through the mid-nineteenth century. The early emergence of the physical cultural practice, indeed, followed the

'sportisation' model that Dunning (1999) outlines. But the amateur wing factionalised and a small cluster of British fell runners in the British northwest promoted a cultural logic of practice very close to emerging mountaineering ethics and values held by the British Youth Hostel Association. As such, emphasis among this group of nature/exploration enthusiasts became increasingly placed on it as a wilderness sojourn among groups of loyalists rather than a racing spectacle for public consumption (Askwith 2004). Dissimilar to the counter-cultural/subcultural model of emergence and co-option prominent in Western sports – wherein an outsider or resistance sport culture emerges and then is appropriated into mainstream capitalist cultures (Atkinson and Young 2008b) – fell running developed an outsider ethos in the reverse. Their running routes and racecourses were lengthened and located in hard to reach wilderness areas, and an entire wing developed into a devout figuration of 'soul running' adventurists. The Fell Runners Association did emerge in April 1970 to help structure and organise the amateur sport in the UK (and now internationally), but the adventure and existential spirit of fell running remains alive and well among connected clusters of practitioners.[3]

Figure 3. Ethnographic beginnings.

As part of my personal/academic study of flow, connections, choices and post-sport athletics, I have spent the better part of two years running fells with enthusiasts in order to experience the practice first-hand, and as a vehicle for asking fell runners in the English midlands about their thoughts about its spirit, purpose and meaning. I participated in 27 races, logged over 200 hours in training runs and spent dozens of others with runners discussing the activity's essence. From a very early stage in the research process, I brought theoretical notes with me to our run sessions, used them as fodder for conversation to pass the hours spent driving to remote running spots and

often summarised them over weekend pub sessions. My goal was to encourage the runners to scrutinise my theoretical readings of the practice from the research's earliest stages. Individual and group conversations with fell runners became 'guided theoretical' (Stebbins 2001) dialogues and very open analyses of the existential aspects of fell running. Whereas I had initially approached the project from a figurational sociological perspective, their repeated references to the spiritual, emotional and soulful aspects of the practice led me to (re)visit French existential theory. We shared active conversations about existentialism and fell running as a process of recursive theoretical and methodological analysis (Gubrium and Holstein 1997). For instance, over tea one Sunday afternoon, a 30-year participant in fell running named Eric relayed to me that the meaning of the practice is easily shown but not narrated. He stimulated my sociological imagination further by asking, 'Do you not know about running fells far more by seeing them and touching them as a runner yourself? Can you, yourself, put into words those feelings?'

Following Eric's challenge, I began to experiment with two related visual techniques: *photo-elicitation* and *infography*. After five months in the field, I probed the potential of photo-elicitation as outlined by Harper (2002) as a means of digging analytically deeper into existential experiences fell enthusiasts regularly described to me, and which I experienced first-hand while running. Here, in order for readers to connect physically with a fell running landscape, and to see the fell runners' embodied actions, one should pay visual witness to a degree. First, we discussed aspects of *doing athletics in 'natural' settings* and the experiential effervescence and community bonding that is fostered through connecting with energies in rugged, rural places (what is discussed in this paper as a *biomimetic* process of re-territorialising athletics). Second, I regularly heard narrations about the importance of *communion* in athletics, in the sense of co-producing and experiencing desires and spirituality with others (and air, and the land) as part of running. Eric, and others, encouraged me to show these in my analysis rather than simply preach about communion. Finally, fell runners regularly recount the considerable and yet pleasurable, *physical and emotional suffering* associated with the practice. Suffering in fell running is commonly discussed in a manner evidenced in many post-sports, as a vehicle for self-exploration and transcendence: as a technique for 'forcing out' conscious daily thoughts and simply 'letting go'. To many of the fell runners, the physical process of suffering became cultivated as a technique for experiencing a simultaneous sense of *selflessness* and *present (energetic) awareness*. Again, Eric and others would encourage people to see this visually rather than only read about suffering in this respect. As a first step, I showed runners' pictures that thematically tapped each of the three clusters of stories. Photos of tough/ beautiful terrain, exhausted bodies, groups of communing runners, scenes from training sessions or organised races, and others were introduced to them at pubs or actually during runs as means of stimulating conversations about the phenomenology of running fells. From there, we talked about what it is like to feel the body running up a hill, down rocks, through rivers, in mud and in the misty mountain fog. Reflecting once more on Evans *et al.* (2009), we explored the phenomenological, fleshy body as a device of running and the discursively constructed and narrated fell experience. We tackled the experience of having hallucinations on long-distance runs, willing the body to feel comfort in uncomfortable settings and dealing with mouths parched from dehydration and feet caked in blisters. But the photos also generated deeply emotional accounts of the fraternity of fell culture, the psychological peace generated by fell running, and the connection to higher planes of spirituality and energy forged by

Figure 4. Post-sport dimensions of fell running.

running the fells. Figure 4 illustrates the three conceptual aspects of fell running stories that point to its consideration as a post-sport.

The second visual technique employed in the research is *infography*. I came to infography in heeding Erics' challenge to represent fell running visually, and through reflection on Virilio's (1977, 2005, 2007) construction of dromology (the science of socio-cultural speed), the art of the accident and apocalyptic art. Infography is a scarcely used visual technique in sociology. It is a representational technique based on the reduction of complex systems of information into 'simplistic' visual symbols and icons (Virilio and Petit 1999). In many ways, the body, or a picture of the body, is an infographic symbol of culture. Pictures capture and represent (in a multitude of ways) the carnally and socially experienced body. Virilio (2005) has argued that such forms of representation are becoming the norm in the emergent *cybermonde*, as psychologically relieving alternatives to cultural conditions of information overload and textual articulation to the death. Here, images used in the field as part of photo-elicitation and 26 selected from fell running websites in the UK were inserted into the text below as a means of visually communicating the post-sport culture of fell running. Though infography might seem reductionist, I employ the technique as a means of potentially opening up the representation of a person, group, identity, value system, set of practices or experiences by encouraging readers to see and decode the representation using their own interpretive resources (Gubrium and Holstein 1997). In other terms, infography can be used to allow variously positioned 'interpretive communities' (Fish 1980) to explore – albeit theoretically guided and 'encoded' (Hall 1980) in this paper around the frame of post-sport – communicated representations of social life in a range of ways. In a particularly important way, the representation of bodies with only 'limited' analysis encourages/forces/challenges readers to connect with the photo in order to make sense of them. This might be accomplished on purely intellectual or rationalist ways of seeing the photos (and as directed by a framing theory in a text), but also might be engaged in highly affective or embodied ways, that is readers coming to terms with the photos' content by literally trying to feel or empathise with the scene. Whereas traditional, or at least standard qualitative, texts silently enframe readers constructions of social life through the tactical orchestration of theory/data

representation, infography is fruitful in the process of encouraging audience engage-ment in, disagreement with, affirmation of or multiple-readings of texts along both cognitive and affective lines. While the following list is not meant to be definitive, infography might be classified as a technique that:

(1) integrates words and pictures in a fluid, dynamic way;
(2) stands alone as a representation, but is not entirely self-explanatory;
(3) reveals information that was formerly hidden or submerged;
(4) facilitates multiple, embodied readings of a practice;
(5) universally readable by audiences, but is subject to radical contextualism; and
(6) has aesthetic, artistic, pleasurable characteristics for readers.

In this paper, therefore, what I include as the 'data analysis' below are infographic representations of biomimesis (biomimicy), communion and suffering as key defini-tional features of fell running as a flowing, connecting post-sport. Excerpts or phrases from my ethnographic field notes or from conversations with fell enthusiasts are placed beside photos to render visible my interpretation of fell as a post-sport.

As emergent methodological principles underpinning the project, I deliberately moved away from the comforts and analytic ease of standard, open-ended interview-ing toward interactive data collection and representation methods that privilege first and foremost open, creative discussions about the central experiences and meanings attributed to fell running. The result is, I believe, a mosaic methodological approach that allows participants to considerably direct my theoretical reading of the data, and for audiences to see infographic representations of it as a post-sport. By using their own words, terms and ideas as starting points, we have together reviewed strands of post-structural theory (after some considerable, and at times awkwardly articulated, efforts by me) and stitched together an initial (but neither perfect nor complete) under-standing of fell running.

Utopia found? Critical engagement in post-sport felling

> We might say that critical engagement with real utopias is today an integral part of the project of sociological socialism. It is a vision of socialism that places human society, or social humanity at its organizing center, a vision that was central to Marx but that was too often lost before it was again picked up by Gramsci and Polanyi. If public sociology is to have a progressive impact it will have to hold itself continuously accountable to some such vision of democratic socialism. (Burawoy 2005)

Despite ongoing criticism within the academy, Burawoy's (2005) call for a more public sociology moves scholars to engage with a fuller range of audiences, and with more centrally defined problem-solving goals – such as the search for physically, mentally, emotionally and socially enriching forms of athleticism and leisure excised from the grasps of techno-modernist late capitalism. While sociologists of sport often lament the lack of progression of the sub-disciple toward public engagement (Carrington 2007), few seem ready, willing or professionally stiffened enough to

become public intellectuals in this regard, or to argue from more openly humanistic, moral and politically involved standpoints. While academics fervently debate the form and content of public sociology, a *public sociology of physical activity* or *post-sport* might, in principal, respect the diverse nature of people's expectations, uses and preferences for athletics and leisure; recognise that existing social problems in athletics are materially based and culturally mediated; produce theoretically informed and empirically verifiable suggestions for policy change in athletic organisations in order to make physical activity more accessible and equitable; help generate models of athletics as a site of social integration that celebrates diversity; and argue that athletic cultures are sites where health promotion is evident and human physical, intellectual, artistic and moral potentials are explored without fear or prejudice. In other terms, then, it might centrally advocate the study and introduction of a greater number of (post)sport physical cultures into everyday use. Such a public sociology of (post)sport must ultimately venture beyond theoretical and political critique, it must be able to engage with the aim of resolution. The three main aspects of fell running's post-sport character, I think, illustrate the value of advocating for post-sport styles of athletic engagement rather well.

Biomimicry

> Road running is contrived from start to finish. Estates are cordoned off and small motorways might even be used as your path. When you run it feels like you are a lab rat whizzing around a maze to the delight of the experimenters. If the surfaces [roads] were designed for cars, why should I run on them? (Steve, aged 33)

> *Biomimicry*: an ancient concept recently returning slowly to scientific thought that examines nature, its models, systems, processes, and elements – and emulates or takes inspiration from them to solve human problems. Biomimetics is often used for understanding and applying biological principles to human designs, therapeutic practices and systems configuration. The practice includes biomaterials, biomechanics, biological systems composed of individuals of one species, or multispecies assemblies.

> A friend of mine told me that to be happy running fell, and in truth in running at all, we need to adapt our bodies to be able to run like animals and work with the natural contours and rhythms of the earth. Humans are miserably inefficient runners because of what we run on to become good, like tracks or roads, is terrible to begin with. I can't explain it perfectly, but it's like something comes alive in you when you run off the beaten path as they say. Maybe some deeply buried instinct about how to move. (Stan, aged 39)

The first 800 m of the run went straight, straight up hill. At times, it felt like my nose could touch the grass in front of me. We crawled like a chain of ants in a line, scurrying up the terrain. Move up the hill. The task is to my body, mind and energy to work with the hill, not against it. To find its spaces and points of connection allows me to move quickly. Today, I learned how I need to have an intimate connection with the hill to find a peace there. Luke [fell runner] said to me that if I can imagine the line [of runners] as a big rope of energy or gust of wind caressing the hill, I will be up it in no time … I must think and feel with a hill, rather than just run up it (fieldnotes, June 2008).

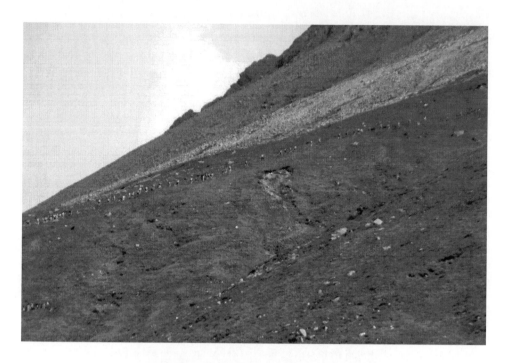

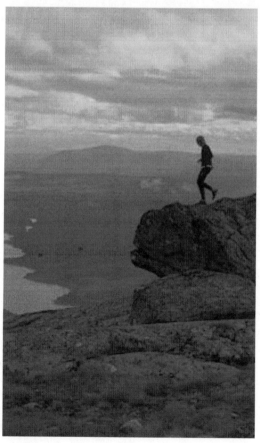

Most of the seriously tough runs take you up the summit of a hill, to a peak where everything in your mind is shot out of consciousness like a cannon ball. It's like a door opens into another universe or vortex, where time and space and everything comes to an abrupt halt and for that one fleeting moment you see and feel the earth, and you are whole. Just maybe it's a post-endorphin rush after climbing a steep ascent, or maybe it's the spirit in you awakening. (Kevan, aged 43)

A good course … well, that's one where you spend, let's say, an hour or two or three running and it seems like ten minutes has passed … it's one where every sense is pricked and prodded and taken to the limit. I sample all of the ground's ridges and bumps, change pace, feel mud and wind and rain, and duck, and jump, bend, and run … and when I finish, I don't feel as if I have beaten anything. Not another person, not a time, and certainly not the course itself. No. That's not it. I felt like I was a part of nature because I ran with it. (John, aged 29)

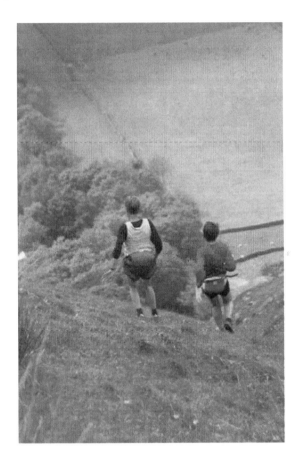

Running down the three-mile descent of the fourth fell today hurtled me to a place of fear and ecstasy I had never experienced in sport. I remember riding a roller coaster at Canada's Wonderland [amusement park] 15 years ago and the feeling of reaching the first climb, and then the gut-wrenching fall downward. That's it precisely with a long drop on a huge fell. Gravity pulls you back into reality, and with legs akimbo, like a cartoon character whose legs swirl in a hurricane of speed, you experience the falling ying to the climbing yang. I have never moved as fast in my life, and I have never been as out of control with my body either. That's the secret, I think, to let go

of control and loosen your body and let the hill do its thing. If you fight it, you will lose with extreme prejudice. I cannot help but think that the hill as de Certeau (1984) might, as a 'tactic' for experiencing sport in a different way. Or, maybe DeBord's (1967) sense of the term 'détournement' captures it best (fieldnotes, April 2008).

Communion

After five or six pints at the pub talking with Gary and Bob after the run tonight, I think I have it. I can appreciate what fell runners are teaching me about communion. Upon first glance, the act of fell running might appear as a collective effort to conquer nature, traverse its boundaries with honed athletic skill and beat its unforgiving essence. I had that impression when I first started. What an idiot I am, and probably say something about how my interpretations of nature are still derivative of colonialist, imperialist and modernist thinking, and reflective of how mainstream sport cultures coloured the value or spirit of conquering in/as the athletic process. I am thinking right now of Heidegger, it should not be about the application of typical sport modes of thinking, and technological applications of training to wilderness sports contexts. Gavin [a 45-year-old runner] told me, 'When you [fell] run and think to yourself, I have to get up and beat this mountain, you don't know what you are doing, Mike. Embrace the mountain and its soul. It has one, you know. These are ancient mystical things we run with. In there, you'll find your soul.' To fell runners like my mate Gavin, it is relished as it places him in a decisively untechnological, raw, stripped and uncommon athletic place. It transformed him, I think in some ways, to be a pre-cultural runner (fieldnotes, October 2008).

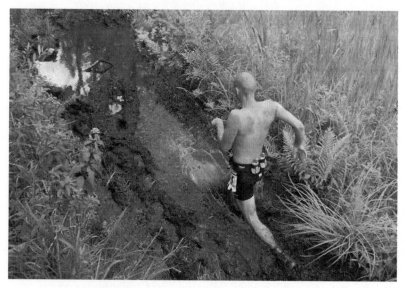

Interrupting machines … running with the river

I've been running [fell] for nearly 30 years. People ask why. I have one answer. There's nothing on this earth I enjoy as much than getting onto the hills and feeling the wind in my lungs, and heaving my body up the slopes. The smell of the rivers, the feel of the wet grass slipping under my feet, the sounds of birds as I scurry through the brush. The feeling

of wholeness and peace, even in the middle of a gruelling run, is almost indescribable … It took a long time to get there, and to have a mindset where I can be alive there. And I am alive, because you never know exactly what you will face on the run. Out there is unpredictable and untamed. (Charlie, aged 35)

Communion: The act or an instance of sharing, as of thoughts or feelings. The exchange of ideas by writing, speech, movement or signals. Coming to co-presence and connection.

We grew up in this place [Derbyshire dales], and we live here. Running is a part of our living and it connects me to my home. It's a part of us. Our church, okay, our place of worship is just as much the land here as the parish is. Friends of mine think what we do is trivial, or in some way silly and nothing more than a weekend jolly out. I guess, not being judgemental or anything, that's what I think about what they do, sat up on their arses at home or in a pub … Running the fells gives me the chance to touch at something special about the preciousness of life and my place in the world. (Nigel, aged 40)

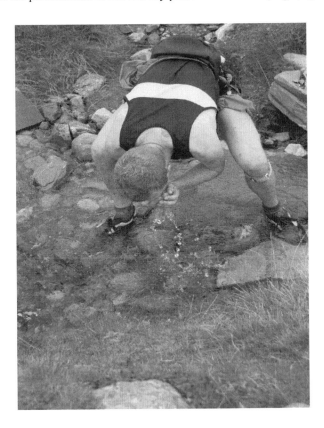

From time to time, I stop and take a second look at what I am doing on a run. Like when I squat down and suck water from the river or use it to cleanse my face from sweat … I use what's there and find rest stops where the course naturally allows. Mike, you might not understand it yet, but getting stuck into a course in all physical ways, fell running becomes a part of your total human being. By drinking the water from the river, you become part of the river. When you eat berries on the hill, the course nourishes you. I can't say I ever felt such a level of integration running marathons [on the road]. (Dave, aged 37)

A fellscape is a place where people cross out the taken-for-grantedness of modernist athletic movement. Jim, a 32-year-old fell runner told me this morning, 'when you get to a mountain and look at the space around you, it forces you to realise that you are beyond the ordinary. You've stepped outside of what running means as a technique, or, like as a competitive sport. It's art, it's beauty, it's everything.' According to my mate Jim and other runners, a fell course is a place where the technological application of modern ideology and technology to sport is disambiguated from athletics. This is how, for all intents and purposes, the zone is given emptiness and is de-territorialised – theoretical note; recheck what Deleuze and Guattari have written about this – I have never seen corporate sponsoring at the races, or heard guys boasting about run times after a race. Sports commodities do not litter the post-race recovery area. I have never needed a timing chip, high tech gadgetry or an ethos of dominance over others to enjoy fell (fieldnotes, May 2009).

I assess the quality or experience of a run by whether or not I come home clean. If I've not been deep in mud, soaked in a stream, torn up by nettles, or up to my ass in peat, I should have stayed out longer. New guys to fell prance over mud or dance across grime on the course. Plow through it and enjoy, I say! (Oli, aged 28)

Suffering: the art of the existential accident

The field of vision is comparable, for me, to the terrain of an archaeological dig. To see is to be on guard, to wait for what emerges from the background, without any name, without any particular interest: what was silent will speak, what is closed will open and will take on a voice. (Virilio 1994)

Today was the first day I ran in dense fog. We practised running the Kinder Down-fall course, and at 7:35 this morning when we reached the main climb, I could barely see a meter's distance ahead of me. What a contrasting, conflicting sensory experience. Running in the moody, shifting and chilling fog creates a kinetic energy I never feel running under perfect sunshine. It is as if, with every breath, my lungs are filled with high-octane fuel. The world disappears and I run cloaked within a cocoon of moisture, separate from the world. But then I look down from time to time, and sheer fear strikes the heart. I realise I just missed a massive rock jutting from the ground and waiting to knock me to ground, I notice a sharp cliff edge I managed to avoid, or I catch a faint glimpse of a gaping sandpit I should have become stuck in for hours. The sensory deprivation produced by the fog on the high hills creates a frenetic anxiety that at once I love and hate (fieldnotes, April 2009).

> A [fell] run is proper suffering. You have about a hundred mini crises on the run, where legs will look to give out, minds wobble, and lungs want to catch a plane out of the chest to anywhere else in the world … when the run is over, and we are on the other side of fear and self-doubt, there is an amazing elation. (Jacob, aged 28)

> I love it [running] because a long [fell] race is more or less a crash of immaculate bodies across the hills and the dales … The art of suffering results when I am ritually trans-ported beyond nociceptor signals telling me I am a part of the crash, and into a mental state where I am both conscious and unconscious that it is the being in the crash which makes me feel alive. (Raymond, aged 41)

I did my first 10-mile, Category A fell run this morning. No words right now, I'll have to write it about it in detail later tonight or tomorrow when I can focus. My mind is gone, my legs shattered. We head out to do the same run tomorrow, and I cannot wait. The juxtaposition between the beauty of the fell and the existential ordeal generated

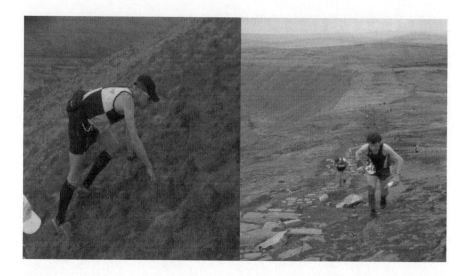

by running it is almost too intense to put into words, almost like raucous sex with the hills (fieldnotes, November 2008).

Involvement in the harshest conditions leads to the most austere revelations about the realities of day-to-day living. Running in the worst environment brings out your best. That's the trick, Mike, because we've been convinced to think snow, and rain and wind are enemies. Then you reach the conclusion that it's not the world here [on a tough course] that's awful and painful, but everywhere else where you are a person sitting, driving or relaxing in a long, painfully boring state. Destroying that reality is beyond cool. (Alex, aged 27)

There is a catastrophe within contemporary art. What I call the 'optically correct' is at stake. The vision machine and the motor have triggered it, but the visual arts haven't

learned from it. Instead, they've masked this failure with commercial success. This 'accident' is provoking a reversal of values. In my view, this is positive: the accident reveals something important we would not otherwise know how to perceive. (Virilio 2005, p. 113)

Postscript: sport without sport

Can post-sports not only survive but also proliferate in the late modern world? Perhaps. In an increasingly dromological [speed-oriented] society thrust into diffuse practices of neoliberal self-reflection, I think there is not only a space for post-sport athletics, but that post-sports may offer attractive lifestyle pursuits for those, for whatever reason, uncomfortable with mainstream athletics. Through deterritorialisation, communion and the athletic accident they create within/against the dominant physical cultures, post-sports show real potential as existential, democratic and community-building activities. Their inclusivity, openness and novel ideologies attract members from many walks of life, with varied physical abilities and sundry ideological backgrounds. While clearly not for all, practices, such as fell running, yoga and Parkour, have become legitimate and viable athletic alternatives for people who wish to be more physically active in their lives, but who do not 'fit into' mainstream sports cultures. If Pronger (2002) is correct, athletic cultures need to eclipse the idea of modern sport in order to ensure its own survival. Forms of athletics, such as fell running, might be one among many lifelines in this worthwhile pursuit.

None of the above is meant to imply that fell running, in the UK and elsewhere, is entirely non-competitive or an untraditional sport-like culture. Or, that fell running communities are the polar, binary opposite of mainstream sports cultures. Emphases on winning, rationalised training programmes, hierarchies among participants, constructions of hyper-masculinity and the sports process (including orientations

toward pain and suffering), and an overall spirit of 'beating' others abounds in partic-
ular fell circles. As with most physical cultural (read *athletic*) practices, a full spec-
trum of uses for, and constructions of, fell running exist. But what particularly struck
me when I first participated in fell running, and what still strikes me to date, are the
ways in which so many of the participants I have encountered either tell cautionary
tales about becoming like 'other runners' (i.e. obsessed with times, rankings, place-
ments, personal bests and so forth), or promote the ancient spirit of running in the
open to commune with 'others' in the open. Even when races are structured like
modernist sports events, there are, in de Certeau's (1984) phrase, 'tactics' of engage-
ment making them feel qualitatively different for many runners. There are, of course,
evident paradoxes and contradictions in their constructions of fell running utopias at
times, but their desire to be athletic in novel ways unquestionably calls us to examine
the cultural possibilities of post-sport.

Notes

1. This argument by no means implies that mainstream sports are entirely insignificant in reli-
 gious or spiritual ways. Parry *et al.* (2007) and Sing (2004) provide two of the best over-
 views of how religion and spirituality are often interwoven, in incredibly complex ways,
 into the practice of (mainstream) sports.
2. For a full discussion of the risk of neoliberalism in North America, see Giroux (2005).
 Here, I fundamentally and politically agree with Giroux's arguments regarding the struc-
 tural and cultural insidiousness of late modern neoliberalism, but still question whether or
 not the liquid modern (Bauman 2000) ideological bedrock of contemporary neoliberal
 culture allows for a heightened degree of questioning and withdrawal from modernist sport
 practices as a matter of personal freedom and moral responsibility. Giroux (2005) might
 respond by arguing that we must make sport a more inclusive, safe, accessible and differ-
 ence accepting space; others, including myself, would argue it is prime time to foster an
 appreciation for a much wider athletic ethnosphere.
3. Anyone familiar with fell running knows there is a considerable culture of serious racing
 enthusiasts who approach the practice as a mainstream sport. Competitions can be incred-
 ibly competitive, and act as feeder systems into international cross-country and mountain
 racing challenges and figurations. Like any athletic practice, fell running is not immune to
 modernist sport ideologies and constructions. This paper in no way implies that fell
 running is entirely devoid of modernist sport trappings, but rather that a significant popu-
 lation of the runners downplay or even eschew outright the competitive, sporting aspects
 of the practice.

References

Andrews, D., 2006. *Sport–commerce–culture.* New York: Peter Lang.
Askwith, R., 2004. *Feet in the clouds: the tale of fell running and obsession.* London:
 Auryum.
Atkinson, M., 2009. Parkour, environmentalism and poiesis. *Journal of sport and social
 Issues*, 33, 164–194.
Atkinson, M. and Young, K., 2008a. *Deviance and social control in sport.* Champaign, IL:
 Human Kinetics.
Atkinson, M. and Young, K., 2008b. *Tribal play: subcultural journeys through sport.*
 London: Emerald.
Bauman, Z., 2000. *Liquid modernity.* Cambridge: Polity Press.
Bauman, Z., 2005. *Liquid life.* Cambridge: Polity Press.
Beck, U., 1992. *Risk society: towards a new modernity.* London: Sage.
Booth, D., 2002. *Australian beach cultures: the history of sun, sand and surf.* London: Frank
 Cass.

Burawoy, M., 2005. 2004 American Sociological Association Presidential Address: for public sociology. *British journal of sociology*, 56, 260–290.

Carrington, B., 2007. Merely identity: cultural identity and the politics of sport. *Sociology of sport journal*, 24, 49–66.

DeBord, G., 1967. *The society of the spectacle.* Detroit, MI: Black & Red.

de Certeau, M., 1984. *The practice of everyday life.* Berkeley: University of California Press.

Deleuze, G. and Guattari, F., 1972. *Anti-Oedipus.* London/New York: Continuum.

Deleuze, G. and Guattari, F., 1980. *A thousand plateaus.* London: Continuum.

Dunning, E., 1999. *Sport matters.* London: Routledge.

Evans, J., Davies, B., and Rich, E., 2009. The body made flesh: embodied learning and the cultural device. *British journal of the sociology of education* 30, 391–406.

Fish, S., 1980. *Is there a text in this class? The authority of interpretive communities.* Cambridge, MA: Harvard University Press.

Giddens, A., 1991. *Modernity and self-identity: self and society in the late modern age.* Cambridge: Polity Press.

Giroux, H., 2005. Cultural studies in dark times: public pedagogy and the challenge of neoliberalism. *Fast capitalism*, issue 1.2. Available from: www.fastcapitalism.com [Accessed 28 May 2009]

Gubrium, J. and Holstein, J., 1997. *The new language of qualitative method.* New York: Oxford University Press.

Hall, S., 1980. Encoding/decoding. *In*: S. Hall, D. Hobson and A. Lowe, eds. *Culture, media, language: working papers in cultural studies, 1972–1979.* London: Hutchinson, 197–208.

Harper, D., 2002. Talking about pictures: a case for photo-elicitation. *Visual studies*, 17, 13–26.

Heaphy, B., 2007. *Late modernity and social change: reconstructing social and personal life.* London: Routledge.

Heidegger, M., 1954/1977. The question concerning technology. *In*: D.F. Krell, ed. *Martin Heidegger: basic writings.* New York: Harper and Row, 99–124.

Kincheloe, J., 2008. Critical pedagogy and the knowledge wars of the twenty-first century. *International journal of critical pedagogy*, 1, 1–21.

Latour, B., 2005. *Reassembling the social: an introduction to actor-network theory.* Oxford: Oxford University Press.

Lyotard, J.-F., 1989. Scapeland. *In*: A. Benjamin, ed. *The Lyotard reader.* Oxford: Basil Blackwell, 212–219.

Malcolm, N., 2006. Shaking it off and toughing it out. *Journal of contemporary ethnography*, 35, 495–525.

Nixon, H., 1996. Explaining pain and injury attitudes and experiences in sport in terms of gender, race and sports status factors. *Journal of sport and social issues*, 20, 33–44.

Parry, J., *et al.*, 2007. *Sport and spirituality: an introduction.* London: Routledge.

Pronger, B., 1998. Post-sport: transgressing boundaries in physical culture. *In*: G. Rail, ed. *Sport and postmodern times: culture, gender, sexuality, the body and sport.* Albany, NY: SUNY, 277–298.

Pronger, B., 2002. *Body fascism: salvation in the technology of physical fitness.* Toronto: University of Toronto Press.

Prout, A., 2000. *The body, childhood and society.* Basingstoke: Palgrave Macmillan.

Rinehart, R. and Sydnor, S., 2003. *To the extreme: alternative sports, inside and out.* Albany, NY: SUNY.

Sing, S., 2004. *Spirituality of sport.* Cincinnati, OH: St. Anthony Messenger Press.

Stebbins, R., 2001. *Exploratory research in the social sciences.* London: Sage.

Virilio, P., 1977. *Speed and politics: an essay on dromology.* New York: Semiotext(e).

Virilio, P., 1994. *Bunker archaeology.* Princeton: Princeton University Press.

Virilio, P., 2005. *The accident of art.* New York: Semiotext(e).

Virilio, P., 2007. *The original accident.* Cambridge: Polity Press.

Virilio, P. and Petit, P., 1999. *Politics of the very worst.* New York: Semiotext(e).

Wheaton, B., 2004. *Understanding lifestyle sport: consumption, identity and difference.* London: Routledge.

Young, K., 2004. *Sporting bodies, damaged selves.* London: Elsevier.

Talking T-shirts: a visual exploration of youth material culture

Clive C. Pope

Department of Sport & Leisure Studies, School of Education, University of Waikato, Hamilton 3240, New Zealand

Readers should also refer to the journal's website at http://www.informaworld.com/rqrs and check volume 2, issue 2 to view the visual material in colour.

The author completed a visual ethnography, first to explore the sport experiences of high school students taking part in New Zealand's major rowing competition, the Maadi Cup. Additionally, the project set out to explore the process and potential of using photographs as representations of such experiences. The core of this research project was based on spending 10 days and nights at the regatta site, living the everyday life of rowers and rowing. The compressed time frame required the convenience of digital photography and video. In addition to the obvious artefacts of rowing, there is a notable influence of material culture. Part of the rowers' everyday practice included this cultural production represented through the wearing and trading of T-shirts. Despite its highly competitive nature, this regatta is important to young people as an opportunity to socialise and explore individual identities. For many of these students, Maadi is both grueling and gregarious. True, it is important for them to participate as competitors, but these objects of material culture (e.g. T-shirts) help us understand how these young people communicate the wider meanings of being rowers.

Introduction

It is 5:45 A.M. on an October morning…and both air and water are chilly. Already my hands ache with cold and I have yet to shove off from the dock; on the river, the frigid breeze will penetrate skin, flesh, and bone. That much is familiar: nothing more than intense, torturous pain. As a rower I am used to that. The terrifying thing is the athletic test confronting me: a double head, something I have never attempted before and am not sure that I can even do, let alone do well. Performing well matters deeply, but today my first concern is staying alive out there. (Lambert 1998, p. 4)

The words of Craig Lambert resonate with the many conversations I had with my father, who rowed for Wanganui Collegiate, a successful New Zealand rowing school with a proud history (see Irvine 2008). I would hear of his blistered hands, the count-less mornings breaking the fog on the local river, the chilled waters that acted like anaesthetic to exposed skin upon contact, the countless trips up and down the river refining technique and testing the body's reserves. I learned that this was a sport that demanded so much, taking athletes to their limits and often beyond. His ruminations would be tinged with great affection for the sport, the time, the commitment, yet they

Figure 1. An early start on the chilly lake.

remained mere impressions for me. Rowing did not become a tradition within my family. Half a century since and 20 years after his passing, I submitted to my father's evocative descriptions.

Rowing in New Zealand has a relatively high profile. It has secured several Olympic medals and presented a collection of household names. For many young people, induction into the sport of rowing takes place at the secondary school level. A robust system staffed by parents, volunteers, coaches, administrators and teachers ensures that opportunities are available to nearly a third of the 340 secondary schools in the country. Not all students will have such opportunities. The cost to compete in rowing is significant: a new 8's shell can cost in excess of $40,000. But many schools make do, relying on older equipment and improvisation to create opportunity. Over the course of the autumn and summer, rowers learn, train and compete on rivers and lakes throughout the country (see Figure 1). Their season culminates in a national regatta held in late March. The Maadi cup is a 7-day event that hosts almost 400 races and 80 finals. To row at Maadi is an annual opportunity for 2500 students. And while more and more sports and many more sedentary options become available to today's students, the attraction of rowing continues to thrive.

Aside from the stories of my father, I knew nothing of the culture of rowing. Like many sports, rowing has unique artefacts, values, language and peculiarities. A conventional ethnography would have required prolonged exposure to such a culture but to learn of the sport and the experiences of youth participants, a compressed ethnography (Jeffrey and Troman 2004) over the seven-day Maadi Regatta was completed. This visual ethnography (see Pink 2007) utilised photography and video to record and revisit the action and interactions between the sport and the participant.

A visual record allowed the observation process to continue beyond the week-long event. The need for photos to help relive the experience of Maadi is unlike many conventional ethnographies (Pope 2009). There was not sufficient time available at this setting to gain a full appreciation for what was happening at this regatta and why. The photos (drawn on for this paper) and videos allowed me to rewind, revisit and reframe the setting, repeatedly seeking new learnings and understandings. This process replaced the inductive and emerging discoveries that often evolve in situ during prolonged conventional ethnographies.

An event such as The Maadi Regatta reveals the enmeshing of multiple cultural forms. Youth are constantly moving between sites, negotiating their identities marked by a shift from traditional influences of family, community and school towards less formal global, social and popular options (Weis and Fine 2000). Capturing the nature and extent of those shifts is crucial to the ethnographer and is a significant part of the ethnographic project. Moreover, cultural scrutiny includes 'the what' as well as 'the where'. Material culture targets objects that may contribute to the identity of youth. A third cultural component can be the sport. Rowing has seldom been placed under the cultural microscope, yet it remains an attractive option for many New Zealand second-ary school students. The choices made by youth sport participants have diversified and expanded as many lifestyle sports emerge as viable options. Yet, a traditional sport such as rowing has retained a strong presence on the sporting radar for many New Zealand youth. These shifts invite new questions, and new theoretical lenses and research methods.

To help analyse the positioning and relationships of these three cultural forms, I have engaged the work of Michel de Certeau, particularly his most popular and arguably the most influential work *The Practice of Everyday Life*, where the everyday ways of doing things no longer assume the status of background but instead become highlighted as models of action and significant components of 'culture' (de Certeau 1984). This paper does not focus on the theory associated with what appears on these T-shirts; rather, it focuses on how images allow a different form of analysis and insight.

Material culture, clothing and T-shirts

The analysis of material culture may contribute to an understanding of social and structural relationships within the ethnographic enterprise (O'Tool and Were 2008).

Schlereth (1982) argues that through material culture, we can learn of the values, beliefs and attitudes of particular communities or groups, often across time. Material culture is the object-based aspect of the study of culture and, by definition, 'is the study – through artifacts, of the beliefs, values, ideas, attitudes, and assumptions – of a particular community or society at a given time' (Prown 1982, p. 1). Material culture is classified by Prown (1982) into six functions: *art, diversions* (such as books or games), *adornments* (such as jewelry or clothing), *modification of landscape* (such as mines or agriculture), *applied arts* (such as furniture or furnishings) and *devices* (such as vehicles, machines or musical instruments). Prown's third function, adornments, and specifically clothing, are an important aspect of many youths lives. How young people look and what choices they make for their personal wardrobes are strongly anchored to their identities. Adornment as a component of material culture became a focus for this paper.

Preston proposes that material culture might invite attention on two fronts. The first aspect is the form of the object such as its shape or its constitution. Secondly, the

function of the object includes its intended purpose or the purposes to which it is put. She explores how and why the functions of things change. Many of her observations are pertinent to the ubiquitous T-shirt. For example, Preston states, 'it is clearly the exception rather than the rule for a thing to have only one function' (2002, p. 30). This perspective has been endorsed more recently by others, claiming that 'material objects and places are ostensibly constructed and possessed for an operational purpose, but also create and communicate meaning' (O'Tool and Were 2008, p. 618). It is perhaps pertinent to examine the T-shirt from such a viewpoint.

Cloth and clothing have been described as the largest imaginable category of material culture (Schneider 2006). In addition to their obvious operational function, clothes in general and T-shirts in particular can serve as indicators of who somebody is perceived to be with an anticipated reaction from others of how they might be treated (Dant 1999). Often clothing choices will signal an individual's need to fit within a desired group (Piacentini and Mailer 2004). This is especially true for young people, who often define themselves by the messages they project to others (Kenway and Bullen 2001). Probably more than any other cohort, they are vulnerable to the pressures associated with clothing selection, peer status and style failure (Croghan *et al.* 2006). When membership within a selected peer group is often imperative, 'clothes along with rock music and lifestyle, have become integral parts of the increasingly diversified and factionalized youth culture' (Symes 1989, p. 88). Young people often define themselves through the goods they possess and display.

Whereas many products have had to work to gain entrée into the youth culture, such as Apple's iMac or iPod, the T-shirt appears to have been embraced without any deliberate or focused gesture. It, seemingly, always has been there. However, the form and function of the T-shirt has seen it remain as part of this age cohorts' identity cache. The rich overlay of meaning associated with clothing can often be tied to maturing yet precarious states, with particular emphasis placed on sexuality and identity. It could be argued that much of the evident popularity of the T-shirt stems from its cheapness and versatility (Symes 1989), an affordable yet functional asset for so many groups within the youth culture:

> The T-shirt has risen, at least metaphorically, to assume an important symbolic role. It has become one of the prime emblems or icons of modern life encoded in changing codes, and carrying sign functions. It is a sign vehicle whose functions not only express selves, but the social and political fields in which it exists. (Cullum-Swan and Manning 1994, p. 417)

Callum-Swan and Manning propose seven codes that allow us to shift attention from the T-shirt as an object to its perception and use. Code 1 represents the T-shirt as a utilitarian undergarment, originally an unmarked cotton vest, often home made and worn under heavier outer shirts. Code 2 is the T-shirt as a manufactured item that soon became mass produced, sold via major retail outlets or mail order catalogues. It quickly became a commodity designed to promote retail sales. During the social upheaval of the 1960s, T-shirts featured more as outer garments, a trend designated as Code 3. Changes in fabric technology and added features with automatic washers and dryers meant that the traditional white T-shirt became enhanced through a range of colours, styles and textures. The T-shirts quickly became signifiers of identity. Code 4 refers to the T-shirt as a representational sign vehicle, conveying messages about experience, role, status and symbolisation. Institutions such as Oxford University, affiliations to brands such as Ferrari, or events such as Woodstock have appeared on

T-shirts. However, claims of having been to certain places or being affiliated to particular groups or organisations is often a cause for reservation, leaving the integrity of such claims in question. Code 5 addresses the T-shirt as a problematic symbol where it 'has become the quintessential modern icon' (1994, p. 423), sold as commercial jokes, references to the putative self, status or membership claims. Generally, such claims or ironic statements refer to what the wearer is not. They have also become the billboard for live advertising connoting a certain person who prefers certain brands or products and therefore conveys a particular lifestyle. Code 6 is assigned to the T-shirt as a walking pun. This may include seeing something in terms of something else. T-shirts are often reflexive or self-referential, containing iconic puns such as 'your name here' or 'this side up'. The final code is copies and real copies. Many multinational or large franchise organisations license to make, merchandise and distribute 'official copies' such as T-shirts. They are often not the same official team apparel but rather are officially sanctioned. The authors ague that following the early and late industrial eras, the post-modern era has seen the T-shirt connect closely with the wearer in only a physical sense. They argue that 'T-shirts now question the credibility of the viewer by presenting evocative, floating, adrift and elusive signifiers that are free from easy assumptions, conventions or social verification procedures' (Cullum-Swan and Manning 1994, p. 430).

While T-shirts have long been part of many sport communities, the nature and scope of their role within such communities has seldom attracted the interest of academics. Many of the points raised by Symes (1989) and Cullum-Swan and Manning (1994) can be directly applied to sport cultures or sub-cultures. Any hesitation by academics may in part be due to the visual character of T-shirts; their appearance, function and impact are received and processed through visual contact. It stands to reason then that exploring how these garments are presented and received should enlist appropriate research tools that celebrate and privilege the visual nature of such material objects.

Embracing the visual

For ethnographers and many other qualitative researchers who are selecting research tools, 'the basic issue is simple: How best to describe and interpret the experiences of other peoples and cultures' (Lincoln and Denzin 2000, p. 1050). Researcher interpretations should provide an orientation to the everyday practices and objects associated with a selected group of people. Visual research methods have received a quite sudden and accelerated attention from academics as a means to understanding, experiencing and interpreting culture (Pink 2006 2007, Rose 2007, Prosser and Loxley 2008, Pope 2009).

Images are worthy because they encode a huge amount of information in a single representation. The interpretation of that information, however, is dependent on who is looking, so the reflexive process varies between viewers. Within visual ethnography, 'any photograph may have ethnographic interest, significance of meanings at a particular time or for a specific reason. The meanings of photographs are arbitrary and subjective, they depend on who is looking' (Pink 2007, p. 67). Moreover, visual anthropologists have used images as a representation of culture, while visual sociologists are interested in the meanings contained within such images. My exploration of Maadi initially leaned towards the former; however, it would be fair to say that the latter has warranted attention post event.

While traditional ethnographies have often attempted to present portraits of a people, group or culture, the product has historically been translated into words (Wright 1998) as part of the 'scientific project'. The potential of visual representations has always been subordinated to text, while images 'hover precariously at the edge of a discipline of words' (Grimshaw 2001, p. 2). The outcome has often been a limited or incomplete description of a designated cultural setting. Researchers have often been constrained by the manner in which we are able to present, discuss, critique and improve the knowledge about such portraits.

However, new technologies, particularly visual technologies, have allowed greater access to ways in which our understandings can be informed. With a greater array of tools in the research toolbox, there is arguably justification that 'established ways of doing ethnography need overhauling' (Murdock and Pink 2005, p. 10).

Images, and for this project photographs, help us to read the surfaces of social life (Harper 1997). They can capture the ineffable; they make us pay attention in new and different ways; they are often quite memorable: the vast array of digital accessories, lenses and choices between monochrome and colour enhance the impact factor of photographs. They hold the potential to possess and reveal multiple layers – allowing for capture of everyday happenings that may have otherwise been overlooked, inviting stories or enquiry. Photographs can help us see what others have seen and compare their interpretations with our own impressions or perspectives. They can transmit theory in different and expressive ways. They are increasingly accessible to wider members of the community, not just academic communities (Weber 2008). Images can, in essence, affect discussion in new and profound ways. Of course, one important group within any community is young people.

Young people and cultural sites

Contemporary young people creatively appropriate information from adults and from their 'wired' worlds. This information is then adapted to assist in the production of unique peer cultures, a process referred to as *interpretive reproduction* (Eder and Corsaro 1999). The interpretive process transforms what society offers to them; it is then selected and adjusted to address their unique needs. There is evidence to indicate that goods and consumption form a significant feature of peer cultures. The goods marketed directly to them (Linstrom and Seybold 2004) are evaluated and, in some cases, adopted as signifiers to their peers as the operational purpose of a product may be of lesser value than the associated meaning of the product or brand (Kenway and Bullen 2001).

Consumption and the associated display of objects can play a role in the constitution of youth identities as youth make sense of the vast array of choices often available to them. Moreover, music and dress are offered as key markers of identity, where artefacts such as clothing are utilised in identity construction. Such a process is significant because 'for young people, these symbols are especially pertinent, as they are often in stages of uncertainty, gathering material possessions as a way of establishing their identity and gaining much-needed prestige' (Piacentini and Mailer 2004, p. 251).

Consumption becomes something that is culturally created, in this case by youth, whereby the object or artefact is resignified or remodelled and therefore reproduced. Consumption has become re-production. For example, the baseball cap was transformed from a garment designed to shield the sun from the eyes to a cultural statement

simply by turning it to either 90° or 180° as a symbol of individuality or affiliation to groups such as 'gansta'.

Many of the objects embraced by youth are aligned to technology and communication. Today's secondary school students are often regarded as the 'wired ones' (Wallis 2006). Their peer cultures and statuses are often associated with particular brands of cell phone, MP3 player or computer brand. These objects offer fun, convenience and connectivity (Mechthild 2007) as peer groups seek each other out, communicating constantly through their own text (txt) language and on numerous social networking websites.

Objects embody and reflect cultural beliefs and, in the case of youth, much can be learned about modern youth culture through its material aspect (Graves-Brown 2000). However, when the typical sites of youth culture (school, home, malls, or friends' places) are shifted, communication, interaction and connection can be displaced. For an event such as a rowing regatta, some objects of technology remain, while others may be substituted. How do young people who are moved to a new site select from what is available to them to address their needs?

The way in which people operate as users of everyday sites is often associated with the pre-eminent theorist Michel de Certeau. Since the time of his passing in 1986, de Certeau's writings have become increasingly circulated around the English-speaking world. His most popular work, a two-volume publication entitled *L'Invention du quotidien* (*The Practice of Everyday Life*) revealed his interest in how 'culture' is composed in part by 'consumers' who are dominated by other elements in society but who employ *tactics* as ways of operating to resist the control of authorities. For de Certeau, 'a tactic insinuates itself into the other's place, fragmentarily, without taking it over in its entirety, without being able to keep it at a distance' (de Certeau 1984, p. xix). The employment of such practices or tactics can often occur in small spaces designed for something or someone else:

> The space of a tactic is the space of the other. Thus it must play on and with a terrain imposed on it and organized by the law of a foreign power. … It operates in isolated actions, blow by blow. It takes advantage of 'opportunities' and depends on them, being without any base where it could stockpile its winnings, build up its positions and plan raids. What it wins it cannot keep. This nowhere gives a tactic mobility, to be sure, but a mobility that must accept the chance offerings of the moment. (de Certeau 1984, pp. 36–37)

Tactics are the ways in which individuals and groups negotiate the systems and structures imposed by dominant institutions that are in positions of power. One example discussed by de Certeau is that of navigation. The layout of a city is marked by networks, signage and rules imposed by councils and government that can, in turn, be adapted by individuals to meet their needs as they travel at their choice. A similar example could apply to the layout and structure of a daily newspaper. Readers employ a chosen order in which they read selected pages (sports section, international news, editorial etc.), rather than follow the prescribed layout offered by the publisher. Practices imposed from others are referred to by de Certeau as *strategies*:

> I call strategy the calculation (or manipulation) of power relationships that becomes possible as soon as a subject with will and power (a business, an army, a city, a scientific institution) can be isolated. It postulates a place that can be delimited as its own and serve as the base from which relations with an exteriority composed of targets or threats (customers, competitors, enemies, the country surrounding the city, objectives and

objects of research, etc.) can be managed. As in management, every 'strategic' rational-ization seeks first of all to distinguish its 'own' place, that is, the place of its own power and will, from 'environment'. (de Certeau 1984, p. 36)

de Certeau's work has received increased attention (Ahearne 1995, Buchanan 2000, Ward 2000, Highmore 2006) and offers great insight and perception on social representation and behaviour. His work on resistance and autonomy within everyday practices offers a cultural lens to the setting based at Lake Karapiro. For the rowers at Maadi, life is marked by routine, ritual and rules imposed by the regatta organisers and staff. The imposed *strategies* had to be negotiated by a series of counter-practices. Visual markers such as clothing illustrated how institutional power required particular uniforms but on selected occasions rowers would select *(tactic)* and display other apparel, namely T-shirts, to convey the importance of social interaction within a highly competitive sporting context.

To an observer of a rowing regatta, the artefacts are many and varied. Aside from the vast and impressive array of equipment, the clothing worn by rowers reveals part of the particularity of the sport (see Figure 2). Lycra shorts and cotton singlets address the need for freedom of movement and the reduction of any excess weight created by selected uniforms. Perhaps the most distinctive aspect of the rowing regalia is the traditional woolen rugby socks worn by many rowers. These thick and colourful adornments often act as footwear around rowing venues and are worn during races, slipping into the shoe-like stirrups attached inside the boat.

Any visitor to a regatta like Maadi is immediately struck by the colour created from the tracksuits, singlets, boats, oars and school marquees that line the bank beside the lake. Students lived in their sport attire through much of the week. Between races, they mingled with others around the venue, displaying their school colours and labels.

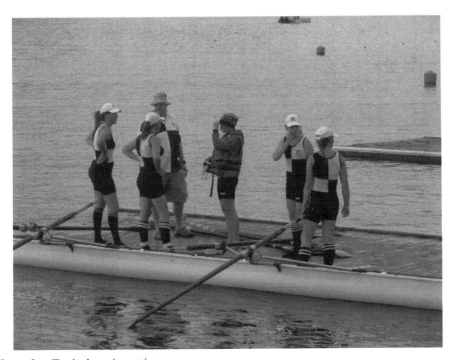

Figure 2. Typical rowing attire.

Aside from the official uniforms, my attention was quickly drawn to a supplementary costume based on the ubiquitous T-shirt. These shirts were to become quite powerful indicators of identity as well as distinctiveness. The unofficial uniforms were objects of great attention and interest among the competitors. Each shirt was often adorned with a slogan or statement and acted as a communicator to fellow rowers, unknown rowers, yet rowers who simultaneously could relate to the espoused messages. The T-shirts 'talked to' rowers who, in turn, received their messages, and if there were sufficient attraction to the message, it would be the target of a swap at the conclusion of the regatta.

The Maadi Regatta is a cultural site, a venue where the culture of rowing and the youth culture meet and blend. In addition, it is a site of material culture marked by objects that matter, manifested through symbols and artefacts and exchanged through gesture. The significance of these material objects and the rituals performed by these rowers is pertinent because 'the most powerful organizing forces in modern life are the activities and associated interpersonal relationships that people undertake to give their lives meaning' (Schouten and McAlexander 1995, p. 43).

In the next section, I present some selected exemplars from my visual ethnography of the Maadi Regatta. I should emphasise that they represent a small proportion of the 550 images taken. The selected frames represent the way in which these T-shirts 'talked to' their wearers or 'spoke to' their peer groups, made up mostly of rowers. These garments often projected real 'in-your-face' statements, supporting the claim that 'unlike most clothes which mumble and stammer their messages, the T-shirt 'talks' directly to its audience' (Symes 1989, p. 88). More importantly, images of those statements can be captured and shared with readers in a way that written description could not address. The camera allows the shirt to be connected directly to the context, thereby highlighting the links between sport, youth and material culture. The meaning of an image could not be understood if context was not represented. Photos also document the graphical nuances, style, shading, colour and richness of these garments. Verbal or written description of these T-shirt statements could not do justice to the vibrancy and detail depicted through image.

Seeing the talking

Despite the many and varied backgrounds of these students, their school decile level (socio-economic rating), whether their school is single sex or co-educational, their age, ethnicity, whether they are scullers, sweepers, coxwains, 'novies' (novices) or seniors, the appearance and presence of the T-shirts and associated slogans was the key indicator of homogeneity between rowers, but also distinctiveness from other groups. These slogans and statements were personal advertisements – 'advertisements applied to the self … using the torso as a bill-board, as a peripatetic commercial' (Symes 1989, p. 88) (see Figures 3–10).

The shared messages of these rowers echoed the descriptions of Craig Lambert and my father mentioned earlier in this paper. The messages were similar but the medium was different. T-shirts, like most objects, act as media. They mediate messages between people across space and time.[1]

This passing on of valued knowledge between rowers is a form of pedagogy, 'a term which signals the physical synthesis of the questions "what would be taught and why" with considerations as to how that teaching should take place' (Simon 2008, p. 73). Pedagogy can occur in formal sites such as schools, universities, churches and

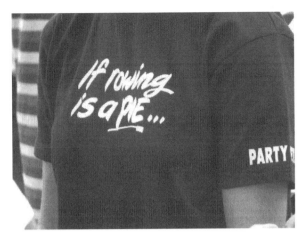

Figure 3. If rowing is a pie – front.

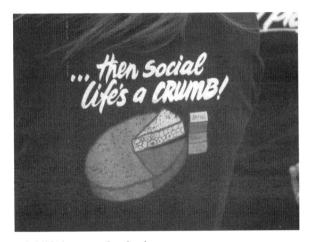

Figure 4. Then social life is a crumb – back.

numerous institutions. It can also occur in informal settings including shopping malls, billboards and T-shirts. In such settings, 'the pedagogical practices or devices are intended to (re)produce valued knowledge. There is an intention to do certain peda- gogical work' (Tinning 2008, p. 417).

Young people communicate to one another to share knowledge and perspectives as pedagogical work, sharing their proclivities and interests, dreams and fears, and ambitions and actions. At the Maadi Regatta, textile became textuality.

The swap

After many of the T-shirts were paraded and vetted by their peers, competitors embarked on a ritual swap that took place on the last afternoon while finals were being conducted on the adjacent lake. In essence, the climax of the competitive experience was taking place on the water, while the culmination of the social week was conducted behind the many school tents and marquees on a nearby access road. The timing of

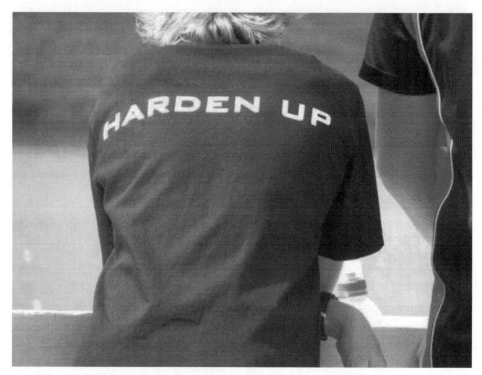

Figure 5. Harden up.

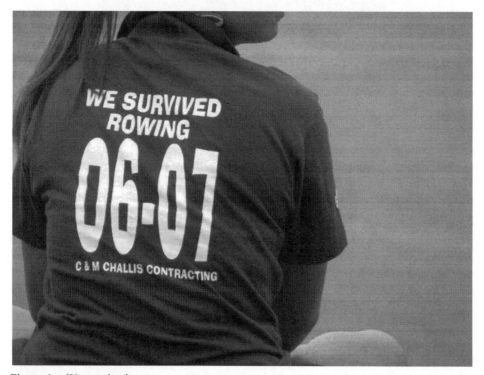

Figure 6. We survived.

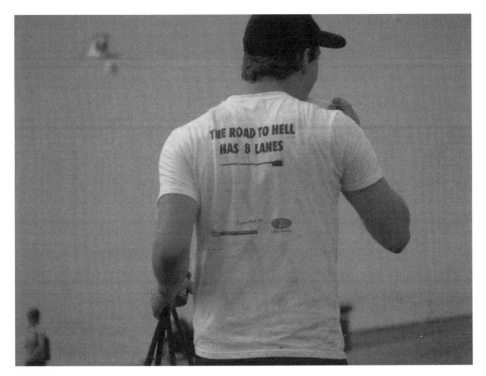

Figure 7. Road to hell.

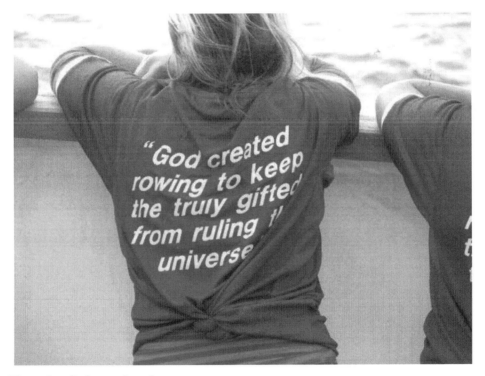

Figure 8. God created rowing.

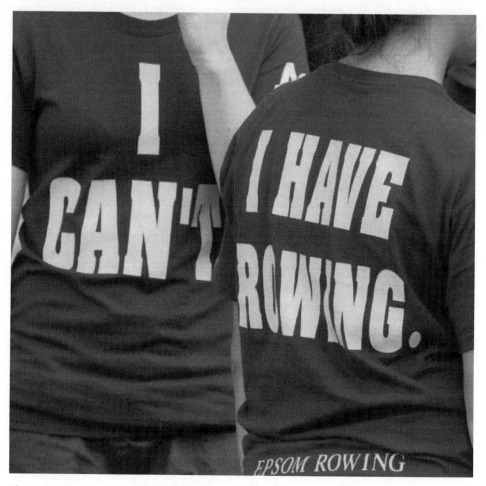

Figure 9. I can't – I have rowing.

these two phases of the regatta possibly illustrates how the competitive and social experiences of these young rowers were juxtaposed. At 2.00 P.M. on finals afternoon, the access road was relatively clear, except for a few customers travelling to and from the numerous food and drink vendors who lined both sides of the roadway. By 3.30 P.M., there were over 1000 students stationed on the roadway, swapping T-shirts and singlets of rowers with rowers from other schools (see Figures 11–14). There had been no public announcement or advertised warning of this occurrence. It appeared like an act of serendipity, snowballing and expanding, forcing bodies to compact as space became more and more precious.

In essence, the swap resembled a *tactic* employed by the rowers who chose to *poach* space at the regatta (de Certeau 1984). These rowers discretely selected and utilised an appropriate terrain, working within an absence of power which was held by the regatta authorities. Space was created or *poached* for play to occur (see Figure 12). In keeping with the sport metaphor, de Certeau refers to a game as:

Innumerable ways of playing and foiling the other's game *(jouer/de jouer le jeu de l'autre)*, that is, the space instituted by others, characterize the subtle, stubborn, resistant

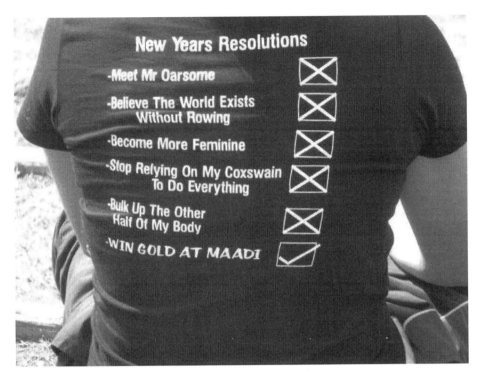

Figure 10. Check box.

Figure 11. The swap gains momentum – Tents and lake in the background.

Figure 12. Finals on the lake; rowers *poaching* on the road.

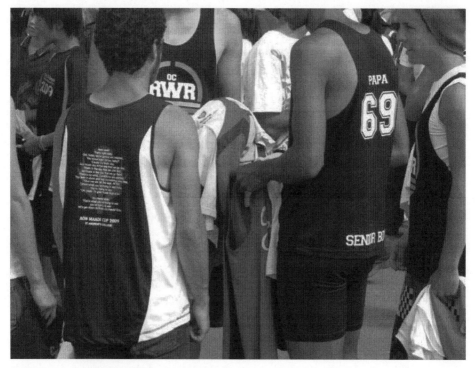

Figure 13. Negotiating a trade.

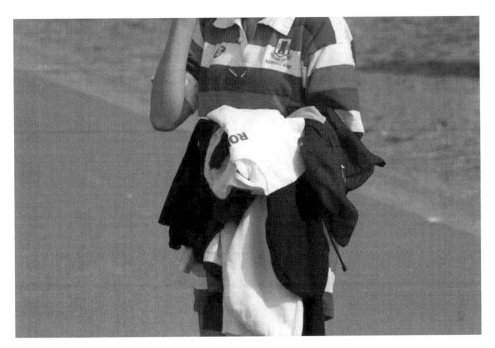

Figure 14. A successful day's trading.

activity of groups which, since they lack their own space, have to get along in a network
of already established forces and representations. (1984, p. 18)

In this sense, rowers who assembled for this swap and others who chose to wear
these T-shirts around the lake throughout the week demonstrated what de Certeau
described as consumption. But because they privileged the act of wearing and swap-
ping these T-shirts, they were actually producing or dissolving the polarity between
consumption and production.

Rowers would mingle through the throngs, shirts draped over arms that had
propelled oars down the lake all week, negotiating trades, and if there was mutual
approval, a short conversation before the next cotton trophy was sought.

Some of the shirts were more sought after than others. The primary endorsement
was the degree of wit, sarcasm, irony, cleverness or simplicity of the created slogans.
The craze for the slogan far exceeds the need for the garment itself – novelty outweighs
functionality. Millennials (as this generation is referred to) (Howe and Strauss 2000)
respond to humour, irony and the apparently unvarnished truth (Klein 2000).

Much of the advertising for products is pitched at young people and yet here is an
example of the message being pitched within the youth culture. The double-sided
statement 'I can't' (front) 'I've got rowing' (back), which offered qualities of simplic-
ity, wit and sarcasm, was highly prized. As the week ensued, it became evident that
these young people had put in a great deal of effort to compose their slogans. The
degree of creativity, variety and impact were powerful indicators that 'youth scan or
graze their visual worlds – anything at their visual disposal (e.g. movies, other kids'
looks, MTV, store merchandise etc.) for ideas or cues for interpretation' (Hethorn and
Kaiser 1998, p. 114). Clearly many of these competitors could relate to the messages
being broadcast across the front and backs of shirts. Meaning is shared. Glass suggests

'through the performative act of wearing, the wearer becomes the type of person who would be identified by the shirt's message rather than simply communicating some pre-existing sentiment' (2008, p. 3). These created T-shirts, as opposed to mass-produced versions, align with Callum-Swan and Manning's (1994) code 4, emphasising the carriage of messages about experience and status.

The T-shirt and the associated comments are an invitation – a tool of social networking between these rowers, an illustration of what has become part of the network society (Castells 2000). Individually and collectively, these T-shirts become important to understanding culture and social life – in the world of youth sport and physical education, this would seem to be integral to learning more of our field. Teachers and coaches who work with young sportspeople should be cognizant of the wider culture of the sport and its various 'ways of operating' (de Certeau 1984, p. xi). While there is little doubt, a great deal of time, the effort and knowledge allocated to the technical aspects of sport, the social experiences sought by many young people and the practices they will adopt to create such experiences warrant greater attention from researchers and providers. Sport does not occur in a social vacuum and yet a technocratic approach to teaching and coaching often prevails in many junior sport settings, while social influences are often subjugated.

Concluding thoughts

Daniel Miller argues: 'culture is always a process and is never reducible to either its object or its subject form. For this reason, evaluation should always be of a dynamic relationship, never of mere things' (Miller 1987, p. 11). Miller posits that any analysis of modern society that focuses on material objects such as the T-shirt runs the risk of appearing fetishistic and ignoring or masking the vital social relations associated with such objects. The T-shirt and the social relations should be positioned in a non-dualistic manner.

T-shirts are emblems of authentic youth culture. They have become a vital mode of visual representation in what Glass (2008) refers to as 'cultures of display':

> But why are objects held to matter? The answer is not just because they are more plentiful or ubiquitous, but because they are involved in social representation or symbolization, and are recognized as containing important meanings for social action... objects represent or symbolize some aspect of culture. (Woodward 2007, p. 28)

For me, these T-shirts reveal the significance of the socialness of this event: 'socialness is a neologism...to call attention to the integration of objects in the social fabric of everyday life' (Riggins 1994, p. 1). They also reveal the degree to which social interaction is valued among these young competitors. As O'Tool and Were (2008) state, such objects or artefacts are possessed and constructed at an operational level – but also to communicate meaning – illustrated by example through the messages and forms of T-shirts paraded, and eventually swapped, at this venue. True, it is important to participate as a competitor, but these objects of material culture help others understand what multiple meanings these young people communicate about the shared 'meanings' of being a rower and their motivations to participate in this often grueling sport.

I came to this project as a storyteller, hoping to observe and record real young people in real settings. And while this ethnography was focused on the experiences of

youth rowers, like many other ethnographies, it was the unexpected that proved one of the most exciting aspects of the project. The presence of these T-shirts, these communicative tools of material culture, and their power and function as a social vector became almost as powerful as the draw of the sport itself. It demonstrated the degree of value young people accord to their material worlds. Despite its highly competitive nature, the Maadi Regatta is important to young people as an opportunity to socialise and explore individual identities.

While these images may convey the messages sent between rowers, they cannot capture or do justice to the movement, gesture, attitude or expressed emotion that was often associated with these projected statements. Images can reveal another side to culture, be it youth, sport or material culture. These messages can only be interpreted at an individual level.

But a more important consideration is the power of the image as a research tool to attract our attention and invite our responses. Arguably, 'it is possible for a picture to contain many meanings and sustain multiple interpretations. In a sense, images cry out to us to imbue them with meaning and it is this, above all, which provides them with their unique capacity to engage us' (Grady 2004, p. 20). The challenge for researchers in this century will be to explore the many sites of social practice that connect and reveal the multiple arenas that young people inhabit. It will require ethnographers to utilise the many and varied tools available to us to represent their experiences fully, to dredge down to the underlying meanings of their worlds, meanings that are often shared and/or confirmed. Each of these contexts invite detailed and prolonged attention so that we may learn more of the pace, diversity and complexity of young people's lives.

Visual ethnography, or any visual research form, offers an alternative kind of data that allows us to reposition the questions we ask – questions that perhaps verbal information is not able to do (Stewart and Floyd 2004). Not only are the T-shirts 'speaking' but the photographs of the T-shirts 'talk' as well, telling the viewer about meanings and experiences. Like many researchers, I am coming to learn of the capacity of photos to talk (Mitchell and Allnutt 2008). Photographs can be rich sources of insight into the dynamics of youth culture and their everyday practices. Audiovisual technologies can record visual culture, based on an epistemology that 'culture is manifested through visual symbols embedded in gestures, ceremonies, rituals and artifacts situated in constructed and natural environments' (Ruby 2005, p. 165). Technology now allows us to slow down and even revisit our observations and potentially enhance the opportunity for reflexivity through the interpretation process. The fast-paced world we now live in means that compressed projects can be expanded on and revisited to reveal detail and depth using accessible tools such as visual methods.

Acknowledgements

The author would like to express gratitude to Associate Professor Bob Rinehart and an anonymous reviewer for their helpful comments on an earlier draft of this paper.

Note

1. While it would be a valuable exercise to explore in detail the nature of these messages, I wish to reiterate that this was not the purpose of this paper. Rather, it was to explore youth sport experiences, and in this case the impact of material culture, as well as discuss how visual research could capture those experiences. These conversations (represented through

their slogans) were between the rowers and I believe that imposing my interpretation of their messages diminishes their voices. The voices of these rowers has been addressed (Pope 2010) elsewhere.

References

Ahearne, J., 1995. *Michael de Certeau: interpretation and its other.* Cambridge: Polity Press.

Buchanan, I., 2000. *Michael de Certeau: cultural theorist.* London: Sage.

Castells, M., 2000. *The rise of the network society: the information age. Economy, society and culture.* 2nd ed. Oxford: Blackwell.

Croghan, R., *et al.*, 2006. Style failure: consumption, identity and social exclusion. *Journal of youth studies*, 9 (4), 463–478.

Cullum-Swan, B. and Manning, P.K., 1994. What is a T-shirt? Codes, chronotypes and every-day objects. *In*: S.H. Higgins, ed. *The socialness of things: essays on the socio-semiotics of objects.* Berlin: Mouton-de Gruyter, 415–434.

Dant, T., 1999. *Material culture in the social world.* Buckingham: Open University Press.

de Certeau, M., 1984. *The practice of everyday life.* Berkeley: University of California Press.

Eder, D. and Corsaro, W., 1999. Ethnographic studies of children and youth. *Journal of contemproary ethnography*, 28 (5), 520–531.

Glass, A., 2008. Crests in cotton: 'souvenir' T-shirts and the materiality of remembrance among the kwakwaka'wakw of British Columbia. *Museum anthrpology*, 31 (1), 1–18.

Grady, J., 2004. Working with visible evidence: an invitation and some practical advice. *In*: C. Knowles, ed. *Picturing the social landscape: visual methods and the sociological imagination.* London: Routledge, 18–31.

Graves-Brown, P.M., ed., 2000. *Matter, materiality and modern culture.* London: Routledge.

Grimshaw, A., 2001. *The ethnographer's eye.* London: Cambridge University Press.

Harper, D., 1997. Visualizing structure: reading surfaces of social life. *Qualitative sociology*, 20 (1), 57–77.

Hethorn, J. and Kaiser, S., 1998. Youth style: articulating cultural anxiety. *Visual sociology*, 14, 109–125.

Highmore, B., 2006. *Michel de Certeau: analysing culture.* London: Continuum International Publishing Group.

Howe, N. and Strauss, W., 2000. *Millennials rising: America's next generation.* New York: Vintage Books.

Irvine, P., 2008. *The Maadi cup story.* Wanganui: Peter Irvine.

Jeffrey, B. and Troman, G., 2004. Time for ethnography. *British educational research journal*, 30 (4), 535–548.

Kenway, J. and Bullen, E., 2001. *Consuming children: education–entertainment–advertising.* Buckingham: Open University Press.

Klein, N., 2000. *No logo: no space, no choice, no jobs.* London: Flamingo.

Lambert, C., 1998. *Mind over water: lessons on life from the art of rowing.* Boston: Houghton Mifflin Company.

Lincoln, Y.S. and Denzin, N.K., 2000. The seventh moment: out of the past. *In*: N.K. Denzin and Y.S. Lincoln, eds. *Handbook of qualitative research.* 2nd. ed. Thousand Oakes, CA: Sage, 1047–1065.

Linstrom, M. and Seybold, P.B., 2004. *BRANDchild: insights into the minds of today's global kids. Understanding their relationship with brands.* London: Kogan Page.

Mechthild, M., 2007. Understanding how information and communication technologies matter to youth: a network of developmental, social and technological dynamics. Unpub-lished thesis (PhD), University of Victoria, BC.

Miller, D., 1987. *Material culture and mass consumption.* London: Basil Blackwell.

Mitchell, C. and Allnutt, S., 2008. Photographs and/as social documentary. *In*: J.G. Knowles and A.L. Cole, eds. *Handbook of the arts in qualitative research.* Los Angeles: Sage, 251–263.

Murdock, G. and Pink, S., 2005. Ethnography bytes back: digitalising visual anthropology. *Media international Australia incorporating culture and policy*, 116, 10–23.

O'Tool, P. and Were, P., 2008. Observing places: using space and material culture in qualitative research. *Qualitative research*, 8 (5), 616–634.

Piacentini, M. and Mailer, G., 2004. Symbolic consumption in teenagers' clothing choices. *Journal of consumer culture*, 9 (5), 251–262.

Pink, S., 2006. *The future of visual anthropology: engaging the senses.* London: Sage.

Pink, S., 2007. *Doing visual ethnography.* 2nd ed. London: Sage.

Pope, C.C., 2008. *Visualizing the social landscape of high school sport.* Paper presented at the Australian Association for Research in Education's 2008 International Education Research Conference, Brisbane.

Pope, C.C., 2009. Sport pedagogy through a wide-angled lens. *In*: L. Housner, *et al.*, eds. *Historic traditions and future directions in research on teaching and teacher education in physical education.* Morgantown: FIT Publishing, 227–236.

Pope, C.C., 2010. Got the picture? Exploring student sport experiences. Using photography as voice. *In*: M. O'Sullivan and A. MacPhail, eds. *Young people's voices in physical education and youth sport.* London: Routledge, 186–209.

Preston, B., 2000. The functions of things: a philosophic perspective on material culture. *In*: P.M. Graves-Brown, ed. *Matter, materiality and modern culture.* London: Routledge, 22–49.

Prosser, J. and Loxley, A., 2008. *Introducing visual methods.* Review paper. ESRC, National Centre for Research Methods.

Prown, J.D., 1982. Mind in matter: an introduction to material culture theory and method. *Winterthur portfolio*, 17 (1), 1–19.

Riggins, S.H., ed., 1994. *The socialness of things: essays on the socio-semiotics of objects.* Berlin: Mouton-de Gruyter.

Rose, G., 2007. *Visual methodologies: an introduction to the interpretation of visual materials.* 2nd ed. London: Sage.

Ruby, J., 2005. The last 20 years of visual anthropology: a critical review. *Visual studies*, 20 (2), 159–170.

Schlereth, T.J., 1982. Material culture studies in America, 1876–1976. *In*: T.J. Schlereth, ed. *Material culture studies in America.* Nashvoille, TN: American Association for State and Local History, 1–78.

Schneider, J., 2006. Cloth and clothing. *In*: C. Tilley, *et al.*, eds. *Handbook of material culture.* London: Sage, 203–220.

Schouten, J.W. and McAlexander, J.H., 1995. Subcultures of consumption: an ethnography of the new bikers. *Journal of consumer research*, 22 (June), 43–61.

Simon, R.I., 2008. Forms of insurgency in the production of popular memories: the Columbus quincentenary and the pedagogy of counter-commemoration. *Cultural studies*, 7 (1), 73–88.

Stewart, W.P. and Floyd, M.F., 2004. Visualizing leisure. *Journal of leisure research*, 36 (4), 445–460.

Symes, C., 1989. Keeping abreast with the times: towards an iconography of T-shirts. *Studies in popular culture*, 12 (1), 87–100.

Tinning, R., 2008. Pedagogy, sport pedagogy and the field of kinesiology. *Quest*, 60 (3), 405–424.

Wallis, C., 2006. The multitasking generation. *Time*, 19 Mar. Available from: http://www.time.com/time/magazine/article/0,9171,1174696,00.html [Accessed 17 April 2009].

Ward, G., ed., 2000. *The Certeau reader.* Oxford: Blackwell.

Weber, S., 2008. Visual images in research. *In*: J.G. Knowles and A.L. Cole, eds. *Handbook of the arts in qualitative research.* Los Angeles: Sage, 41–53.

Weis, L. and Fine, M., 2000. *Construction sites: excavating race, class and gender among urban youth.* New York: Teachers College Press.

Woodward, I., 2007. *Understanding material culture.* Los Angeles: Sage.

Wright, C., 1998. The third subject: perspectives in visual anthropology. *Anthropology today*, 14 (4), 16–22.

Setting the scene: hailing women into a running identity

Meridith Griffin

School of Sport and Health Sciences, University of Exeter, St. Luke's Campus, Heavitree Road, Exeter, Devon EX1 2LU, UK

Readers should also refer to the journal's website at http://www.informaworld.com/rqrs and check volume 2, issue 2 to view the visual material in colour.

With the ethos of providing 'all women whatever their age, size or ability the opportunity to run together', the Women's Running Network (WRN) emphasises its accessibility to the 'true beginner'. The network provides a social and physical space in and through which (often) previously inactive, non-elite, non-competitive women of all ages learn to experience and perceive their bodies in a different way. The literature exploring all-female leisure settings has highlighted the importance of these environments for promoting physical and psychological empowerment, enhancement of body image, and improved perceptions of women and the female body. However, within this social field, the specific ways in which women learn to live with and through their bodies – and indeed are taught to do so – have received limited attention. In this paper, I focus upon the role of the visual and material culture of the WRN to examine how women are *told* and *shown* particular gendered and embodied identities. I suggest that, via narrative text and images, the WRN *hail* women of a specific social location to seek out and embody the ethos of the network. Using the concepts of gendered identity performance and commercialised feminism, I highlight how the visual culture of the WRN can be interpreted as constructing a moral, gendered obligation for sport/exercise participation through midlife and beyond. I conclude by discussing how the visual and material culture of the WRN has implications for framing and facilitating would-be participant's potential identity performance, socialisation experiences, embodiment and physicality within this women's-only context.

Introduction

Women are continuously bombarded with messages about how they are supposed to look, feel and act in their bodies (Grosz 1994, Bordo 1995). Though imbued with ageist, healthist and sexist discourses and varying according to context, these

messages influence and shape women's lived embodied experience in everyday life, at any age. Much of the extant literature concerning women's bodies in physical culture concerns issues such as access, motivations and barriers to physical activity, and body image, as well as explorations of the entrenched sexism and heteronormativity present within sport culture (Hargreaves 1994, Shaw 1994, Fredrick and Shaw 1995, Hall 1996, Heywood and Dworkin 2003). That which has focused upon all-female leisure settings has emphasised the importance of these environments for promoting physical and psychological empowerment, enhancement of body image, and improved perceptions of women and the female body (Theberge 1987, Hall 1996, Gilroy 1997, Wright and Dewar 1997, Castelnuovo and Guthrie 1998, Little 2002, McDermott 2004). However, literature in this area has tended to extrapolate the findings of female participants in particular settings to be representative of all women, thereby suggesting the existence of a universal experience and failing to encompass the complexities of difference that exist between and among women (Wearing 1990, Green 1998). In addition, the specific and varied ways in which women might learn to live with and through their bodies – and indeed are taught to do so – have received limited attention (Yarnal *et al.* 2006). As sport is inescapably both physical and embodied, it is an important context within which to explore how women learn about possibilities and potentialities for physicality and embodiment therein. In addition, little is known about the role of visual and material culture in the early stages of social-isation into a sport or leisure context, as well as any resultant implications it may have for embodied experiences and identity performance within the same domain.

With these considerations in mind, this paper draws from an ongoing ethnography of the Women's Running Network (WRN), a nationally successful women's-only running group within the United Kingdom. Starting in the South West England with just a few members in 1998, the WRN now has 2306 members and 242 leaders, distributed across 118 groups nationwide, and is funded by England Athletics (interview with WRN office staff, 29 June 2009). The ethos of the WRN is to provide 'all women whatever their age, size or ability the opportunity to run together to improve their health, fitness, confidence and safety' (WRN 2009).[1] Unlike the majority of running clubs, although it has many long-term members, the WRN consciously emphasise their accessibility to the 'true beginner'. As such, the WRN can be conceptualised as an important social and physical space in and through which (often) previously inactive, non-elite, non-competitive women potentially learn to experience and perceive their bodies in a different way.

What has been especially apparent in the research thus far is the proliferation of visual and material culture through which the WRN is depicted to prospective members, via narrative text and images (i.e. websites, brochures, pamphlets, posters, and significant media coverage particularly within the South West region). Thus, the purpose of this paper is to examine the ways in which the visual culture of the WRN presents an active running identity and constructs a framework and narratives intended to hail initiates to perform, and perhaps begin to embody, this identity.

Literature review

Theoretical framework: embodiment, identity and the leisure context

Waskul and Vannini (2006, p. 3) describe embodiment as 'the process by which the object-body is actively experienced, produced, sustained, and/or transformed as a subject-body'. Considering embodiment, then, requires an approach to the self that

includes the body and physical experiences as the basis of human experience (Merleau-Ponty 1962). For Goffman (1972), the body is a site for learning, power, and resistance and thus is crucial to learning about the physical and social context. This process begins from birth, as individuals are socialised and influenced into particular ways of looking, feeling and acting in their bodies, according to social norms as well as according to age, gender, ethnicity and ability (West and Zimmerman 1987, West and Fenstermaker 1995, Laz 1998, 2003). From this perspective, the body is understood to be an 'active process of embodying certain cultural and historical possibilities' (Butler 1988, p. 521). The possibilities for embodiment are thus highly contingent on the social, historical and cultural context within which this process takes place. Further, the body is not a static entity but is forever both 'being' and 'becoming' and is always capable of both action and performance in the constitution of self-identity (Grosz 1994). According to Goffman (1959), individuals are constantly involved in the performance of their identity and the reading of the performance of others. In Butler's words, 'one is not simply a body, but, in some very key sense, one does one's body' (1988, p. 521). As a result, identity is also not just 'being' but also 'doing' and 'to be a given kind of person…is not merely to possess the required attributes, but also to sustain the standards of conduct and appearance that one's social grouping attaches thereto' (Goffman 1959, p. 81).

Merleau-Ponty (1962) also emphasises the interactive elements of embodiment and identity, noting that we experience ourselves (as an embodied being) *as* something or other by interacting with others and garnering outside perspective on ourselves by comparison. Indeed, considering the world in terms of relational confluence, Gergen (2009) asserts that we are all primarily relational beings, and as such 'we exist in a world of co-constitution' (pp. xv). Further, identity formation is also a fluid, active process that takes place within the same considerations, possibilities and constraints of the context. Somers (1994, p. 626) refers to this context as a 'relational setting' and argues that 'identity formation takes place within these relational settings of contested but patterned relations among narratives, people and institutions'.

Leisure contexts can be categorised as a type of relational setting within which certain public narratives and social practices shape and are shaped by the individuals therein (Somers 1994). Indeed, leisure can also be seen as a source and expression of identity (Wheaton 2000, Stebbins 2001). Feminist researchers have found that for some women, leisure activities provide an avenue for intentional or unintentional resistance to dominant societal paradigms, and women-only leisure contexts have been conceptualised as providing specific opportunities for resistance to gender stereotyped roles and images (Wearing 1998, Shaw 2001). Most applicable here, however, is the theorisation of women's leisure with respect to the concepts of affiliation, friendship and community (Green 1998). As Hey (1997) argues, identities are variously practised, appropriated and negotiated between and among women as friends. As such, (gendered) identities are performed according to a set of meanings that are already socially established within a given leisure setting. These performances are neither reflective of individual choice nor purely imposed or inscribed upon the individual subject (Butler 1988). As such, it is important to emphasise that women perform multiple and complex identities within a given relational leisure setting in varying ways, according to individual context, agency and experience. However, that these performances are enacted in accordance with certain contextual sanctions and prescriptions requires reflection on the process by which women might begin to learn, anticipate and embody them.

In this paper, I argue that the visual culture of a leisure context is integral to the relational, interactive and perceptual components of the process of embodiment therein and also has implications thereafter for the action, experience and identity constitution of the social actor. Borrowing from Donnelly and Young (1988, p. 224), the information that women acquire about a specific setting, prior to initial participation in the activity, can be thought of as a form of 'presocialisation'. As these authors elucidate, uninitiated knowledge and understanding of specific sport contexts is developed from a variety of sources, including 'family and peer group awareness, direct or indirect contact with established members and, most significantly, *the media*' (Donnelly and Young 1988, p. 225, emphasis added). Donnelly and Young (1988) argue that this knowledge may be absorbed by an individual to facilitate a process of anticipatory socialisation whereby characteristics and roles of the setting, context or activity in question may be enacted – or performed – before the actor's current audience.

Importantly, recognising the significant influence of the media within presocialisation requires attention to the visual and narrative elements of the resources available to potential initiates. In this way, images and text can act to 'hail' or 'call' individuals into subject positions or towards the acceptance, performance and embodiment of a social role – a process that Althusser (1971) defines as 'interpellation'. While Althusser (1971) was primarily concerned with how ideology is deployed and imposed through the process of hailing, my interest lies in the relationship between narrative and interpellation. As such, throughout this paper, the term 'narrative hailing' refers to that relationship, or more simply, to the narrative dimension of the hailing process.

There are, however, prerequisites that must be present in order for an individual to be recruited and/or select and seek out membership, including opportunity, motivation, interest, proximity and life circumstances (Donnelly and Young 1988). A consideration of such prerequisites (i.e. by the organisation, or the cultural producers, of the media) in turn shapes the strategic deployment of stylistic, visual and textual narratives designed to be unchallenged by the audience being hailed or recruited into a role (Althusser 1971, Boje 2008). That individuals bring their own life texts, socio-cultural and political contexts, knowledge, and values and beliefs to the meaning-making process determines the narratives that the organisation is able to construct and the power that such narratives are able to exercise (Crinall 2009). As such, attention to life circumstances and prerequisites has the potential to reveal who might be excluded on the basis of them. Further, a consideration of visual artefacts can reveal insight into how narratives operate in, through and alongside visual texts and can offer insight into how identities are presented, constructed, negotiated and performed within a specific leisure setting, or culture.

Methodology and methods

Visual culture in ethnography

Visual methods within a larger ethnographic project allow greater insight into how people may view themselves, others and situations that they may face within their social world (Coffey and Atkinson 2004, Ball 2005, Hammersley and Atkinson 2007, Riessman 2008). Indeed, ethnographic methods generally include participant observation combined with qualitative interviews and techniques and also often incorporate a myriad of other documents, artefacts and data sources (i.e. visual images, newspaper cuttings, maps, surveys and statistics) (O' Reilly 2005, Hammersley and Atkinson 2007). Highlighting the potential of visual research methods, Pink (2001, p. 1)

describes how photography, video and electronic media are becoming increasingly incorporated into ethnographic work 'as cultural texts, as representations of ethnographic knowledge and as sites of cultural production, social interaction and individual experience that themselves constitute ethnographic fieldwork locales'. As such, an ethnography that employs all available visual resources allows sensitisation to potential themes, images and metaphors that form part of the narrative of the culture (Hammersley and Atkinson 2007, Riessman 2008). This approach 'recognizes the interwovenness of objects, texts, images and technologies in people's everyday lives and identities' (Pink 2001, p. 6), permits an exploration of the dynamic relationship between the visual and the textual and elucidates the master and counter narratives that operate in and through a particular social context.

As Riessman (2008, pp. 179–180) states, 'working with images can thicken interpretation. Images can evoke emotions and imaginative identification'. It is this process of interpretation and identification that will be probed more thoroughly in this paper, particularly by examining the visual culture that is available to those women who are in the 'presocialisation stage' – prior to any level of participation in the WRN. The primary means of collecting any of this information is through engagement with various images and associated narratives, within a visual culture that is primarily produced and/or mediated by the organisation itself. For the purposes of this paper, the first step in data collection was the identification and compilation of these available material resources.

Collecting and analysing visual narratives within the WRN

Since March 2009, I have been attending WRN sessions and events, immersing myself in the field by running alongside members and subsequently recording reflexive field notes, as well as collecting and taking note of the visual culture of the group. Indeed, true to the tenets of ethnography, this paper will include a wide variety of visual resources, including the WRN website, promotional material (i.e. posters, leaflets, etc.), as well as media coverage of the organisation (i.e. press releases and newspaper articles). According to Banks (1995, p. 1), this approach falls under the category of studying 'representations whether pre-existing or produced', rather than visual records produced by the investigator or the researcher. The focus was on those sources that are most readily available and easily sought out by those who are not yet members of the WRN (i.e. text and image-based materials that are publicly available to non-members, with the caveat that those who view these images will not be representative of the whole population). All images on the website were included, and the marketing materials and a large file of media coverage were provided to me by the WRN staff. I excluded the quarterly newsletters produced by the WRN, since they are sent to existing members only. While the content of the promotional material and the website are solely determined by the WRN, the media coverage is multi-authored, though often includes interviews with WRN leaders or staff and/or existing WRN members.

Analysing visual material is a complex process which is shaped and informed by a wide variety of perspectives and methods. It is not characterised by essentialist step-by-step procedures (Collier 2001, van Leeuwen and Jewitt 2001). However, in approaching the task of interpreting the visual culture of the WRN, I have found Riessman's (2008) description of visual narrative analysis highly useful. Specifically, it is argued that attention must be paid to the production of the image, the image itself and the possibilities for various interpretations by different audiences (Rose 2001,

Harrison 2002, Stanczak 2007, Riessman 2008). Following Riessman (2008), the first analytical step for this paper was the examination of all selected images for how and when the image was made, and social identities of the image maker and intended recipient(s), as well as other relevant aspects of the image-making process. As such, the data directly produced by the organisation (i.e. website, brochures, pamphlets, posters, etc.) were analysed separately from the data that was not (media/newspaper coverage).

Secondly, the image itself was considered, with attention to the story it suggested, what it included (and by association, excluded), how component parts were arranged, and the use of colour and technologies relevant to the genre. A third level of analysis examined the interface of the visual and the textual, with an attempt to draw connections between images and some kind of discourse: 'a caption, written commentary, and/or letters of the image-maker that provide contexts for interpreting the image' (Lupton 1994, Riessman 2008, p. 145). Subsequently, narrative patterns and strategies were identified in the data as a whole, followed by careful and methodical checking and double-checking for tensions and areas of disjuncture in order to refine emergent patterns (Spencer *et al.* 2003, Sturken and Cartwright 2003).

Recognising the complexity of material objects (artefacts), narratives, texts, and images within people's everyday lives and identities, reflexive epistemologies of visual research hold that images should be read interpretively (Rose 2001, Riessman 2008). As it is beyond the scope of this paper to consider interpretation from the perspective of the potential or targeted audience(s), it is crucial that I acknowledge at the outset that the interpretations to follow are mine alone. The foundation for my interpretations, or my positionality, is thus important to elucidate my whiteness, femaleness, relative youth of 29 years of age, Canadian heritage, and middle-class upbringing, which all come to bear on how I read these texts and images. In addition, my academic background in the areas of Sociology, Women's Studies and Human Kinetics provide a kaleidoscopic lens through which my assessments, critiques and evaluations inevitably pass. By this token, the interpretations presented below do not (nor do they claim to) represent all possible interpretations by differently located social actors and are to be read with this in mind.

The visual culture of the WRN

Hailing and interpellation – 'we welcome women just like you'

Analysis of the promotional material, website, and media coverage of the WRN revealed a distinctive visual and textual narrative strategy for encouraging new members to join the organisation. On the national WRN website, the homepage contains text that introduces the organisation and states the philosophy, or ethos, of the group: 'Giving women whatever their age, size or ability the opportunity to run together to improve their health, fitness, confidence and safety'. When a region is selected from the menu on the left-hand side, the web page navigates to the regional homepage upon which the image shown in Figure 1 appears. Words of the ethos are superimposed on a composite image, citing reasons as to why women might choose to participate in the group ('fun', 'fitness', 'health' and 'confidence') as well as the words 'welcome', 'run' and 'inspire'. Silhouettes of female runners appear as if floating in a grassy field, with blue skies in background and visible smiles on the faces that are pictured.

Figure 1. Regional homepage banner of WRN website.

This ethos is echoed, and indeed ubiquitous, within and throughout all of the promotional material and the majority of media coverage considered in this paper. Paired with the ever-present ethos is the picture below (Figure 2), featured on the front cover of the beginner's training log book, as well as on the majority of the promotional material (i.e. advertising pamphlets and posters) of the WRN.

Appearing underneath this same image, the text on the poster reads, 'Come and join us with our complete beginners running group, designed to help the novice woman start running in a fun way!' On the back of the pamphlet, two smiling women in running kit embracing each other are pictured. The images are suggestive of celebration or congratulatory support, friendship, fun and happiness.

Via these images and explicit textual invitations, narratives within the visual culture of the WRN interpellate, or hail, women into a specified identity, role and activity: that which is embodied by a WRN member. This identity is desirable by design and supposed characteristics: not many women would eschew the promised attributes of fun, friendship, fitness and achievement. Interpellation can be understood as the process by which individuals come to recognise themselves as having the potential to belong to particular subject positions, or identities (Althusser 1971). In this view, subject positions are conferred and assumed through an authority's action of 'hailing' individuals into social or ideological positions (Butler 1997a, Aston 2009). Althusser's (1971) classic example is that of a policeman shouting 'Hey, you there!' to a passerby (thereby 'hailing' her), and upon hearing the policeman's official address, the passerby believes/suspects/knows that it is for her and turns around to accept the salutation. As Aston (2009, p. 614) points out, the passerby thus 'recognizes that she has been spoken to and begins to engage with and accept the social role being offered to her'. With respect to the WRN, the reader of the promotional material is hailed by the narratives therein, seemingly being meant to feel as though she is

Figure 2. Image from WRN log book front cover as well as promotional posters and pamphlets.

being directly addressed and personally invited to join, as well as see herself (or want to see herself) as a subject in the images in question. Simply, she is meant to see the possibility of a shift in identity.

Further according to the introduction on the website, the WRN 'genuinely supports the complete beginner'. It does this by offering personal accounts of success stories and using images that certain kinds of women are likely to identify with, as well as by explicitly targeting and drawing individual women in through storylines that many can relate to: 'But I have never run before!', a headline on the website reads, with subsequent reassurance that if that is the case, 'We welcome women just like you'. Statements such as these continue the trend of narrative hailing by both developing and promoting a specific social identity and by offering storylines that the reader/audience is invited to take hold of and make part of her own narrative repertoire (Somers 1994). For example, the phrase 'women just like you' has the effect of both creating a self from which an other can be distinguished and simultaneously likening that self to certain and particular others, thus emphasising the relational aspect of identification. Paired with images such as those included here, women in the audience may perceive themselves as either the subject (self/potential WRN member) or the other. The promotional material and media coverage are rife with such narrative hailing, as well as an identification of potential fears and barriers, with an immediate attempt to address or alleviate them. Using phrases and headlines such as 'You're Invited … to do something amazing!', 'Get your body back on track', 'Try something new', 'Make a date' and 'Step on it!', media coverage in particular attempts to hail the audience to participate in the image and the ideological role as narrated by the organisation (Althusser 1971). An image such as the one shown in Figure 3, from a newspaper article, then, can be

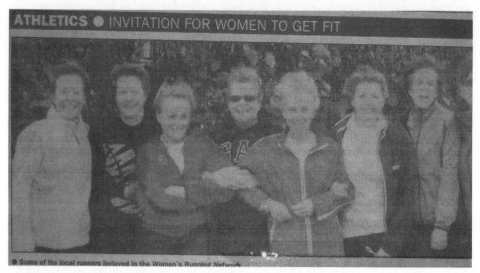

ATHLETICS ● INVITATION FOR WOMEN TO GET FIT

● Some of the local runners invloved in the Women's Running Network

Figure 3. An image from newspaper coverage of the WRN.

seen to narratively hail or interpellate certain individuals as subjects – or as members of the WRN.

Again, this image visually emphasises the characteristics said to be gleaned from WRN participation and acts to invite the reader to embrace a 'new' identity that is embodied by these characteristics. The women pictured are smiling, looking confidently at the camera and standing close together, with some linking arms to demonstrate camaraderie, support and happiness. However, not every woman engaging with the images above (Figures 1–3) will be able to see, or picture, themselves therein. The women pictured are all white, are all relatively youthful and slim, and present a limited body type and size. As such, it would seem that not all readers would relate to the narratives present and thus not all individual bodies are equally hailed by these images.

Another point that is emphasised within the visual culture of the WRN is the element of fun. This sentiment is clearly demonstrated in the images found on all of the promotional material as well as within newspaper coverage (see example from the promotional pamphlet in Figure 4). Women are shown being social, having a laugh and smiling.

The notion of 'fun' is further confirmed and emphasised in the text surrounding the images, in the words of WRN members and in the headlines of media articles hailing would-be WRN participants. For example, one woman, quoted in a newspaper article, noted, 'I just wouldn't be out there on those rainy nights if it weren't for the support of the other girls. I've found new friends and lost two stone and we all have a good laugh while we're out'. A poster advertising a specific running group includes the sentence, 'Come on give it a go and be frivolous!!!' The material is spurring the reader to 'take a chance!' and 'be exciting!' by taking up the offered opportunity of shifting into a new identity of WRN member and runner. Another newspaper article states the following: 'Any notions of austere training regimes and timed sprints should…be banished. Fun is the catalyst'. This method of framing participation has the positive intention of making physical activity more appealing to those who either have had negative experiences in the past or who generally have a hard time getting motivated on their own.

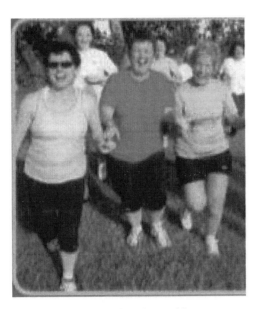

Figure 4. An image from the WRN promotional pamphlet.

The media coverage generally features groups of women (such as in Figure 3), often with their stories included in the text. These stories tend to voice and then refute commonly held preconceptions regarding starting to run from the perspective of a novice. This strategy corresponds with the ideas of Butler (1997b), who asserts that in order for interpellation to be effective, certain factors must be in place. Specifically, an individual must have some 'readiness to turn' or some openness or vulnerability to the authority doing the hailing (Butler 1997b, p. 107). As Butler (1995) describes, this openness may consist of a promise of identity, the right timing, a guilty conscience or some or all of these. This also fits well with the prerequisites that Donnelly and Young (1988) identify as important within the 'selection and recruitment' stage of socialisation into a sporting identity. For example, one newspaper article acknowledges that, 'It can be daunting to get started…if you haven't done anything athletic in years, were never that sporty at school or gave up exercise when you had children'. However, by offering the success stories of women who once had such insecurities, these narratives function to hail the would-be WRN member to reconsider. For example, for those many women who feel motivated to try but simultaneously fear exercise due to excess weight, this story is presented:

[Name] started running after her 50th birthday. She went along to the Women's Running Network group in Cullompton and surprised herself by running four miles on the first night. She's lost four stone in the year and a half since she started running. 'I was a lot bigger last year', she says. 'I love it. I think I'm addicted to it. It was a challenge for my 50th birthday to run a half marathon, and I just went further. It is a complete addiction'. She started off running the Exeter half marathon, the Great West Run, last year. This year, she is planning to do four half marathons. 'I think it has improved my mental health as well as my physical health', she says. 'I went for eight months and lost weight every week, with being careful about what I ate. I have had the best social life over the past 12 months than I have ever had'.

While weight loss was emphasised in many headlines and narratives within the media coverage (see next section for discussion on the feminine body ideal, weight loss and gendered identity performance), similar stories were presented for those women who have encountered and overcome different social, emotional and physical barriers. Via these presented narratives, readers of a similar social background may recognise the possibility that participation in the WRN could offer a means of re-storying their body and identity in an athletic context.

Another article leads with the image given in Figure 5 and the by-line: 'Fit or unhealthy, young or old, experienced or a newcomer, the Women's Running Network promises everyone a warm welcome'.

Quoting the founder of the WRN later in the article, the narrative hailing continues:

> Ninety percent of our members are women whom other running groups would not want because they are too slow. That's what makes us different: we encourage beginners. I see people who have never actually run before go on to complete a marathon.

As such, the WRN endeavours to define itself, and by association its participants and would-be participants, by what they are not: 'You don't have to be on a strict diet and run like a complete nutter'. The narratives presented in this section tend to empha-sise fun and the social aspects of running with the group and are disseminated in combination with images emphasising support, happiness and what is purported to be embodied heterogeneity (i.e. in shapes, sizes, ages and fitness). With this, I argue that the WRN is attempting to create a visual culture that not only aspires to redefine the general/typical representation of a running body but also depicts and describes

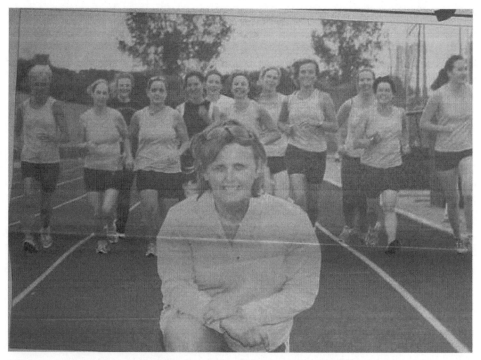

Figure 5. An image accompanying a newspaper article on the WRN.

specific embodied identities that are performed, accepted and celebrated within this context.

Commercialised feminism and the performance of gendered identities

Blinde *et al.* (1994) note that most research examining the empowering aspects of female sport has occurred in woman-controlled sport organisations, feminist sport leagues or lesbian sport teams and that it is within these gynocentric environments that we see overt challenges to hegemonic practices in sport. With its emphasis on accessibility for women of all shapes, sizes, ages and abilities, the WRN can be seen to be aligning with a feminist sporting ethos – seeking to offer an alternative to supposedly masculinist aspects of sport such as an overemphasis on winning, elitism, hierarchy of authority, social exclusion, and hostility towards and endangering opponents (Birrell and Richter 1994, Krane 2001). In contrast, there is an attempt within the visual culture of the WRN to create the image of an accessible, supportive, social and empowering environment. This is emphasised by an image depicted within the WRN's beginner's log book (Figure 6). Rather than attempting to achieve individual success in terms of finishing position or time, the women are clasping hands, smiling, and helping each other towards their assumed collective goal. This image underscores the message that participation in the WRN is not competitive but is instead about

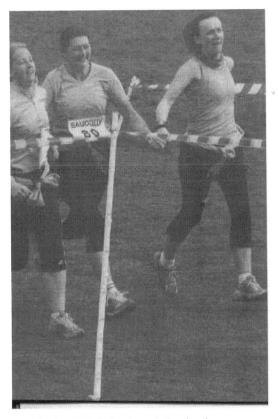

Figure 6. An image within the WRN's beginner's log book.

building relationships and an ethic of care and support. However, there are alternative readings of this material, in that the very existence of a log book is suggestive of the monitoring of performance and/or improvement and thus could be interpreted as contradictory to a non-competitive ethic.

Speaking on the issue of competition, one newspaper article includes a quotation from the founder describing why the network is just for women: 'I had a couple of guys in the group once and they immediately hared off into the distance and disappeared. That's not what we're about … It's about staying together and supporting each other'. This sentiment is continually reinforced through the bodily positioning within many images – participants are pictured embracing, holding hands, and always in close proximity to each other. These can be read as 'images of collectivity', wherein the connection of the bodies pictured makes the group of women appear as an entity perceptible to themselves and any spectator: a plural self (Pillsbury 1996, p. 36). Further asserting that there are differences between genders to think about when it comes to running, a group leader is quoted in another newspaper article as saying, 'Women have to think about a sports bra and men don't have to think about that. Women tend to have to fit their running in around working and looking after the children or getting all the jobs done at home … And then there are other issues like pregnancy and menstruation, of course'. Similarly, on the website and within the beginner's log book, a list of what is needed for participation includes 'a well-fitting sports bra'. As such, the visual culture of the WRN includes an effort to show a commitment and orientation to women and their perceived distinctive needs.

Continuing to stress stereotypical differences with respect to gender and competition, another leader, in a different article, remarked, '[the WRN is] non-competitive and non-pressured and people run at their own levels'. This is possible due to the technique of 'looping' within a WRN run, wherein front-runners loop back behind those who are running less quickly at regular intervals in order to keep the group together. However, for those not familiar with this structure (i.e. likely anyone within the audience who is not yet a member of the group), some women may very well interpret that unless they feel able to keep up with the group, they are not welcome. In addition, the same leader then continued on to mention, and valorise, specific races that members of her group had participated in. While competition is underplayed, and even ideologically opposed by the WRN, leaders do actively encourage members to participate in organised races and events. Indeed, this contradiction is both visible and pervasive and is reinforced within the visual culture: in 20 of the 26 images included in the beginner's log book, there are visible race numbers and the women pictured are either shown in motion (running) or with medals around their neck after finishing an event (see selection of three images below in Figure 7, also Figures 1 and 6).

On one level, these images can be said to embody the ethos of the WRN – the women pictured are of varying ages, body sizes and types, and the medals are finisher's medals rather than awarded to the top finishers (discernable because there is one image in the log book where all nine front-facing women in the picture can be seen wearing a medal). However, images of a competition overwhelmingly predominate in what would be the initiate's first glimpse into the allegedly non-competitive athletic world of the WRN. In addition, while the 'typical' running body is not presented here (young, slim, toned, etc.), there are numerous bodies that are conspicuously absent from the images above (i.e. women of colour, severely overweight and obese women, women of considerably advanced age, women with disabilities and women without the financial means to participate).

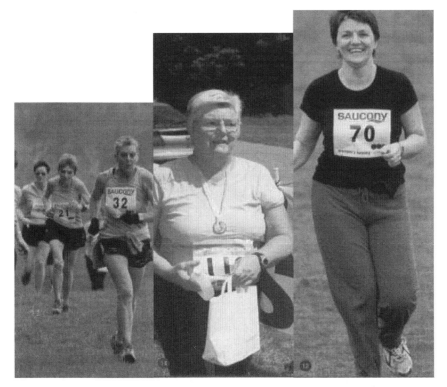

Figure 7. Images of 'competition' from the beginner's log book.

Gendered assumptions go beyond just the concept of competition. Paired with observations such as, '…quite a few of the women are surprisingly fit', and 'the network … works on the principle that anyone can run and can surprise themselves by just how much they can achieve', the media coverage perpetuates the perceived limits and abilities of gendered bodies, with men's bodies presumed to be naturally faster, stronger and more powerful than their female counterparts (Dowling 2000). Headlines such as 'Run along, women!' and 'Girls on the run' could be interpreted as condescending or as humouring those women who are engaging with running as a leisure pursuit. Presenting the WRN as a 'larky all-female running group' (another phrase from a newspaper article) has the effect of excluding those women who do take it seriously and are, in fact, competitive – or want to be so, if we look from the perspective of the beginner. Indeed, an emphasis on frivolity, or fun (as detailed in the previous section), can be interpreted as a trivialisation of sport for women (Krane 2001, Dworkin and Messner 2002). In highlighting the 'feminine' aspects of participation in this leisure context, the visual culture of the WRN presents female members as culturally acceptable women by exaggerating their performance of femininity. The underlying message presented is that athleticism and femininity are contradictory and women are encouraged to negotiate and perform gender in a particular and prescribed way if they wish to be both athletic and socially accepted. By emphasising fun and camaraderie in female sport via a range of visual and textual narratives, the visual culture of the WRN assures women that running is an appropriate activity for them to participate in.

Women who do see, or can imagine, themselves in the presented visual culture are meant to be enticed by the emphasis on fun and sociality, as well as by media headlines

such as 'Get your body back on track', and 'If you've only ever run for a bus, it may be time to get moving'. In deliberately distancing themselves from traditional measures of success and performance (race times, speed, etc.), the WRN aligns itself with other measures that can be seen as gendered, particularly concern with weight loss and the achievement of a feminine body ideal. These gendered motivations and rationales were echoed in members' narratives of their participation within the media coverage. One newspaper article, entitled 'I started running to lose weight', included this quotation from a WRN member:

> I still can't believe I've run a marathon, especially when I look back to my school days. I was the one lagging behind everyone else on the sports field. Sport was a chore not a pleasure, which is a real shame … Running has totally changed my life. I'm not just fitter, my skin's clearer, I'm toned, I've dropped a dress size, don't have any cellulite and I've met some great people.

Presenting numerous similar narratives of 'success', the visual and textual narratives within the WRN serve to propagate gendered body ideals, responsibilities and types of participation. Within both the newspaper coverage and the WRN marketing materials, women are urged to run both for their own health and the health of others, or, ideally, for a cause. Underlying these narratives is a commercialised version of feminism (Kelly *et al.* 1996, Goodkind 2009), characterised by a focus on the potential for empowerment alongside both moral and individual responsibility. In effect, 'the individual change promoted by commercialized feminism is not only for the purpose of creating personal satisfaction but also is intended to create citizens who will regulate and govern themselves' (Goodkind 2009, p. 400). In the case of the WRN, it is the individual woman's responsibility for her own health, weight control, safety, social fulfilment, confidence, self-esteem and, ultimately, happiness. This perspective can bracket the individual from the social and cultural realms, shifting the location of the problem from outside the self (e.g. patriarchal society) to within the self (Goodkind 2009). 'Personal fulfilment thus becomes a social obligation' and those who fail to achieve or engage with this reform are categorised as 'social problems' (Cruikshank 1996, pp. 232–234). As such, the message within the visual culture of the WRN may be interpreted as being mixed: alongside inspirational declarations such as 'If I can run a marathon, anyone can', (a quotation by a WRN member within a newspaper article) is the moral imperative that the reader/would-be runner *should* run a marathon – and is somehow irresponsible and morally lacking should she decide not to do so.

Reflective comments

This paper considers the visual culture of a non-elite, women's-only running group with respect to the concepts of embodiment and the learned performance of identity. In examining the visual images and textual narratives within the promotional material and media coverage of a specific organisation (the WRN), the process by which information is relayed to would-be runners, or potential members of the WRN, is partially elucidated. That noted, a secondary purpose of this paper has been to demonstrate the applicability and usefulness of visual methods within sport ethnography. Specifically, I point to the insight that can be gleaned when focusing on the narrative images and texts that are ubiquitous within this particular social world.

In attending to the visual culture of the WRN, the analysis revealed the distinctive visual and textual strategy of narrative hailing, meant to target and encourage new

members to join the organisation. By considering prerequisites such as opportunity, motivation, interest, proximity and life circumstances of potential members (Donnelly and Young 1988, Butler 1997b), the visual and textual narratives collectively act to hail women of a specific social location to seek out and join the group. Indeed, despite the claimed ethos of welcoming 'all ages, sizes and abilities', the audience likely to respond to being hailed is composed of a particular 'type' of woman: one who is primarily white, young to middle-aged, able and who has the leisure time and financial means to participate. Further, though these images and textual narratives are publicly available, it is important to note that those who actually view and engage with these images are not representative of the whole population. The audience is likely to be women who are already seeking some form of physical activity (for health, weight or social reasons) and who – at least on some level – see themselves as able to perform the task in question (in this case, running). Thus, while attempting to represent embodied heterogeneity, the images and texts analysed actually reproduce a particular woman's body as the norm and may exclude other women (who deviate from this norm) from participating.

Readers of a similar social location to those within the visual and textual narratives are encouraged to see themselves as the 'before' women in the stories presented: those who struggled with sport at school, those who are carrying extra weight or those who are trying to get active after having taken a break from being so. Having made this social identification, the WRN initiate is then hailed via narratives designed to encourage and convince her that she also has the potential to make life healthy, positive and exciting and to identity changes should she decide to join the WRN. Consuming these visual images and narratives, then, the would-be WRN member is beginning to learn and absorb the knowledge of what an average WRN member is and looks like. Further, these images and narratives portray and present gendered identity performances that, I argue, begin to instigate relational reflection and anticipatory negotiation from the perspective of the initiate.

Building upon the technique of narrative hailing (or personal invitation) in enticing new members, the analysis also revealed an overt alignment of the WRN with a feminist sporting ethos. Defining itself in opposition to sporting values imbued with hegemonic masculinity, the WRN is, according to it, non-competitive, non-pressured, social, fun, supportive and empowering. This again entails an effort to demonstrate accessibility, positive aspects and benefits of participation, and ultimately difference if not opposition to traditional masculinist conceptions of sport, such as competition and elitism. However, while dominant constructions do position masculinity as active and femininity as passive, and sport therefore as not a feminine activity, research has shown that the construction and performance of masculinity and femininity in sport is far more complex than is represented by a simple, binary division (Theberge 2000, Neverson and White 2002, Evans 2006). Indeed, although dominant discourses exist regarding the performance of gendered identities within sport, it is important to note that individual women respond, resist and negotiate these by constructing their bodies and performing identities in many different ways (Nelson 1999, Krane 2001). Thus, the binary approach to the performance of heterosexual femininity within the visual culture of the WRN denies the experiences of those women who do not fit neatly into these categories: those who are competitive or who do view themselves as athletic.

However, rather than presenting the WRN as a space where multiple and varied gender identities are played out, the visual culture of the WRN is replete with images and discourses of heterosexual femininity. As such, narratives presented as supportive

(i.e. references to women-specific needs and issues such as sports bras, pregnancy and menstruation) may actually reproduce women's bodies as less able to engage in sporting activities. Pointing to the distinctive needs of women has the potential of reinforcing a form of 'inhibited intentionality': a tendency for women to underestimate their physical potential or ability on the basis of gender (Young 1990, p. 147). Further, framing participation as 'fun', 'larky' and 'frivolous', the visual culture of the WRN again emphasises stereotypical and extreme heterosexual feminine values. By association, women's sport participation is trivialised and the images and voices of those women who take their running seriously, are competitive in a myriad of ways or take pride in their athleticism are silenced.

The analysis also revealed that the visual and textual narratives championing the availability of empowerment via participation cannot be separated from those underpinned by individual choice and responsibility. As Goodkind (2009, p. 411) asserts, this 'reflects the neoliberal belief that because an individual has the capacity to choose, she is solely responsible for her actions and the consequences'. In examining the images for the context and politics of their production, the WRN and the media can be conceptualised as 'cultural producers' or entities who exert social influence through both text and visual imagery (Childs and Barkin 2006, p. 36, Otanez and Glantz 2009). Via commercialised feminism, the WRN can be seen to engage in 'rhetorical acts of public persuasion that rely on cultural formations and that appeal to cultural values' (Benjamin 2007, p. xiii) in an attempt to establish a positive and desirable image and social identity. Potential members of the WRN are thus presented with a commercialised feminist message through which they are shown and told that they are morally obliged to engage in projects of self-control, self-management and self-regulation (Haney 2004) – projects such as joining and running with the WRN. In addition, the visual culture of the WRN simplistically implies that the achievement of, and what constitutes, 'empowerment' is the same for all women.

As the visual and textual narratives included in this paper are integral to how potential participants first learn of and about the WRN, it follows that they also underpin the identity of a typical WRN member as conceived by the organisation and influence the process of presocialisation into a running identity as defined by the WRN. These dominant narrative strategies and patterns, then, have implications for framing and facilitating would-be participants' identity performances, socialisation experiences, embodiment and physicality within this women's-only context. Initially, as interested women are hailed by the visual and textual narratives in the promotional material and media coverage of the organisation, they are gaining 'uninitiated knowledge and understanding', something which Donnelly and Young (1988, pp. 224–225) claim facilitates a process of 'anticipatory socialisation', or presocialisation. I argue that this process also engenders a form of *anticipatory embodiment*, wherein potential members begin to reflexively experience their own bodies via their interaction with the images and text that are depicting possibilities for embodiment and identity performance within the WRN. For example, as women are hailed to participate and are confronted with ideologies emphasising heterosexual femininity, they are learning what it might mean to be embodied within a WRN social identity. Further, they are being called to reflect and act upon their bodies (Crossley 2006) by joining the WRN, via discourses that are laced with commercialised feminism and associated moral responsibility. Simply, they are being told what is a good way of being in the body, hailed or called to desire this form of being in the body, and then informed that they are both individually and morally responsible for achieving this type and method of

being in the body. However, it is important to note that individual women (i.e. those who choose to join the WRN) are not devoid of agency when performing/enacting their gendered identities in negotiation with these messages and thus do not unthinkingly reproduce the discourses therein.

This paper is not intended to be a critique of the WRN or the WRN's marketing and promotional strategies; commercialised feminism is reflected in the narrative images and texts available to the WRN initiate, but is not a product of them. The narrative strategies and identified patterns are effective for a particular audience because they allow the organisation to appear both feminist and gender-specific, are congruent with neo-liberal imperatives towards health and fitness and provide for many women who were previously unable to engage in physical activity a comfortable and appealing avenue of doing so. In many ways, the visual culture of the WRN actively redefines the running body and the running experience, thereby making both more accessible – something that is both positive and admirable. Indeed, while it is difficult (as well as unnecessary) to argue with the desirability of increasing confidence and self-esteem and engendering empowerment via sport participation, I propose that the seemingly feminist and inclusive ethos of the WRN possibly essentialises the female member experience. Far from reflecting diversity, the narrative images and text examined in this paper present, ultimately, one type of woman and one type of sport participation. Positively, it is a type often excluded – but it is one type nonetheless and is thus exclusionary on many levels.

With respect to both ethos and design, there are innumerable positive things to say about the WRN as a sporting organisation. They lay claim to getting over 10,000 women running over the past 10 years and attempt to share their joy of running with everyone possible, particularly those who are frequently excluded. Thus, the goal here was not to find fault with something that is working on some level but instead to critically examine how it is working – and, ultimately, if it could work better. Doing so, I argue, entails attention to the visual culture of the WRN – a calculated awareness of the visual and textual narratives being presented and mediated via the organisation to potential members. This awareness could lend insight into the concepts of presocialisation, identity performance and anticipatory reflexive embodiment within a physical culture. More importantly, this awareness could provide impetus for change and improvement. Specifically, can the WRN become ever more inclusive and accessible? Are there women who are currently excluded who may want to give running a go? Finally, how might the WRN best target, recruit and convert non-runners to the running lifestyle that it so passionately advocates? Scrutiny and contemplation of the visual resources, materials and artefacts within the WRN culture elicits, and perhaps goes some way towards answering, these questions.

Specifically, I suggest that the WRN might deliberately include images of women of colour, women of size and women of a wider variety of ages within its promotional materials and on its website. In addition, to avoid the tendency of essentialism, there is a need for the WRN to go beyond defining itself in diametric opposition to masculinist sport and instead to challenge the conception that athleticism and femininity are contradictory (Krane 2001). For example, to achieve the ostensible goal of an accessible and inclusive sporting environment, the visual culture of the WRN would do better to work towards expanding the parameters of embodiment and gendered identity performance therein, rather narrowly defining it via narrative text and images. This would entail including and presenting the performance of a diverse continuum

of gendered identities, including those who dare not to conform to the (typically narrowly defined) characteristics of heterosexual femininity. In addition, to avoid 'inhibited intentionality' (Young 1990, p. 147), the WRN might do well to attempt not to emphasise distinctions on the basis of gender, or at least might simultaneously acknowledge narratives of strength, power and endurance that widen the definition of femininity within the context. As such, rather than criticising what is there, what I am arguing for is an expansion of the visual and textual narratives available within the visual culture of the WRN.

It is important to note that the scope of the visual material included in this analysis was limited. Specifically, I do not purport to include all published media coverage of the organisation over a given time period, nor do I endeavour to do a content analysis on what is included here. Further, although the media coverage often includes the voices of WRN staff, leaders and members, it is multi-authored, and as such cannot be said to wholly represent the views of the WRN as an organisation. To simplify, I have treated the media coverage as an extension of the WRN corporate image, assuming that the organisation had some level of influence and mediation over what was written and pictured therein. However, I recognise that this is a simplification, and future analysis would require investigating this further. Further, I acknowledge that the media coverage included in this analysis was both collected and retained by the organisation, suggesting a bias towards positive representation. In addition, it is beyond the scope of this paper to consider how the audience (in this case, the would-be WRN member) actually interprets or reads the visual and textual narratives with which it is presented. Thus, further research is warranted to examine how these narratives are perceived and consumed by those who are targeted, the effect that this has on socialisation and identity performance when going from the status of an initiate/beginner through to a full-fledged WRN member/runner, and the concomitant implications for embodiment.

Acknowledgements
Permission has been granted to use and reproduce all text and images included in this paper. I would like to thank, as well as acknowledge credit, for the images and material acquired via the WRN, the Express & Echo and the SouthWest Media Group. Finally, I would like to express my sincere appreciation to the two anonymous reviewers for their insightful comments on an earlier version of this article, as well as to Brett Smith for handling the paper throughout the reviewing process.

Note
1. The images analysed and referenced within this paper from this source are no longer current or in the same location. The WRN have launched a new/upgraded website at the URL: http://www.womensrunningnetwork.com/

References

Althusser, L., 1971. Ideology and ideological state apparatuses. *In*: L. Althusser, ed. *Lenin and philosophy and other essays*. New York/London: Monthly Review Press, 127–242.

Aston, S., 2009. Identities under construction: women hailed as addicts. *Health: an interdisciplinary journal for the social study of health, illness and medicine*, 13 (6), 611–628.

Ball, M.S., 2005. Working with images in daily life and police practice: an assessment of the documentary tradition. *Qualitative sociology*, 5 (4), 499–521.

Banks, M., 1995. Visual research methods. *Social research update*, 11, 1–6. Available from: http://www.soc.surrey.ac.uk/sru/SRU11/SRU11.html [Accessed 15 February 2010].

Benjamin, B., 2007. *Invested interests: capital, culture, and the World Bank*. Minneapolis: University of Minnesota Press.

Birrell, S. and Richter, D.M., 1994. Is a diamond forever: feminist transformations of sport. *In*: S. Birrell and C.L. Cole, eds. *Women, sport, and culture*. Champaign, IL: Human Kinetics, 221–244.

Blinde, E.M., Taub, D.E., and Han, L., 1994. Sport as a site for women's group and society empowerment: perspectives from the college athlete. *Sociology of sport journal*, 11 (1), 51–59.

Boje, D.M., 2008. *Storytelling organization*. London: Sage.

Bordo, S., 1995. *Unbearable weight*. Berkeley: University of California Press.

Butler, J., 1988. Performative acts and gender constitution: an essay in phenomenology and feminist theory. *Theatre journal*, 40 (4), 519–531.

Butler, J., 1995. Conscience doth make subjects of us all. *Yale French studies*, 88, 6–26.

Butler, J., 1997a. *Excitable speech: a politics of the performative*. New York: Routledge.

Butler, J., 1997b. *The psychic life of power: theories in subjection*. Stanford, CA: Stanford University Press.

Castelnuovo, S. and Guthrie, S., 1998. *Feminism and the female body: liberating the Amazon within*. Boulder, CO: Lynne Rienner Publishers.

Childs, G. and Barkin, G., 2006. Reproducing identity: using images to promote pronatalism and sexual endogamy among Tibetan exiles in South Asia. *Visual anthropology review*, 22 (2), 34–52.

Coffey, A.J. and Atkinson, P., 2004. Analysing documentary realities. *In*: D. Silverman, ed. *Qualitative research: theory, method and practice*. 2nd ed. London: Sage, 56–75.

Collier, M., 2001. Approaches to analysis in visual anthropology. *In*: T. van Leeuwen and C. Jewitt, eds. *Handbook of visual analysis*. London: Sage, 35–60.

Crinall, K., 2009. Appealing for help: a reflection on interpellation and intertextuality in the visual narrative of an Australian welfare campaign poster. *Current narratives*, 1, 11–22.

Crossley, N., 2006. *Reflexive embodiment in contemporary society*. Maidenhead: Open University Press.

Cruikshank, B., 1996. Revolutions within: self-government and self-esteem. *In*: A. Barry, ed. *Foucault and political reason: liberalism, neo-liberalism and rationalities of government*. Chicago, IL: University of Chicago Press, 231–251.

Donnelly, P. and Young, K., 1988. The construction and confirmation of identity in sport subcultures. *Sociology of sport journal*, 5 (3), 223–240.

Dowling, C., 2000. *The frailty myth*. New York: Random House.

Dworkin, S.L. and Messner, M.A., 2002. Just do… what? Sport, bodies, gender. *In*: S. Scraton and A. Flintoff, eds. *Gender and sport: a reader*. New York: Routledge, 17–29.

Evans, B., 2006. 'I'd feel ashamed': girls' bodies and sports participation. *Gender, place and culture*, 13 (5), 547–561.

Fredrick, C. and Shaw, S., 1995. Body image as a leisure constraint: examining the experience of aerobic exercise classes for young women. *Leisure sciences*, 17 (2), 57–73.

Gergen, K., 2009. *Relational being: beyond self and community*. New York: Oxford University Press.

Gilroy, S., 1997. Working on the body: links between physical activity and social power. *In*: G. Clarke and B. Humberstone, eds. *Researching women in sport*. London: Macmillan Press, 96–112.

Goffman, E., 1959. *The presentation of self in everyday life*. New York: Doubleday.

Goffman, E., 1972. *Interaction ritual: essays on face-to-face behaviour.* London: Allen Lane.

Goodkind, S., 2009. 'You can be anything you want, but you have to believe it': commercialized feminism in gender-specific programs for girls. *Signs: journal of women in culture and society*, 34 (2), 397–422.

Green, E., 1998. 'Women doing friendship': an analysis of women's leisure as a site of identity construction, empowerment and resistance. *Leisure studies*, 17 (3), 171–185.

Grosz, E., 1994. *Volatile bodies: toward a corporeal feminism.* St. Leonard's: Allen & Unwin.

Hall, M.A., 1996. *Feminism and sporting bodies.* Champaign, IL: Human Kinetics.

Hammersley, M. and Atkinson, P., 2007. *Ethnography: principles in practice.* 3rd ed. London: Routledge.

Haney, L., 2004. Introduction: gender, welfare, and states of punishment. *Social politics*, 11 (3), 333–362.

Hargreaves, J., 1994. *Sporting females: critical issues in the history and sociology of women's sports.* London: Routledge.

Harrison, B., 2002. Seeing health and illness worlds – using visual methodologies in a sociology of health and illness: a methodological review. *Sociology of health & illness*, 24 (6), 856–872.

Hey, V., 1997. *The company she keeps: an ethnography of girls' friendships.* Buckingham: Open University Press.

Heywood, L. and Dworkin, S., 2003. *Built to win: the female as cultural icon.* Minneapolis: University of Minnesota Press.

Kelly, L., Burton, S., and Regan, L., 1996. Beyond victim or survivor: sexual violence, identity and feminist theory and practice. *In*: L. Adkins and V. Merchant, eds. *Sexualising the social: power and the organization of sexuality.* London: Macmillan, 77–101.

Krane, V., 2001. We can be athletic and feminine, but do we want to? Challenging hegemonic femininity in women's sport. *Quest*, 53 (1), 115–133.

Laz, C., 1998. Act your age. *Sociological forum*, 13 (1), 85–114.

Laz, C., 2003. Age embodied. *Journal of aging studies*, 17 (4), 503–519.

Little, D.E., 2002. Women and adventure recreation: reconstructing leisure constraints and adventure experiences to negotiate continuing participation. *Journal of leisure research*, 34 (2), 157–177.

Lupton, D., 1994. Analysing news coverage. *In*: S. Chapman and D. Lupton, eds. *The fight for public health: principles and practice of media advocacy.* London: BMJ, 23–57.

McDermott, L., 2004. Exploring intersections of physicality and female-only canoeing experiences. *Leisure studies*, 23 (3), 283–301.

Merleau-Ponty, M., 1962. *The phenomenology of perception.* London: RKP.

Nelson, L., 1999. Bodies (and spaces) do matter: the limits of performativity. *Gender, place and culture*, 6 (4), 331–353.

Neverson, N. and White, P., 2002. Muscular, bruised and sweaty bodies: this is not Barbie territory. *Canadian woman studies*, 21 (3), 44–49.

O'Reilly, K., 2005. *Ethnographic methods.* New York: Routledge.

Otanez, M.G. and Glantz, S.A., 2009. Trafficking in tobacco farm culture: tobacco companies' use of video imagery to undermine health policy. *Visual anthropology review*, 25 (1), 1–24.

Pillsbury, G., 1996. Creating the plural self: athletic teams' use of members' bodies. *Qualitative studies in education*, 9 (1), 35–48.

Pink, S., 2001. *Doing visual ethnography.* London: Sage.

Riessman, C.K., 2008. *Narrative methods for the human sciences.* Thousand Oaks, CA: Sage.

Rose, G., 2001. *Visual methodologies: an introduction to the interpretation of visual materials.* Thousand Oaks, CA: Sage.

Shaw, S.M., 1994. Gender, leisure, and constraint: towards a new framework for the analysis of women's leisure. *Journal of leisure research*, 26 (1), 8–22.

Shaw, S.M., 2001. Conceptualizing resistance: women's leisure as political practice. *Journal of leisure research*, 33 (2), 186–201.

Somers, M.R., 1994. The narrative constitution of identity: a relational and network approach. *Theory and society*, 23 (5), 605–649.

Spencer, L., Ritchie, J., and O'Connor, W., 2003. Analysis: practices, principles and processes. *In*: J. Ritchie and J. Lewis, eds. *Qualitative research practice: a guide for social science students and researchers.* London: Sage, 199–218.

Stanczak, G.C., ed., 2007. *Visual research methods: image, society, and representation.* Thousand Oaks, CA: Sage.

Stebbins, R.A., 2001. Serious leisure. *Society*, 38 (May–June), 53–57.

Sturken, M. and Cartwright, L., 2003. *Practices of looking: an introduction to visual culture.* Oxford: Oxford University Press.

Theberge, N., 1987. Sport and women's empowerment. *Women's studies international forum*, 10 (4), 387–393.

Theberge, N., 2000. *Higher goals: women's ice hockey and the politics of gender.* Albany, NY: State University of New York Press.

van Leeuwen, T. and Jewitt, C., eds., 2001. *Handbook of visual analysis.* London: Sage.

Waskul, D.D. and Vannini, P., 2006. *Body/embodiment: symbolic interactionism and the sociology of the body.* Aldershot: Ashgate Publishing.

Wearing, B., 1990. Beyond the ideology of motherhood: leisure as resistance. *Journal of sociology*, 26 (1), 36–58.

Wearing, B., 1998. *Leisure and feminist theory.* Thousand Oaks, CA: Sage.

West, C. and Fenstermaker, S., 1995. Doing difference. *Gender & society*, 9 (1), 8–37.

West, C. and Zimmerman, D., 1987. Doing gender. *Gender & society*, 1 (2), 125–151.

Wheaton, B., 2000. Just do it: consumption, commitment, and identity in the windsurfing subculture. *Sociology of sport journal*, 17 (3), 254–274.

Wright, J. and Dewar, A., 1997. On pleasure and pain: women speak out about physical activity. *In*: G. Clarke and B. Humberstone, eds. *Researching women in sport.* London: Macmillan Press, 80–95.

WRN. 2009. http://womensrunningnetwork.co.uk [Accessed 5 August 2009].

Yarnal, C.M., Hutchinson, S., and Chow, H., 2006. 'I could probably run a marathon right now': embodiment, space, and young women's leisure experience. *Leisure sciences*, 28 (2), 133–161.

Young, I.M., 1990. *Throwing like a girl and other essays in feminist philosophy and social theory.* Bloomington: Indiana University Press.

Power and focus: self-representation of female college athletes

Vikki Krane[a], Sally R. Ross[b], Montana Miller[a], Julie L. Rowse[c], Kristy Ganoe[a], Jaclyn A. Andrzejczyk[a] and Cathryn B. Lucas[d]

[a]Bowling Green State University, Ohio, USA; [b]University of Memphis, Tennesse, USA; [c]Bellevue West High School, Nebraska, USA; [d]University of Iowa in Iowa City, USA

Readers should also refer to the journal's website at http://www.informaworld.com/rqrs and check volume 2, issue 2 to view the visual material in colour.

This study examined how female athletes prefer to be represented photographically. In past research, such representations can be interpreted as an expression of power, agency and resistance as well as constrained by the patriarchal construction of women's sport. Our exploration of athletes' choice of representation is grounded in a multidisciplinary perspective that joins feminist cultural studies and social psychological theory. Twenty female college athletes participated in a photo shoot in which they selected how they would be portrayed (e.g., attire, location, pose) and a short interview in which they chose and discussed their favourite photograph. Analysis of the athlete interviews revealed four primary higher order themes emerging from the data: *being an athlete*, *psychological characteristics*, *social identities* and *progressive interpretation of femininity*. Overall, the participants emphasised the power and strength of female athletes, which we interpret to signify pride in their athleticism and musculature. Why these photographs differ considerably from typical media images of female athletes are discussed relative to our conceptual framework.

Introduction

Female athletes frequently struggle with the social expectations surrounding femininity juxtaposed with the physical demands of their sport (Krane *et al.* 2004, Ross and Shinew 2008). Mediated images of female athletes exacerbate this conflict as they often highlight the beauty and sexuality, rather than athleticism, of the women. These 'heterosexy' (Griffin 1992) images of female athletes are found in the popular press (Vincent 2004) as well as on the covers of media guides[1] for university women's sport teams (Buysse and Ember-Herbert 2004). In the current climate of elite sport, where allegations of performance-enhancing drugs, illegal activity and sexualised photographs of athletes are common, authentic and credible role models are especially important. Based on this need to provide young children positive role models of healthy physical activity and sport participation, we believe alternative images of successful female athletes are needed. We also believe it is important to consider how female athletes themselves prefer to be represented photographically as these representations

can be interpreted as an expression of the power and agency enabled female athletes or as constrained by the patriarchal structure of women's sport. We approach our exploration of athletes' choice of representation from a multidisciplinary perspective that joins a feminist cultural studies foundation with social psychological theory.

Conceptual framework

Cultural studies examine many of the taken-for-granted aspects of our daily social lives, specifically focusing on the relationships between social construction of meanings and differential distribution of privilege, power and resources (Sardar and Van Loon 1997, Sandoval 2000). Particularly germane to our study, cultural studies also probe how images replicate lived reality, reflect representation and influence power and oppression. For example, how audiences 'read' images in popular culture influence how people then use these images in the construction and negotiation of new social meanings (Hall 1991). Feminist cultural studies specifically consider how social practices influence and construct ideas about gender as well as how gender is negotiated through common social practices (Hall 1996). Certainly, mediated images are gendered and they construct social expectations about how females should look and act.

Bartky (1990) and Butler (1990, 2004) describe gender as a negotiated performance. That is, individuals can choose how to present themselves (e.g., as consistent with social expectations of femininity or not). While this 'choice' may appear volitional, there also are palpable social ramifications of not presenting an appropriately female image. Thus, individuals actually choose whether to follow social conventions or whether to contend with social reprimands. Individuals who adhere to normative ideals of gender are rewarded with social privilege and avoid social sanctions (Butler 1990). Often, individuals are unaware of even making this choice; instead, they simply dress and act in ways that seem 'natural'. Krane (2001) and Choi (2000) have extended this concept of performativity to specifically address how female athletes perform femininity. Female athletes learn the importance of presenting a suitably feminine image; those who do not perform femininity acceptably often are labelled deviant and face discrimination. Uncharacteristic performances of gender and femininity may incite significant social sanctions, yet they also play an essential role in transforming traditionally heterosexist social institutions (Butler 1993). Non-conforming gender and femininity performances stretch acceptable social boundaries and can become a model of alternative performances that could materialise in the future. These unconventional performances also can provide inspiration for gender non-conformists who observe them. Thus, to some degree, individuals have agency in constructing personal performances of gender and femininity. At the same time, there are considerable social constraints on the ability to do so unencumbered. Shaw (1994), specifically focusing on elite female athletes, suggested that involvement in sport provides them with the opportunity to go against the grain of cultural sex-role prescriptions and allows them to resist constraining gender roles that permeate culture and reconstruct social norms about women.

Social identity perspective provides a complementary psychological explanation about how group sanctioned norms guide individual behaviour. According to this perspective, social identity emerges from recognition of social group membership and individuals' social identities reflect the emotional significance of group membership (Tajfel and Turner 1979). As individuals embrace their social identity, behaviour becomes more consistent with group values and expectations. Group members who most closely adhere to highly valued norms will garner the greatest social status within the

group (Hogg 2001). Individuals who do not conform to group norms are perceived to reflect badly on the whole group and may face social repercussions (Marques *et al.* 2001). In sport, gendered social norms tenaciously are upheld and strong social conventions dictate acceptable appearance and behaviour for female athletes (Krane 2008). Social identity perspective focuses on the individual behaviours produced by female athletes, which is grounded within the broader social culture. Altogether, feminist cultural studies and social identity perspective allow us to examine how female athletes navigate their potential agency in self-representation against the social constraints facing them.

As social identity perspective proposes, people have multiple social identities (e.g., based on gender, race or sport) and the context will influence the saliency of a particular identity. Much previous research has supported that female athletes often find themselves attempting to balance their 'athletic' identities and 'female' identities. For example, Krane *et al.* (2004) described female athletes as 'living the paradox' in which they needed to negotiate femininity with their muscularity. While they found that female athletes were proud of their strong, muscled bodies, these athletes also recognised that their large bodies contradicted socially sanctioned femininity. Similarly, Russell (2004) found female athletes described a contradiction between recognising the positive aspects of sporty bodies due to their athletic functionality and 'concerns about their physical appearance when placed in social environments' (p. 571). This continuous negotiation of femininity and athleticism has been expressed by women across a variety of sport contexts, including soccer (Cox and Thompson 2000), rugby (Baird 2001, Chase 2006), gymnastics and softball (Ross and Shinew 2008).

The impact of this negotiation may be manifest in a number of ways. Highly muscled female athletes, who complain about their large bodies, may experience body dissatisfaction, constant surveillance and monitoring of body size and weight, and in some cases unhealthy eating patterns (Chapman 1997, Krane *et al.* 2001). Athletes also may avoid gaining muscle, and the associated increased body size, by limiting the amount of weight lifted in their conditioning programmes and by engaging extra aerobic training (George 2005). Not only will these decisions and resulting behaviours negate their ability to reach their athletic potential, they also may increase the likelihood of injury.

In contrast, many athletes are proud of their developed bodies. Feeling physically and mentally strong empowers them both inside and outside the sport context. For example, female athletes have expressed feeling self-assured, safer than smaller women, and able to cope with adversity, and they described a sense of self-esteem, independence and confidence as attributes gained through sport (Cox and Thompson 2000, Krane *et al.* 2004, Kauer and Krane 2006). Further, Kauer and Krane (2006) found that female athletes who embraced their athlete identities were willing to counter negative stereotypes about female athletes and speak out about injustice towards female athletes.

As explained in a social identity perspective, through the process of social comparison, individuals compare their social status to that of other social groups (Hogg and Abrams 1990). Female athletes recognise that they are not perceived to be as feminine as their peers (Ross and Shinew 2008), which, in turn, translates into perceptions of having less social privilege than their feminine peers (Krane 2008). One outcome of this revelation is that female athletes may engage in behaviours aimed at enhancing their femininity and concomitant social status and social acceptance; that is, they perform femininity (Krane 2001). It is not unusual to see female athletes competing while wearing make-up or with bows in their hair, which are obvious artefacts of femininity. These feminine personas often are constructed and maintained through photographs of female athletes seen in popular media.

Photographic images of women in sport

Current controversy regarding media portrayal of female athletes focuses on athletes who pose while wearing sexy outfits or while wearing minimal clothing. One interpretation of revealing photos is that they are heterosexist, objectifying and sexualising (Kane 1988, Heywood and Dworkin 2003). This line of thinking emphasises the patriarchal context of women's sport, that sport privileges males and as such markets women's sport in a way to be appealing to men. Sexualised images of female athletes are presented for the male gaze and commodify female athletic bodies. According to this perspective, female athletes who 'willingly' participate in photographs that sexualise their bodies are actually constrained by the patriarchal structure of sport (Carty 2005). Explained through Butler's (1990) and Krane's (2001) notion of performing gender/femininity, this 'choice' is greatly limited if the only perceived option to gain financial benefits and enhance one's sport audience is through presenting one's body in a sexually objectifying manner. Athletes who emphasise their femininity and sexuality over their athleticism, consequently, are complicit in reinforcing the exploitation of women and any gains attained benefit only the individual and not the larger community of women athletes (Carty 2005). Such action reveals a lack of agency and the constraints imposed by social and self-surveillance while pursuing an appropriate and marketable feminine presentation.

Another perspective asserts that presenting female bodies that are muscled and athletic transcends the constraints of patriarchal structures (Heywood and Dworkin 2003). As such, athletic women who choose to be portrayed in sexy images are displaying pride in their non-conforming bodies and are presenting revolutionary images extending the boundaries of acceptable female bodies. Emphasising the combination of femininity, sexuality and muscles is perceived to underscore their personal agency as women reclaim their bodies and express pride in their athletic bodies. Thus, these athletes are resisting social constraints, taking control over their images and transforming popular notions of female athletes and femininity.

The notion of personal agency when engaging gender in non-conforming behaviour has been examined in adults who self-identified as tomboys in their youth (Carr 1998, Ballardie 2003). These women expressed consciously choosing to reject traditional femininity and instead actively performing stereotypical masculine behaviours (e.g., being tough, non-emotional, physically active) (Carr 1998). This is relevant when considering athletes' self-presentation because, as a study of adolescent softball players revealed, one aspect of being a tomboy is participating in sports (Malcom 2003). The tomboys also described increasing pressure to conform to femininity as they grew older (Carr 1998). As Halberstam (1998) explained, tomboyish behaviour is punished if it is considered extreme or it continues into adolescence. This social situation is consistent with Butler's theorising that non-conforming gender performances are chastised.

As girls age, they learn the importance of correctly performing femininity, which is reinforced in sport. Further, promoting women's sport through vehicles such as provocative calendars validates the marketability of sexualised, feminine female athletes (cf. Mikosza and Phillips 1999). As Lines (2001) stated, 'sports women are likely to receive recognition when they are perceived to be sex goddesses, reflecting traditional heterosexual feminine stereotypes' (p. 291). Altogether, sportswomen's self-presentation can be viewed as agentic, purposeful, culturally guided or constrained by social expectations. Yet, it is impossible to know the motivation behind published

photographs of female athletes and these images are tainted by what is perceived to enhance sales and attract fans.

Even the athletes in the sexualised images conflate these motivations. For example, Amanda Harkleroad, a professional tennis player, explained why she posed naked in *Playboy* saying, 'I'm proud of my body. I was representing a female athlete's body' (Amanda Harkleroad's *Playboy Spread*, 2008). Similarly, Amanda Beard, a US Olympic swimmer, posed in a 2007 issue of *Playboy*. In a brief *Sports Illustrated* interview she proclaimed, 'I work extremely hard to get the body I have, so I kind of want to flaunt it a little bit' (Deitsch 2007, p. 28). Other athletes also have expressed the desire to let younger female athletes know they should be proud of their athletic bodies. For example, when commenting on a *Playboy* photo spread featuring Olympic athletes in which she participated, US Olympic high jumper, Amy Acuff stated, 'I don't see it as shameful ... We're promoting pride in our bodies' (Huang 2004, p. 36). Ironically, while seemingly good-intentioned, these photographs often are published in magazines with a primarily adult male audience.

Therefore, we designed this study to explore how female athletes would choose to be portrayed if the structural constraints imposed by traditional sport media and marketing were removed. We provided athletes the opportunity to self-select their photographic representation and then discuss the intended message of the chosen images. As Pink (2007) stated, 'the connection between visual images and experienced reality is constructed through individual subjectivity and interpretation of images' (p. 33). Yet, what happens when an individual constructs, is the subject of, and interprets the image? This is the crux of the present study. The research questions guiding our investigation are: (1) how do female athletes choose to be portrayed in photographs (i.e., construct the image), and (2) why do female athletes choose to be portrayed in this manner (i.e., interpret the image).

Method

Participants

Our sample included 20 female college athletes who were competing at a Midwestern US National Collegiate Athletic Association (NCAA) Division I university. These women were members of the following teams: basketball, cross-country running, diving, golf, soccer, softball and track. Eighteen of the athletes were White and two were Black and they ranged in age from 18 to 22. At the time of the photo shoots, they included seven first-year students, three sophomores, four juniors and six seniors.

Procedure

Participant recruitment

After receiving approval from the Human Subjects Review Board and the Intercollegiate Athletics Committee Research Subcommittee, a researcher contacted all of the head coaches of the women's varsity athletic teams at the university to request a meeting with the team to explain the study to the athletes. Upon coach approval, researchers met with teams and invited athletes to participate in a photo shoot in which the athlete would select how she wanted to be portrayed: athletes chose the location (limited to on or near campus), her attire and the poses. A researcher then asked the athletes to complete an interest form; athletes interested in participating also provided

contact information so that subsequent meetings could be scheduled. These forms were collected at the end of the meeting. Initially, over 60 athletes indicated an interest in participating in the photo shoots. However, given the constraints inherent in student-athletes' schedules, about one-third of these athletes were able to complete each component of this study.

Photo shoot preparation

A researcher contacted the athletes who indicated they would participate in the study. The researcher reiterated the overall study procedure and confidentiality information, and provided a detailed description of the procedure for the photo shoot. Athletes were told, (1) the research team was developing a photo essay titled *This is a Female Athlete*, which would be shown to younger athletes in subsequent research and (2) during this photo shoot, you will have full control over how you will appear in the photographs, including the location, attire and poses for the photographs. Each athlete was scheduled to meet with an advanced photography student who conducted the photo shoot.

Prior to taking photographs, student photographers, who were working under the guidance of a photography professor, met with the researchers who provided specific guidelines concerning confidentiality, the photo shoot, and proper handling of the film and printed photographs. These guidelines included that the athletes should guide the process while the photographers would contribute their knowledge about aesthetic and technical aspects and the photographs of the athletes may be used for academic purposes only. For lack of other types of guidance on acceptable photo content, we used the standards set for media by the Motion Picture Association and instructed the athletes and photographers that the images must adhere to a PG-13 rating:

> A PG-13 film is one which, in the view of the Rating Board, leaps beyond the boundaries of the PG rating in theme, violence, nudity, sensuality, language, or other contents, but does not quite fit within the restricted R category … If nudity is sexually oriented, the film will generally not be found in the PG-13 category. (Motion Picture Association of America 2005, ¶ 4)

We chose to impose this guideline to ensure that the student photographers did not encounter any uncomfortable situations and that the photos would be appropriate for a younger audience. Each student photographer ($n = 8$) signed a Student Photography Agreement that outlined their responsibilities and constraints on photo usage.

Photo shoot procedures

Prior to each photo shoot, a researcher e-mailed the athlete an informed consent form so that she could carefully read the form before arriving for the photo shoot. Also, the photographer typically contacted the athlete to discuss the photo shoot prior to their meeting. During this discussion, the photographer attempted to establish initial rapport, increase the athlete's comfort about the photo shoot, establish where the photo shoot would take place and consider initial ideas about how the athlete wanted to be represented.

Once at the scheduled time and location, a researcher, the photographer and the athlete met for the photo shoot. The researcher reminded the photographer and athlete of the guidelines for the photos and their approved uses. Then the researcher asked the

athlete to sign a printed copy of the informed consent form. After obtaining informed consent, the researcher left and the photographer and athlete began the photo shoot. While the athletes guided how they wanted to appear in the photos, the photographers provided suggestions regarding aesthetic considerations (e.g., lighting) necessary to attain high-quality photographs. On average, each athlete engaged in nine different poses. Once developed, the photographers gave the researchers the proofs from each photo shoot.

Photo selection interviews

Upon receipt of the proofs, a researcher scheduled a time for each photographed athlete to view the photos. All of the athlete's photos were laid out on a conference room table and the athlete was given time to examine them and select her favourite. This process was followed by a semi-structured interview (Kvale 1996) in which each athlete described the meaning and intended message of the selected photograph and explained why that image was her favourite. Then the interviewer reminded the athlete that the photo will become part of the photo essay *This is a Female Athlete* and asked the athlete to develop a caption for her photograph. The photo review and discussion was audio-recorded and video-recorded to assist in the data analysis.

Data analysis

We implemented open and axial coding (Corbin and Strauss 2008) to analyse the interview data. After transcribing the interviews, each member of the research team independently examined the data and attached code names to each meaningful segment of data. As Corbin and Strauss (2008) described, 'in the beginning, analysts want to open up the data to all potentials and possibilities contained within them' (p. 160). This process occurred through group discussion of all of the proposed codes. After considering various meanings and interpretations of the data, the next step, consistent with Corbin and Strauss (2008), was 'to put conceptual labels on the data' (p. 160). Thus, during axial coding, we organised the many open-coded categories into meaningful groups and continued hierarchical coding until distinct primary themes emerged from the data. During the axial coding, we overtly considered our emerging findings within our conceptual framework. Merging theory and data is essential towards understanding the athletes' discussion of their self-representations (e.g., Fine *et al.* 2000, Smith and Deemer 2000). As Fine *et al.* (2000) stated, 'we refrain from the naïve belief that these voices should stand on their own or that the voices should (or do) survive without theorizing' (p. 120).

Results

Our analysis resulted in four primary higher order themes emerging from the data: *being an athlete*, *psychological characteristics*, *social identities* and *progressive interpretation of femininity*. In the following, each athlete is identified with a pseudonym.

Being an athlete

As the athletes talked about their photographs, *being an athlete* was a prominent theme and included descriptions of the photos that reflected the essence being athletic.

This theme was composed of the data categories: *athletic pose*, *natural habitat*, *trophy clothes* and *practice clothes*. Each of these concepts signifies some common facet of being a female college athlete. As is evident visually, several athletes chose to be portrayed in an athletic pose that was consistent with how they might appear in competition. For example, Natalie, a senior, chose to be photographed set in the blocks on the indoor track (see Figure 1) while Lisa (see Figure 2) was in her catching gear and in a catching stance. Lisa, also a senior, described her photo as:

Figure 1. Natalie, a senior sprinter on the track team (reprinted with permission of Krane *et al.* 2008).

Figure 2. Lisa, catcher on the softball team (reprinted with permission of Krane *et al.* 2008).

It's something that you see very often in a game where the catcher may be looking over at the coach for a signal … I wanted to do this type of pose because it is something that you'll see a lot in an actual game.

Other athletes also seemed to want to depict a realistic athletic appearance; in fact, all but three athletes chose to be photographed in what we called their *natural habitat* or their practice or competition sites. As Sheila stated, 'this is where we practice; this is probably where I am most comfortable taking the photos.' She also noted, 'you have

my whole body, you have the ball, you have the playing surface, the field and every-thing around it, and it just captures a soccer player.' Helen was sitting on a green with her golf clubs while Shana, a diver, was sitting pool-side. Samantha, photographed in the stands in the basketball arena, explained:

> I like the oldness of our gym, it has that old feeling and I think it just shows the tradition of everything, like the banners in the background. I mean, it's my second home, so it just made sense.

When asked why she chose the location she did for the photograph, Christy explained, 'I'm just being myself and in my element, with my golf bag and every-thing … This is where we practice and some of our equipment was there so I figured that would be the best place to be.' Although not obvious in the photograph, Amanda, a senior, was photographed near the softball diamond and was wearing her letter jacket. She explained, 'the softball field … was always in the background, part of [the photos] in some way, so it just seemed like the obvious choice, me being a softball player.' Athletes, who were not in a sport venue, still wore clothing that identified them as athletes. Kendra, who chose to be depicted in the elementary school class-room where she was doing her student teaching, was wearing her golf warm-up jacket. This example reflects the thought that went into selecting their attire for the photo shoots.

The category of *trophy clothes* provided evidence that some athletes chose to wear especially meaningful attire. Their clothing reflected significant accomplishments or symbolised their membership on an intercollegiate athletic team. Exemplifying this concept, Susan, a junior on the cross-country team, explained:

> I have my running shoes on, the ones I actually run in and my shorts. The shirt, it was kind of an honour when I got that shirt at that meet 'cause I had a great meet that day. So I wanted to look as if I was going to a work out, to do a track work out at practice. So that's why I wore that.

Sheila, a soccer player, described her attire, explaining, 'this is our uniform. I thought if we were taking athletic [photos], I would rather be wearing a uniform.' Helen, a golfer, stated, 'I wore my outfit for if we play in a tournament. We pick our favourite polo that we like and this is what I wear on a normal basis.' Other athletes chose athletic attire that did not necessarily reflect a special occasion or uniform, but was consistent with what may be worn in practice. Melissa remarked, 'it's just like what we wear; it's our team shirt … That's what I wear everyday. Usually like from prac-tice on, I'm in golf clothes for the rest of the day. So, it's just my golf clothes.' Serina, a first-year sprinter, noted, 'I chose this 'cause this is what I work out in. I figured if they're showing women athletes, I should show them what I wear to practice.' Kim elaborated saying, 'it's the clothing that I participated in most of my basketball activ-ities in, it's my practice gear, the stuff I do all my hard work in.'

While emphasising the authenticity of being female athletes, several of these women also stressed the effort that goes into being a college athlete. This notion was reflected in several of the photo captions: 'Kim reflects on all of the hard work and long hours spent in the gym.' Cindy, a sophomore soccer player, developed the caption 'practicing on your own raises your personal skill level'. Likewise, part of Amanda's caption included, 'she is determined, focused, and knows that if you want to be successful, you have to work hard'.

Psychological strength

Another major theme that emerged from the athletes' descriptions of their photo-graphs was the importance of portraying the psychological strength of a female athlete. The psychological characteristics they talked about included being intense, focused, confident, calm and determined. The largest category within this theme was *intensity*, which was mentioned primarily by athletes who chose athletic poses (i.e., those that likely would occur during competition). For example, a catcher on the soft-ball team (Lisa) stated, 'there's just something about the look in my eyes that says a lot about catching and playing softball, that there must be that determination in your eyes to keep doing what you're doing' (see Figure 2). She further expressed, 'I'm intense in what I'm doing.' Susan, a distance runner, particularly appreciated the representation of what she described as 'a determined look, aggressive, like confident … I think strength, determination, I would say no fear'. Ann, in a batting stance, described her photograph as 'I just like the way my eyes look 'cause it looks like I'm staring down the pitcher.' Revealing similar intent, Serina felt she looked 'in the moment, being tough'.

Being portrayed as *focused* was another category that emerged through the descriptions of the photographs. Natalie, who appeared in the blocks on the track, described her photograph as revealing 'what track is about, because it seems like a very calm-before-the-race type picture, with track it takes a lot of mental focus'. Posed as she would be just before the starter calls the runners into the ready pose, with her head down, Natalie further described her photo stating, 'it looks very focused, and that's why I like [this photo] the most.' Ann simply stated, 'I just like how I'm concen-trating in the picture' while Kim, holding the basketball net at the end of a very successful season, described, 'it's not really an action shot, it's more of a reflect-ing. I look like I'm reflecting on something, I'm focused.' Similarly, Susan expressed about her photo, 'I would describe it as … me standing, like focused.'

Displaying their *confidence* also was important to the athletes. Many of the favou-rite photos reflected this attribute. Ann described about her photo in a batting stance sharing, 'I think it portrays a cocky confidence and I think like that's what I take to every bat; I try to be not too cocky, but confident and I think that makes you more successful.' Helen, a golfer, intimated confidence in her pose; she described her look as, 'this is my competitive side, I kind of look intimidating.' Kendra's caption reflects her confidence; as she stated, 'athletes can conquer anything! Set your goals high and you can achieve them!' Similarly, Shelly, a sprinter, captioned her photograph, 'if you believe, then you can achieve; all dreams can come true.'

The athletes' photos also revealed the mental preparation that is part of competi-tion. Ann, a runner on the track, described her pose as, 'I'm just trying to think about my race, like before a race and what I'd be thinking about then, just concentrating.' In her photo, Arielle, a distance runner, was sitting on the track listening to her iPod. She described this depiction as, 'that's how I get ready personally to race. Music kind of takes me away to get in the zone.' A golfer, Helen, described her photo as, 'it has me looking at the course, and it has me looking forward, looking at everything,' much like a golfer may do at the beginning of each hole. Other mental states also were reflected in the athletes' photographs. Melissa, a golfer photographed standing on the green, described her image as, 'it's more likely what I do on the course. I just look calm and in the zone.' Shelly, depicted squatting on the track, simply said her photo reflected 'confidence and motivation'. The essence of this mental toughness discussed by these

athletes is evident in several photo captions. For example, Susan, a runner, created the caption: 'Have no fear. Be strong, determined, and ready to fight for what you want.' Shana's caption read: 'The focus and determination necessary to compete as a diver is 99% of the battle. It's all a mental game.' In all, eight of the photo captions reflected the psychological strength of female athletes.

Social identities

Another theme that emerged from the athletes' descriptions of their photographs was *social identities*. These data revealed the importance of their athlete identity as well as indicated the multiple social identities of female athletes. When expressing that the photos reflected their athlete social identity, several athletes were very straightforward in their descriptions. For example, Christy stated, 'golf is part of who I am … It just is me. It's just who I am.' Similarly, other athletes stated, '[basketball is] what's defined me for so long' (Lori) and 'that's what I identify myself as, as an athlete, as a runner' (Arielle). Kim and Amber, both basketball players, took a bit of a different tack. They wanted to depict a different, less obvious, albeit important, side of being an athlete. Kim, sitting in the stands holding a net, noted, 'it's just a kind of a behind the scene picture that no one ever really gets to know besides myself. That's why I enjoy it' (see Figure 3). Whereas Amber, photographed in the weight room, stated, 'the weight room is part of my everyday life for the past four years, so I think it's a good representation of my life here.'

Several of the athletes also wanted to express that athletes have other social identities. So while Christy noted that golf 'is who I am', she captioned her photo with 'this is me, who I am, and golf is only a small part of that.' Kendra, photographed in an elementary school classroom, described, 'I was trying to get that a female athlete can do more than one thing, like be an athlete and then, for me, be a teacher as well.' Amanda, portrayed in a business suit near the softball field (see Figure 4), explained:

> The [letter jacket] shows that I'm a softball player, the business suit I thought was a good idea 'cause … it could portray many roles. 'She's a business woman, she's a teacher, she's the principal, she's a supervisor, she's President.' It could encompass so many things so I thought it was a powerful uniform to portray as someone who is to be taken seriously, someone that works hard and is focused and wants to be respected.

While Susan wanted to be seen as a runner, she also wanted her photo to reflect 'more qualities that I would want, like as a strong determined person'. Samantha, a first-year athlete photographed in a dress in the basketball arena, combined her athletic and female identities:

> I liked that it shows the other side of a female athlete. I think that's why I chose to dress up, because I feel like that's the good thing about being a girl, you can always have that other side. You can be a grungy boy on the floor, but you can turn around and get dressed up. I just think it shows the different side.

The photographs reflected the women's passion for their sport and their pride in being an athlete. Most overtly, Leah expressed her passion for basketball as, 'I like [the photo] 'cause my tattoo is in it and it says 'Passion' and that's like how I feel about basketball and about life.' Helen described her photograph as 'for the love of the game'. Kim captured the essence of pride when she said:

Figure 3. Kim, a junior on the basketball team (reprinted with permission of Krane *et al.* 2008).

I feel this portrays a female athlete who, I mean I'm holding a net, so a female athlete who's won something and accomplished something, and just someone who knows where she came from, who knows that practice has gotten her to that point this far because I would say it reflects my career thus far.

It is important to note that this photograph was taken at the end of the most successful basketball season in the university's history.

Figure 4. Amanda, senior softball player (reprinted with permission of Krane *et al.* 2008).

Progressive interpretation of femininity

Although not as common as the previous themes, several of the athletes used the photographs to push the boundaries of social expectations of femininity. These photo-graphs were intentionally transgressive and allowed the athletes to express alternative images of being female. Amanda, the senior softball player wearing a business suit near the field, described her photograph as, 'to see somebody that is German and kind of muscular, she's intimidating yet you would take her seriously. And she's not portrayed as a girly girl but yet you know she takes care of business and she's an athlete.' Samantha toyed with traditional notions of femininity by wearing non-athletic attire in the gym. As she stated, 'I think it's that the outfit allowed me to dress

up, but not to the point where I'd look out of place in a gym. So it's just kind of a fun dress.' Samantha's photograph juxtaposed being in what could be perceived as a feminine dress and pose with 'the bigger thing about me, like the ball and the court is in the background'. In essence, she presents a seemingly traditionally feminine pose, but with basketball accessories.

Depicting female strength and musculature also traverses traditional boundaries of femininity. This theme is evident visually in the actual photographs, most of which clearly show strong, athletic women. Two athletes specifically referred to their musculature when saying what they liked about their photographs: 'I like the way you can see all of the muscle' (Susan) and 'you can see my muscles' (Sheila; see Figure 5). Athletes also described their representations as: 'athleticism and dedication to getting better, strength' (Amber), 'it makes me look like a stronger female athlete' (Susan), and Natalie captioned her photograph as 'the strength of a female athlete'. Simply by being photographed in the weight room, Amber (a senior basketball player) made this point. She expressed, 'I think it's a cool picture in the fact that it kind of throws people off guard ... It's that females aren't seen as necessarily strong.' Amber captioned her photograph 'Falcon strength'.

Alternate considerations

While our goal was to give the athletes great freedom in selecting how they wanted to be represented in the photographs, we also realise that there remained some potential constraints to their choice of representation. Therefore, we asked them, 'if you had had complete freedom, what would have been different about your photo shoot?' The most common response was that they would rather have had an action shot; however, the photographers did not have appropriate equipment for that type of photograph. Four of the athletes noted that they would rather have had their shoot outdoors on their field or the track, which was not possible due to frigid temperatures or rain, and therefore led them to take the photos in their indoor facilities. Importantly, five athletes (Ali, Arielle, Christy, Kendra and Samantha) said that they did not feel limited and they would not have changed anything. Also, across all 20 interviews, there was only a single negative comment aimed at personal body image. Lori, a basketball player stated, 'I chose the shooting shirt instead of just the jersey because I wanted sleeves on. Basically I didn't want to show my arms.' What the athletes did not say also seems important to consider; no one expressed that they would have dressed or posed differently if the photos were not intended for young athletes (i.e., the PG-13 guideline).

Discussion

In this study, we sought to understand how female athletes preferred to be represented photographically and their images spoke volumes. There was an overriding emphasis on the power and strength of female athletes, which we interpret to signify pride in their athleticism and musculature. The photographs developed by the athletes in this study differ considerably from typical media images of female athletes seen in advertising (cf. Daddario 1998) and even many US college media guides (cf. Buysse and Embser-Herbert 2004). The athletes in this study did not over-accentuate their femininity nor downplay their muscularity. Although previous research revealed female college-aged athletes to be conflicted when negotiating social expectations of

Figure 5. Sheila, sophomore forward on the soccer team (reprinted with permission of Krane *et al.* 2008).

femininity with their athleticism (Krane *et al.* 2004, Russell 2004), this was not apparent in the images we obtained.

 There are several reasons for the discrepant findings between this and previous research. It appears that when women's sport is contextualised within a patriarchal structure, as in most college and professional women's sport, traditional expectations of femininity emerge (Carty 2005). Photographs of female athletes within this context often emphasise their beauty and femininity. Yet, seemingly, when expectations of femininity are minimised and social constraints reduced, female athletes have greater

freedom or agency, which was revealed through the progressive and transformative images of the women we obtained. It is also possible that through their long-term involvement in sport, women become comfortable within their muscular bodies, even outside of sport contexts. As Krane and Kauer (2007) concluded, 'through sport, girls and women gain robust self-assurance that underlie attempts at social change' (p. 287).

In sport, female athletes may be developing a sense of agency and may be prompted to question society's gender prescriptions. Female athletes interviewed by Ross and Shinew (2008) recognised displays typically associated with traditional femininity, yet they admitted that these descriptors were not wholly compatible with their personal experiences. Since sport participation for women is not aligned with preferred femininity, some athletes create their own views of socially acceptable gender performances and representations. Being valued as athletes, gaining a sense of accomplishment and learning to overcome obstacles within sport may buffer athletes from concerns about being perceived as different from 'normal girls' (Kauer and Krane 2006). Personal relationships gained in sport further reassure athletes as they resist traditional social expectations (Stevenson 1997, Kauer and Krane 2006).

When asked to assist in developing a photo essay for younger athletes, the women in this study chose to emphasise the reality of their athletic lives, their physical and psychological strength, and the multiplicity of college women's identities. One interpretation of these images is that the athletes embraced the opportunity to be role models and wanted to show young athletes what may be possible. Although our society may stress that one can be athletic and feminine (e.g., Krane 2001), the messages encompassed in these photographs are much more profound. The college athletes in the present study illustrated the typical clothing worn, that practice and strength training are parts of their routine, and where they practiced and competed. They also exhibited that women can be mentally tough, large and muscular, strong and accomplished; a female athlete works hard to achieve her goals and takes pride in her accomplishments.

Previous studies have revealed how participation in sport can be empowering for women (Stoelting 2004, Kauer and Krane 2006). Athletic women challenge themselves and test their abilities while also learning lessons that generalise to many other areas of their lives. Many of the images in our collection of photographs, as well as the athletes' descriptions of them, depict the mental strength of the athletes. The photographs show determined, confident, focused women. This is a powerful message for younger athletes, that through sport one can gain skills necessary to be successful in other avenues of life. This concept is as important for girls as for boys, although historically this message has been primarily aimed at males (Messner 1988).

Also discernible in our photographs are the multiple social identities expressed by these women. Consistent with social identity perspective, individuals have multiple social identities and the context will influence what identity is most salient at any given time. In the context of this study, clearly the athletic identity became salient. When asked to depict a female athlete, all of the women in this study portrayed some aspect of their athletic identities. In every photograph, there is something that signifies that the individual is an athlete (e.g., a piece of equipment, athletic clothes). Further, the connection between how female athletes interpret their bodies and the social context was evident. As explained in previous research (e.g., Krane *et al.* 2004, Ross and Shinew 2008), bodily interpretations differ relative to the salient social identity within a specific context (e.g., sport versus social setting). For the women in this study, as their athlete identity was made salient, they portrayed empowerment, strength,

exuberance and pride related to their athletic bodies, whereas when social contexts are made salient, female athletes often express the need to be feminine or experience dissonance between their bodies and social expectations. The lack of negative comments about body image throughout 20 interviews is a powerful testament to what can occur when female athletes are encouraged to focus on being an athlete as opposed to being a female.

While these women's choices about their photographs were made under certain constraints, we argue that there are always some constraints, as any representation of self is made with an awareness of the intended audience. For photographs intended for marketing purposes – whether through official university media guides, sport media or unofficial online social networks – might these athletes have chosen more hetero-sexy images? Possibly so, yet it seems that when given the chance to participate in a collection of photographs specifically for younger athletes, these college women consistently framed themselves as role models. They were young athletes once them-selves; therefore, we suggest that they deliberately chose to portray the kind of athlete they would like to have envisioned at that age.

Additionally, that none of the athletes wanted to present a heterosexy image also sends an important message: women can be respected for their athleticism without complying with debasing social pressures. Sport scholars have long voiced the need to market female athletes as female athletes (e.g., Kane 1988). That is, mediated images of female athletes should highlight their skills, strength and athletic identities, not their appearance. As Buysse and Embser-Herbert (2004) stated:

> As sport becomes more commercialized, and more money is to be made from girls' and women's participation in sport, we think that those in control of media and advertising should have a vested interest in making sport more appealing to a greater number of girls and women. (p. 79)

In fact, Kane and Buysse (2005) did find current college media guides depict female athletes as more serious athletes than those of the past. Compared to past trends, female athletes more often were shown in uniform, on the course, and actively partic-ipating in their sport. 'In effect, they were presented simply and unapologetically as athletes' (2005, p. 230). Still, there is a strong emphasis on presenting a feminine athletic image throughout media representation of female athletes (Christopherson *et al.* 2002, Vincent 2004). Although the women in this study seem to be caught in the midstream of transition, it is clear that they are proud, female athletes who want to be recognised as such. These images can have important influences on younger girls who then can gain all the benefits enjoyed by sporting and physically active women.

Acknowledgements

We greatly appreciate and want to acknowledge the assistance of the advanced photography students at BGSU who conducted the photo shoots. Photographs taken by Lindsay Akens (Figures 1, 2 and 4), Adam Rensch (Figure 5) and Crystal Weaver (Figure 3) appear in this paper.

Note

1. A media guide is an informational booklet about a team including coach and athlete biog-raphies, team statistics and other pertinent information.

References

Baird, S., 2001. Femininity on the pitch: an ethnographic study of female rugby players. Unpublished master's thesis, Bowling Green State University.

Ballardie, R., 2003. An exploration of tomboy identity: the development of a 'marked' gender identity in women. *Australian journal of psychology*, 55 (Suppl.), 2.

Bartky, S.L., 1990. *Femininity and domination: studies in the phenomenology of oppression.* New York: Routledge.

Butler, J., 1990. *Gender trouble: feminism and the subversion of identity.* New York: Routledge.

Butler, J., 1993. *Bodies that matter: on the discursive limits of sex.* New York: Routledge.

Butler, J., 2004. *Undoing gender.* New York: Routledge.

Buysse, J.M. and Embser-Herbert, M.S., 2004. Constructions of gender in sport: an analysis of intercollegiate media guide cover photographs. *Gender and society*, 18, 66–81.

Carr, C.L., 1998. Tomboy resistance and conformity: agency in social psychological gender theory. *Gender and society*, 12, 528–553.

Carty, V., 2005. Textual portrayals of female athletes: liberation or nuanced forms of patriarchy? *Frontiers: a journal of women studies*, 26, 132–172.

Chapman, G., 1997. Making weight: lightweight rowing, technologies of power, and technologies of the self. *Sociology of sport journal*, 14, 205–223.

Chase, L.F., 2006. (Un)disciplined bodies: a Foucauldian analysis of women's rugby. *Sociology of sport journal*, 23, 229–247.

Choi, P.Y.L., 2000. *Femininity and the physically active woman.* London: Routledge.

Christopherson, N., Janning, M., and McConnell, E.D., 2002. Two kicks forward, one kick back: a content analysis of media discourses on the 1999 women's world cup soccer championship. *Sociology of sport journal*, 19, 170–188.

Corbin, J. and Strauss, A., 2008. *Basics of qualitative research.* 3rd ed. Los Angeles: Sage.

Cox, B. and Thompson, S., 2000. Multiple bodies: sportswomen, soccer and sexuality. *International review for the sociology of sport*, 35, 5–20.

Daddario, G., 1998. *Women's sport and spectacle: gendered television coverage and the Olympic games.* Westport, CT: Praeger.

Deitsch, R., 2007, June 7. *Q&A: Amanda Beard.* Available from: http://sportsillustrated.cnn.com/2007/writers/richard_deitsch/06/05/beard.qa/index.html [Accessed 28 August 2007].

Fine, M., *et al.*, 2000. For whom? Qualitative research, representations, and social responsibilities. *In*: N.K. Denzin and Y.S. Lincoln, eds. *Handbook of qualitative research.* 2nd ed. Thousand Oaks, CA: Sage, 107–132.

George, M., 2005. Making sense of muscle: the body experiences of collegiate women athletes. *Sociological inquiry*, 75, 317–345.

Griffin, P., 1992. Changing the game: homophobia, sexism, and lesbians in sport. *Quest*, 44, 251–265.

Halberstam, J., 1998. *Female masculinity.* Durham, NC: Duke University Press.

Hall, M.A., 1996. *Feminism and sporting bodies: essays on theory and practice.* Champaign, IL: Human Kinetics.

Hall, S., 1991. *Culture, media, language* (Working papers in cultural studies, 1972–79). New York: Routledge.

Harkleroad, A., 2008, May 27. *Playboy spread: US tennis star to bare all.* August ed. Available from: http://www.huffingtonpost.com/2008/05/27/Amanda-harkleroads-playbo_n_103710.html [Accessed 28 May 2008].

Heywood, L. and Dworkin, S.L., 2003. *Built to win: the female athlete as cultural icon.* Minneapolis: University of Minnesota Press.

Hogg, M.A., 2001. A social identity theory of leadership. *Personality and social psychology review*, 5, 184–200.

Hogg, J. and Abrams, D., 1990. *Social identifications: a social psychology of intergroup relations and group processes.* New York: Routledge.

Huang, T., 2004, August 22. Olympians cashing in on sex appeal. *The Dallas Morning News.* Available from: http://www.kvue.com/news/top/stories/082204kvuesexsells-jw.a03b8249.html [Accessed 22 June 2008].

Kane, M.J., 1988. Media coverage of the female athlete before, during, and after Title IX: Sports Illustrated revisited. *Journal of sport management*, 2, 87–99.

Kane, M.J. and Buysse, J.A., 2005. Intercollegiate media guides as contested terrain: a longitudinal analysis. *Sociology of sport journal*, 22, 214–238.

Kauer, K. and Krane, V., 2006. 'Scary dykes and feminine queens': stereotypes and female athletes. *Women in sport and physical activity journal*, 15 (1), 43–56.

Krane, V., 2001. We can be athletic and feminine, but do we want to? Challenging hegemonic femininity in women's sport. *Quest*, 53, 115–133.

Krane, V., 2008. Gendered social dynamics in sport. *In*: M. Beauchamp and M. Eys, eds. *Group dynamics advances in sport and exercise psychology: contemporary themes*. New York: Routledge, 159–176.

Krane, V., *et al.*, 2004. Living the paradox: female athletes negotiate femininity and muscularity. *Sex roles*, 50, 315–329.

Krane, V. and Kauer, K., 2007. Out on the ball fields: lesbians in women's sport. *In*: E. Peele and V. Clark, eds. *Out in psychology: lesbian, gay, bisexual and transgender perspectives*. West Sussex: Wiley, 273–290.

Krane, V., Ross, S.R., and Miller, M., 2008. Self-selected images of female college athletes. Unpublished photograph collection, Bowling Green State University.

Krane, V., *et al.*, 2001. Body image, and eating and exercise behaviors: a feminist cultural studies perspective. *Women in sport & physical activity journal*, 10 (1), 17–54.

Kvale, I., 1996. *Interviews: an introduction to qualitative research interviewing*. Thousand Oaks, CA: Sage.

Lines, G., 2001. Villains, fools or heroes? Sports stars as role models for young people. *Leisure studies*, 20, 285–303.

Malcom, N.L., 2003. Constructing female athleticism. *American behavioral scientist*, 46, 1387–1387.

Marques, J.M., *et al.*, 2001. Social categorization, social identification, and rejection of deviant group members. *In*: M.A. Hogg and S. Tinsdale, eds. *Blackwell handbook of social psychology: group processes*. Malden, MA: Blackwell, 400–421.

Messner, M.A., 1988. Sports and male domination: the female athlete as contested ideological terrain. *Sociology of sport journal*, 5, 197–211.

Mikosza, J.M. and Phillips, M.G., 1999. Gender, sport and the body politic: framing femininity in the Golden Girls of Sport Calendar and The Atlanta Dream. *International review for the sociology of sport*, 34, 5–16.

Motion Picture Association of America, 2005. *What do the ratings mean?* Available from: http://www.mpaa.org/FlmRat_Ratings.asp [Accessed 4 October 2006].

Pink, S., 2007. *Doing visual ethnography*. 2nd ed. Thousand Oaks, CA: Sage.

Ross, S.R. and Shinew, K.J., 2008. Perspectives of women college athletes on sport and gender. *Sex roles*, 58, 40–57.

Russell, K.M., 2004. On versus off the pitch: the transiency of body satisfaction among female rugby players, cricketers, and netballers. *Sex roles*, 51, 561–574.

Sandoval, C., 2000. *Methodology of the oppressed*. Minneapolis: University of Minnesota Press.

Sardar, Z. and Van Loon, B., 1997. *Introducing cultural studies*. New York: Totem.

Shaw, S.M., 1994. Gender, leisure and constraints: towards a framework for the analysis of women's leisure. *Journal of leisure research*, 26, 8–23.

Smith, J.K. and Deemer, D.K., 2000. The problem of criteria in the age of relativism. *In*: N.K. Denzin and Y.S. Lincoln, eds. *Handbook of qualitative research*. 2nd ed. Thousand Oaks, CA: Sage, 877–896.

Stevenson, C.L., 1997. Christian athletes and the culture of elite sport: dilemmas and solutions. *Sociology of sport journal*, 14, 241–262.

Stoelting, S.M., 2004, August. *She's in control. She's free. She's an athlete: a qualitative analysis of sport empowerment and the lives of female athletes*. Paper presented at the annual meeting of the American Sociological Association, San Francisco. Available from: SocINDEX [Accessed 21 June 2008].

Tajfel, H. and Turner, J.C., 1979. An integrative theory of intergroup conflict. *In*: S. Worshel and W.G. Austin, eds. *The social psychology of intergroup relations*. Monterey, CA: Brooks-Cole, 33–47.

Vincent, J., 2004. Game, sex, and match: the construction of gender in British newspaper coverage of the 2000 Wimbledon championships. *Sociology of sport journal*, 21, 435–456.

Embodying understanding: drawing as research in sport and exercise

Hannah M. Gravestock

Wimbledon College of Art, University of the Arts, London, UK

Readers should also refer to the journal's website at http://www.informaworld.com/rqrs and check volume 2, issue 2 to view the visual material in colour.

As researchers in the arts embrace drawing as a means to facilitate new encounters with the external world in order to reveal and create new embodied knowledge, drawing as a research approach in sport and exercise science has yet to be examined. Using an ethnographic case study conducted in art and design and the sport of figure skating, I introduce drawing as an interdisciplinary research method that could enhance research in this field. Focusing on drawings of the performing body, I discuss the external visualisation of an internal thought process through mark-making. I outline the strengths and weaknesses of using this approach and contextualise this dialogue using Lecoq's understanding of the relationship between the physicality of mark-making and performance training practices. I conclude by suggesting how, through the provision of training in drawing as research, both the sports researcher and participant can further understand the complexities of human lives.

This paper examines how drawing can be used as a visual research method to provide new understanding in the sport and exercise sciences. However, in order to do this we must first address the question of drawing as noun or drawing as verb. Without addressing this question, drawing remains external to the body of the sports researcher and/or participant, and the possibility for an embodied knowledge within sports and exercise science is limited. It should also be acknowledged that throughout this paper I often draw on literature from within arts practice and research for conceptual and exemplar purposes. This is necessary as there are no conceptual discussions and few examples of drawing as a visual research method within sport and exercise sciences. If we within sport and exercise sciences are going to harness the potential of drawing for certain purposes, and do this well, we must understand the conceptual foundation of this approach and respect the long history of drawing within art and design.

Drawing (noun) or drawing (verb)?

Whilst the use of the term 'drawing' will always be associated with notions of product and will inevitably conquer up images of the framed canvas hanging on a gallery wall, the term also refers to a process; a physical, analytical, inventive act of mark-making.

Drawing as process is not created for exhibition but for the development of thought and understanding and is more often than not found in sketchbook rather than on a wall. In the publication *what is drawing?* (Kingston 2003), descriptions of the drawing process used by artists and designers demonstrate how drawing can be both a noun and a verb. For these artists, drawing facilitates encounters with the external world and enables them to re-examine experiences that may have gone unnoticed, forgotten or that have become habit over time and through repetition. As artist Lucy Gunning (2003, cited in Kingston 2003, p. 155) asserts in her discussion of drawing 'the destination is the journey'.

Of course, what this journey is and what it will become depends on a number of issues, for example, the experience of the drawer, and how and what they draw. But for drawing, unlike painting, the marks that are made are often a more visible record of the encounters made on this journey. Mistakes are visible, changes in direction etched into the paper, thought process transformed into interlocking lines, and previously unseen possibilities are tried and tested (Burstein 2005, online):

> Drawing leaves traces. In comparison with painting, it is difficult to obscure them, and for the most part drawing doesn't want them to be obscured. Anywhere one finds a series of traces, in the metaphoric sense, one has a story.

In relation to art and design practice, the story that these traces tell is simultaneously created and communicated through the body; through the movement of the arm, moving the hand, moving the fingers, to make the pen or pencil dance over the paper. The representation of an original object, sound and image through such a process creates one of many perspectives, each unique to the person who makes the marks and unique to the time and space in which they draw. Phillip Rawson (1969, p. 1) explains this succinctly, claiming 'a drawing's basic ingredients are strokes or marks which have a symbolic relationship with experience'.

The application of drawing as a phenomenological research method is based on this understanding of the relationship created through line between the experience of the drawer, the drawn image and the original subject of that drawing. However, drawing as research is also built on the foundations of a vast history during which many artists have observed, examined and represented the external world. Through their interpretation we, the spectator, can see the world through different eyes and, when we train our eyes to read this new visual language it can challenge out understanding and our existing knowledge. In art, there may be good technique but there is no right or wrong experience. Instead, there are many truths created through the collisions between each rendered image. Abstract painting, for example, can place multiple perspectives of one object on one page, making the artist as well as the spectator examine the differences and conflicts between viewpoints. Drawing can similarly juxtapose perspectives as theatre designer Kathryn Henderson (2007 cited in Garner 2008, p. 33) writes:

> They (Sketches) serve as thinking tools to capture fleeting ideas on paper where they can be better understood, further analysed and refined and negotiated ... Once on paper, sketches serve as talking sketches, collaborative tools for working out ideas with other designers.

This type of drawing is of course a subjective process. But it is this subjectivity that makes drawing an important phenomenological and analytical tool capable of creating new understanding of thoughts, feelings and actions.

Why is this relevant to sport and exercise sciences?

Within the field of sport and exercise sciences, the application of drawing is rarely seen as a visual method of investigation. Perhaps, as has been the case in the social sciences, this has developed from a perception that arts practice lays false claims to objectivity. The lack of use within sport and exercise sciences of drawing as a research method may also be due to assumption that the written word is 'what counts' as good scholarship. However, in recent years the application of art as research within the social sciences has challenged such views. When done well, and when chosen for good reasons, the practising artist as researcher has drawn attention to the potential value of drawing as a research method. It is therefore possible that when done well and when chosen for good reasons sport and exercise could also gain from utilising drawing. Accordingly, in this section, five key reasons for using drawing are suggested. However, these reasons, or rationales for turning to drawing, are not only based on knowledge and research in the field of art and design. They are also based on a number of understandings developed through my ethnographic research that applied a combination of art and sports practice. This research examined the development of embodied understanding in design and performance, as well as physical culture in sports practice and pedagogical practices in the sport of figure skating.

Firstly, referencing the perspective of artist Paul Klee (1920 cited in Chipp 1968, p. 182) that 'art does not reproduce the visible; rather, it makes visible' drawing is a conceptualisation process; the externalisation of a series of internal thoughts and ideas through the physical act of mark-making in order to create something new. The accumulation of these marks on the page and within a sketch is a way that the drawer can brainstorm many different ideas in one collective space and clarify their thoughts. Meaning is created between the marks on the page and between the object or subject drawn and the sensations felt by the drawer. Applying different weights of a mark, altering tone, direction, colour, shape and form the drawer can explore what and how they feel in relation to what they see. Such responses seek to create and construct rather than imitate and in doing so reveal a particular point of view. In these cases, the aim of making what is hidden visible through drawing becomes an exploration of meaning through new encounters with the external world and a comparison of these subjective responses with existing understanding. As a result, the interpretation of the world through line and mark becomes part of the development of the meaning the artist gives to the object or subject that they draw. An example of a research approach that uses the different qualities of the mark made on the page and relationship between marks to create new understanding is the work of artist, Lucy Lyons. In her recent research, Lyons used her drawings (Figure 1) to investigate encounters with a rare disease called FOP (Fibrodysplasia Ossificans Progressiva).

This research provided new insights into the disease not only to her as the artist but also to medical experts (Lyons 2009). Lyons writes of the drawing process:

> The activity of drawing reveals new insights through close observation highlighting relevant detail. Encounters with familiar objects that are taken for granted are treated as unique and specific. Those that are unfamiliar and initially daunting become understood more clearly through the activity of drawing.

In this case Lyons's individual drawing ability, her training, experience and knowledge were crucial in providing new understanding. Medical experts in the field would not have been able to observe and encounter the disease in this way. Sport and

Figure 1. Delineating disease (Lucy Lyons).

exercise scientists in a similar vein might develop new insights into their topic through drawing.

Secondly, because the drawing approach I refer to focuses on drawing the moving and performing body, the time in which a drawing can be made is limited. This limitation of time is, however, not limitation per se. For sport and exercise researchers who may wish to use drawing as a research method, the limitation of time can enable a form of embodied understanding rather than cognitive understanding since the body of the drawer must move first before consciously thinking about how to do so or why. The drawer/practitioner/researcher responds to sensation and feeling first before analysing the data. As the 'original' subject is re-presented through the body meaning and understanding is embodied and communicated through further physical acts. The teaching and creative processes of theatre practitioner and founder of the International School of Mime and Theatre, Jacques Lecoq provides crucial context to embodied understanding developed through encounters with and through the body, including the act of drawing. Lecoq (2001) called drawing a mime and used such mimes to enable a student to 'become one' with an object or action. He writes (2001, p. 22), 'to mime is literally to embody and therefore to understand better … miming is a way of rediscovering a thing with renewed freshness. The action of miming becomes a form of knowledge'. Lecoq's training school for theatre designers, scenographers, performers, architects and playwrights, Le Laboratoire d'Etude du Mouvement uses a combination of drawing and movement to develop these embodied skills.

In my research on embodied understanding in costume design, drawing is a mime, and like the performance it exists alongside and seeks to re-present, it is fleeting. This limitation of time prevents the over-intellectualisation of the marks being made. The body responds, visually, viscerally and experientially. The body moves, marks the

page and then responds again to further observations. However, this time marks are made in relation to new embodied understanding created through the existing marks and how they relate to what was observed. As the artist becomes more accustomed to this process the drawings become more fluid and expressive and, as with sport, repeated practice facilitates greater ability. Accordingly, another strength of drawing is that the physical act of mark-making can slow down time, thereby providing the sport and exercise scientist with the opportunity to feel the body rather than understand it cognitively as traditional approaches to research often foster.

Thirdly, and following on from the above understanding of the similarity between the performance and the drawing process, through a physical response to the performing body the drawer develops a more relevant vocabulary to the performer. With the drawings available for use as external and reflective references, the drawer can start to develop a shared language through which to discuss understanding with a new audience. For example, artist Alyson Brien (2002) demonstrates a connection between embodied understanding and the physical act and resulting language of drawing. By audio recording, her thoughts and feelings she experienced as she both created and erased her marks, Brien's research examined the relationship between the physicality of her drawing process and an embodied understanding that developed as a result. The 'sweeping', 'turning', 'curling', 'flicking' and the 'looping' motion she describes, highlight a journey that Brien suggests made her, 'look at the shape I was originally drawing differently'. The transcriptions of her drawing experience, included in her paper, 'Thinking through mark and gesture', (2002) highlight these changes and demonstrate the variation of qualities relating to what could viewed as a more universal physical language than a language isolated within the field of drawing. In Brien's research, this physical language of 'sweeping', 'pecking', 'turning', 'curling' and 'flicking' seems to be built through an on-going exploration of the experience of these physical qualities and in relation to each new context that the marks appear within or next to. Contrasts become visible as her descriptions move from velvety and smooth textures to heavily weighted marks, and as she starts moving the direction of her marks diagonally rather than in a curve, either working over the top of, or erasing the marks. Brien explains that this external action of mark-making produced an internal reflection that resulted in a new understanding of the drawing as a whole.

The Fourth understanding is that conflicting data revealed during the drawing process becomes a positive and essential element of the research method. Like performance students who use the deliberate imbalance of the body to find an awareness of different levels and qualities of movement, disequilibrium between what is felt, what is seen and what already exists as the drawing process develops, creates new understanding. New data that do not make sense in relation to existing knowledge not only creates the need for further drawing but can also be used to initiate a dialogue with the subject of the drawing in order to bring about a sense of balance.

Lastly, and another reason why researchers in sport and exercise might consider using drawing for certain purposes, as a result of the factors mentioned above the drawing process becomes a means to develop the skills of the researcher, primarily through a greater sensory awareness. When used correctly, the relationship between the mind and the body developed through the repeated act of drawing enables the drawer to react and respond to external stimulus more effectively and efficiently. This provides a research method not only capable of providing new data specific to a research project, but one that, like interview methods, enables and depends upon the on-going development of the skills of the researcher.

The skating/drawing research case study

My research in the field of theatre and in the domains of costume design and scenography provides an example of how drawing as research can provide embodied understanding that develops both the skills of the researcher and examines and informs performance. To demonstrate the potential value of this visual research method in sports research and for those that wish to use drawing as research for certain purposes I focus on a case study that used both figure skating and drawing to examine embodied understanding in theatre design. Informed by my training and performance in figure skating, along with my training and experience in theatre design, I was able to examine the role of the figure skater through the eyes of the designer/drawer and the designer/drawer through the eyes of the figure skater. Subsequently, although drawing as a tool to create embodied understanding in costume design was the primary focus and was examined through sporting practice, my experience of that practice, when developed through drawing was itself indirectly re-examined through the drawing act.

The case study was structured so that, working with a choreographer, coach and costume constructor I developed both a costume design and skating performance through the acts of drawing and performing. During the choreographic and training process for this performance, I created drawings from the memory of sensation and experience of the physicality I used in my on-ice practice. Through the drawing process, I identified points of change, contrast and differences that challenged my existing understanding of my performance, both from the perspective of a designer and of a skater. This understanding created a personal and emotional connection to the qualities that seemed to define the performance I was creating.

Key gestures, movements and expressions that seemed to define the 'character' of the performance were used to develop the choreography. This process involved maintaining and developing key movements or 'motifs' in the performance, and adding new movements and expressions that appeared to confirm the descriptive qualities identified in the drawings. For example, as in Figure 2, an exaggerated change of direction or change in my body position revealed through the focus of my drawings were integrated into the choreography and explored further in relation to other elements within the programme/routine and the music. Secondary drawings were created in response to this new choreography and enabled me to re-assess my existing understanding of the performance. The secondary drawing phase was crucial in removing my role as participant and subject and providing a way of reliably analysing the drawing process. These secondary drawings either confirmed or challenged my understanding of the performance, but were an important control method that enabled me to analyse the research data by grounding them within an art and design context.

Each mark made on the paper as I drew my movement (in first and secondary drawings) tested and re-tested that particular drawing as well as challenging understanding developed before it through earlier drawings. Using shape, weight, tone, direction and the point at which one mark intersected another I revealed and shaped my own understanding. In response to the drawings of my skating performance (Figure 1), I wrote in my research diary:

> I drew my movement at its initial starting point and then drew the next step from this. I can start to see something in-between these two images. I have re-drawn this a few times to help understand the changes in tensions and emotions within the movement – the stretch of the leg and weighting of the hip. From this I could see the shift in weight and how this alters the tension in the body and how through this there is a new emotional content.

Figure 2. Rehearsal drawings of my figure skating performance (Hannah Gravestock).

The drawings revealed a development of movement from equal balance of body weight and a symmetrical body shape, to a more angular movement where the body weight was pushed more onto one foot, causing the body to lean and twist unnaturally. It was this unnatural twist of the body and the sense of fragility and vulnerability I attributed to it that I focused on in further drawings, re-playing the movement by repeating the act of drawing.

Conflicts between the original sensation of strength created through the constant rhythm of the marks I made in the first drawing, and an opposing sensation of fragility, experienced through, and recorded in the second drawing led to new understanding of the 'original' movement. Exploring these discordant qualities in further drawings helped me to find an understanding of the levels of expression needed to convey this narrative through my movement and give it a greater depth of meaning than I had gained through performing it on the ice. Figure 3 demonstrates the analysis of the original movement using a secondary drawing process through to its performance on the ice.

It is important to consider that this drawing process is not without its weaknesses, for example, it does not address sensory stimulus in isolation and does not address the sensory response of smell. It could be focused to do so, but the drawing process would need further investigation and would need to be structured to prevent distractions from other external influences. The process I outline is also limited by the position of the drawer within the performance space and the amount of space available in which to create the drawings. My drawings were made at the ice-rink in which I was training, which meant due to lack of table space drawings were small, and created on my lap on A4 paper. Although this was used as a way to force a more focused drawing, where there was only enough room to re-present the most important details, there is still the possibility that larger drawings could enable greater levels of expression. Further to this, in my case study I was both performer/skater and drawer/designer, which although gave me a unique insight into the drawing process also meant I was unable to provide a completely removed and reflective position as a researcher.

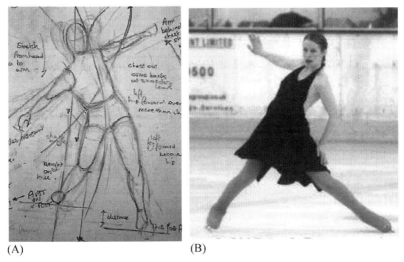

(A) (B)

Figure 3. (A) Left: re-drawing: secondary drawing based on the first drawing of my on-ice practice (Hannah Gravestock). (B) Right: my final skating performance (Photography by Icephoto).

However, I suggest that in weighing up these issues against what the drawing process can reveal, drawing as research, when applied in the right situation by a trained researcher could be a valuable approach to creating and examining new understanding. In this case study, the drawing process enabled me to examine my experience as a designer and as a performer and the relationship between the two roles. As a designer, I was able to understand the performance on a sensory level and use this understanding to develop it further. As a figure skater, I was able to use the differences between the understanding developed from the drawings and my own sensory response to my on-ice performance to develop my understanding of the overall performance and alter my performance accordingly. The result, I would suggest, was an enriched understanding of the body; how it moves, what it can do, the limits it imposes on performance, and what it feels like to be a figure skater and designer.

Challenges in using drawing as a resource in sport and exercise research

As my research case study highlighted drawing as research can enable multiple understandings ranging from individual embodiment and development of sensory awareness to a shared physical vocabulary that could initiate collaborative practice. However, the application of a drawing as research approach by sport and exercise scientists wishing to use it for certain purposes raises a number of questions. For example, can just anyone turn to drawing? What constitutes 'good' and 'bad' drawing when it is used as research? To address these questions and suggest how drawing as research might be effectively used in the field of sport and exercise for certain purposes I will briefly highlight some challenges involved when using drawing as a visual method and how these can be addressed.

In presenting this drawing as research approach at the 2008 Inaugural Conference of the Division of Sport and Exercise Psychology, organised by the British Psychological Society questions were raised by researchers in the field about the effectiveness of engaging non-artists with the artistic practice of mark-making; not

everyone can draw, especially when a drawing is based on the moving and performing body. This is an important question since the quality of the research data can depend partly on respecting and maintaining the integrity of the creative process and training of the artist. A trained artist/designer will know how to vary a mark and the spaces between marks to create a particular meaning, how to create multiple viewpoints on one page, layer images, textures and colours and use shape and form to represent a subject, not as an imitation, but to reveal something new. Because the artist develops their ability to render this visual work and contextualise it appropriately amongst other artwork their ability to 'read' and analyse the marks of a drawing also develops. Training a researcher who is inexperienced in working through mark-making to develop and apply these skills is therefore crucial if drawing is to be used as a visual and qualitative research method in sport and exercise. Simply put, not everyone can draw well. Often – but not always – training is required.

The issue of training a researcher in the creative process of mark-making and the analysis of an art work in order to apply it effectively as a research method brings to light the problems of defining what type of drawing should be used and what constitutes 'good' drawing for research purposes. I am not suggesting that drawing is applied simply for its sake or that anything goes, but that drawing like any form of art needs to maintain high standards; standards that are not absolute or universal.

Standards for assessing what is a good or bad drawing as research approach depends very much on the context of each research project. As Sparkes and Smith write in their paper, 'Judging the quality of qualitative inquiry: Criteriology and relativism in action' (2009, p. 491) what counts as good quality qualitative research and the criteria used to assess this should be 'open to reinterpretation as times, conditions and purposes change'. Just as the use of lists, created through open-ended and re-interpreted characterising traits (Smith and Deemer 2000 cited in Denzin and Lincoln 2003) can be used to assess 'good' and valuable research 'good' drawing is also open to re-interpretation. In fact, assessing the value of drawing as research can be seen to follow a similar approach to that suggested by Sparkes and Smith (2009, p. 495) who write that a 'list gets challenged and changed not by abstracted discussion but by the application and engagement with actual inquiries'.

In Smith's paper, 'Judging research quality: from certainty to contingency' (2009) the assessment of qualitative research and a definition of good and bad social and educational qualitative research is discussed in relation to historical time, social/cultural and political place. Here, echoing an art as research approach, the 'person as researcher' is emphasised over the 'researcher as person'. By acknowledging the role of the individual experiences and dynamic perspectives of the researcher even 'scientific' research is viewed by Smith as a 'matter of telling stories' and likewise, just as in the telling of, and listening to stories a drawing used as research cannot be judged on a fixed criteria.

In practice-based arts research the subjectivity of the researcher is a deliberate and valued part of the research method; a way to provide multiple understandings in order to make sense of the world in which we live and inform and challenge our existing understanding. As Merleau-Ponty (2002, Preface ix) wrote, 'All my knowledge of the world, even my scientific knowledge, is gained from my own particular point of view, or from some experience of the world without which the symbols of science would be meaningless'.

Because the research context, arts practice and the skills and individual experiences of the researchers change so too must the way in which the research method is applied and evaluated. Since the practice is the research method and the research method the

practice when one changes the other is inevitably required to be re-assessed and re-defined. For example historically, fine art has been judged in relation to established aesthetic guidelines that are dependant on culture and tradition and are visible within the finished piece of art. Whereas post modern and conceptual art has been defined by the artist's creative process; how it is created and how it is communicated to the spectator. As Sol Lewitt wrote in his 'Sentences on Conceptual Art' (1969) and as listed in the *Art in Theory* publication by Harrison and Wood (2003, p. 850):

> When words such as painting and sculpture are used, they connote a whole tradition and imply a consequent acceptance of this tradition, thus placing limitations on the artist who would be reluctant to make art that goes beyond the limitations … If words are used, and they proceed from ideas about art, then they are art and not literature; numbers are not mathematics.

Each process used by an artist will reference not only a different time and place in art history but a unique process defined by the experiences and skills of the artist. Criteria used to assess the art research method is therefore hard to pin down and perhaps is better phrased as a series of questions addressing, for example, how and why a sensory response of the artist is created, what embodied knowledge is created and how is the art work received by the spectator. Or, as Sparkes and Smith (2009) suggest, a list format could be used. The 'AHRC review of practice-led research in art design and architecture' (Rust *et al.* 2007) demonstrates the importance of outlining criteria to assess the success and value of research methods such as drawing and painting and the need for detailed dialogues to ascertain this type of list. Questions asked in this research review for the United Kingdom Arts & Humanities Research Council, carried out between 2005 and 2007 and investigating what art as research is and should be included, 'Does the tangible outcome of the work convey knowledge? How? Is it unambiguous? If it is ambiguous how is it still conveying knowledge?' Such questions are an important part of how the Arts and Humanities Research Council are able to judge what research should be given funding. If these types of questions are to be used as criteria to assess what is 'good' or 'bad' drawing as research then those who apply drawing as research must understand the implications of the marks made on the page; how they were created and how they can be used to analyse data. This requires appropriate training opportunities and requires that the sports researcher, like the arts researcher investigating a science-based subject, is open to new encounters with a different field and professional practice.

Responding to the challenges: interdisciplinary collaboration

Reflecting a similar approach to that of Lyons (2009), whose research can be placed within and between the fields of both art and medical science, the encounters that I speak of are defined by collaboration between two fields. In this instance, collaboration between researchers in the fields of art, design and sport. For a successful collaboration between these individuals those involved must understand how and why the drawing process can create understanding on an embodied level. As the key to drawing as research is the act itself, to provide this understanding I suggest the 'doing' of drawing rather than just a theoretical studying of it.

Clearly, there are many ways in which we can engage with the 'doing of drawing'. If our attempts to draw for research purposes within sport and exercise are to be done well, and if one lacks the relevant skills to produce 'good' drawings, training may be needed.

Practical training structures relevant to the teaching and application of drawing as research include the Laboratoire d'Etude du Mouvement (LEM), founded by Jacques Lecoq and now run by Krikor Belekian and Pascale Lecoq. At the LEM, based within a space that previously housed a boxing ring, and at the school founded by a former gymnast students explore how to create understanding through the movement of their body. At the École Internationale de Théâtre Jacques Lecoq (http://www.ecole-jacqueslecoq.com) drawing, alongside writing, movement and the construction of three-dimensional forms, is used to enable the students to experience for themselves how opposing forces can create movement. It is in the moment of performance; moving or drawing that the student understands how such movement can create different types of energy, sensation and emotion. By learning to create and control such energy the student continues to develop and improve their ability to create performance. The LEM website explains that 'this link with the body remains essential. Before discovering that which can be reasoned, the student discovers through his body the dynamic sensation, which will enable him to reason better'.

The LEM teaching is used in current theatre, performance and scenographic training to develop the sensory awareness and responses of students in creating performance. With its focus on structured 'play' and 're-play' and physical exploration, including drawing, to create embodied knowledge, it is certainly possible that researchers in the field of sport and exercise, coaches and athletes could benefit from such training.

Training workshops I run in the UK for scenography students, based on the LEM training and my drawing research, use a combination of drawing and movement exercises to enable students to understand and create performance. These workshops do not depend on the level of artistic skill of the student, but on their ability and openness to explore ideas through their body.

Many students begin the workshops with concerns that they 'cannot draw', and as a result both their drawings and their sensory response created through drawing begins small and tight and they struggle to connect effectively with the subject of the encounter. However, by providing the right training environment, the opportunity to repeat and practice the drawing process, and with a focus on the encounter rather than the product, students are able to free their body and mind (Zarrilli 2009) and make visible what is invisible. Applying different weights of a mark, altering tone, direction, colour, shape and form the scenographer explores what they see and how they feel in relation to what they see. Such responses seek to represent rather than imitate and in doing so reveal a particular point of view. The interpretation of the visual response on the page therefore becomes part of the development of the meaning the scenographer gives to the subject of the drawing itself. This interpretation of a text, sound, object or image can be developed through relationships between the marks on the page, between the drawing and the subject and between individual drawings. Figure 4 is a drawing that resulted from a student responding to three different types of music. After the drawing process, conducted as the music is playing, students reflect and discuss their drawings based on how they felt as they drew, how they feel looking at the image after the event, the quality of the marks, the spaces between the marks and the differences between each three parts of the drawing. Working first in isolation and then in groups the students go on to interpret the drawings in the form of narratives which are used to create objects, spaces and movements. As this knowledge has been developed through the body of the scenographer; through the movement of the hand as it moves across the page, each external action

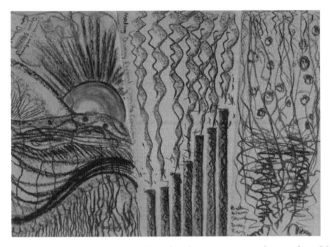

Figure 4. Exploring responses to music (drawing by a scenography student 2008).

created can in turn create an internal reaction specifically connected to the mark that it leaves behind.

The flexibility of this training approach enables the outcome of the drawing made by a participant to determine what is drawn next and how best to approach a creative process that will benefit the dynamics of a group or the needs of an individual. Passing over control of drawing to the participants in this way means that they can choose what they draw and how and can, with the guidance of the researcher, go on to examine and explore what they have learnt from this process. This approach enables the researcher to become observer and means that their observations can be used in addition to the drawing data to create new understanding and new performances. Developing this approach, a group drawing, where each person contributes to one large drawing could be used to further examine multiple perspectives and challenge existing knowledge by creating new visually conflicting data.

In conclusion, although these applications of drawing will not be relevant to all researchers and whilst the possible variations of its application to the sport and exercise sciences still require further examination, the approach has much to offer researchers. Not least because, through a momentary, reflective, expressive and repeated physical act it uniquely enables the creation and development of something new in response to what was initially examined. However, to pinpoint more accurately how this process can be applied more opportunities are needed for dialogues and exchanges of data between artists and sports researchers/practitioners. Through this discussion and through collaborations it is also possible that other theatre-based training structures and practice-based research methods could be investigated in relation to sports research. For example, although in performance theory the complexity of the similarities and differences between sport and art are acknowledged, sport like theatre performance is also seen to possess artistic qualities that could reveal new ways of seeing. As performance theorist Richard Schechner (2002, pp. 25–26) observes:

the moves of basketball players are as beautiful as those of ballet dancers, but one is termed sport, the other art. Figure skating and gymnastics exist in both realms. Deciding what is art depends on context, historical circumstance, use and local conventions.

Schechner (2002, p. 26) goes on to comment that with the use of slow-motion photography other sports less known for such artistic values such as football and wrestling can 'attain an aesthetic dimension' more apparent when seen through a review or replay. With the way in which drawing can be used as a mime to re-present and through such re-presentation create embodied knowledge it has the potential to illuminate the complexities of human lives; both in terms of the researcher and participant.

Acknowledgements

The author would like to thank Brett Smith for his helpful comments on earlier drafts of the paper, and Simon Jenkins, Laura Gonzalez, Jill Gibbon and Lucy Lyons for their support.

References

Brien, A., 2002. *Thinking through mark and gesture* [online]. TRACEY, Loughborough University. Available from: http://www.lboro.ac.uk/departments/ac/tracey [Accessed 8 March 2010].

Burstein, D., 2005. *Traces II: drawing/poetry* [online]. The association of painters and sculptors. Jerusalem Artists. Available from: http://www.art.org.il/en/exhibition_about.php?id=89 [Accessed 8 March 2010].

Chipp, H.B., 1968. *Theories of modern art: a source book by artists and critics.* Berkeley: University of California Press.

Denzin, N.K. and Lincoln, Y.S., eds., 2003. *Collecting and interpreting qualitative materials.* 2nd ed. Thousand Oaks, CA: Sage.

Garner, S., ed., 2008. *Writing on drawing: essays on drawing practice and research.* Bristol: Intellect Books.

Harrison, C. and Wood, P., eds., 2003. *Art in theory 1900–2000: an anthology of changing ideas.* 2nd ed. Oxford: Blackwell.

Kingston, A., ed., 2003. *What is drawing? Three practices explored: Lucy Gunning, Claude Heath, Rae Smith.* London: Black Dog.

Lecoq, J., 2001. *The moving body: teaching creative theatre.* Translated from *Le Corps Poétique* by D. Bradby. New York/London: Routledge.

Lewitt, S., 1969. Sentences on conceptual art. *Art-Language*, 1 (1), 11–13.

Lyons, L., 2009. [online]. Available from: http://lucylyons.org/ [Accessed 8 March 2010].

Merleau-Ponty, M., 2002. *Phenomenology of perception.* 2nd ed. Translated by C. Smith. London/New York: Routledge.

Rawson, P., 1969. *Drawing: the appreciation of the arts/3.* London: Oxford University Press.

Rust, C., Mottram, J., and Till, J., 2007. *AHRC review of practice-led research in art design & architecture* [online]. Arts and Humanities Research Council, Sheffield Hallam University, Nottingham Trent University & University of Sheffield. Available from: http://www.archive.org/details/ReviewOfPractice-ledResearchInArtDesignArchitecture [Accessed 8 March 2010].

Schechner, R., 2002. *Performance studies: an introduction.* New York/London: Routledge.

Smith, J., 2009. Judging research quality: from certainty to contingency. *Qualitative research in sport and exercise*, 1 (2), 91–100.

Sparkes, A. and Smith, B., 2009. Judging the quality of qualitative inquiry: criteriology and relativism in action. *Psychology of sport and exercise*, 10 (5), 491–497.

Zarrilli, P., 2009. *Psychophysical acting. An intercultural approach after Stanislavski.* London/New York: Routledge.

'What it was in my eyes': picturing youths' embodiment in 'real' spaces

Laura Azzarito and Jennifer Sterling

School of Sport, Exercise, and Health Sciences, Loughborough University, Leicestershire, UK

Readers should also refer to the journal's website at http://www.informaworld.com/rqrs and check volume 2, issue 2 to view the visual material in colour.

Current global educational trends towards homogenisation and deterritorialisation have resulted in limited attention to the multiple and contradictory ways youths frame, construct and view their physicalities. The purpose of this research was to explore the ways in which young people of different ethnicities in two urban schools engaged with physical culture in their everyday lives. To investigate youths' embodiments, researchers employed a qualitative visual methodology with secondary school students. By giving the participants digital cameras, the researchers explored the ways young people pictured and created their body-selves in 'real spaces'. Data was collected from multiple sources: field notes, interviews and visual *Moving in My World* diaries, which participants created to represent their emplaced body experiences. Findings shed light on the multiple ways young people engaged in visual and verbal meaning-making about their physicalities based on the range of resources, opportunities, and/or constraints existing in the material contexts available to them. While students envisioned themselves as physically active and as creative of their body-selves, most girls' visual diaries pictured recreational bodies in gender-segregated, shielded spaces, whereas most boys' visual diaries presented sporting bodies in public performances. Our discussion raises critical questions about 'real' opportunities for young people's moving bodies in the localities of their everyday lives.

Introduction

Current global educational trends towards homogenisation and deterritorialisation have resulted in limited attention to the multiple, contradictory ways youths' lives are framed, constructed and viewed in their everyday localities (Dolby and Rizvi 2008). While globalisation puts forward ideas of 'cosmopolitan democracies' (Torres 2009), economic and social disadvantages and limited opportunities at the micro level tend to be overlooked. Wells (2008, p. 271) makes a convincing argument that a 'school's student body is a community of theoretical equals insulated from the economic and political inequality that is very evident in the local neighbourhood'.

The youth's body, therefore, has become a site of conflictual discourses: corporeal ideals of size and shape, norms of health and physical activity, and the 'risk' of being and becoming different. Contemporary discourses, circulating and reinforced through global media, produce inactive physicalities, especially minority youths' bodies, as 'at

115

risk', 'disadvantaged' or 'socially deprived' (De Knop *et al.* 1996, Walseth and Fasting 2004, Walseth 2006). In this cultural context, minority youth might dangerously embody negative self-concepts as they negotiate alarmist public discourses of the body 'at risk', and simultaneously face educational, social, and economic challenges (Azzarito 2009a). Shedding light on youths' everyday, local existence, therefore, is critical to tackling the global discourses of bodies 'at risk' and to addressing the structural inequalities constraining some youths' physicality. Research on youths' engagement with physical culture is especially relevant in the current educational landscape as it offers possibilities for revealing youths' embodiment as emplaced in the localities of their everyday lives.

Bodies, 'real' spaces and the visual turn

Youth and physical culture

The study of the body has become central to addressing enduring inequality issues (Kirk 1999, Duncan 2007, Hargreaves and Vertinsky 2007, Oliver *et al.* 2009, Azzarito 2009a). In theorising youths' embodiments, Kirk proposes 'recast[ing] the notion of young people's participation in physical activity as engagement of young people with physical culture' (1999, p. 71). Physical culture, as manifested in the myriad body practices of sport, health and recreation inside and outside of schools, is regulated and codified by gender and racial discourses of the body produced by dominant global and local institutions (i.e. media, schools, health, sport clubs etc.).

Kirk (1999) advocates for scholars' adoption of the concept of physical culture in researching the links among the body, the self and the actual sites of practices of the body; such sites might range from physical recreation (e.g. walking, domestic work, 'pick-up' or non-competitive games, recreational dance etc.), to sport (competitive, structured practices that require specialised techniques and strategies), to exercise (practices associated with health). Physical culture concerns the ways people cultivate the body-self as an active physical corporeal process; this process, however, is situated and contingent upon the opportunities, sense of choice and desires young people embody (Hargreaves and Vertinsky 2007). In a broader and more complex sense, the notion of physical culture engenders young people's narratives of *moving bodies* in a wide range of ways based on their different degrees of engagement with the discursive resources that physical culture provides (Loy 1991). As disciplined and normalised, but also as transgressive of dominant discourses of gender, race/ethnicity and social class, moving bodies account for the complexity of power relations that encode high- and low-status bodies as institutionalised in particular places and times.

The body is 'a phenomenon of options and choices', according to Shilling (2006, p. 3). Girls' and boys' (dis)engagement with various body practices might thus be understood as a reflection of a wide range of opportunities, from many to very limited; and the various choices youths adopt depend on the range of educational, economic and social resources of physical culture available to them. Young people do not simply subsume dominant discourses of the body produced in society; rather, they are active agents in constructing their physicality, creating, using and adopting physical culture and the global/local narratives contemporary physical culture provides.

Youths' emplaced embodied learning

Whereas youths' engagement with the physical culture of media, TV and virtual space (visual pedagogical sites) imbue their imagination with fantasies of who they

are and who they should become (Dolby and Rizvi 2008), school sites represent 'real' learning spaces, where they engage in meaning-making processes of their body experiences, trying out their identities in multiple ways (Bettis and Adams 2005). The body expresses the self in its spatial dimension, making visible a wide range of feminine/masculine modalities of body comportments, actions and motions in and through spaces of inclusion and/or exclusion (Young 2005). The wide range of girls' and boys' body performances 'occur in material contexts and are made possible through opportunities and constraints existing in these contexts' (Datta 2008, p. 198).

School community contexts, in particular, offer powerful sites of socialisation and acculturation (Azzarito and Ennis 2003) in and through which young people connect, explore and manage their emergent identities in contested and fluid ways. Youths' embodied learning of various body values, attitudes and stigma occurs through their socialisation, actions and behaviours across 'real' spaces, as well as through their imaginative engagement with varied visual texts and virtual resources. In 'real' spaces, however, youths' physicality is emplaced – displayed, constructed and regu-lated – by the micro-practices their bodies perform in their everyday lives and spaces (Datta 2008). Physical locations such as school playgrounds, gyms and parks offer sites for young people's enactment of body performances, displaying social identities in multiple and contradictory ways. Seeing and accounting for the geographical loca-tion of embodiment opens up possibilities for maintaining, subverting or challenging the body as a masculinist illusion in society (Longhurst 1995) in the public, male-dominated spaces of sport (Duncan 2007).

Research on youth, the body and spatiality

A number of scholars have shown the ways the youth's body represents a site of dominant discourses of gender, race and class; a body performed in a range of socially constructed spaces of inclusion and exclusion (James 2001, Braham 2003, Azzarito and Solmon 2006, Azzarito and Harrison 2008, Oliver *et al.* 2009). As they make sense of their body experiences in relevant physical activity sites, young people learn who they are and who they want to become in the world. In the US, for instance, researchers have revealed the ways girls and boys account for and construct racialised ideals of femininity and masculinity through their readings of media body texts, and how racialised discourses such as the 'naturally superior' body are performed in multiple ways on 'real' sites, such as basketball playgrounds (Azzarito and Harrison 2008, Azzarito 2009b). For some minority girls, however, the school playground does not serve as a site for affirming athletic physicality but rather as a site of struggle to affirm 'play' in their own terms, especially where boys occupy, dominate and define playground spaces as 'male' (Oliver *et al.* 2009).

The spatial dimension of the body, constructed within a gender and racial order and on a continuum from public to private, informs youths' ways of being and becom-ing in 'active' spaces (Scraton and Watson 1998, James 2001). In the UK and Norway, empirical findings evidence the complexity of girls' and boys' body movement in and through urban physical activity localities and the intimate connections between the ways they move and the ways they feel, see and are viewed by others in those spaces (Carrington *et al.* 1987, James 2001, Strandbu 2005, Green and Singleton 2006). For example, Strandbu's (2005) investigation of the contradictory ways girls with immi-grant backgrounds' body experiences inform their participation in sport clubs (i.e.

aerobics and basketball) revealed how gendered space (single sex vs. mixed) influenced their embodiment.

As Strandbu (2005) discusses, while some girls could see themselves as active bodies in a gender-mixed arena, others feared that their body experience in these spaces would be accompanied by feelings of self-consciousness, shame or bashfulness for cultural, family and personal reasons. Furthermore, Carrington *et al.* (1987) found that, when compared with their male counterparts, many South Asian girls often experienced their body as confined within the realm of home and often felt their desire to pursue 'out-of-home leisure' (p. 266) physical activities constrained. For the majority of the South Asian girls in their study, single-sex youth sport clubs were experienced as shielded, yet meaningful and indeed liberating, as 'a means of escape from home' (Carrington *et al.* 1987, p. 272). Gender-mixed spaces were not a problem, however, for girls in Strandbu's (2005) findings, who, in spite of their upbringing in single-sex physical activity spaces, got 'used to being' with boys in gender-mixed sport spaces.

This existing research brings to light how the embodied self is culturally and historically situated in space, constituted through youths' choices and decisions to resist and/or to enter and fully experience their moving bodies in physical activity. Green and Singleton (2006) have suggested that as the design of public space for physical activity and leisure is often embedded in the dominant White, male, heterosexual perspective, girls (and especially minority girls) might experience these public domains as spaces of exclusion. Girls become 'outsiders' in public 'active spaces' when these spaces, constructed as boy-centred, evoke feelings of risk, unwelcome, anxiety and potential ridicule (James 2001). Boys as well distance themselves and resist moving into active sites when dominated by a peer culture they feel they do not belong to. Further empirical evidence has shown how a group of British Asian boys became 'anti-sport', positioning themselves and being positioned by their White British peers as 'anti-PE' or 'puffs,' (low-status masculinities) when the physical education (PE) space was dominated by hegemonic White masculinity displayed through football (Braham 2003).

While researchers' investigations of the ways youth organise and re-organise their gender subjectivities at the intersection of class and ethnicity have provided valuable insights about youth, the body and inequality issues (Gorely *et al.* 2004, Azzarito and Harrison 2008, Oliver *et al.* 2009, Azzarito 2009a), exploring youths' own visual representation of their body-selves in relevant spaces can further this enquiry. In this vein, Nash (1996) has called for feminist scholars to conduct visual research that explores the complexity of the 'landscape of the body' to open up possibilities for critically examining difference, subversion and resistance to dominant representations of the body in its spatialities.

Whereas an oral storytelling approach to exploring young people's embodiments (Sparkes and Smith 2007) offers a 'reflective project of self' (Kehily 2007, p. 80), a visual storytelling approach to studying the body probes young people's creation of and engagement with physical culture in creative ways and may offer authentic representations of how they experience their bodies (Clark-Ibanez 2004, Rose 2007). Therefore, the purpose of this research project was to explore – through digital photography – the ways in which young people in two diverse urban schools engaged in physical culture in their everyday lives. By giving the participants digital cameras, the researchers investigated the multiple ways young people picture and create their body-selves as emplaced in relevant spaces in their communities.

Methodology

The settings for this research were two state-funded, inner-city schools with diverse student populations located in the Midlands region of the UK. The findings reported in this article are part of a larger 2-year visual ethnographic research project sponsored by the UK Economic and Social Research Council. Visual methodologies have increasingly occupied a central role in education research, as they can offer innovative tools for exploring the complex ways youth make sense of, talk about and see themselves and their bodies (Rose 2007, Thomson 2008). In particular, in researching youths' embodiments, photography provides 'a medium of seeing that is shaped by the social context, by identity, and by experience' (Wissman 2008, p. 14). Therefore, visual methodology, and in this case photography-generated 'visual diaries', can be particularly successful when researching young people, because it enables participants to communicate and express themselves in meaningful and contextualised ways (Gauntlett and Holzwarth 2006).

This article draws upon the visual and verbal narratives of 13 high school students, aged 15 and 16 (three White females, four South Asian females, two South Asian males and four White males) in single-sex PE classes. Students were selected after a 4-week observation period based on the following criteria: (1) diversity of gender and ethnicity, (2) different body sizes and shapes, (3) different levels of physical activity outside of school, and (4) different levels of participation in PE in school. Ethical consent forms were obtained for the visual diaries and interviews from each of the students and their parents/guardians. Student names referred to in this article are pseudonyms.

Data collection and analysis

Data was collected from multiple sources: field notes, formal and informal interviews and participants' digital photographs ('visual diaries') of their body experiences. Participants were asked to create a visual diary, *Moving in My World*, representing their physicalities in school and relevant communities. Field notes of observations in PE classes were collected over a 3-month period (i.e. 10 observations; 60 min each class observation). Written and verbal explanations of how to use the digital camera and the focus of the visual diary were provided to all student participants. The written instructions aimed to help them create their visual diary and included the following guiding questions: (1) How do I move in my world? (2) Why do I move in my world? and (3) How does my body feel when I move in my world? Students were instructed to include 10–20 pictures. To enhance clarity and validity of the visual diary instructions, a pilot study was conducted with three 15-year-old non-participants.

Following the completion of their visual diaries, each participant was interviewed using a 'photo-feedback' technique (Harper 2002). The interview questions, organised using a standardised, open-ended interview protocol (Patton 1990), aimed to probe participants' interpretations of their visual diaries, eliciting reflections on and personal narratives about their *Moving in My World* images. To ensure the accuracy of the data, a member check was conducted with each participant during a second formal interview. In addition, an inductive and deductive analysis of participants' discourses, as articulated through visual images (Rose 2007) and verbal text, was conducted, centring on the notions of recreational and sporting bodies (Kirk 1999) and relevant spaces.

Results

Moving in my world: picturing sporting and recreational body-selves in public and shielded spaces

The ways participants pictured their body actions and repertoires in their everyday lives revealed differences in their meaning-making about the body-self in and through various relevant spaces.

Sporting body-selves through, and in, the public domain: 'I'm very sporty, I'm up for anything, anything.'

This first theme shows how youths engaged with physical culture through pictures and talking about their body-selves as 'sporting bodies' (Whitson 1990), bodies visible and centred in public domains. Robert's visual representation of his body-self narrative exemplifies this theme. Robert initially included 185 pictures in his visual diary. When asked to select those pictures (no more than 20) that best represented his body experience in physical activity contexts, he selected 19: 13 images of him and his classmates/friends playing basketball on the school playground and six photos of him playing football on the school astroturf. During his interview, Robert explained that he had hoped to include photos of himself playing football at his boys' city football club, but the season had just ended. Robert described himself in this way:

> I rap and play football for the Swan Football Club. … My life is being active. … I would say I try to chill out, but I'm pretty aggressive, funny, try and be friendly when I can, when it's needed. … I would say I switch when I play sport with referees and other players. … I play basketball for school and I got in the national finals…

Robert's narrative of moving in his world symbolised the notion of a 'sporting body' (Shilling 2008), a body-self constructed through sport training, athleticism and competition with self-defined 'highly skilled' friends inside and outside of school PE. Because the physical culture he engages with centres on highly competitive, sport-driven performances, PE is a 'restricting' space in his eyes. When asked what he meant by this assertion, he explained: '[In PE] you can't experience the same amount of competitiveness or the same amount of skill against you, so you're never going to get any better at it'. When he was asked to explain his visual diary, looking at the selected pictures, Robert elaborated:

> The project was what it was in my eyes about. What you do in sports. So this is what I do at lunchtimes and it's movement in my world as you put it. … Because the football season was over at this point, I couldn't do anything [take pictures] out of school. … So I had to do it in the playground and stuff. … Like they [the pictures] are all just how basketball is in the playground. This one (Figure 1) I chose because it looks like I'm getting checked … and then, like I said, being in control with a football.

In the pictures Robert included in his visual diary, his body occupies a centred and visible position, displaying ball control in football (Figures 2 and 3) and shooting in basketball (Figures 1 and 4). Sites of specialised body practices, conventionally institutionalised as 'male domains' (Azzarito and Solmon 2006), provide a wide range of resources for boys to try out, view and establish competitive, sport-driven and highly specialised physicalities. Robert's emplaced embodiment of masculinity is consti-

Figure 1. Robert 'getting checked'.

Figure 2. Robert dribbling a football.

Figure 3. Robert controlling a football.

Figure 4. Robert shooting a basketball.

tuted through ongoing daily training in a wide range of public spaces, at the club and school football pitches, on the school playground and in the school gym, to acquire and develop sophisticated sport techniques and strategies and to refine specialised body performances.

In the UK in particular, football, Robert's favourite sport, represents a significant space for boys' investment in White working-class masculinity (Ismond 2003). For Robert, his sports and sporting localities such as clubs, playgrounds and PE – sites constructed as male spaces in and through the public domain – provided him with the material conditions for his embodiment of masculinity to take shape and become legitimated. According to Duncan (2007, p. 63), gendered dominant discourses of normative sporting bodies in 'the mediated world of sport' frames men as the 'standard' or 'normal' physicality, implicitly maintaining the exclusion of female bodies in sports. While Robert is clearly centred in the images of his visual diary and imagines himself as skilled, he suggests that the playground is a second choice space for his moving body, saying he 'couldn't do anything' without having access to seasonal football practices. His choice of an exemplary picture as one where he's 'getting checked' reveals how his moving body is circumscribed within ideals of competitive masculinity.

Like Robert's expression of his emplaced body-self, Vijay's body meaning-making centred on developing and maintaining a 'sporting body' in technocratic and performance terms. Similar to Robert's view of moving in his world, sport is central to Vijay's life, and his own sport performance at the school tennis court is focal to his visual diary. Vijay asserted:

> I'm very sporty, I'm up for anything, anything. ... I love exercising, anything, any group which are on, I'll go to boxing club, tennis club, badminton, I just go to it. ... I like, I mostly like training by myself. But in a group, I don't mind, but I like personal, like going jogging myself.

All 20 photos Vijay included in his *Moving in My World* diary pictured him on the tennis court while performing different tennis strokes, such as the smash, serve and drop-shot (Figures 5–8). Some of his photos, shot at the tennis centre at school, aimed to portray the sequence of appropriate body actions required for each skill, like a tennis training manual or a tennis magazine. Similar to Robert, Vijay shows a 'sporting identity' performed at 'autonomous proficiency', when automatism and advanced sporting skills are embodied, self-regulated, mechanised and displayed with proficiency (Shilling 2008, p. 52). Vijay's PE coach encouraged his training and commitment to tennis, because, as Vijay declared, 'I was good at it'. During the interview, he provided a technical narrative of his body actions:

Figure 5. Vijay preparing to smash the ball.

Figure 6. Vijay taking the racket back and pointing the ball with left hand.

Figure 7. Vijay following through on the Figure 8. Vijay's half-volley.
serve.

> Here I'm just getting ready to hit a shot. … I'm just mostly hitting shots in all of them.
> And then this one I'm serving. This one I'm just about to hit the ball. And then that one,
> volleying a ball. … These three are just me smashing. … You can tell I'm like defensive,
> because I stand really far back, away from the baseline.

Vijay evoked a body-self narrative as a 'practiced body' in his favourite sport, tennis. According to Duncan (2007), 'the practiced body' is a highly skilled body, a body that disciplines itself and is regulated and normalised by masculinising body-athlete discourses of competition, skilfulness and athleticism promoted and embedded in the widespread web of sport media spaces and public, male social spaces (i.e. play-grounds, sport clubs, school PE etc.). Vijay's *Moving in My World* diary, which conveys the process of being the tennis player he is and wants to become, envisions Vijay's everyday body-project.

There are clearly inconsistencies, however, in the ways boys perform masculini-ties (Azzarito and Katzew 2010). As boys display masculinities in fluid, conflicting and multiple ways, Vijay took up a practiced-body discourse, but unlike Robert, belonging to a group of 'highly skilled friends' was not as relevant to his sense of himself. Rather, as his visual body narrative represented, he embodied a willingness to separate, even isolate himself. None of the photos portrayed him with friends. All of the pictures portrayed him playing or posing by himself. Vijay, who self-identi-fies as Indian, pictured a non-relational, embodied self on the tennis court that trans-gressed traditional discourses of South Asian boys' masculine body performance, since within the hierarchies of masculinities, South Asian boys' physicality is stereo-typically viewed as either physically inferior, less able or less sporty than their White or Afro-Caribbean male peers (Braham 2003) or constructed upon the recre-ational space of cricket (Fleming 1995, Ismond 2003). Furthermore, Vijay constructs his sporting body by representing himself as in command of the tennis court itself. The image projects this space as 'his' alone.

The narrative of a body-self disciplined through sport and implicated in traditional male discourses was shared by most of the other boys, but not by the South Asian girls. In this study, only two girls, both White, emphasised the importance of sport in their lives. Dynamic forms of masculinities, just like femininities, are performed not just by boys but by girls as well (Azzarito and Katzew 2010). For example, Kate presented herself by recalling the masculinising spaces she lived and experienced while growing up:

I'm a bit of a tomboy, I think. … I don't like, you know, the skipping and ballet and all that. I prefer, you know, things like rugby. … It's because I grew up with my brother and all his friends, so all of them, all of his friends are guys, and I was a bit rough when I was younger.

However, Kate decided to represent moving in her world not through rugby but through surfing (Figures 9–11). In her *Moving in My World* diary, Kate included nine pictures (eight photos of her surfing, two of her preparing for coasteering, and one photo showing her hiking), all taken in the public domain of a coastal area that she visits with her family. In 7 out of the 9 photos, Kate is engaged in body actions, while in the coasteering pictures, she is posing next to a boat in her wetsuit and/or with equipment (Figure 12). Kate explains the 'Me surfing' photos in the following terms:

I go surfing quite a lot with my dad. … All these [photos of her surfing], on the same day were of me surfing. I mean, yeah, like I say, my dad, I've never had lessons, my dad teaches me. … I really enjoy it, I mean it's really, no one else really does surfing. It's quite individual and . … and the image as well I think is pretty cool.

Differently from Robert and Vijay, competition is not relevant to Kate's embodiment. However, surfing continues to be central to her body-self for recreational and leisure purposes with her family. Kate's emplaced embodiment was portrayed, for the most part, through her public performance of highly developed and specialised body actions that surfing demands. Kate, similar to Robert and Vijay, shows a 'practiced

Figure 9. 'Me surfing'.

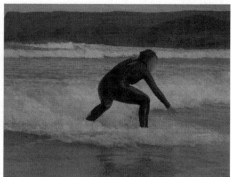

Figure 10. Kate surfing.

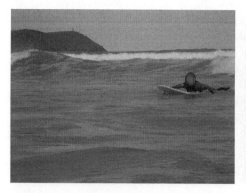

Figure 11. Kate paddling.

Figure 12. Kate in her wetsuit.

body' surfing, a body whose highly skilled actions become nearly automatic through rehearsal of movement sequences over time (Shilling 2008) by using specialised equipment. The pictures taken by her father make visible Kate's developed technique, control on the surfboard, and specialised surfing equipment and attire.

Recreational body-selves in shielded spaces: 'I just do, because that's how I am!'

Sporting bodies as displayed in various public sport-based domains were absent in the ways South Asian girls and one White girl created, crafted and expressed their body-selves. Their visual diaries represented moving bodies that did not participate in any competitive, organised sports at or outside of school or sports that required highly specialised body actions. None of the girls described their body-selves as inactive, passive or lazy, inside or outside of PE, however. For instance, Radhika explained that pictures in her visual diary – jumping on the trampoline or 'messing around' with the football along with her cousin and participating in PE – represent how she moves in her world with friends and family members, people who are important to her and with whom she feels familiar. During the interview, she said that she wants to become a PE teacher and commented:

> PE is definitely my favourite (Figure 13) because we go out and play and then come in and do written work as well. ... Basketball is quite fun or netball. ... I haven't joined any teams, anything. I didn't join anything out of school, but I did like badminton, tennis and stuff and trampolining. I didn't really do anything out of school.

When she explained what the pictures meant to her, she clarified:

> It's just like what I do weekly, like my lifestyle ... the [pictures] with my cousin, like playing football (Figure 14) and trampoline and stuff ... that's in my back garden (Figures 15 and 16). It's just active and fun really. ... Yeah, moving around with football, I do every weekend, like the one [picture] with my cousin, like playing football and trampoline. ... I just do [physical activity] because that's how I am and I like enjoying things and not just sitting.

While Radhika presents herself as someone who 'enjoy[s] doing sports very much', her engagement with physical culture through competitive sport-based practices was absent from her visual diary and the interview. With regard to sport and her

Figure 13. PE class, Radhika's favourite subject.

Figure 14. Playing football with her cousin in the backyard.

Figure 15. Radhika's cousin doing a hand-stand on the trampoline in the backyard.

Figure 16. Jumping on the trampoline with her cousin.

engagement with sport, and in expressing her subjective experience of what it feels when moving, Radhika pointed out:

> I feel great when I do it … but if I go overboard I'm quite knackered. … Say you go training and you have to push yourself to your limit, that's when you are obviously not enjoying it. That's what I'm trying to say, like, just all the things I've taken the pictures of is like enjoyment of like activities I like, if you get what I mean.

As pictured in her visual diary, both the school PE spaces and the backyard symbolise relevant spaces for Radhika's embodied experiences of moving in her world. Radhika's *Moving in My World* visual diary includes 17 pictures (i.e. 10 photos of her cousin on her trampoline, six picturing her single-sex PE class and one of rounders equipment representing her participation in GCSE PE).

In Radhika's eyes, her 'corporeal places' do not reflect traditional masculinist dominant knowledge of the body publicly displayed for people to look at, appreciate and evaluate (Longhurst 1995) but rather alternative ways of seeing. Radhika pictures moving bodies as recreational bodies that diverge from and possibly challenge and/or subvert the masculine structure and geographical location of moving bodies represented as public sporting bodies. Radhika views her physicality as shaped by games, non-competitive informal and formal schooling single-sex practices, and she connects these games to educational, career-related or recreational purposes.

Notably, such embodiments may incorporate or display a 'feminised dimension' of the body, and so to a certain extent, Radhika's narrative frames her body-self as shielded within the boundaries of women's spaces and away from a 'predominantly male gaze onto the public arena' (Scraton and Watson 1998, p. 125). Her *Moving in My World* diary conveys geographical locations of body experiences that celebrate moving bodies, but also confine, protect and restrict them to backyard or female-only spaces. Because as she explained, 'I'm not that photogenic really', Radhika included photographs of her cousin's and friends' moving bodies in her visual diary (10 photos). Walseth (2006) suggests that family members play a significant role in minority girls' sense of belonging in their recreational-time activities. The rest of the photos show her classmates running or playing organised games in her single-sex PE classes. Radhika's moving body remains unseen in her visual narrative. The spatiality of her body, as displayed in her visual diary, her home backyard, the school single-sex playground and PE, symbolically represents geographical locations that shield her

body-self from the public gaze, but simultaneously make visible what it means to her to be physically active.

Ameera visualised her engagement with physical culture in pictures of her body-self involved in recreational activities with friends at the school site. Like Radhika, Ameera loves to be active, as she stated:

> It feels good, to be honest. It's like I'm actually doing something that helps with my health. … It's [physical activity] quite important, cuz like, I don't know, I just don't feel right, I just sit around all day. I just feel really, like weird and then I have to do some sort of activity.

When narrating her visual diary (Figures 17 and 18), she added:

> I move around quite a lot. It's like, yeah, I mean like improving myself, to be honest, rather than just, like sit there with everyone at lunch, I feel bored sitting around. … Sometimes my friend brings her basketball and we like play at lunch and we try to do as much of things as we can to like burn off our calories. … I like playing like games like basketball. … I love climbing trees, I'm not really good at [climbing] them.

While researchers report 'problems' with South Asian girls' lack of participation in sport (Walseth 2006), in this study, Radhika, Ameera and other South Asian girls engaged with the resources of physical culture available to them, resources that included recreational, non-competitive, 'pick-up' sport-based games offered in PE classes and organised by themselves in the school playground during breaks with their female friends. For South Asian girls, social networks created by friendships and families or extended families tend to be highly valued and play a crucial role in their identity formation and active physicality (Basit 1997, Scraton and Watson 1998).

Most pictures portray Ameera's female friends running, dancing or climbing in the same location: the single-sex school site. In a total of 11 pictures, Ameera is visible in

Figure 17. Ameera on a tree in the school playground.

Figure 18. Ameera's classmates on the school playground.

Figure 19. Ameera and her friend doing jumps on the school playground.

Figure 20. Basketball in the gym in PE class.

two photos: in one, she is by herself on a tree (Figure 17), and in the second one, she is jumping with her friend on the school playground (Figure 19). As Radhika's diary evidences, Ameera's visual narrative of her subjective experiences of the body in space might represent her means for developing a sense of belonging and social bonding with girlfriends in recreational sport-based and other physical activity spaces (Figure 20). Such relevant contexts become 'girl-defined' spatialities of the body in which girls contest, re-define and re-construct stereotypically 'passive' or 'subordinated' South Asian femininities as active, relational and creative in their body narratives. Ameera's subjective sense of belonging is tied to experiences of active recreational bodies.

While similar to other girls, Jo did not construct herself as 'competitive' or 'athletic'. Also different from her classmates, Jo pictured her emplaced embodiment strictly outside of school contexts. Moreover, none of the five pictures she included in her visual diary portrayed either herself or her friends; instead the photos framed places relevant to her physicality. 'I don't socialise a lot', Jo briefly stated. Jo made sense of her body experiences, the ways and why her body moves in the world by reflecting on the five pictures she included in her visual diary as follows:

> I do a lot of walking, I don't do cars, I don't do transport or stuff, and I like to ride with my bike. …I like romance novels. … I walk to school and home every day. I ride my bike, not so much every day, but quite a lot. … I avoid public transport because one, they are helping to destroy the planet, and second, I hate them.

Jo further explained:

> To me, moving in my world isn't just about sports or activities you do, it's about everything. … Like things you do instead of sports or the lifestyle you choose. … I found it difficult to explain it why I don't do a lot or more sport. … [I]t's because I feel no need to do any more sports, to me, I do enough activities to stay healthy and happy. I run around a lot and play with my dog Max, I ride my bike to parks and lots of other places. I walk and bike everywhere, I play basketball with my brother and I find that enough exercise. … Sport should be about having fun, not who is the best at this and that.

In her *Moving in My World* visual diary, Jo chose to display city spaces in her neighbourhood (Figures 21 and 22), books displayed on the bed in her bedroom

Figure 21. Walking to school and home everyday.

Figure 22. 'I hate public transport; they destroy the planet'.

(Figure 24) and a friend's bike (Figure 23) to symbolise her emplaced body-self. She engaged with physical culture by constructing her body as a 'walking body' and a 'biking body' that enjoys moving around the city and is particularly aware of ecological issues. As she explained how she moves through relevant spaces, her body narrative evoked feelings of risk and fear. She described her neighbourhood as follows:

> Pretty dangerous. ... There's a couple of parks [near]by, people smoke [in] them, and I'm not a big fan of smoking and drinking. And I walk a lot, so walking there and there's lots of people I don't like that don't like me, so I don't go there. ... A couple of months ago me and my friend got beat up a lot. My parents are a bit protective and I can't go out much so. ... I would prefer to move somewhere nicer and calm.

Jo pictured public city spaces as relevant to her everyday moving 'bodies', which are also, in her eyes, sites of apprehension, tension and risk. In talking about her experience of her body in motion (Duncan 2007), such public spaces represent contested spaces through which identities are formed and negotiated, sites of inclusion and exclusion of body practices relevant to her physicality. Jo brings to light a gendered dimension of the city (Scraton and Watson 1998) that in and through her emplaced embodiments reveals an ongoing conflictual negotiation of pleasure, risk, enjoyment and fear. For Jo, the pleasure of a biking and walking body co-exists with the risks of encountering violence or harassment on the city street, and under the gaze of parental surveillance and control. While her biking and walking bodies display someone who chooses to be active and enjoys it, her embodied fear and apprehension of public spaces potentially 'serve as a powerful mechanism of self-exclusion from public spaces and places' (Green and Singleton 2006, p. 859).

Jo's embodiment manifested a fluid, conflictual negotiation of discursive practices of the body and the (un)safe places she inhabits in her world. Her *Moving in My World* diary introduces other leisure activity she enjoys: reading and writing (Figure 24). Given her embodied narrative of fear and apprehension about her neighbourhood city space, her room may be a place where she feels safe and protected in her favourite leisure practices. In her research with girls, James found that, away from what they view as potentially unsafe and uncomfortable recreational and sport-related places, 'girls' use of their bedrooms as an alternative recreational space ... is a real choice' (2001, p. 71) where they can 'be themselves' (2001, p. 88). During their teens, girls experience a sense of control over their body in their own room, control of the

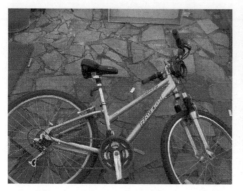

Figure 23. 'I like to ride on my bike'.

Figure 24. Romance novels on Jo's bed in her room.

body they feel they do not have in other physical activity spaces, sport-based, male-dominated spaces or public sites of the city. The bedroom epitomises for Jo, like for other girls in James's study, a 'refuge', a 'private', 'protected' space where she can read and write her 'world'.

Conclusion

This article presents the visual and verbal narratives of a group of girls and boys of different ethnicities engaging in physical culture as recreational and sporting bodies in the 'real' spaces of their everyday lives. While researchers have theoretically challenged the gendered and racialised stereotype of South Asian boys and, especially, girls as passive and inactive (Ismond 2003, Walseth and Fasting 2004), findings emerging from this study provide evidence to disrupt such stereotypes and to show the ways minority youths view physical activity as relevant to who they are and want to become.

Notably, none of the minority girls and boys viewed, constructed or narrated themselves as a 'problem', 'at risk' or 'at a disadvantage' in physical activity contexts. Rather, they created and expressed themselves as 'moving bodies' given their social and economic resources and through the discursive practices that were available to them in their school and community contexts. What clearly emerged from the minority youths' picturing of their body-selves is that the 'risk' does not reside within the body. Rather, the 'risk' lies with the ways youths' embodiment is emplaced; the ways cultural, educational and economic constraints institutionalise and differentiate access to movement within the 'real' spaces they inhabit.

Except for Kate's representation of her sporting body ('Me surfing'), the spatial dimension of girls' recreational bodies was emplaced in single-sex school PE, city spaces (viewed as 'unsafe') or in private homes. Through the eyes of the South Asian girls and Jo, the micro-practices of their bodies emerged as confined within traditional constructions of women-only sites. In the majority of these girls' photographs, their moving bodies are invisible to the public gaze. Sport clubs in the school and community emerged as more significant to boys' physicalities. Except for one, none of the girls included in this article indicated that they belonged to a school or city sport club.

Girls, apart from the two White girls previously mentioned, constructed their body-selves as recreational bodies in 'girl-defined' spaces. Their visual representations of

the body neither pictured a wide range of public, open domains, nor ranged across various recreational, sport and fitness practices. Specialised, highly skilled body actions in the public domain were absent from their visual body-self representation as well. On the other hand, just as popular media culture presents sporting bodies as highly skilled and perfection driven, Kate, Robert and Vijay's diaries featured highly skilled body actions and specialised and proficient movements; they centred themselves in the pictures taken in a wide range of public spaces. Identifying herself as a 'tomboy', Kate explained that she felt comfortable in male sporting domains from an early age, growing up and playing sport with her brother and his male friends. Kate and the boys pictured their sporting bodies as public displays in public spaces.

Given the findings presented in this article, while single-sex PE may increase girls' participation in school physical activity, it is evident that the gendered spatial dimension of the girl's body might (especially for South Asian girls) constrain their view of themselves as moving bodies in public space beyond and outside of school or home. Seeing and constructing moving bodies within the boundaries of single-sex spaces informs the ways girls see themselves and their bodies. Their body views, as learned in school (and at home), might eventually limit their participation in physical activity in public spaces, as confined within single-sex PE or school ground, their embodied self becomes codified by and their physicality sedimented in gender and cultural ethnic norms. What they learn about the body, values, attitudes and practices and their spatial dimension in school is carried on outside of school in the city spaces they inhabit in their everyday lives. Importantly, for many of these young people with an immigrant background, and for Jo, their school site, the space of home or 'safe' places in the city were the only 'real' spaces for them to be and become active, recreational bodies. For many of the girls (and boys) in this study, learning body practices such as surfing in coastal locales is neither a reality nor a possibility.

To open up possibilities for all youths (and especially girls and South Asian girls) to be and become moving bodies more fully, freely and in safer ways, the spatial dimension in and through which the body is constructed needs to be considered. As evidenced in this article, girls' recreational body-selves become constrained or invisible when spaces in their worlds are not constructed as single-sex or are not shielded from the public gaze. We suggest that as long as school physical activity spaces remain gender segregated and city spaces viewed and experienced by girls as public, male spaces (Green and Singleton 2006) or as unsafe, as Jo experienced, many girls' engagement with physical culture will be limited to single-sex PE, enclosed in their rooms, or confined to the backyards. For many girls, and South Asian girls in particular, who with regard to family and cultural background, grow up learning how to shield themselves and become invisible to the male gaze (Strandbu 2005), moving in the world of public domain might become an embodied issue.

The geographies of girls' bodies in school should reflect and connect to the spatialities of youths' bodies in the city as mixed-gender public spaces so that all young people can freely and safely move outside of school in sport/fitness clubs, parks and playgrounds. Because schools are educational 'real' spaces of embodied learning, and taking into account the difficulties in pursuing cultural and institutionalised changes, as Strandbu (2005, p. 42) advocates, pupils should have 'gender-mixed groups from day one – to break with the gender segregate[ed]' upbringings (p. 42). Educational changes regarding gender-mixed physical activity in schools should be accompanied by local, cultural efforts to inform and educate the school and broader communities,

including school staff, students, pupils' families and teacher educators, about the limits of gender-segregated PE in relation to girls' emplaced physicality.

Young people, and especially girls, in urban spaces, such as the one described in this study, could benefit from increased access to public sport, recreational and fitness sites where they have the opportunity to develop their moving bodies through a range of physical activity practices and performances. Moreover, such spatial and institutional changes must challenge the discursive and spatial construction of the public space as a male body domain if they are to invite youths – boys and girls – to fully develop the potential of their physicality and to re-envision the story of their emplaced embodiment. In order to make the school student body more than just 'a community of *theoretical* [emphasis added] equals' (Wells 2008), school communities must create 'real' spaces for youths' moving bodies, spaces that will open up opportunities for young people to learn what it means to move in their worlds freely, safely and fully.

Acknowledgements

The research described in this article was funded by the UK Economic and Social Research Council. I would like to thank the ESRC for its support. I am grateful to all of the young people who participated in this study, and all of the teachers and school staff for their support.

References

Azzarito, L., 2009a. The rise of the corporate curriculum: fatness, fitness, and whiteness. *In:* J. Wright and V. Harwood, eds. *Biopolitics and the 'obesity epidemic': governing bodies.* New York: Routledge, 183–196.

Azzarito, L., 2009b. The panopticon of physical education: pretty, active and ideally white. *Physical education and sport pedagogy*, 14 (1), 19–39.

Azzarito, L. and Ennis, C., 2003. A sense of connection: toward social constructivist physical education. *Sport, education, and society*, 8 (2), 179–198.

Azzarito, L. and Harrison, L. Jr. 2008. 'White men can't jump': race, gender and natural athleticism. *International review for the sociology of sport*, 43 (4), 347–364.

Azzarito, L., and Katzew, A., 2010. Performing identities in physical education: (en)gendering fluid selves. *Research quarterly for exercise & sport*, 81 (1), 25–37.

Azzarito, L. and Solmon, M.A., 2006. A feminist poststructuralist view on student bodies in physical education: sites of compliance, resistance, and transformation. *Journal of teaching in physical education*, 25 (2), 75–98.

Basit, T.N., 1997. 'I want more freedom, but not too much': British Muslim girls and the dynamism of family values. *Gender and education*, 9 (4), 425–439.

Bettis, P.J. and Adams, N.G., 2005. Afterword: girlhood, place, and pedagogy. *In:* P.J. Bettis and N.G. Adams, eds. *Geographies of girlhood: identities in-between.* Mahwah, NJ: Lawrence Erlbaum, 271–280.

Braham, P., 2003. Boys, masculinity and PE. *Sport, education and society*, 8 (1), 57–71.

Carrington, B., Chivers, T., and Williams, T., 1987. Gender, leisure and sport: a case-study of young people of South Asian descent. *Leisure studies*, 6 (3), 265–279.

Clark-Ibanez, M., 2004. Framing the social world with photo-elicitation interviews. *American behavioral scientist*, 47 (12), 1507–1527.

Datta, A., 2008. Spatialising performance: masculinities and femininities in a 'fragmented' field. *Gender, place and culture*, 15 (2), 189–204.

De Knop, P., *et al.,* 1996. Implications of Islam on Muslim girls' sport participation in Western Europe. *Sport, education and society*, 1 (2), 147–164.

Dolby, N. and Rizvi, F., eds., 2008. *Youth moves: identities and education in global perspective.* New York: Routledge.

Duncan, M.C., 2007. Bodies in motion: the sociology of physical activity. *Quest*, 59 (1), 55–66.

Fleming, S., 1995. *'Home and away': sport and South Asian male youth.* Aldershot: Avebury.

Gauntlett, D. and Holzwarth, P., 2006. Creative and visual methods for exploring identities. *Visual studies*, 21 (1), 82–91.

Gorely, T., *et al.,* 2004. Muscularity, the habitus and the social construction of gender. Toward a gender relevant physical education. *British journal of sociology of education*, 24, 429–448.

Green, E. and Singleton, C., 2006. Risky bodies at leisure: young women negotiating space and place. *Sociology*, 40 (5), 853–871.

Hargreaves, J. and Vertinsky, P., eds., 2007. *Physical culture, power, and the body.* London: Routledge.

Harper, D., 2002. Talking about pictures: a case for photo elicitation. *Visual studies*, 17 (1), 13–26.

Ismond, P., 2003. *Black and Asian athletes in British sports and society: a sporting chance?* Basingstoke: Palgrave Macmillan.

James, K., 2001. 'I just gotta have my own space!': the bedroom as a leisure site for adolescent girls. *Journal of leisure research*, 33 (1), 71–90.

Kehily, M.J., ed., 2007. *Understanding youth: perspectives, identities and practices.* London: Sage.

Kirk, D., 1999. Physical culture, physical education and relational analysis. *Sport, education and society*, 4 (1), 63–73.

Longhurst, R., 1995. The body and geography. *Gender, place and culture*, 2 (1), 97–105.

Loy, J., 1991. Introduction – Missing in action: the case of the absent body. *Quest*, 43 (2), 119–122.

Nash, C., 1996. Reclaiming vision: looking at landscape and the body. *Gender, place and culture*, 3 (2), 149–169.

Oliver, K.L., Hamzeh, M., and McCaughtry, N., 2009. Girly girls can play games/las ninas pueden jugar tambien: co-creating a curriculum of possibilities with fifth-grade girls. *Journal of teaching in physical education*, 28 (1), 90–110.

Patton, M.Q., 1990. *Qualitative evaluation and research methods.* Newbury Park, CA: Sage.

Rose, G., 2007. *Visual methodologies: an introduction to the interpretation of visual methods.* London: Sage.

Scraton, S. and Watson, B., 1998. Gendered cities: women and public leisure space in the 'postmodern city'. *Leisure studies*, 17 (2), 123–137.

Shilling, C., 2006. *The body and social theory.* 2nd ed. London: Sage.

Shilling, C., 2008. *Changing bodies: habit, crisis and creativity.* London: Sage.

Sparkes, A. and Smith, B., 2007. Disabled bodies and narrative time: men, sport, and spinal cord injury. *In:* J. Hargreaves and P. Vertinsky, eds. *Physical culture, power, and the body.* London: Routledge, 158–175.

Strandbu, A.S., 2005. Identity, embodied culture and physical exercise: stories from Muslim girls in Oslo with immigrant backgrounds. *Young*, 13 (1), 27–45.

Thomson, P., 2008. Children and young people: voices in visual research. *In:* P. Thomson, ed. *Doing visual research with children and young people.* New York: Routledge, 1–19.

Torres, C.A., 2009. *Education and neoliberal globalization.* New York: Routledge.

Walseth, K., 2006. Sport and belonging. *International review for the sociology of sport*, 41 (3), 447–464.

Walseth, K. and Fasting, K., 2004. Sport as a means of integrating minority women. *Sport in society*, 7 (1), 109–129.

Wells, K., 2008. Diversity without difference: modelling 'the real' in the social aesthetic of a London multicultural school. *Visual studies*, 22 (3), 270–282.

Whitson, D., 1990. Sport and the social construction of masculinity. *In:* M.A. Messner and D.F. Sabo, eds. *Sport men, and the gender order: critical feminist perspectives.* Champaign, IL: Human Kinetics, 19–31.

Wissman, K.K., 2008. 'This is what I see': (re)envisioning photography as a social practice. *In:* M.L. Hill and L. Vasudevan, eds. *Media, learning, and sites of possibility.* New York: Peter Lang, 13–45.

Young, I.M., 2005. *On female body experience: 'throwing like a girl' and other essays.* New York: Oxford University Press.

The influence of *marianismo* beliefs on physical activity of mid-life immigrant Latinas: a Photovoice study

Karen T. D'Alonzo[a] and Manoj Sharma[b]

[a]College of Nursing, Rutgers, The State University of New Jersey, Newark, NJ, USA; [b]Health Promotion and Education, University of Cincinnati, Cincinnati, OH, USA

Readers should also refer to the journal's website at http://www.informaworld.com/rqrs and check volume 2, issue 2 to view the visual material in colour.

Various explanations have been proposed to explain the low levels of physical activity among Latinas. Included is the construct *marianismo*, which describes the influence of cultural beliefs on gender role identity, including prioritisation of familial responsibilities over self-care. The purpose of the study was to explore the influence of *marianismo* beliefs on participation in habitual and incidental physical activity among middle-aged immigrant Hispanic women, using a community-based participatory research approach and Photovoice methodology. Eight immigrant Hispanic women were given digital cameras and asked to photograph typical daily routines, including household activities, family/childcare and occupational responsibilities. Subjects then met to discuss their impressions. Data were analysed using Spradley's Developmental Research Sequence. Results revealed that a combination of *marianismo* beliefs and socioeconomic pressures appeared to negatively influence women's ability to participate in physical activity.

Physical activity is widely recognised as an important health promotion behaviour for women. However, it is well documented that women of all ages report less physical activity than men and that married women with children are less likely to report participation in regular exercise (Verhoef and Love 1994). This lack of physical activity appears to be more profound among Hispanic women (Latinas), even when compared to other minority groups (Evenson *et al.* 2002, National Center for Health Statistics 2007) and exists regardless of socioeconomic status (Crespo *et al.* 2000). Furthermore, the levels of both habitual (planned) and incidental (accrued over the course of daily activities) physical activity among Hispanic immigrant women decrease dramatically following their arrival in the USA (Juniu 2000, Himmelgreen *et al.* 2003).

Sedentary habits among Hispanic women place them at significantly higher risk for the development of over 20 chronic illnesses, including hypertension, Type 2 diabetes mellitus and cardiovascular disease (Booth *et al.* 2002). This is of particular importance for mid-life women, since the rate of coronary artery disease is two to three times higher among postmenopausal women than among those who are premenopausal (American Heart Association 2008). Since rates of cardiovascular disease among Latinos have been found to increase with the length of time spent living in the

USA (Koya and Egede 2007), it is imperative that the need for cardio-protective measures (e.g., regular physical activity) be emphasised among mid-life immigrant Hispanic women.

Various hypotheses have been advanced to explain the lack of physical activity among Hispanic women. Latinas are often socialised into placing family needs above their own throughout their lives. This construct, referred to as *marianismo* (Stevens 1973, Comas-Diaz 1988, Gil and Vasquez 1996), may contribute to the feelings of depression and low self-efficacy for physical activity among immigrant Latinas (Alvarez 1993). Few studies have examined the belief systems of Hispanic women with regard to exercise and physical activity. Furthermore, no reported studies have explored the relationship of cultural norms, gender-based role beliefs and socioeconomic pressures on immigrant Hispanic women to influence participation in incidental and habitual physical activity. Thus, little is known about how to encourage such health-promoting lifestyle behaviours among mid-life immigrant Latinas.

The purpose of the study was to explore the influence of *marianismo* beliefs on participation in habitual and incidental physical activity among middle-aged immigrant Hispanic women and to identify the participants' common views of the place that physical activity has in a woman's life. The study was an example of community-based participatory research (CBPR) using Photovoice methodology. Photovoice is a qualitative research method that utilises photography, reflection, writing and discussion to understand an essential phenomenon (Wang 2005). The specific aims of this Photovoice study were to: (1) explore, within the Latina community, the interplay of gender role identity and culture and how this affects participation in physical activity; (2) discover and legitimise the participant's 'popular knowledge' as a source of expertise; (3) promote participants' critical dialogue and knowledge about physical activity through group discussion of photographs; and (4) mobilise formal and informal community leaders to help implement changes recommended by the women.

Background

Physical activity among Latinas

Gender, ethnicity, culture and race are all determinants of physical activity (Sallis and Owen 1998). Physical activity can be broken down into two types: 'incidental' (lifestyle) and 'habitual' (planned) (U.S. Department of Health and Human Services 1996). Compared to men, women typically spend a larger percentage of their time engaged in incidental forms of activity (e.g., household, family care and occupational pursuits) than in habitual, leisure-time or fitness activities (Ainsworth 2000). Participation in vigorous physical activity among females in the USA peaks around the ninth-grade and declines thereafter. This decline is steeper in Hispanic women as compared to Black and non-Hispanic White women (Centers for Disease Control and Prevention [CDC] 2003). Such racial and ethnic differences in levels of moderate to vigorous physical activity are apparent between Hispanic and White non-Hispanic females as early as eight years of age (Grunbaum *et al.* 2004). These disparities suggest that culture-specific beliefs and 'popular' attitudes about exercise may influence participation in physical activity among Hispanic females. In an ethnographic study of Black and Latina college students, D'Alonzo and Fischetti (2008) reported that Hispanic women were: (1) less likely than Black women to have role models for healthy physical activity, (2) more likely to feel that familial responsibilities were a

major barrier to participation in physical activity, and (3) more likely to believe that some types of vigorous physical activity were not suited for women. These beliefs were strongest among first generation Hispanic-American women. Since Latinas are often less likely to participate in habitual physical activity, it has been suggested that assessments of incidental physical activity acquired through informal, home-centred activities may provide important information, not found elsewhere, regarding Latina behavioural patterns (Floyd 1998).

Marianismo

The term *marianismo* was first coined by Stevens (1973) and has been identified as the female counterpart of *machismo*. The ideal Latina (*marianista*) places family needs above her own and adheres to traditional Hispanic values, including male supremacy, female self-sacrifice (*sacrificio*) (Cofresí 2002) and deferment of plea-sure, in imitation of the Blessed Virgin (Comas-Diaz 1988, Gil and Vasquez 1996). In Hispanic culture, the family is conceptualised as the nuclear and extended families, as well as friends, neighbours and communities (Falicov 1996). *Marianismo* beliefs have been shown to negatively impact health promotion behaviours among Hispanic women (Cianelli *et al.* 2008). Latinas with strong *marianismo* beliefs are likely to perceive physical activity as a selfish indulgence rather than a health-promoting life-style behaviour for women. Attempts to maintain *marianismo* and other traditional values while acculturating into mainstream American society often result in cultural conflict, which in turn can lead to depression and low self-efficacy for exercise. Rather than mandate that these women follow American cultural norms and adopt a more autonomous, individualistic perspective to self-care, healthcare providers need to assist Latinas to problem-solve culturally appropriate ways to achieve a satisfying balance between responsibilities towards others (*marianismo*) and participation in healthy self-care activities such as physical activity.

This study focused on middle-aged women for two reasons. First, peri-menopausal and menopausal women are at greater risk for the development of coronary heart disease than their younger counterparts (American Heart Association 2008) and being sedentary is an independent risk factor for atherosclerotic heart disease in women (Eaton *et al.* 1995). Second, since their children are likely to be older, mid-life women may be less affected by the impact of *marianismo* with regard to direct childcare responsibilities and thus may have more time available to engage in leisure-time phys-ical activity.

Constraints on leisure-time activity

Leisure research, particularly leisure constraints research, offers one promising framework for examining the barriers to participation in physical activity by immi-grant women. Leisure constraints are said to 'limit the formation of leisure prefer-ences and inhibit or prohibit participation and enjoyment in leisure' (Jackson 1991, p. 279). In their Hierarchical Model of Leisure Constraints, Crawford *et al.* (1991) identified three major types of constraints to leisure activity, including intraper-sonal, interpersonal and structural. Intrapersonal constraints are defined as psycho-logical factors internal to the individual, interpersonal constraints arise from interaction with others, while structural constraints include factors relating to the external environment. Empirical data from studies using the constraints framework

suggest that women do face more constraints on their leisure time than men (Jackson and Henderson 1995), largely because of paid and unpaid work, caregiving responsibilities and household duties. These activities may collectively contribute to a prioritisation of family needs and may cause women to suffer from a lack of a sense of entitlement to leisure activity (Bedini and Guinan 1996). Likewise, Green and Hebron (1988) have reported that some women are less likely to participate in leisure activities which are deemed socially inappropriate, particularly by their husbands.

An emerging area of study is a consideration of the ways in which constraints to leisure may be similar or different across cultures. Several researchers (Stodolska 1998, Chick and Dong 2003, Walker *et al.* 2007) have observed that culture appears to be a type of constraint that is not easily subsumed by interpersonal, intrapersonal or structural categories and that these constraints may in fact be subordinate to culture. Immigrant groups in particular have numerous constraints to participation in leisure activity that are not generally found among majority populations, including inadequate language skills, social isolation/separation from family and friends and lack of familiarity with the environment (Stodolska 1998, Stodolska and Yi-Kook 2005). Many immigrants report little leisure time, as they are focused on attaining economic stability, creating a secure future for their children and sending remittances home to relatives. It is apparent that differences in leisure styles result from variations in norms and values among ethnic and racial groups, including those cultural beliefs relating to the role of immigrant women, such as *marianismo*. Therefore, a comprehensive understanding of the influence of cultural beliefs on Hispanic immigrant women's participation in physical activity requires an examination of the context of cultural identity as it relates to leisure activity (Arab-Moghaddam *et al.* 2007). At present, there are no published studies which examine the interplay of cultural norms, gender-based role beliefs and socioeconomic pressures on immigrant Hispanic women to influence participation in incidental and habitual physical activity.

Research design and methods

Community-based participatory research (CBPR)

CBPR models call for a collaborative approach between the researcher and the community with the aim of combining knowledge and action for social change to improve community health and eliminate health disparities (Minkler and Wallerstein 2003). One such approach is Paulo Freire's empowerment model, based upon his work in adult literacy in Brazil (Wallerstein and Bernstein 1988). Freire posited that the purpose of education is human liberation, where individuals become the subjects of their own learning. Freire referred to this as the 'learner as subject' approach (Freire 1973). The learning process (depicted in Figure 1) is characterised by structured dialogue, wherein everyone involved participates as a co-learner. Freire's approach, sometimes referred to as 'popular' or 'empowerment' education, has become the basis for community-based health promotion programmes for oppressed populations throughout Latin America, Asia and Africa and, to a lesser extent, the USA. Freirian methods seek to optimise empowerment of individuals and communities to move beyond feelings of powerlessness, assume control of their lives and promulgate the formation of a partnership between the investigator and participants

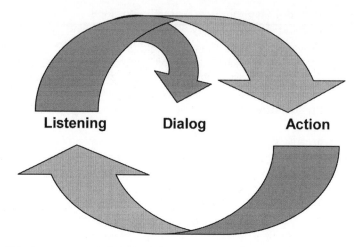

Figure 1. Frierian structured dialog model. Adapted from Wallerstein and Sanchez-Merki (1994).

(Freire 1970). Freire's empowerment framework appears to hold much promise to assist low-income individuals and communities to become empowered to adopt health promotion behaviours.

Photovoice

As a philosophical approach to research, CBPR does not dictate a specific data collection or analysis method. However, the use of a qualitative methodology, i.e., Photovoice (Wang and Redwood-Jones 2001, Wang 2005), can facilitate a better understanding of the cognitive elements surrounding the adoption of health promotion behaviours such as physical activity. This is particularly true with regard to complex cultural values such as *marianismo*. Photovoice emphasises the importance of participants speaking about their experiences and analysing the connections between situations and solutions using photography (Wang and Redwood-Jones 2001) Wang, who developed this method, outlined the process as follows: (1) conceptualise the problem, (2) define goals and objectives, (3) conduct Photovoice training, (4) take photographs, (5) facilitate group discussion, (6) encourage critical reflection and dialogue, and (7) document the stories.

Since Photovoice integrates Paulo Friere's approach to critical education and CBPR, it is ideally suited to this type of investigation. The use of Photovoice in healthcare research can be viewed as an attempt to empower participants to help disrupt and ultimately reject unhealthy behaviours that are influenced by gender, class, ethnic and other types of oppression. In this respect, Photovoice can be seen as a type of empowerment intervention. Photovoice has been used successfully in several studies among Hispanic immigrant populations (Gallo 2002, Keller *et al.* 2007).

Setting

Photovoice participants met in the Salvation Army centre of a suburban community in central New Jersey, USA, where almost 40% of the town's inhabitants are first and second generation Hispanic-American. The Salvation Army provides numerous

community services for the immigrant population from Central America in this area and serves as a neighbourhood meeting centre for Latinos. Refreshments were served during the two sessions.

Sample

The purposive sample consisted of eight females, ages 35–55 years old, who self-identified as first-generation Hispanic or Latina. The subjects, who were members of a women's ministry group, were invited to meet at the Salvation Army centre for a *charla* (informal social gathering) and Photovoice group orientation by a key informant at the Salvation Army. The subjects were purposefully selected (Creswell 2009) by the key informants because they were considered 'typical' of the immigrant women in the congregation and had voiced an interest in improving their health. Wang and Pies (2004) have noted that 8–12 subjects are the ideal size for a Photovoice project. Six of the eight subjects were from Costa Rica, one was from Puerto Rico and the other was born in El Salvador. Seven of the eight women spoke only Spanish, while one was bi-lingual. Length of residence in the USA for the women in the group ranged from 2 months to 35 years. Immigration status was not assessed. All of the women were employed outside the home as cleaners, housekeepers, factory or childcare workers, and most worked a number of part-time jobs for an hourly wage. Seven of the eight women were married and all had children or grandchildren living with them in the USA.

Data collection

The study was conducted based on the process identified by Wang and Pies (2004). A preliminary two-hour session was held in Spanish to introduce the research question ('How do cultural beliefs influence participation in physical activity among Hispanic immigrant women?') and to familiarise the women with the goals and methods of Photovoice. The investigator and research team described the method and use of the camera and its application to physical activity, using principles of popular education advocated by Freire (1973). Ethical issues associated with the use of Photovoice, including what and who to photograph and measures to minimise invasion of privacy, were also discussed. Following the presentation, the women were given the opportunity to ask questions and discuss the use of the camera. The subjects were required to complete three consent forms for the study. In addition to the conventional informed consent, subjects completed a consent form to have their photograph taken, and another to permit their photographs to be used only for research purposes. Subjects were given multiple copies of the last two forms, in the event they wished to photograph other women engaged in physical activity.

Following informed consent, the women were given a digital camera and asked to photograph: (1) a typical day's activities, including household tasks, family/childcare and occupational responsibilities; (2) examples of both habitual and incidental physical activity accrued throughout the day, including walking to work, to a neighbour's home or grocery store; and (3) examples of other Latinas participating in such activities. Participants had one week to take the pictures and then return the memory card to the investigator. Two sets of photographs were developed, enlarged and printed, one set for the investigator and one for the participants. Utilising what Freire referred to as 'culture circles' (Freire 1970), the women met for a second time and were asked

to select one or two photos they felt were most significant in terms of describing a typical day and in illustrating physical activity.

A copy of the question guide for the study is included in Table 1. A few broad, open-ended questions were scripted to encourage participation from the women and focus on the emic perspective. Additional questions flowed from the responses of the informants, as noted in Table 2. Discussions were audio-taped and later transcribed by a bi-lingual transcriptionist. Two tape recorders were used in the event of equipment malfunction. The culture circle discussion session lasted approximately 2–2.5 hours. Each woman was given the camera to keep as compensation for her participation in the study.

Data analysis

Spradley's Developmental Research Sequence (DRS) was used to guide data collection and analysis of the Photovoice transcripts (Spradley 1979). The DRS is based upon ethnosemantic analysis; the researcher learns about the reality of an individual's experience through a study of the meaning behind the spoken word (Frake 1962), informants share details of their experiences, while the researcher identifies common beliefs and values that emerge from the data. Spradley (1979) asserted that cultural knowledge can be elicited through a systematic process, which can be organised in a structured manner. Spradley's DRS was selected for this study because of its systematic and rigorous approach to data collection and analysis, and strong emphasis on the emic perspective. Like Photovoice, this aspect was felt to be especially important when working with a population (immigrant Latinas) that is seldom heard from. The tandem use of two qualitative methods (Photovoice and the DRS) created an integrated package, upon which to build a framework to better understand the life experiences of immigrant Latinas. Triangulation of the findings was ensured by the use of multiple data collection strategies, including interview transcripts, participant photographs, field notes and participant demographic information. Because of the DRS's emphasis on semantics and the fact that the discussions were conducted in Spanish, the Principal Investigator (PI) and transcriptionist paid particular attention to the translation/back translation process when transcribing and analysing the data.

The steps in Spradley's DRS as well as how they were utilised in the study are summarised in Table 2. In this study, words that related to daily activities, including household tasks, family/childcare, occupational responsibilities, and forms of habitual and incidental physical activity suggested by the informants formed the basic semantic relationship used for domain analysis. A taxonomic analysis refined the meaning of each term included within a domain by determining a set of categories that described the attitudes associated with each category. Cultural themes that reflected the participants' views of the place physical activity has in a woman's life were then determined (Spradley 1979).

Table 1. Interview guide.

1. Which photographs have you selected?
2. What is it about these photographs that are important to you?
3. What do these photographs tell us about: yourself, your family, your everyday life?
4. What do these photographs tell us about the meaning of physical activity in your life?

Table 2. Spradley's Developmental Research Sequence (DRS).

Steps	Implementation
1. Locating an informant	• Purposive sampling • Key informants • Good rapport with informants
2. Interviewing an informant	• Naturalistic setting • 'Culture circle' format • Interviews tape-recorded, transcribed, translated and back-translated
3. Making an ethnographic record	• Field notes, tape recordings, transcripts and photographs
4. Asking descriptive questions	• *Grand tour questions* – Which photographs have you selected? What is it about these photographs that are important to you? • *Mini-tour question* – What do these photographs tell us about: yourself, your family, your everyday life? • *Example question* – What kinds of exercise did you used to do? • *Experience question* – How many houses do you typically clean in a day? • *Native language question* – What does the term *marianismo* mean to you?
5. Analysing ethnographic interviews	• Cultural meaning created by the use of symbols, categories
6. Making a domain analysis	• Overall term given to a symbolic category. Includes cover term, included terms and semantic relationships
7. Asking structural questions	• *Help to clarify terms already used or develop new categories* – What kinds of work do you do in a normal day?
8. Making a taxonomic analysis	• *In depth study of the domain; includes cover term and included terms* – 'I am working all these jobs to put my children through college'
9. Asking contrast questions	• *Distinguish between included terms and their subsets* – How did you take care of yourself differently in your own country?
10. Making a componential analysis	• Reduce each term to a plus or minus value
11. Discovering cultural themes	• Focus on values inferred from data

The moderator, co-moderator and recorders met immediately after the culture circle discussion session to debrief and then engage in member checking with study participants. The audio-taped recordings were later transcribed into English and back-translated into Spanish by a paid transcriptionist and the results were reviewed by the research team and informants. Transcripts were checked for accuracy against original tapes and field notes to verify consistency. To ensure adequate reliability and identify errors and incomplete data, the authors replayed the audiotapes while reviewing a copy of the transcript. Responses were first hand-coded and then domain, taxonomic, componential and cultural theme analyses were performed. Included terms and themes were developed following member checks with study participants (Creswell 2009). The

research team then recoded the transcripts using computer software (Ethnograph, Version 5.7, Qualis Research). Inter-coder reliability (Weber 1990) was satisfactory and minor coding, category and theme discrepancies between the two versions were discussed and resolved among the members of the research team and study participants. Triangulation of data sources and member checking were used to assure the validity of the findings. In addition, a peer debriefer (Creswell 2009) who was not involved in the study assisted in reviewing the study transcripts and data analysis methods.

Human subjects

Approval from the University Institutional Review Board was obtained before the study was initiated. The study was described and explained to the participants, both in English and in Spanish. Each participant received a copy of the consent form (in English or Spanish, as preferred), which included information regarding confidentiality and the right to refuse to participate or to terminate participation at any time.

Results

All of the eight women who participated in the Photovoice project indicated that their primary motive for residence in the USA was 'to make money for my family'. For all but one of these women, this phrase meant working to save money to help with their children's college education. Six of the women related they had previously not worked outside the home in their native countries. The women indicated that their work was overwhelmingly seen as the biggest obstacle to leisure-time physical activity. Indeed, most of the photographs were taken of the women at work. The domain term, which represents the main idea addressed within the study, was 'Trabajando todo el tiempo' – 'Working all the time'. This term was best represented by a Costa Rican woman in her photo and caption (see Figure 2).

Although all of the women were familiar with the term '*marianismo*', they initially saw *marianismo* beliefs and work as two separate issues. With discussion, one of the informants pointed out that their need to work could be driven by an overriding desire to improve the life of their children. At this point, the other subjects acknowledged the likelihood of a connection between this behaviour and *marianismo*.

Four included terms and three cultural themes were identified from the transcripts. In this section, the terms and themes are described in detail, along with descriptions of the photographs and the participants' quotations.

Included terms

No time for myself

All of the women noted they typically took on as many jobs as they could fit into a day and scheduled the rest of their daily activities around work. Most of the jobs entailed heavy physical work, e.g. scrubbing floors, hanging mirrors and moving furniture. One informant described this as 'the work that no one else wants to do'. The women reported being 'exhausted' by the end of her shift in a factory, which was her 'day job' (see Figure 3).

Since they were still responsible for domestic duties at home, many of the women reported sleeping only three to four hours at night and eating meals on the run at fast-food restaurants and convenience stores. This schedule left little if any time for

Figure 2. 'I have been in this country for six months and I'haven't rested a single day. There is too much stress. God willing, I am leaving on Saturday.'

Figure 3. 'This is my friend. She and I are co-workers and this is our work. In this picture, I was taking a break from so much work and work and barely had time for anything else.'

healthy self-care practices such as leisure-time physical activity. One respondent, faced with acknowledging her hectic lifestyle for the first time after viewing her photograph, verbalised her frustration with this arrangement (see Figure 4):

Living the life

The participants admitted that they envied other women who were able to arrange their time to engage in health-related behaviours, e.g. exercise. Free from work responsibilities outside the home and surrounded by the support of extended family members, several of the women reported having been more physically active in their home country. Only one woman, who worked as a caregiver for small children, currently had a schedule that allowed her to exercise in the morning before work and she walked frequently with the baby in a stroller. She was also the oldest member of the group and no longer had her own children living with her at home. She referred to her relative independence as 'living the life'.

Work comes first

All of the subjects noted the economic necessity to put work ahead of everything else. Two of the women recalled going to work while ill because 'they had no choice but to keep the job'. Most worked six days/week, taking only Sunday off to attend church

Figure 4. 'I saw that all those pictures were taken of me working. I realised that I don't have time for myself. I only have time to work.'

Figure 5. 'My pastor took this photograph of me while I was reading the Bible. Sunday is my only day off and reading the Bible is my only form of relaxation.'

services. One of the women selected a photograph in which she was smiling, the only such photograph taken of any of the women. When questioned about it, she explained her Pastor took the photograph of her as she was reading the Bible, which was her only form of relaxation (see Figure 5).

Staying healthy

All eight of the women acknowledged that their lifestyles were unhealthy. Two of the photographs were taken while the women were preparing dinner, late at night. All were aware of the need to eat healthier foods, get sufficient rest and engage in some type of aerobic activity. Several were concerned that as they became older, they would not be able to maintain their health with this type of schedule. Three of the women related stories about female friends who were now suffering from severe health problems that should have been addressed in the earlier stages. One woman reflected:

> This is why we need to go to the doctor when we don't feel well. We should not say, 'I need to go and clean a house.'

One woman acknowledged the influence of *marianismo* beliefs in the manner in which she handled illness in the family, both here and in her native country:

> This issue we are discussing, 'marianismo', is seen in our countries a lot. If a child gets sick, then we run to the hospital with him … but if I get sick, I just deal with it.

Figure 6. 'We are in such a hurry to clean the houses that we don't feel hunger, we don't even feel the time. When you look at the clock, it's already getting dark.'

Another woman admitted she rarely eats on a regular basis, saying (see Figure 6): Eventually, one woman summed up the feelings of the group when she said:

We know this is no good for us. We are killing ourselves.

Cultural themes

Leisure time?

It became apparent through the photographs and discussion that the women in the group had little or no leisure time in which to engage in physical activity. Leisure time was seen as a luxury they could not afford. Many lost track of the hours in the day,

going to work and coming home in the dark. Two of the women who still had high school aged children commented that after they returned from work, they still had to make dinner for their families and help with homework late into the night. One of these women commented that her only 'free time' was 2 a.m. in the morning. She selected a photograph that her husband took while she was watching television late at night (see Figure 7).

Living in America

For the most part, the women believed that working long hours to save money and 'get ahead' was part of the American lifestyle. They commented that the owners of the homes where they worked also had long workdays and that 'everyone here seems to be on the run all the time'. One of the women in the group was returning to her home in El Salvador that weekend, as her visa was expiring. In discussing her photograph, where she was scrubbing the floors of a large home, she exclaimed:

> There is too much stress in this country. God willing, I am leaving on Saturday.

Feeling trapped

All of the women in the study acknowledged high levels of stress and unhappiness with their present lifestyle. This was obvious in their discussions as well as the photographs.

Figure 7. 'Even though I knew I need to sleep, I stayed up watching television because this is "my time." The only time I have to myself is from about 11:30 p.m. to about 2 a.m. After that, I go to bed and then I get up around 5:45 a.m.'

However, giving up this existence meant depriving their families of needed funds, particularly money for college tuition for their children. These women described 'feeling trapped'. What began as a short-term adaptation to contribute to the family income had grown into a long-term strategy that was draining them physically and emotionally.

Discussion

All of the women in the study verbalised that working long hours outside the home was the major obstacle to regular exercise. These findings are consistent with published studies that emphasise the impact of work on the lifestyles of immigrant Hispanic women (Juniu 2000, Easter *et al.* 2007). Ironically, the women in this study were working to contribute to their children's college education, yet neglecting their own physical and emotional needs, which is consistent with the self-sacrificing nature of *marianismo*. In this example, *marianismo* both explains reality and becomes a strategy which women use to deal with reality (Ehlers 1991). The women believe that to be 'good mothers', they must work this hard to meet the needs of their families. At the same time, the reality of economic pressures forces them to make money the only way they know how, by putting together work from a series of low-paying, unskilled jobs. In this environment, the women are often more marketable than their husbands.

Even though the women were clearly prioritising family responsibilities above their own, perhaps the participants did not initially see this as typical *marianista* behaviour because the majority of the women had not been employed outside the home prior to immigrating to the USA. This may represent the '*Nuevo marianismo*', an 'Anglo twist' on the traditional Latino/gender roles, coupled with the influence of socioeconomic pressures, to negatively influence women's ability to engage in self-care activities such as physical activity. Alternatively, it may be argued that terms such as 'machismo' and 'marianismo' may have different meanings to immigrant Hispanic men and women because the expressions have been created by 'outside' researchers and are not part of everyday speech. Kinzer (1973) has noted the tendency for some researchers to cling to the machismo/marianismo model when interpreting data even when there is compelling evidence not to do so. Further research is needed to examine how various groups of immigrant Latinas accommodate work outside the home and balance family responsibilities with their own physical and emotional needs. Margarida Julia (1989) noted Puerto Rican women who seek to challenge and renegotiate their family's expectations while maintaining strong connections within their families are often successful in balancing needs and expectations for self within their relationships with others.

Perhaps an even greater irony in this study is that all of the women were engaged in a series of part-time jobs, which often involved heavy physical labour. This finding is consistent with the previous published research (Ransdell and Wells 1998, Brownson *et al.* 2000), which suggests that Hispanic men and women accrue more physical activity through work and domestic chores than through leisure-time physical activity. Given the fact that work is seen as a survival strategy among immigrant populations, and that jobs requiring hard, physical labour are most often held by poor and minority populations (Ehrenreich 2001), the phrase 'leisure-time physical activity' can be seen to reflect an elitist mindset. Since the majority of public health recommendations for physical activity are based upon the notion of leisure-time physical activity (CDC 2008, American College of Sports Medicine [ACSM] 2009), total physical activity levels of Hispanic women may be substantially higher if work-related physical activity (WRPA)

is included in the calculation. Future studies should assess the contribution of WRPA and household activities among low-income Latinas using more global measures of physical activity (Wareham *et al.* 2002).

An original assumption of the researchers was that middle-aged women, freed from the responsibilities of raising young children, might likely have more free time to engage in physical activity. This assumption was not supported in this study. First, three of the women in their mid-fifties still had teenagers at home, indicating that they bore their last child at age 40 or later. Although data from Latin America are scarce, the childbearing period for women from developing countries appears to be much longer than for those from industrialised nations (Lloyd 1986). Such women tend to have their first child at an early age and their last child at a relatively late age, thereby increasing the period of time they are engaged in childcare activities. Second, as the children became older, the informants in this study were freed up to work more hours outside the home to support the family. Therefore, these middle-aged women had no more leisure time available to them to engage in physical activity than younger women.

The combination of long work hours, poor eating habits, lack of sleep, chronic socioeconomic stress, lack of social support and little, if any, leisure time substantially increases the risk for cardiovascular events in these middle-aged women. Morbidity and mortality rates for cardiovascular disease are generally lower among Hispanic immigrants than among US-born non-Hispanics regardless of socioeconomic status, a phenomenon that has been dubbed 'The Hispanic Paradox' (Markides and Coreil 1986). However, cardiovascular mortality increases rapidly with acculturation. Given the increased prevalence of cardiovascular disease among successive generations of Hispanic immigrants, empowering interventions are sorely needed to address these issues among new immigrants (Sharma 2008).

Data from this study supported many of the findings of studies among immigrant groups in leisure constraints research. Although the socialisation of many Hispanic women to place family needs above their own is closely related to women's feelings of lack of entitlement to leisure (Henderson 1990), it is necessary to examine this behaviour from the perspective of both gender and culture. As Gil and Vasquez (1996) has noted, women who espouse *marianismo* values are highly revered within traditional Latino cultures. There may be great pressure from within the family and community but also from the woman herself to maintain such behaviours upon immigration. Conflicts may occur when a woman attempts to reconcile *marianismo* beliefs with Anglo values such as independence and autonomy. Working too long and hard to find time for leisure activity has been reported in studies among Latin American immigrants (Juniu 2000) as well as other immigrant groups (Tsai and Coleman 1999, Stodolska and Yi-Kook 2005). It has been suggested that immigrants with lesser degrees of assimilation/acculturation may be particularly prone to experience more work-related constraints (Stodolska 1998). Similarly, Comas-Diaz (1988) has observed that *marianismo* beliefs are often strongest in low-acculturated women. The subjects in this study differed greatly in the amount of time they had resided in the USA. Although some studies have reported that levels of leisure-time physical activity among Hispanics appear to increase with acculturation (Crespo *et al.* 2000), this may be less likely if socioeconomic status does not improve. Given the existence of the 'Hispanic paradox' longitudinal studies are needed to explore the long-term effects of acculturation on physical activity and weight gain, particularly among low-income Latinas. A potentially useful framework for encouraging salutogenic behaviours among immigrant

Latinas is what Portes and Rumbaut (2006) refer to as selective acculturation. In this form of biculturalism, families selectively choose what to accept and reject from their home culture as well as from the host culture as needed. Laganá (2003) has observed that this approach can help women to reduce the stress associated with acculturation as well as to foster culturally appropriate health-promoting practices.

The results of this study demonstrate that Photovoice can be an effective strategy to empower individuals to identify the need to change unhealthy lifestyles and make the connection between situations and solutions. The visual impact of the photographs led several of the women to recognise the social influences that affected their lives and to acknowledge the need to make significant personal lifestyle changes. These steps towards individual and group empowerment were most evident in the comment:

> We know this is no good for us. We are killing ourselves.

Empowerment education, as developed from the writings of Paulo Freire (Wallerstein and Bernstein 1988), emphasises that the process should not stop here. The final step in Friere's problem-posing process focuses on the need for participants to take action at the community level. Empowerment strategies identified during the session included: (1) taking higher paying jobs with fewer working hours, (2) support groups for both immigrant men and women, and (3) assistance with childcare and domestic responsibilities, particularly from husbands. Because Hispanic women often seek employment in the domestic sphere, their work is largely 'invisible' to much of the outside world. Although the pay is generally poor, it is usually not difficult for these women to find work. This is in contrast to many of their husbands, who had all experienced periods of unemployment in the USA. Interestingly, although the women discussed the need to improve their work situations, none of them considered returning to school for additional education/training or English language skills, in order to secure a higher paying job, which may have afforded them more leisure time. In their study of leisure-time, household and work-related physical activity among White, Black and Hispanic women, He and Baker (2005) determined that differences in educational attainment accounted for virtually all of the racial and ethnic differences in leisure-time physical activity.

The difficulty of maintaining such chaotic lifestyles in mid-life became obvious when, a month after the study was completed, four of the eight women returned home to their native countries. This finding was unexpected, as the women's ministry group had been rather stable during the previous two years that the PI had contact with the organisation. Although the precise reasons are not known, it is likely that a combination of socioeconomic pressures and escalating anti-immigrant sentiment within the community caused some of the women to return home. Current immigration patterns are clearly different than those of previous generations (Portes and Rumbaut 2006). Perhaps the women were able to endure much of the stress of immigration because they only saw it as a temporary lifestyle. As one subject reported:

> You can come here, work as many jobs as possible for six months, then go home and have enough money for you and your family for the next five years.

Given the fact that empowerment is a long-term process (Wallerstein and Bernstein 1988), the relatively brief period of engagement was a major limitation of the study. Ideally the study should have continued after the Photovoice dialogue, but lack of resources to follow the women once they had left the USA led to closure of

the study. Future studies should follow up with participants for at least six months after the Photovoice session. Another limitation of the study was that no quantitative method was used to triangulate the findings. A mixed method model would have added greater confidence in the results.

Qualitative methods, such as Photovoice, show great promise to assist researchers to build culturally appropriate practice theory and to design intervention strategies to ameliorate sedentarism and hypokinetic diseases among immigrant Hispanic women. Such approaches must integrate knowledge and action to improve the long-term health of community members.

Acknowledgements

This study was partially funded by a Faculty Research Grant from the College of Nursing, Rutgers, The State University of New Jersey. The authors would also like to thank the Salvation Army Bound Brook Corps for their assistance with this study.

References

ACSM, 2009. *ACSM's guidelines for exercise testing and prescription.* 8th ed. Philadelphia: Lippincott Williams & Wilkins.

Ainsworth, B.E., 2000. Issues in the assessment of physical activity in women. *Research quarterly for exercise and sport*, 71 (Suppl. 2), S37–S42.

Alvarez, R.R., 1993. The family. *In*: N. Kanellos, ed. *The Hispanic American Almanac: a reference work on Hispanics in the United States.* Detroit, MI: Gale Research, 151–173.

American Heart Association, 2008. *The heart truth for women.* Available from: http://www.nhlbi.nih.gov/health/hearttruth/press/nhlbi_04_age_fact.htm [Accessed 30 May 2008].

Arab-Moghaddam, N., Henderson, K.A., and Sheikholeslami, R., 2007. Women's leisure and constraints to participation: Iranian perspectives. *Journal of leisure research*, 39, 109–126.

Bedini, L.A. and Guinan, D.M., 1996. If I could just be selfish: caregivers' perceptions of their entitlement to leisure. *Leisure sciences*, 18, 227–240.

Booth, F.W., *et al.*, 2002. Waging war on physical inactivity: using modern molecular ammunition against an ancient enemy. *Journal of applied physiology*, 93, 3–30.

Brownson, R.C., *et al.*, 2000. Patterns and correlates of physical activity among US women 40 years and older. *American journal of public health*, 90, 264–270.

CDC, 2003. *Youth risk behavior surveillance (YRBS).* Atlanta, GA. U.S. Department of Health and Human Services, CDC.

CDC, 2008. *Behavioral risk factor surveillance system (BRFSS).* Available from: http://www.cdc.gov/brfss/ [Accessed 10 June 2008].

Chick, G. and Dong, E., 2003. Possibility of refining the hierarchical model of leisure constraints through cross-cultural research. *Proceedings of the 2003 Northeastern Recreation Research Symposium* (Gen Tech Rep NE-317). Newtown Square, PA: U.S. Department of Agriculture, Forest Service, Northeastern Research Station.

Cianelli, R., Ferrer, L., and McElmurry, B.J., 2008. HIV prevention and low-income Chilean women: machismo, marianismo and HIV misconceptions. *Culture, health & sexuality*, 10 (3), 297–306.

Cofresí, N.I., 2002. The influence of Marianismo on psychoanalytic work with Latinas: transference and countertransference implications. *Psychoanalytic study of the child*, 57, 435–451.

Comas-Diaz, L., 1988. *Feminist therapy with Hispanic/Latina women: myth or reality?* Binghampton, NY: Hayworth Press.

Crawford, D.W., Jackson, E.L., and Godbey, G.C., 1991. A hierarchical model of leisure constraints. *Leisure Sciences*, 13, 309–320.

Crespo, C.J., *et al.*, 2000. Race/ethnicity, social class and their relation to physical inactivity during leisure time: results from the Third National Health and Nutrition Examination

Survey, 1988–1994. *American journal of preventive medicine*, 18, 46–53.

Creswell, J.W., 2009. *Research design: qualitative, quantitative and mixed-methods approaches*. 3rd ed. Thousand Oaks, CA: Sage.

D'Alonzo, K.T. and Fischetti, N., 2008. Cultural beliefs and attitudes of Black and Hispanic college-age women toward exercise. *Journal of transcultural nursing*, 19 (2), 175–183.

Easter, M., *et al.*, 2007. Una mujer trabaja doble aqui: vignette-based focus groups on stress and work for Latina blue-collar women in Eastern North Carolina. *Health promotion practice*, 8 (1), 48–49.

Eaton, C.B, *et al.*, 1995. Physical activity, physical fitness, and coronary heart disease risk factors. *Medicine and science in sports and exercise*, 27 (3), 340–346.

Ehlers, T.B., 1991. Debunking marianismo: economic vulnerability and survival strategies among Guatemalan wives. *Ethnology*, 30 (1), 1–16.

Ehrenreich, B., 2001. *Nickle and dimed: on (not) getting by in America*. New York: Macmillan.

Evenson, K.R., *et al.*, 2002. Environmental, policy and cultural factors related to physical activity among Latina immigrants. *Women and Health*, 36 (2), 43–57.

Falicov, C.J., 1996. Mexican families. *In*: M. McGoldrick, J. Giordano, and J.K Pearce, eds. *Ethnicity and family therapy*. New York: Guilford Press, 169–182.

Floyd, M.F., 1998. Getting beyond marginality and ethnicity: the challenge for race and ethnic studies in leisure research. *Journal of leisure research*, 30 (1), 3–22.

Frake, C.O., 1962. The ethnographic study of cognitive systems. *In*: L.T. Gladwin and W.C. Sturtevant, eds. *Anthropology and human behavior*. Washington, DC: Anthropological Society of Washington, 72–93.

Freire, P., 1970. *Pedagogy of the oppressed*. New York: Seabury Press.

Freire, P., 1973. *Education for critical consciousness*. New York: Seabury Press.

Gallo, M.L., 2002. Picture this: immigrant workers use photography for communication and change. *Journal of workplace learning*, 14 (2), 49–57.

Gil, R.M. and Vasquez, C.I., 1996. *The Maria paradox*. New York: G.P. Putnam's Sons.

Green, E. and Hebron, S., 1988. Leisure and male partners. *In*: E. Wimbush and M. Talbot, eds. *Relative freedoms: women and leisure*. Milton Keynes: Open University Press, 75–92.

Grunbaum, J., *et al.*, 2004. Youth risk surveillance – United States. *Surveillance summaries: morbidity and mortality weekly report*, 53, 1–100.

He, X.Z. and Baker, D.W., 2005. Differences in leisure-time, household, and work-related physical activity by race, ethnicity, and education. *Journal of general internal medicine*, 20 (3), 259–266.

Henderson, K.A., 1990. The meaning of leisure for women: an integrative review of the research. *Journal of leisure research*, 22, 228–243.

Himmelgreen, D.A., *et al.*, 2003. The longer you stay, the bigger you get: length of time and language use in the U.S. are associated with obesity in Puerto Rican women. *American journal of physical anthropology*, 125 (1), 90–96.

Jackson, E.L., 1991. Special issue introduction: leisure constraints/constrained leisure. *Leisure sciences*, 13, 273–278.

Jackson, E.L. and Henderson, K.A., 1995. Gender-based analysis of leisure constraints. *Leisure sciences*, 17, 31–51.

Juniu, S., 2000. The impact of immigration: leisure experiences in the lives of South American immigrants. *Journal of leisure research*, 32, 358–381.

Keller, C., Fleury, J., and Rivera, A., 2007. Visual methods in the assessment of diet intake in Mexican American women. *Western journal of nursing research*, 29 (6), 758–773.

Kinzer, N.S., 1973. Priests, machos, and babies: or, Latin American women and the Manichaen heresy. *Journal of marriage and the family*, 35 (2), 300–312.

Koya, D.L. and Egede, L.E., 2007. Association between length of residence and cardiovascular disease risk factors among an ethnically diverse group of United States immigrants. *Journal of general internal medicine*, 22 (6), 841–846.

Laganá, K., 2003. Come bien, camina y no se preocupe – eat right, walk, and do not worry: selective biculturism during pregnancy in a Mexican American community. *Journal of transcultural nursing*, 14 (2), 117–124.

Lloyd, C.B., 1986, July. Women's work and fertility, research findings and policy implications from recent United Nations research. Unpublished paper presented at the Rockefeller Foundation's Workshop on Women's Status and Fertility, Mt. Kisco, NY.

Margarida Julia, M.T., 1989. Developmental issues during adulthood: redefining notions of self, care and responsibility among a group of professional Puerto Rican women. *In*: C.T Garcia Coll and M. de Lourdes Mattei, eds. *The psychosocial development of Puerto Rican women.* New York: Praeger, 115–140.

Markides, K. and Coreil, J., 1986. The health of Hispanics in the southwestern United States: an epidemiologic paradox. *Public health reports*, 101 (3), 253–265.

Minkler, M. and Wallerstein, N., 2003. Introduction to community-based participatory research. *In*: M. Minkler and N. Wallerstein, eds. *Community-based participatory research for health.* San Francisco: Jossey-Bass, 3–26.

National Center for Health Statistics, 2007. *Health, United States, 2007 with chartbook on trends in the health of Americans.* Hyattsville, MD: National Center for Health Statistics.

Portes, A. and Rumbaut, R.G., 2006. *Immigrant America: a portrait.* Berkeley: University of California Press.

Ransdell, L.B. and Wells, C.L., 1998. Physical activity in urban white, African-American, and Mexican-American women. *Medicine science in sports and exercise*, 30 (11), 1608–1615.

Sallis, J.F. and Owen, N., 1998. *Physical activity and behavioral medicine.* Thousand Oaks, CA: Sage.

Sharma, M., 2008. Physical activity interventions in Hispanic American girls and women. *Obesity reviews*, 9 (6), 560–571.

Spradley, J.P., 1979. *The ethnographic interview.* New York: Holt, Rinehart and Winston.

Stevens, E.D., 1973. Marianismo: the other face of machismo in Latin America. *In*: A. Decastello, ed. *Female and male in Latin America.* Pittsburgh, PA: University of Pittsburgh Press, 89–102.

Stodolska, M., 1998. Assimilation and leisure constraints: dynamics of constraints on leisure in immigrant populations. *Journal of leisure research*, 30 (4), 521–551.

Stodolska, M. and Yi-Kook, J., 2005. Ethnicity, immigration and constraints. *In*: E.L. Jackson, ed. *Constraints to leisure.* State College, PA: Venture Publishing, 55–73.

Tsai, E.H. and Coleman, D.J., 1999. Leisure constraints of Chinese immigrants: an exploratory study. *Loisir et Sociele/Society and leisure*, 22, 243–264.

U.S. Department of Health and Human Services, 1996. *Physical activity and health: a report of the Surgeon General.* Atlanta, GA: U.S. Department of Health and Human Services, CDC, National Center for Chronic Disease Prevention and Health Promotion.

Verhoef, M.J. and Love, E.J., 1994. Women and exercise participation: the mixed blessing of motherhood. *Health care women international*, 7, 10–16.

Walker, G.J., Jackson, E.L., and Deng, J., 2007. Culture and leisure constraints: a comparison of Canadian and mainland Chinese university students. *Journal of leisure research*, 39 (4), 567–590.

Wallerstein, N. and Bernstein, E., 1988. Empowerment education: Freire's ideas adapted to health education. *Health education and behavior*, 15 (4), 379–394.

Wallerstein, N. and Sanchez-Merki, V., 1994. Freirian praxis in health education: research results from an adolescent prevention program. *Health education research*, 9, 105–118.

Wang, C., 2005. *Photovoice: social change through photography.* Available from: http://www.photovoice.com/index.html [Accessed 16 June 2008].

Wang, C.C. and Pies, C.A., 2004. Family, maternal and child health through Photovoice. *Maternal and child health journal*, 8 (2), 95–100.

Wang, C.C. and Redwood-Jones, Y.A., 2001. Photovoice ethics: perspectives from Flint Photovoice. *Health education and behavior*, 28 (5), 560–572, 645.

Wareham, N.J., *et al.*, 2002. Validity and repeatability of the EPIC-Norfolk physical activity questionnaire. *International journal of epidemiology*, 31, 168–174

Weber, R. P., 1990. *Basic content analysis.* 2nd ed. Newbury Park, CA: Sage.

Renewal, strength and commitment to self and others: older women's reflections of the benefits of exercise using Photovoice

Joanie Sims-Gould[a,b], Laura Hurd Clarke[c], Maureen C. Ashe[a,b], John Naslund[a] and Teresa Liu-Ambrose[a,d]

[a]Centre for Hip Health and Mobility, Vancouver Coastal Health Research Institute, University of British Columbia, Vancouver, BC, Canada; [b]Deparment of Family Practice, University of British Columbia, Vancouver, BC, Canada; [c]School of Human Kinetics, University of British Columbia, Vancouver, BC, Canada; [d]Department of Physical Therapy, University of British Columbia, Vancouver, BC, Canada

Readers should also refer to the journal's website at http://www.informaworld.com/rqrs and check volume 2, issue 2 to view the visual material in colour.

This study used Photovoice to examine how 38 older women (aged 65–75) perceived and visualised their physical health and the benefits of engaging in an exercise programme. Recruited from an exercise programme designed to examine the influence of exercise on executive function (cognition), the women were given disposable cameras and asked to photodocument how they experienced health and physical activity. Over a two-month time period the participants collectively took over 700 photographs and each participated in a face-to-face interview. The photographs and interview transcripts were organised and analysed using a process designed by the researchers based on other Photovoice research. The analysis revealed that the women perceived exercise to be a means of renewing the self, a way to regain physical and social strength and an essential tool that would enable them to maintain their commitments to themselves and to others. We discuss our findings in light of the research and theorising concerning ageism and physical activity in later life.

Introduction

But the one [photo] that I really thought demonstrated my feeling about the [exercise] study I was in is the one I took of the flagpole – because ... the biggest thing plus strength is I can stand straighter. (Woman aged 74 with arthritis and visual impairment)

Despite the well-documented benefits that exercise can have on the health and well-being of older adults (Williams and Lord 1995, Boutcher 2000, Nadasen 2008), older women are among the most sedentary (Lee 1993, Rhodes et al. 1999, Ashe et al. 2008, Wilson and Spink 2009). Levels of physical activity have been shown to decrease with age (Rhodes et al. 1999), and it has been estimated that between 70% and 80% of older women exercise less than the recommended amount for maintaining good health (Koltyn 2001).

Psychological variables shown to negatively impact the adoption of exercise among older women include: the perception that other health-related behaviours, such as healthy diet and adequate rest, are more important than exercise (Lee 1993); the belief that physical activity is risky and has the potential to do them harm (O'Brien Cousins 2000, Wilcox *et al.* 2005); and the misconception that exercise must be strenuous and painful to be beneficial (Lee 1993). Other factors include feelings of vulnerability in exercise settings (O'Brien Cousins 2000), the inability to perceive any personal relevance from exercise regimes (Lee 1993), and unrealistic optimism about avoiding illness (Lee 1993).

Research has also shown that societal attitudes contribute to the over-representation of older women in the more sedentary groups of the population (Lee 1993). Societal influences include: the attitudes of physicians towards older women's exercise; the over-representation of men in leisure activities; and the role of the media in trivialising women's participation in sport (Lee 1993). It has also been suggested that older women have developed poor exercise habits because they have traditionally been discouraged from participation in physical activity and, consequently, have been provided with fewer physical activity opportunities and experiences over the life course (Vertinsky 1991, 1995, Vertinsky and O'Brien 1991, 1995, Eyler *et al.* 1997, Rhodes *et al.* 1999). Older adults' experiences of and attitudes towards physical activity are further influenced by ageist cultural norms, which suggest that later life is inevitably a time of frailty, senility and decay (Bytheway 1995), that older adults are set in their ways and unable to learn new things (Palmore 1999, Nelson 2002), and that sport and rigorous exercise are the purview of the young (Phoenix and Sparkes 2007).

Additional barriers that have been shown to deter women from participating in exercise include: having children (Lee 1993), greater domestic responsibilities (Lee 1993), lack of time (Lee 1993, Eyler *et al.* 1997), lack of experience, knowledge and confidence (O'Brien Cousins 2000, Newson and Kemps 2007, Rimmer *et al.* 2008), pressure of work, family commitments, inconvenience of exercise locations, lack of transportation (Rimmer *et al.* 2008) and insufficient access to financial resources (Lee 1993, Eyler *et al.* 1997, DiPietro 2001). Many older adults further report not being able to engage in physical activity as a result of their pre-existing health conditions (Booth *et al.* 1997, 2007, Newson and Kemps 2007).

At the same time, socio-cultural theorists have argued that women's experiences of exercise are shaped by societal discourses concerning femininity and the moral imperative to discipline the body (Crawford 1980, Duncan 1994, Markula 2001, Bordo 2003). Women are under strong societal pressure to engage in exercise, among other forms of beauty and body work, in order to achieve an idealised appearance (Markula 2001, Bordo 2003). Rather than alleviating the 'normative discontent' of poor body image (Rodin, Silberstein, and Striegel-Moore 1984), exercising in structured fitness classes and spaces as well as interactions with instructors may lead women to feel more negatively about their bodies (Martin Ginis, Jung, and Gauvin 2003, D'Abundo 2007, 2009).

While there have been studies that have examined various psychological, physiological and societal factors that influence older women's decisions to initiate exercise and to adhere to exercise regimes, few have looked at the perceived benefits from the perspective of the participants. To address this gap, our study is guided by an interpretative theoretical framework, namely symbolic interactionism. Symbolic interactionism suggests that 'the meanings that things have for human beings are central in their own right' (Blumer 1969, p. 3) and that these meanings derive from and form

the basis of social interaction. Thus, human behaviour must be understood from the perspective of individuals who exercise agency as they construct their own realities (Prus 1996, Hewitt 2006). At the same time, we draw on a strengths-based perspective (Saleebey 2006), where the focus is not just to identify 'problems' or deficits but rather to examine individuals' capabilities. In this way, we investigate the perceived benefits of exercise and motivations for adherence to an exercise programme from the perspective of older women. A strengths-based interpretative perspective guides us to ask questions about what is working and, in doing so, has the potential to provide insight into possible strategies for addressing physical inactivity.

Methods and sample

Photovoice is a unique research strategy 'by which people create and discuss photographs as a means of catalyzing personal change' (Wang *et al.* 1998, p. 75). Used to elicit the perspectives of individuals who have not typically had a voice in research (examples of studies using Photovoice include studies of refugee children, homeless adults, rural women and battered women; see Wang, Burris, and Ping 1996, Wang 2003, Moffitt and Vollman 2004, Frohmann 2005, Lopez *et al.* 2005). Photovoice is both a method of research and a tool for social action. Participants are given disposable cameras and asked to photograph, reflect upon, depict and dialogue about their experiences. The resultant photographs provide powerful visual representations of experiences and conceptions, in this case older women's own conceptions of health and physical activity. We chose Photovoice in anticipation that the photographs would act as a catalyst for discussion and promote an understanding of how older women visualise their physical health and the benefits of engaging in an exercise programme ('a picture is worth a thousand words'). The research team felt that this was particularly important in this study as the women had already been 'subjects' in the randomised controlled trial (RCT). Providing the women with an active, collaborative role, it was intended that Photovoice would allow the older women to be in control of the generation of the research material, thereby promoting agency in and ownership of the research process and products.

Sample

The sample for the Photovoice study was drawn from a group of 155 women who participated in a randomised, controlled 52-week prospective study of exercise (NCT00426881) from May 2007 to April 2008 with three measurement periods (baseline, mid-point and trial completion). The primary research aim of this RCT was to investigate the effect of resistance training (RT) on executive function and the secondary aim was to examine the effect of RT on brain function, falls risk and bone health. Study participants were randomised into three exercise groups: (1) once a week RT (1x RT), (2) twice a week RT (2x RT), and (3) balance and tone (BAT) exercise (see Liu-Ambrose *et al.* 2010). This research took place in an urban setting on the west coast of Canada. The exercise classes (RT and BAT) were conducted at a fitness gym. Recruitment for the Photovoice project began in February 2008, pictures were taken in March 2008 and interviews were conducted in April 2008.

During the RCT study, the research team became interested in the women's own perceptions of their physical health and well-being as well as their motivations for coming back week after week. Following a general call for participants to all members of the randomised control trial, 38 women were recruited for the Photovoice study. The

women in the Photovoice sample ranged in age from 65 to 75 with an average age of 70 years. The women were all living independently and had no physical condition(s) for which exercise was contraindicated. The number of chronic conditions reported ranged from zero to five, with the majority of respondents reporting one or two conditions. The most commonly reported conditions were arthritis, osteoporosis and obesity.

While 57% of the participants were born outside of Canada, 53% lived alone and 47% lived with either a spouse or adult child. The women also reported varying degrees of formal education as 5% had less than a high school education, 21% had a high school certificate or diploma, 18% had a trade or professional certificate or diploma, 3% had some university certificate or diploma and 36% had a university degree. During the RCT intake assessment, a satisfaction with life scale was administered. Using a scale ranging from 1(strongly disagree) to 7(strongly agree), participants indicated agreement level with five statements: (1) In most ways my life is close to my ideal. (2) The conditions of my life are excellent. (3) I am satisfied with life. (4) So far I have gotten the important things I want in life. (5) If I could live my life over, I would change almost nothing. The maximum score is 35, minimum is 5. Scores ranged from 7 to 33 with an average of 27 indicating that most of the women in the Photovoice study had relatively high satisfaction with life. The 38 women in the Photovoice study had varying levels of physical activity prior to joining the RCT study, with one-third describing themselves as sedentary and two-thirds as somewhat or moderately active (with the exception of two individuals who considered themselves extremely active).

Data collection

In order to provide participants with some background in the methodology, we arranged for a photography instructor to give a one-hour session on how to use a camera and on photo composition. Following the workshop, the participants were given disposable cameras and were asked to take photographs over a two-week time period that best represented their responses to the following questions: How would you describe/depict your current health and physical status? What are the benefits of participating in an exercise programme like the RCT study? What keeps you coming back each week? Participants were instructed to not to take pictures of any minor children (under 18 years) and to obtain permission (using a signed consent form) for anyone over 18 included in their photos. Collectively, the 38 participants in this study generated a total of 713 photographs depicting their perceptions of physical health and the benefits of engaging in an exercise programme. The number of photos taken by each participant ranged from 5 to 27. In addition to the visual representations (photos), participants also provided us with written descriptions of the relevance and meaning of each photograph. These descriptions varied in length and complexity from long paragraphs to short points or single words. Finally, participants participated in one taped interview where they were asked to choose several of their most preferred photographs and reflect on what the pictures represented and why they were considered one of their favourites and/or provided the best representation of an answer to the research questions. Ranging in length from 10 to 45 minutes (average length of 22 minutes), the interviews were taped and transcribed verbatim.

Data organisation and analysis

To organise and analyse the photographs, logs and transcripts, we used a five-step process which was based on similar processes used by Castleden, Garvin, and

Huu-ay-aht First Nation (2008) and Wang (1999). Steps included: (1) overview of the photos, (2) matching the photos with corresponding descriptions, (3) examining themes and trends across the photo descriptions using NVivo 8.0 software, (4) content analysis of interview transcripts, and (5) confirming themes (member checking) with participants through two photo exhibitions. In the first step, two investigators categorised the visual images captured in each photograph and generated a list of 31 broad categories and six sub-categories. While some photographs fell into only one category, those photographs with multiple images were placed in as many categories as was appropriate. In the second step, we matched the participants' descriptions of their photographs in the photo logs with their visual images. We did this so we could look at the corresponding photographs and descriptions together, broadly familiarising ourselves with the data. In the third step, the researchers examined the descriptions accompanying each of the photographs and generated 37 open codes (Strauss and Corbin 1998), which were subsequently used to code the textual descriptions using NVivo 8.0. The goal of this stage was to create descriptive, multi-dimensional categories, which formed a preliminary framework for analysis (Strauss and Corbin 1998). In the fourth step, the transcripts from the interviews were independently read and re-read by two investigators. In subsequent team meetings, the investigators compared the 37 textual categories from step 3 with the interview data and the analytical categories were condensed into three over-arching explanatory themes, namely strength, renewal and commitment to self and others.

Finally, in step 5, we engaged in 'member checking' (Charmaz 2006) in order to verify and establish the credibility of our findings (Patton 1990). To that end, we held a photo exhibition where the women's favourite photographs and the corresponding textual descriptions were put on display in the front entrance of a local hospital. All of the study participants were invited to attend and during the event the researchers solicited feedback concerning the overarching themes from those who were present. Additionally, the researchers presented the key themes at two separate research events for the study participants and invited them to discuss and verify the key themes.

Results

The data that emerged from this Photovoice study were richly nuanced and revealed the complex meanings that the women attributed to ageing, physical activity and health. In the sections that follow, we elucidate each of the three over-arching themes, namely renewal, strength and commitment to self and others.

Renewal

Nearly three quarters of the participants' visual and textual images reflected their sense of renewal. Renewal was both captured and discussed in three interconnected ways – as a rebirth of one's physical self, a recognition that one could re-define or re-conceptualise themselves (from inactive to active), and a renewal of one's interest and ability in participating in physical activity.

To begin, many of the women used images of budding flowers, new leaves on trees and bulbs shooting up from the ground to describe how they experienced their participation in physical activity to have resulted in the regeneration of the physical selves (please see Photograph 1). Participants collectively took over 150 photographs of this nature.

Photograph 1. Renewal.

When asked about the benefits of physical activity and her thoughts about health, a 72-year-old woman who had osteoporosis said that for her a budding tree best captured her feelings about physical activity and growing older. She felt that she was blossoming and in the process nurturing her soul (spiritual self) and physical health:

> The tree that had those particular blossoms was so beautiful. It's a young tree and so it doesn't have as many branches or blossoms as, you know, it will as it grows older. But they're the deepest pink I've ever seen. And I don't know. Spring, and all the blossoms and the beauty around us, just does so much to nurture my soul and restore me to health.

For others, renewal was a recognition that one could re-create or re-define oneself, where some of the women had defined themselves as 'couch potatoes' they could now see themselves as physically active. The women spoke about how their involvement in exercise helped them to recognise their physical and social potential. In this way, they spoke about renewal as a realisation that they could be physically active and that they could experience benefits like feeling more active, sleeping better and looking better. Visual images ranged from pictures of pieces of exercise equipment, to feet standing on a scale (showing weight loss) to photographs of travel brochures of hiking destinations. Having taken a photograph of a dancer with a caption about feeling good and looking good, a 76-year-old woman who had arthritis, osteoporosis, heart disease and a degenerative disk had this to say:

> The sign that said 'feeling good, looking good' … that sort of captured, for me, not that I ever think that I would be able to dance like that. But just the whole idea of feeling better and looking good would, I guess, maybe in words, capitalise how I feel.

Photograph 2. Renewal.

Renewal was also defined as a reiteration of still being 'in the game' – having the ability and willingness to participate in social and physical activities. At least half of the participants had experienced some type of disability or loss of function that they felt that they regained (or a new one) through participation in physical activity. A 69-year-old participant with no known chronic conditions stated, 'You know something, I was starting to have some bladder incontinence happening so I couldn't run anymore. I can now run.' By participating in strength training exercises, this participant had regained some of her bladder control, a previous impediment to exercise, with the concomitant result that she now had the confidence and ability to start running again.

Similarly, Photograph 2 metaphorically depicts the notion of 'still being in the game' or still being able to do those social and physical activities that are personally meaningful, including things like walking and shopping. When asked to explain her photo, a 71-year-old woman who had no known chronic conditions stated:

> And so this one I took at the curling rink … to demonstrate that – it's not quite perfect but – you're still trying to achieve goals and even if you're not totally on the bull's eye … it still all counts … the purpose of that is that you can't be discouraged because it's not perfect. But just keep doing the best you can and then … you're still in the game, kind of thing.

Strength

In the context of the photographs and the text, strength consisted of two aspects, namely balance and the ability to be strong and feel confident in one's physical abilities. Half of the women spoke about balance as being central to their ability to move in their every-day activities. They discussed how their involvement in physical activity helped them to gain and maintain balance, which in turn gave them a feeling of strength. Entitled 'strength and balance', Photograph 3 is an example of one participant's representation

Photograph 3. Strength and balance.

of strength. For this woman, the artistic balancing of rocks found in the inuksuk was a metaphor for how she felt that physical activity had enabled her to become physically strong and stable.

Balance was not just considered the ability to be stable on one's feet but also balance in terms of other indicators of physical balance, including stable blood sugar, mood, heart rhythms and weight, which were frequently cited as ongoing and often debilitating health concerns. A 72-year-old woman who had diabetes, depression and a history of stroke asserted:

> And I don't know this might sound weird but there's a couple [of pictures] that have to do with my battle with diabetes. And I guess the one that I like the best of that is the one that has attitudes in it. It has my monitor – because I discovered that on the days that I do the exercise, when I come home if I take my – if I did take my glucose reading before dinner it was always down. And so I know that that bit of extra exercise is really helpful. The other part of that is that – and I guess the reason I took the pill bottles and everything is that it is a reality of my life. And it is one that, you know, like all diabetics I have a tendency to deny.

Suggested that physical activity resulted in improved balance of various physiological rhythms, the participants emphasised repeatedly that strength was not how much weight you could lift (brute strength), but rather how 'steady' you could be.

Participants identified physical strength and personal confidence as additional benefits of engaging in physical activity. Feeling confident in one's physical strength

was also related to balance as one-third of the women spoke about their fear of falling and fear of stairs. A 69-year-old woman who had no known conditions and who considered herself a 'faller', captured a picture of cats sitting on a set of steps. When asked to discuss her photo and how it reflected her feelings about the benefits of physical activity she stated:

> Cats demonstrate wonderful balance. So … the kitties were there and I had thought of taking photos of steps. But what does that mean … travelling up and down stairs more safely type thing [because of engagement in physical activity]. And the cats, I think, are very well-balanced critters so they simply were there, munching on little bits of stuff on the steps.

Similarly, a 67-year-old woman who had arthritis, obesity and osteoporosis, and who had had multiple hip replacements stated:

> I took the picture of the stairs because I've had a couple of hip replacements and I know how hard it was to go up and down. And so the stairs said to me that it was a symbol of my freedom 'cause I can now go up and down stairs [after engaging in a physical activity programme]. And the exercises have helped my physical mobility to be able to do that.

Although most of the women discussed strength as benefit of exercise and as essential to instilling confidence, several of the participants discussed 'just not knowing about the future'. When responding to questions about how they would describe their physical health, they stressed how you could look well and feel strong but have something 'sinister lurking'. For example, a 67-year-old woman with gastro-intestinal problems and hearing impairment took a photograph of a large bolded black question mark and explained her picture stating:

> As far as I know I feel good but who knows what's lurking inside our bodies. It's my mammogram soon. I'm not at all worried but you never know, right?

Commitment to self and others

Commitment to self and to others was a central theme in the pictures and the interviews. Commitment was conceptualised in two ways, a commitment to self and others (relationships) as well as in being committed (obligated) or feeling an obligation to attend classes.

Two thirds of participants discussed the importance of making and keeping a commitment to oneself and to others. Many of the participants spoke about taking the time for physical activity and the long-term benefits of doing so. They described commitment as committing to a relationship with themselves, their well-being and with others. A 70-year-old woman who had no known conditions emphasised the importance of committing to herself through exercise as she stated:

> I picked this one because I liked the contrasts between the flowers that are out in bloom, the trees that have no leaves yet and then the evergreens behind. And I think that altogether the pictures of nature, they sort of reinforce our feelings about the continuity of life and as you get older you want to enjoy life and I think exercising is a very important part of that.

Commitment to others was captured in many of the photographs, the discussion logs and interviews. Emphasising the importance of ongoing relationships, many of the

Photograph 4. Commitment to self and others.

women spoke about grandchildren and great grandchildren, their role as caregivers (for grandchildren and spouses) and their commitment to their roles as friends, mothers, sisters and wives. Photograph 4 is an example of one participant's commitment to playing with her grandchildren.

Participants also spoke about commitment in terms of obligation. According to participants, one of the benefits of engaging in this particular physical activity programme was that it required them to make that commitment (in part because they were also signing on to a research study). For many, having the commitment to others (instructors and classmates) gave them the extra push to attend. For others, making a commitment to oneself to feel better, to look better by fitting into ones clothes or to regain balance and mobility was experienced as a commitment to their future. A 71-year-old woman with arthritis, visual and hearing impairment and a degenerative disk asserted the following:

> I committed myself to it for a couple of different reasons and one of them was that really I knew that if I committed myself to it I would have to go which I did and got over my fear or dislike of gyms. And I will join the [name of gym] and continue, you know, to do something with these machines and so forth by myself. So in that sense it really is a pattern change.

Although commitment was cast as predominantly a positive thing, there were several participants who spoke about barriers to commitment. One participant aptly described how her low-income status was a barrier to commitment. She simply did not have the financial resources to pay for a class, get to a gym or buy appropriate footwear. However, in the same breath, her poverty was also a motivating factor to engage in exercise. She explained that she could simply not afford to lose her apartment, which was situated in a three storey walk up building. She noted that with osteoporosis she was at risk for an injurious fall and she had to 'keep up her balance' so as not to injure herself. In her interview, she captured the dichotomy of being committed while simultaneously struggling to honour that commitment. Another participant spoke of her longstanding battle with depression. In response to questions about the

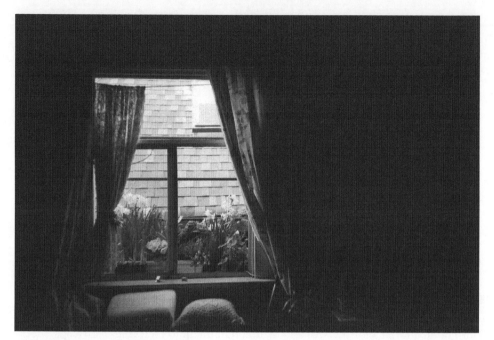

Photograph 5. Beyond the darkness.

benefits of physical activity, this participant described her photograph in detail (Photograph 5). She explained for her – it was like being a dark room looking out at a patch of flowers. She knew that there was beauty and fulfilment beyond the dark room, but sometimes it was really difficult to get there. Similarly, the woman suggested that while she knew that physical activity would ultimately benefit her in a myriad of ways, she had a hard time 'getting out'.

Discussion and conclusions

> There's visual strength in the softness of the flowers. And it's – and I likened it to being developed through core strength and development. So, you know, you're as strong as that but you're not a weight-lifting kind of woman. (Woman aged 75 with arthritis and chronic obstructive pulmonary disease)

Previous research on older women's exercise has examined various psychological, physiological and societal factors that influence older women's decisions to initiate exercise and to adhere to exercise regimes. Our work extends this research, drawing on a strengths-based perspective (Saleebey 2006), by focusing on the benefits of exercise from the perspective of 38 older women. Based on an analysis of our visual and textual data, we identified three key themes reflecting the benefits of exercise: renewal, strength and commitment to self and others.

Renewal was discussed in three interconnected ways: a rebirth of one's physical self, a recognition that one could re-define or re-conceptualise themselves (from inactive to active) and a renewal of one's interest and ability in participating in physical activity. By engaging in physical activity, the majority of women experienced some form of personal growth or empowerment through renewal. Participants felt

164

physically better; in many cases, they felt they looked better and others experienced a renewal of interest in being physically active (or confidence in their ability to do so). The theme of renewal underscores older women's ability to recreate and redefine themselves into old age. Some of the women had never exercised prior to becoming involved in the randomised control trial from which the Photovoice participants were recruited. Moreover, these women had considered themselves to be irreparably sedentary ('couch potatoes') and incapable of participating in exercise. In a society that often locks us into a binary category (i.e. active, not active; old, young; thin, fat), the theme of renewal defies binary and ageist assumptions. Our findings show that women of any age (and any ability) can change, grow and experience renewal and construct and attribute new meanings to ageing, physical activity and later life. Our research also suggests that providing women with positive exercise experiences can help them to transcend ageist categorisations of later life to the benefit of their well-being, self-esteem and perceived social power. However, it must be noted that not all of the women in our study shared the same idea of health or had the same goals with respect to physical activity. For some participants, it was about being able to regain or resume previous favourite activities; for others it was about maintaining social connections and for many it was about ensuring that they could meet their own basic needs over time. These differences in personal definitions of health must be considered when designing physical activity programmes.

While many of the participants discussed a sense of renewal, we did wonder if the women felt they *needed* to report a positive change. Researchers Gilleard and Higgs (2002)[4] and Tulle (2008) assert that ageing bodies have been constructed as posing a challenge to agency and identity. Additionally, current health promotion ideologies promote exercise as a form of medicine and suggest that failure to engage in physical activity is indicative of moral bankruptcy. Given these dominant discourses, being involved in an RCT trial, or an exercise programme in general, suggests that the women would (or should) be looking for some type of positive physical change and would experience their increased or newly found physical activity to be constructive and personally rewarding. The discourse on positive ageing certainly suggests that if we exercise, we will feel better and even 'feel' younger (Katz 2001), which is equated with health and increased social currency. It follows then that the women would feel they *needed* (or were expected) to report change or positive results. For us, this is where the personal definitions of health and wellness were so important in understanding the women's perceptions. Within their photographs and interviews, the women certainly expressed that exercise was a benefit with both health and appearance dividends, and maybe even helped address some age-related physical issues, but they also stressed the development or 'renewal' of new meanings of self. Renewal was not just about the positive physical results or changes but also new meanings about self-esteem, relationships and priorities in life.

The theme of strength consisted of two aspects – balance and the ability to feel or be strong with confidence in one's physical abilities. Participants captured and spoke about improved balance as a benefit of engagement in physical activity. Participants also emphasised feeling strong and having physical strength in particular going up and down stairs. These conceptions of strength are in contrast to the usual conception of strength as 'being strong' in a brute strength way (or in an emotional sense). The quotation at the beginning of this section aptly captures the participant's sentiments, where strength is balance and the ability to be strong, but 'not in a weight lifting' kind of way. This is an important distinction and a useful consideration for programmatic

design; women want strength through balance and confidence in one's own abilities. It must also be stressed that while women can feel strong they may still have underlying concerns about their health. In several instances, the women noted the limitations of exercise. These women highlighted that while physical activity could help alleviate some symptoms of chronic illness, the illness itself still persisted. There was a simultaneous acknowledgement of the false dichotomy between having an illness and being well. It was possible for the women to have an illness, yet experience an isolated aspect of strength. Strength was not an all or none experience. In order to meet older women's health goals, these underlying concerns must also be acknowledged.

Commitment to self and to others was a central theme in the pictures and the interviews. Commitment was conceptualised in two ways: a commitment to self and others (relationships) and in being committed (obligated). Many of the women talked about having the time or making the time 'now'. Where their lives had been busy with careers, child raising, caring for a spouse or simply just taking care of day-to-day life, the participants discussed at length about committing to either themselves or to themselves by making an obligation to others. Making time for exercise was clearly a component of making a commitment to oneself. The exercise became a mechanism for the women to assert a time and space for self. Most of the participants recognised or were aware of the benefits of exercise prior to signing up for this programme but had not allowed themselves to commit, until now. Based on our findings, this particular age group of 65–75 years is a unique decade for most women. In some cases there is new found time (post-retirement or family commitments), for others there is a new found commitment to improving self (even for those with caregiving responsibilities to grandchildren, spouses, etc.). Given these factors, it would suggest that this particular age group (post 65 years) is a good age to target for exercise programmes and exercise-related interventions. However, it must also be noted that while commitment was a central theme, several participants discussed barriers to commitment and participation. These barriers, poverty and depression impeded the participants' ability to exercise despite an acknowledgement of the health benefits of exercise.

By utilising a strengths-based perspective and focusing on the benefits of engaging in physical activity, we gain insight into what is appealing about physical activity from the perspective of older women. We also learn about what keeps them coming back to exercise week after week and highlight some of the barriers. We begin to understand how women weave exercise into their personal meanings of self and how this can influence their individual roles and relationships. We did not find that the strengths-based perspective obscured the negative or critical voices in our study, but rather by establishing a benefits focused discourse the women were inclined to clearly articulate what did not work for them (in contrast to what did work or the benefits).

Photovoice was an appropriate methodology to employ, with philosophical underpinnings in community development and individual emancipation (Wang and Burris 1994, Wang *et al.* 1998). Indeed, the participants in this study were able to express themselves both visually and textually using the photos as a metaphor for their feelings about ageing, physical activity and their physical self. It provided the women an opportunity to become involved in the research process at a time in their life where they are actively negotiating and renegotiating their personal meanings of health, independence, well-being and self. By publicly displaying the photos, we were also able to create our own health promotion campaign that simultaneously served to demystify, if not disintegrate, deeply entrenched assumptions about later life. Individuals walking through the hospital lobby could 'see' the benefits of engaging in exercise from the

perspective of these 38 older women who ranged in mobility (many had mobility aids), size, ethnicity, age, etc. The photographs served as evidence that older women can be physically active in ways that are normally associated with younger individuals. Furthermore, the photographs depicted older women enjoying rather than simply physically benefitting from exercise activities. While we did not evaluate the impact of this photo display, future research in this area could involve an evaluation of the impact of these types of photo displays. One older woman passing by stopped to share her reflections on the photo display and commented:

> It made me think about how to keep all of us healthy, right, in a governmental or some programme way, to encourage all at our age, right … it [is] going to make us less diseased … more independent or less costly to the government.

While, Photovoice was both an exciting and appropriate methodology for this study, the research team did note that we had 'chosen' a particularly beautiful time of year on the west coast of Canada to conduct our study. As such many of the photos were of flowers, flowering trees, budding plants, etc. The particular season we chose to conduct the research may have influenced the prominence of the theme of renewal. Seasonality and weather in this type of study should be considered as a possible influence on data. Future studies in this area employing this methodology may want to try conducting the research at a different time of year.

A limitation of our study was that we did not collect information on social class of the participants. We did have postal code data from the RCT and know that the participants lived in moderate- to high-income areas. Future studies would benefit from making the links between social class and the experience of health, exercise and older women's conceptions of their physical self.

Since the meanings that we attribute to behaviour are constructed through and form the basis of interaction (Blumer 1969), understanding how older women perceive and experience physical activity gives us tremendous insights into their motivations for exercise. This in turn has implications for programme design, government health and wellness agendas and exercise intervention studies. We also gain insight into these women's conceptions of their physical selves and their ability to continue to grow, change and improve into old age.

Acknowledgements

The researchers gratefully acknowledge financial assistance for this project from British Columbia Network on Aging Research (BCNAR), The Women's Health Research Network (WHRN), The Vancouver Foundation (BC Medical Services Foundation, Operating Grant to Teresa Liu-Ambrose) and the Michael Smith Foundation for Health Research (Establishment Grant to Teresa Liu-Ambrose).

References

Ashe, M.C., *et al.*, 2008. Older adults, chronic disease and leisure-time physical activity. *Gerontology*, 55 (1), 64–72.

Blumer, H., 1969. *Symbolic interactionism: perspective and method*. Englewood Cliffs, NJ: Prentice-Hall.

Booth, M.L., *et al.*, 1997. Physical activity preferences, preferred sources of assistance, and perceived barriers to increased activity among physically inactive Australians. *Preventive medicine*, 26 (1), 131–137.

Booth, M.L., *et al.*, 2000. Social-cognitive and perceived environment influences associated with physical activity in older Australians. *Preventive medicine*, 31 (1), 15–22.

Bordo, S., 2003. *Unbearable weight: feminism, western culture, and the body*. 10th anniv. ed. Berkley: University of California Press.

Boutcher, S., 2000. Cognitive performance, fitness and aging. *In*: S. Biddle, K. Fox, and S. Boutcher, eds. *Physical activity and psychological well-being*. London: Routledge, 118–129.

Bytheway, B., 1995. *Ageism*. Buckingham: Open University Press.

Castleden, H., Garvin, T., and Huu-ay-aht First Nation, 2008. Modifying photovoice for community-based participatory Indigenous research. *Social science & medicine*, 66, 1393–1405.

Charmaz, K., 2006. *Constructing grounded theory: a practical guide through qualitative analysis*. London: Sage.

Crawford, R., 1980. Healthism and the medicalization of everyday life. *International journal of health services*, 10 (3), 365–388.

D'Abundo, M.L., 2007. How 'healthful' are aerobics classes? Exploring the health and well-ness messages in aerobics classes for women. *Health care for women international*, 28 (1), 21–46.

D'Abundo, M.L., 2009. Issues of health, appearance, and physical activity in aerobic classes for women. *Sport, education, and society*, 14 (3), 301–319.

DiPietro, L., 2001. Physical activity in aging: changes in patterns and their relationship to health and function. Special Issue II, *Journals of gerontology: SERIES A*, 56A, 13–22.

Duncan, M.C., 1994. The politics of women's body images and practices: Foucault, the panopticon and shape magazine. *Journal of sport and social issues*, 18 (1), 48–65.

Eyler, A.A., *et al.*, 1997. Physical activity and women in the United States: an overview of health benefits, prevalence, and intervention opportunities. *Women & health*, 26 (3), 27–49.

Frohmann, L., 2005. The framing safety project: photographs and narratives by battered women. *Violence against women*, 11, 1396–1419.

Gilleard, C. and Higgs, P., 2002. The third age: class, cohort or generation? *Ageing & Society*, 22 (3), 369–382.

Hewitt, J.P., 2006. *Self and society: a symbolic interactionist social psychology*. 10th ed. Toronto: Allyn & Bacon.

Katz, S., 2001. Growing older without aging? Positive aging, anti-ageism, and anti-aging. *Generations*, 25 (4), 27–32.

Koltyn, K.F., 2001. The association between physical activity and quality of life in older women. *Women's health issues*, 11 (6), 471–480.

Lee, C., 1993. Factors related to the adoption of exercise among older women. *Journal of behavioral medicine*, 16 (3), 323–334.

Liu-Ambrose, T., *et al.*, 2010. Resistance Training and Executive Functions: a 12-month randomised controlled trial. *Archives of Internal Medicine*, 170 (2), 170–178.

Lopez, E., *et al.*, 2005. Photovoice as a community-based participatory research method: a case study with African American breast cancer survivors in rural eastern North Carolina. *In*: B. Israel, et al., eds. *Methods in community-based participatory research for health*. San Francisco: Jossey-Bass, 326–348.

Markula, P., 2001. Firm but shapely, fit but sexy, strong but thin: the postmodern aerobicizing female bodies. *In*: A. Yiannakis and M.J. Melnick, eds. *Contemporary issues in sociology of sport*. Champaign, IL: Human Kinetics, 237–258.

Martin Ginis, K.A., Jung, M.E., and Gauvin, L., 2003. To see or not to see: effects of exercis-ing in mirrored environments on sedentary women's feeling states and self-efficacy. *Health psychology*, 22 (4), 354–361.

Moffitt, P. and Vollman, R., 2004. Photovoice: picturing the health of Aboriginal women in a remote northern community. *Canadian journal of nursing research*, 36 (4), 189–201.

Nadasen, K., 2008. Life without line dancing and other activities would be too dreadful to imagine: an increase in social activity for older women. *Journal of women and aging*, 20 (3/4), 329–342.

Nelson, T.D., ed., 2002. *Ageism: stereotyping and prejudice against older persons*. Cambridge, MA: MIT Press.

Newson, R.S., and Kemp, E.B., 2007. Factors that promote and prevent exercise engagement

in older adults. *Journal of aging and health*, 19 (3), 470–481.

O'Brien Cousins, S., 2000. 'My heart couldn't take it': older women's beliefs about exercise benefits and risks. *Journals of gerontology series B: psychological sciences and social sciences*, 55 (5), P283–P294.

Palmore, E.B., 1999. *Ageism: negative and positive.* 2nd ed. New York: Springer.

Patton, M.Q., 1990. *Qualitative evaluation and research methods.* 2nd ed. Newbury Park, CA: Sage.

Phoenix, P. and Sparkes, A., 2007. Sporting bodies, ageing, narrative mapping and young team athletes: an analysis of possible selves. *Sport, education, and society*, 12 (1), 1–17.

Prus, R., 1996. *Symbolic interaction and ethnographic research.* New York: State of New York Press.

Rhodes, R.E., *et al.*, 1999. Factors associated with exercise adherence among older adults: an individual perspective. *Sports medicine*, 28 (6), 397–411.

Rimmer, J.H., Wang, E., and Smith, D., 2008. Barriers associated with exercise and community access for individuals with stroke. *Journal of rehabilitation research & development*, 45 (2), 315–322.

Rodin, J., Silberstein, L., and Striegel-Moore, R., 1984. Women and weight: a normative discontent. *Nebraska symposium on motivation*, 32, 267–307.

Saleebey, D., 2006. *The strengths perspective in social work practice.* 4th ed. New York: Allyn & Bacon.

Strauss, A.L. and Corbin, J.M., 1998. *Basics of qualitative research: techniques and procedures for developing grounded theory.* Thousand Oaks, CA: Sage.

Tulle, E., 2008. The ageing body and the ontology of ageing: athletic competence in later life. *Body & society*, 14 (3), 1–19.

Vertinsky, P., 1991. Old age, gender and physical activity: the biomedicalization of aging. *Journal of sport history*, 18 (2), 64–80.

Vertinsky, P., 1995. Stereotypes of aging women and exercise: an historical perspective. *Journal of aging and physical activity*, 3 (3), 223–238.

Vertinsky, P. and O'Brien, S., 1991. Unfit survivors: exercise as a resource for aging women. *The gerontologist*, 31 (2), 347–357.

Vertinsky, P. and O'Brien, S., 1995. Recapturing the physical activity experiences of the old: a study of three women. *Journal of aging and physical activity*, 3 (2), 146–162.

Wang, C., 1999. Photovoice: a participatory action research strategy applied to women's health. *Journal of women's health*, 8, 185–192.

Wang, C., 2003. Using photovoice as a participatory assessment and issue selection tool: a case study with the homeless in Ann Arbor. *In*: M. Minkler and N. Wallerstein, eds. *Community based participatory research for health.* San Francisco: Jossey-Bass, 179–196.

Wang, C. and Burris, M., 1994. Empowerment through photonovella: portraits of participation. *Health education quarterly*, 21 (2), 171–186.

Wang, C., Burris, M., and Ping, X., 1996. Chinese village women as visual anthropologists: a participatory approach to reaching policy makers. *Social science & medicine*, 42, 1391–1400.

Wang, C., *et al.*, 1998. Photovoice as a participatory health promotion strategy. *Health promotion international*, 13 (1), 75–86.

Wilcox, S., *et al.*, 2005. A qualitative study of exercise in older African American and white women in rural South Carolina: perceptions, barriers, and motivations. *Journal of women and aging*, 17 (1/2), 37–53.

Williams, P. and Lord, S.R., 1995. Predictors of adherence to a structured exercise program for older women. *Psychology and aging*, 10 (4), 617–624.

Wilson, K.S. and Spink, K.S., 2009. Social influence and physical activity in older females: does activity preference matter? *Psychology of sport and exercise*, 10 (4), 481–488.

Shooting a diary, not just a hoop: using video diaries to explore the embodied everyday contexts of a university basketball team

Jim Cherrington and Beccy Watson

Carnegie Faculty of Sport and Education, Leeds Metropolitan University, Leeds, UK

Readers should also refer to the journal's website at http://www.informaworld.com/rqrs and check volume 2, issue 2 to view the accompanying video clips. This will appear as 'Supplementary Content' to this article.

This paper examines video diaries as creative, visual methods and considers their value as a complementary and innovative method in qualitative, social science based, research on sport. Data are presented from a university basketball team and live links to video diaries are incorporated to contextualise and illustrate three key themes of the everyday, identity and the body. Evidence suggests that the players embody varying levels of 'visual capital' that inform their understanding and 'production' of these visual, ethnographic representations. Video diaries are assessed as a potential response to a crisis of representation facing researchers, demonstrating how this form of narrative data, in the context of visual methodology, is an interesting development for qualitative research in sport.

Introduction

In this paper, we examine video diaries[1] as creative, visual methods and in so doing, highlight a number of ways in which they can inform sociological analyses of everyday life, identity and the body for members of a university basketball team. The focus of our discussion is engagement with the process of generating data from video diaries and consideration of their value as a complementary and innovative method in qualitative, social science based, research on sport. The paper incorporates live links to visual data alongside textual accounts to both contextualise and illustrate our assessment of their usefulness as an innovative method for researching sport. We assess video diaries in the context of 'visual methodology' (Rose 2003, Pink 2007a, 2007b), provide an account of the video diary process and use video evidence to illustrate how the diaries are an innovative method that can contribute to theoretical debates on sociological analyses of the everyday, identity and the body. A final discussion section summarises the contributions that video diaries can make and outlines some challenges that the method poses.

Social science research more broadly and ethnography in particular, have seen increased questioning of 'reality' and the possibility of research ever capturing 'true' representations of social life (Gubrium and Holstein 1997). As social science theories (of sport) get ever more complex so the challenges for qualitative research to

gather meaningful empirical data also increase. Concerns surrounding a 'crisis of representation' may be assuaged via engagement with new and emerging qualitative methodologies and is reflected in the paper's focus on the production and use of video diaries in the context of visual methodology.

Denzin (1997) describes a 'crisis of representation', or a 'fourth moment' in academic writing to highlight tensions surrounding language, legitimacy and a (potential) loss of impact in research processes and procedures. Ethnographies are narratively formed (Denzin 1997) and assumptions about 'giving voice' to participants perhaps a naive form of 'ethnographic ventriloquism' (Silk 2005). This is fundamental to a postmodern critique where ethnographic 'truths' are *created* truths, filtered through discursive positioning. As researchers, we often have little choice but to think and write in language, albeit inadequate in capturing embodied, sensuous aspects of living. Thus, Denzin's second feature of crisis, that researchers are writing, rather than representing culture, highlights a problem with the legitimacy of capturing and recording what people are actually saying. Ethnographic texts are created by authors (Clifford 1986), 'our data' merely constructions of other people's constructions of what they are actually up to (Geertz 1973). Denzin's (1997) third aspect therefore problematises a unified and coherent sociology asking what claims researchers can make about understanding (and changing) the social world from relativist positions.

Whilst acknowledging these 'crises' some scholars have turned their focus towards embodied narrative identities (Smith and Sparkes 2002, Sparkes 2004, Sparkes and Smith 2008). Here, it is argued, people live and think in stories (Clandinin and Connelly 2000) and in recounting these stories to others, articulate personal experience and make sense of individual actions (Sparkes and Smith 2002). Simultaneously, these storied lives are inextricably linked to storied bodies (Sparkes 1999, p. 26). For Frank (1995), this means that in constructing narrative identity, we are not only telling stories about our bodies, but out of and through those bodies. Thus, 'the kind of body one has becomes crucial to any story told' (Sparkes and Smith 2008, p. 688). As the discourses within which social identities are narrated proliferate, embodied narratives become more complex. Carr (1997) distinguishes between first and second order narratives, the former being personal, spontaneous stories which allow individuals to make sense of the world around them, often told throughout everyday life and present in varied social interaction situations. Meanwhile, like the narrative offered in this paper, second order narratives are accounts that researchers construct in order to make sense of the social world of their research. These narratives are always 'second hand', interpretations of interpretations (Geertz 1973) and in some respects, resonant of Denzin and others' 'crises'. However, drawing on Markula and Denison's (2005) description of 'research stories', narrative accounts fashioned by researchers as they tell the story of research data and research processes, are not necessarily problematic and can be illustrative, particularly when we look at broader contexts of sport.

Important questions for researchers include how things are said, how bodies tell stories and provide multi-layered accounts that offer rich details beyond transcribed, textual representations of some qualitative research methods. How then, might engagement with visual methodology elaborate qualitative enquiry in sport-related contexts?

Visual methodology

In contemporary mediated culture, it is relevant to consider the ways in which 'visual culture' is increasingly meaningful to researchers and participants. The players in this

study, for example, all members of a university basketball team, are arguably influenced by the genre of 'reality TV' and a steady stream of popular cultural forms in which self-presentation, self-representation, self-reflection and performativity are powerful cultural symbols in highly visible and visualised ways. It makes sense therefore to engage in research that explores visual phenomena and to employ techniques that emerge as a result of new technologies and associated innovative methods of data collection that can be employed. As Pink (2007a, p. 2) reflects:

> During the 1990s, new innovations in visual technology, critical 'postmodern' theoretical approaches to subjectivity, experience, knowledge and representation, a reflexive approach to ethnographic fieldwork methodology and an emphasis on interdisciplinarity invited exciting new possibilities for the use of photographic technologies and images in ethnography.

Unsurprisingly, these methodologies have tended to be harnessed and favoured more by arts and cultural studies scholars and have attracted some 'traditional' ethnographers and anthropologists; they have not always been embraced by sociology (Holliday 2000) and they have certainly featured little in sport-related research to the present. Broadly speaking, visual methodologies have harnessed technical developments that make visual methods more accessible and 'do-able' and cultural developments that reflect visual and mediated imagery's ubiquity in contemporary society. Engaging visual methodology is complementary to qualitative researchers' aims to generate understanding of the complex social world and is part of ongoing endeavours to elicit meaningful data as opposed to privileging certain techniques over others (Gerson and Horowitz 2002).

Visual methodologies have begun to feature in a range of studies with young people, including PE and physical activity (Enright and O'Sullivan 2009). These studies often centre participatory research philosophies that are popular in researching with young people. As Deacon (2006, p. 95) states 'Qualitative researchers are continually searching for research methods that engage their participants in the data collection process', where 'researchers can ask participants to create videos or photo albums that depict their lives or specific events' (p. 103). A combination of visual imagery is often used in education-based research, commonly falling into one of two approaches that Banks (2001) identifies as either pre-published materials or getting participants to generate their own imagery and representations. It is the latter that the video diaries discussed here represent. Visual methodologies embrace narrative approaches in new and dynamic ways (Pink 2007a) and associated methods allow researchers ways to rehearse responses to crises of representation. Video diaries, for example, contribute narrative data that whilst providing illuminating content also say a considerable amount about the performance of narrative and how these are constructed (Elliot 2005, Gibson 2005).

The use of videos in data collection can be described as 'a technology that participates in the negotiation of social relationships and a medium through which ethnographic knowledge is produced' (Pink 2007a, p. 168). As adults over the age of 18 (university students) the players in this study create and give meaning to their video diaries in ways that require a reflexive approach to data collection and analysis (Pink 2007a). In short, a reflexive approach engages with context specific, constructed meanings and contrasts with a realistic, systematic, 'scientific' approach. This is appropriate given the context of complex and interrelated meanings associated with

the everyday, identity and the body that the study was seeking to elicit data on. The diaries generate research data that combine both first and second order narratives; the following section outlines the process of how the video diaries were created and the remainder of the paper highlights the significance of data generated across the topics of the everyday, identity and the body.

Doing video diaries: the 'hows' and 'whats'

The video diaries were part of a six-month long ethnographic study of a university basketball team, chosen because one of the researchers had played with them previously and wanted to 'tell the story' of the team through research (Frank 1995). The diaries of 15 university basketball players provide snapshots of embodied identity in everyday life, offering innovative coverage of storied bodies. Embodied experience and commentary of players 'off the court' capture the mundane aspects of everyday life that contextualise the players 'outside' of the team and beyond the 'spectacular' elements of playing sport. They represent interactions between players and 'the camera' that offer intimate portrayals of participants' sense of self and identity in personalised, private, spatial contexts. This combination of spatial settings in which individuals are visible as bodies and as agents in describing and reflecting their identities was pertinent to the basketball players' diaries. These video diaries are not 'visual facts', they are rich data in the form of *representations* (Pink 2007a her italics), that is, accounts of the players produced by themselves that can be watched as first order narratives and interpreted as research texts, that is, second order narratives. Participants were given guidelines as to the type of content the researcher hoped to elicit, nonetheless there were degrees of flexibility and freedom implicit within these.

Using a digital handheld camcorder, the participants were asked to record a maximum of two recordings a day over a seven day period and then return the recorder to us after that time. Arrangements were made so that once one person had finished recording, they would collect the equipment at the next practice session/game and pass it on to someone else. For ethical reasons, all recordings were removed from the camcorder before passing it on to the next participant. This meant taking a laptop to every practice session and game so the videos could be transferred onto a hard drive, then deleting the remaining footage from the camera. However, it was important that 'production' of the diaries was flexible and in some instances participants had the camcorder for an extra couple of days.

When the video camera was handed to the participants they were given a number of items to take with them including the video camera, power cables, a video camera tripod and all of the associated research documentation. The research documentation contained a guidance sheet, which asked the participants to:

> Talk about your day-to-day experiences of this basketball club both on and off the court. Think about who you are, how you feel, and the different aspects of identity that you bring to the team.

We wanted the recordings to reflect participants' embodied identities in the context of their everyday lives, we also wanted them to feel empowered to tell and produce their own stories. It was hoped that the content of the diaries was participant lead (Gauntlett 1996) and in this regard the above statement was aimed at being practical, prompting aspects of 'identity', 'day-to-day acts' and 'feelings' but did not specify an exact topic

for conversation. The 'research stories' within the diaries were analysed drawing on a 'paradigmatic' form of analysis (Sparkes 1999). This approach entails seeking central themes or typologies told by one or a number of people about a specific topic of interest, in this case their involvement in basketball. Basketball was traced through participants' narratives of everyday life, and 'evidence' sought about identity and the body in this everyday context. The video diaries provided a platform for the development of interview themes at a later stage of the research but are also interesting and informative sources of data in their own right.

Everyday life and the 'basketballesque'

A key starting point for generating video diary material was the recognition that players could actively document their everyday lives themselves. Sport sociology has had few ventures into the study of everyday life and where it has been a research focus, the plethora of connotations that it has for different people has often been ignored (Stone 2007). Felski (2000) alerts us to the 'fuzziness' of the term itself; on the one hand, it has an inevitability, made up of taken-for-granted 'rhythms' (Lefebvre 1992/ 2004) that structure our day-to-day lives, whilst on the other, everyday life seems to be 'everywhere, yet nowhere' (Felski 2000, p. 15). Video diaries allowed us a unique insight into how everyday life was constructed and experienced by the participants, giving us a 'behind the scenes' look at many everyday acts – the 'stuff' of everyday life – which is so often taken for granted. They captured a 'raw' set of first order narratives in that respect. What is interesting methodologically however, is that the paradigmatic analysis approach we employed meant these narratives were consumed fairly rapidly by a developing research story centred upon the key topics of everyday, identity and body.

The video diaries showed us that the players' everyday lives were often mundane and repetitive. Large periods of time were spent washing, eating, sleeping, watching TV, working (paid), going to lectures, speaking to family members on the phone, browsing the internet, doing laundry and travelling, whilst basketball-related activity was sporadic. For example, Dennis provides evidence of this in a diary extract recording in the morning (see video: Dennis' morning). Dennis' quote illustrates the rhythmic nature of the modern world (Lefebvre 1984); those quotidian bodily functions that 'imbue and structure all social and natural phenomena' (Gardiner 2000, p. 239). Dennis made a recording in the morning and every time he made a morning recording he would talk through the same routine. These actions inevitably varied slightly from time to time, but on the whole they had a consistent, predictable pattern that structured his day-to-day life (see video: Dennis' everyday life). This tells us about the (un-)importance of the game of basketball in Dennis' life, because whilst he, like many others, later talks about being a 'basketball nut' he actually spends relatively little time taking part in basketball-related activities. Perhaps this is why many of the players suggested there was only 'so much stuff you can talk about' (Brad) when it came to the university basketball team. Other than the occasional night out, contact with other players outside of practice and competitive games was limited to ephemeral, serendipitous encounters (Maffesoli 1996) such as seeing each other at university, in the library and so on.

The advantage of using video diaries to document these everyday rhythms was that they contained embodied, visual clues as to how the participants felt about their day-to-day lives. For instance, when Dennis is describing going back and forth to his

university workshops, his voice is low and solemn and his movements are long and laboured. As he explains what he has done/is about to do he scratches his head, sighs and tightens his mouth, showing how everyday rhythms are often mundane and ordinary (Lefebvre 1984, Felski 2000, Seigworth 2000). In contrast, when he talks about the spectacular elements of his week (see later example from initiation) his voice is loud, his movements animated and he has a great big smile across his face. These clues are embodied forms of communication, which cannot be completely translated into words (Collins 1981). Video diaries allowed us to capture these tacit forms of communication and use them to understand the (un-)importance of particular everyday activities.

Such quotidian and rhythmic acts were contradicted by reference to spectacular, 'carnivalesque' (Bakhtin 1984) basketball events that players talked about in their diaries. These included team nights out, the beginning of a new season, decisive basketball games and other important social events. One such event was the much anticipated fresher initiation ritual which took place during the second week of the basketball season, and thanks to the embodied, situated (Pink 2007a, Myrvang Brown *et al.* 2008) nature of the video diaries we could sense that the players were looking forward to this (see video: Initiation anticipation). These diary entries not only give us an idea about what the process of initiation entailed, but clearly show the excitement that had built up around the occasion itself.

Again, the benefits of video methods in recording these kinds of emotions *in situ* are hard to capture by other methods (Myrvang Brown *et al.* 2008). In another one of Paul's entries for instance, we were also treated to some of the rudiments of this initiation process:

> Paul turns the camera on. He has just returned after initiation and is very drunk. He is wearing a straw hat, a flower necklace, a white vest and a flowery wrist band. His eyes are red, his words are slurred and his actions are slow and disorientated. After firing obscenities at the researcher (in a jovial way), he talks (or tries to talk) about initiation and how he had 'defeated' the majority of the first years. He finishes (whilst laughing) with some more lurid comments about the researcher and says he is off to drink more with his flat mates.

This is the kind of event that is lucidly captured through video diaries, and an example of the highly visual, embodied nature of this method (Pink 2007a). Had we interviewed Paul or even asked him to put these experiences down in words, he might have given us a quick, convenient and sporadic account of what unfolded that night, which would have been limited by his memory, literacy and temperament (Randall and Phoenix 2009). However, by using video the researchers were able to capture embodied narratives (Sparkes 1999) from this event as it happened, and could appreciate the raw, lived and often 'messy' (Rojek 1999) nature of Paul's day-to-day life.

Much talk during the video diaries also centred on the way in which first year players were treated during this process of initiation:

> Initiation this year was handled quite badly (He is visibly upset about this). There were two players in particular … who were quite violently forcing drinks down the throats of the freshers (looks away from camera and out of the window as if to hide some of his emotions). And all the freshers were throwing up, and some of them quite clearly couldn't handle their drink (Tightens his mouth and screws up his face). They were clearly struggling and were quite ill, and a lot of them had to go home. It just didn't make

it a fun night, not for me anyway. I thought it was dangerous what they were doing and it was all a bit of a joke to them, y'know, selotaping cider to their hands and they've got to drink it before they could go to the loo. I just didn't think that was what basketball was about really. (Player 1, entry1, 1:48)

This player's[2] quote demonstrates how, through the 'lived' and emotive lens of the video diaries, we were able to take part in what Classen (1993) calls 'an anthropology of the senses'. Although we were not 'there' with the participants as they recorded the diaries, the researcher's previous experience of playing on the team enabled us to move alongside the participants' embodied narratives and share a range of 'corporeal experiences' (Pink 2007b, p. 244) that helped us to understand their feelings, thoughts and attitudes. In this case, for example, we could *see* from facial gestures and the tone of his voice that the player was upset by the events that unfolded that night and we could *feel* that he was quite uncomfortable talking about it.

Our use of text instead of video in both of the above examples was deliberate, owing to the many ethical issues that they raised. The fact that Paul was drunk during his recording, for example, questions whether or not he can be held accountable for the content. Although Paul gave consent for the video clip to be shown, this consent was problematic as it is unlikely that he will have truly understood the implications of his video and how it might affect future aspects/representations of his life (Barrett 2004). Similarly, Player 1's account of initiation raises issues of internal confidentiality. If Player 1's video was included in the article, his team mates would have access to personal opinions which were potentially delicate and upsetting. Whilst the participants' voice and appearance could have been altered it would have been difficult, if not impossible to do so without ruining the embodied and subjective nature of the account (Wiles *et al.* 2008).

Through their on-camera performances, we are already beginning to get a glimpse of the players' representations of a range of aspects of identity, for example, Dennis the student, Paul the drinker and Player 1 the caring and sensitive one. Video diary material offers interesting insights to these identities in personal and intimate ways and we now move on to look at these in further detail, exploring how this method captures everyday constructions of identity.

'Life in and out of bounds' – basketball and identity

In most instances, participants described their identities by talking about their role on the team (Weiss 2001), albeit in different ways. For example, Jameer explains his role as the leader (see video: Jameer's role). Following Carless and Douglas (2009, p. 54), Jameer's response exemplifies a 'performance-orientated narrative' in which competition and winning are prioritised, and 'discipline, sacrifice and pain are accepted in pursuit of glory'. This element of identity was also evident in the embodied nature of the response itself, reinforcing the assertion that the players bodies act as both the cause, topic and instrument of any story (Frank 1995). The way Jameer expresses himself both verbally and physically demonstrates his dominant, aggressive character. He has a serious look about him, his language is purposeful and direct and his arms are folded, making his body look big and solid. Therefore, not only did the video diaries allow us to examine Jameer's embodied experiences of the game of basketball, they also allowed us to see how these experiences effected the *manner* in which his story was told. As a research technique, video diaries represent a complex and

interesting interplay between evidence extrapolated to support claims, that is for instance, in our assumptions that bodies are significant in the construction of (sporting) narratives *and* in the telling of these narrative through bodies performed and recorded on film.

In contrast to Jameer, Dennis' storied his role on the basketball team through a 'discovery narrative' (Carless and Douglas 2009), as he locates the game within the broader context of life rather than its overall priority (see video: Dennis' role). Unlike Jameer, his body is open and relaxed and his language reinforces opinions over facts ('I think' as opposed to 'I am'), suggesting he is much more relaxed about 'success'. Dennis' narrative also points to the multiple, varied and often diverse discourses, which inform the participants' narrative identity (Holstein and Gubrium 2000, Lysaker and Lysaker 2002), and in another entry he talks about how important these multiple discourses can be:

> Basketball is quite a big part of my life; I love playing it, I love watching it ... but everything else is the same way ... y'know, I'm an art student, there's my rock music, my hip-hop music and R'n'B music ... that are such different things. (Dennis, entry 5, 4:00)

Whilst basketball is evidently important to Dennis, his identity also appears to be constituted by a multitude of ambivalent and often conflicting leisure interests, which battle for his allegiance (Weeks 1990). This evokes a 'dialogical' model of self (Lysaker and Lysaker 2002) and suggests a 'never-endedness' to identity, in which here, life is seemingly more about choice than security. The video diary data suggest that Dennis is 'trying on' multiple identities and when faced with choice, appears less interested in an 'authentic', solid self than the 'imperative to discard and replace with haste' (Bauman 2007, p. 36). Here again, we can see the interweaving of Dennis' story of himself (his first order narrative) and the evolution of a research story that draws on sociological theorisations of identity. Bauman's (2007) work, for example, alerts us to the consumer-orientated nature of identity, which was continually on show during the recordings. For example, some players recorded in front of a wall of NBA[3] basketball posters, some were wearing sporting apparel and others went as far as giving the audience a detailed run-through of all the material possessions in their room. It is the visual representations in the diaries that conflate what the players say with what we see. Mike was one such person who, upon reading that he needed to describe his identity decided to give a whistle stop tour of his bedroom (see video: Mike's room tour). This is an interesting example as it shows how visual methods can capture substantial amounts of data when located within a domestic environment (Pink 2007a). In just under a minute, we learn about Mike's drinking habits, his music interests, his favourite basketball team, his preferred type of shoe and the kind of clothes he wears in different situations, all of which contribute to his symbolic construction of self and 'home' (DeCerteau 1984).

Considering the generational location of the players, Mike's video says a lot about the (hyper-) representation of identity in a visually mediated culture, as it was evident that he was heavily influenced by 'reality TV' shows such as 'MTV cribs'. Debates about the 'authenticity' of these kind of representations are well rehearsed (Baudrillard 1983, Holliday 2000, Rose 2003), however, we cannot overemphasise the value of video in capturing the performativity of identity in ways that are qualitatively different from other research methods (Holliday 2004). Video shifts the focus away from capturing deep underlying truths, towards the 'imaginative creation of lifeworlds through a

sociology of performances' (Thrift and Dewsbury 2000). They show that how subjects construct identity is not only about available experiences but how we consume products and intertwine their meanings with our everyday identities (Holliday 2000). The visual dimension of the diaries was a great way of glimpsing the configuration of these cultural products as they were mapped on the players bodies (Holliday 2000), and simultaneously woven into narratives of their embodied selves.

Basketballing bodies: dys-ruption, dys-function and empathy

In contemporary society, identity has implications on the way we understand and relate to our bodies (Turner 1984, Featherstone *et al.* 1991, Butler 1993, Shilling 1993, Frank 1995, Sparkes 1996, Smith and Sparkes 2002). This was evident in a conversation, Jameer had with a team mate (see video: Boy done good). From Jameer's account, it is clear that the way he performs in competitive games has a great deal of bearing on his embodied sense of self (Sparkes 1997) and again, the embodied nature of the diary recording (i.e. his folded arms, his muscular body, the serious tone) serves to reinforce this point. In basketball, like most other sports, these performances are judged through a rational view of the world, which accords success with notions of efficiency, precision, productivity and achievement (Franklin 1996). For Pronger (1998), this means that an individual's performance is only deemed 'good' when it legitimises modern virtues of sport, resulting in the contemporary body becoming completely 'functionalised' (Baudrillard 2002, p. 114).

In this respect, the embodied identity of the players is often dependant on achieving a degree of 'alignment' (Carless and Douglas 2009, p. 56) between their own embodied experience and the wider grand narratives in sport. In basketball, for example, players often want to be taller, stronger and more powerful so they can jump higher, run faster and be able to 'hold their own' on the court. This much was evident in a diary entry by Eddie, who talks about his attendance at the gym (see video: Eddie needs muscle mass). Eddie's video shows his desire to be fit, strong and powerful, part of a disciplinary regime in sport (Foucault 1978) that is shaped by an idealised form of athlete (Johns and Johns 2000). Eddie's account is fascinating because of the disparity between his idealised form of self and the body we *see* during the video. We get a fascinating representation as Eddie presents himself to the camera; at the same time we can also *see* that Eddie is not a (stereo-) typical 'big' male athletic build.

The diaries provide an illuminating context for the exploration of the players' everyday body regimes. For example, almost every day he had the video camera, Tashaun took part in physical activity which formed part of his daily routine (see video: Tashaun's body regime). Arguably, these basketball-orientated 'body projects' (Shilling 1993) are synonymous with hegemonic identity projects (Smith and Sparkes 2002, Markula and Pringle 2005) though it is beyond the scope of this paper to address hegemony here. For these players, the 'worked upon' and 'worked out body' is central to their athletic identity and provide distinctive forms of 'identity work' (Collinson and Hockey 2007). Throughout the videos, it was clear that players equated more power, strength and speed with being a better player (and thus person), which is evident when Shaun describes the importance of developing a regular strength and conditioning session (see video: Shaun's strength and cond). As with Eddie's commentary, what is particularly valuable in using visual methods here is exploring embodiment through visual methods and not only through spoken accounts (such as interviews).

Whereas the above video clips illustrate players' perceptions of successful body projects associated with a particular form of 'athletic identity' (Sparkes 1998), such bodily regimes are often disrupted, which evidently compromises players' embodied notions of self (Sparkes and Smith 2008). Unlike the interview or the focus group, video diaries provided a personal and intimate space that allowed them to talk about these (sometimes embarrassing) disruptions in private (Gauntlett 1996). For example, Jameer recorded a diary in the morning after a heavy night of drinking (see video: Jameer gets drunk). Jameer's hangover prevented him from going to the gym and doing anything constructive with his day. Things such as the groan when sitting in the chair and the big dry gulp towards end of the clip give a visceral impression of how bad he might have been feeling that day, enabling us to develop an 'empathetic resonance' with his experience (Spiro *et al.* 1993). This was also the case with Kevin's encounter with illness (see video: Kevin is ill). Whilst Kevin's presentation of self was not as explicit as Jameer's, the scruffy hair, the unshaven face and the exhausted tone in his voice is illustrative of the body under pressure; again, it is the visual method that captures this for researchers.

Kevin's and Jameer's experiences could constitute an example of bodily 'dys-appearance' (Leder 1990). Leder contends that for the majority of our lives the body is absent from perception, caught in a plethora of involvements that all require our full attention. However, when we experience pain or illness, our bodies are thrust back into focus and we are again aware of its materiality. In these instances, the body becomes increasingly present in experience as an 'alien and dysfunctional entity' (Smith and Sparkes 2002, p. 268) and as such, is often a form of biographical disruption (Bury 1982). In the above cases, both Jameer (who wanted to go to the gym) and Kevin (who wanted to go to basketball practice) had to put the construction of their athletic identities on hold whilst they recovered from these short, but disruptive episodes of bodily dys-appearance. The benefit of using the video diaries was that they were 'live' when these disruptions happened and captured them *in situ* (Myrvang Brown *et al.* 2008). The advantage of this is that we could better understand the immediacy and embeddedness of these disruptions, to be faced with the 'raw' first order narratives expressed through these experiences. At the same time, we remain mindful of the extent to which the players, as research participants, were 'producers' of their performances in creating and filming their diaries. We do not claim that the video diaries are necessarily a more 'authentic' representation, they are simply a different and complementary aspect of performativity. This realisation informs our reflexive stance (Pink 2007a), whereby we acknowledge and engage with these issues, as opposed to making claims that we have overcome them.

Discussion

Evidently, video diaries offer exciting alternatives to lifeless and mechanical accounts of everyday life and can contribute to sociology that is 'contextual, kinaesthetic and sensual' (Halford and Knowles 2005, p. 1): a sociology that lives. This visual method arguably minimises the reduction of the immediate subtleties of our participants' lifeworlds, their first order narratives, to words alone (Myrvang Brown *et al.* 2008). They provide opportunities to include visual (and audio) data that deepen our engagement with the social world and encourage a richly textured account (Halford and Knowles 2005, Sparkes 2009). Data incorporated in this paper, detailing the basketball players' everyday lives in their own words and in their private, personal environments

'captured' in the video diaries, builds an embodied resonance with their experiences, across the mundane, rhythmic nature of everyday life through to the painful, often nauseating moments of illness and injury. This is an exciting and relatively new departure for qualitative sport research. Although the recordings do not give direct access to the idiosyncrasies of these sensations, the footage allows a more immediate empathy for their experiences (Myrvang Brown *et al.* 2008) and offers illuminating insights to various aspects of identity, including athletic, student, joker and so on. Undoubtedly, they are a significant and valuable part of the broader ethnography of basketball in the context of the everyday, identity and the body.

The broader ethnography included observation, video diaries and interviews over a six-month period; 13 of the 15 video diarists[4] went on to be involved in semi-structured interviews. Drawing on participatory methods (Fitzgerald 2007, Enright and O'Sullivan 2009, Fitzgerald forthcoming) and engaging a reflexive approach (Pink 2007a), these interviews were informed by reference to participants' video diaries and material presented in them. Thus, video diaries are not only an interesting source of empirical data per se, but offer valuable insights on performative and constitutive narratives, as suggested throughout this paper. We can develop new and further questions on the processes and formations of sporting identities, sporting bodies and their 'lived' representations in everyday life. We also suggest they be considered as complementary to other research methods. These may be visual methods and or other 'traditional' methods that constitute dynamic and innovative research strategies. Exploring and using video diaries within sport contexts also contributes to broader debates about visual culture. For example, exploring how sporty/athletic identities emerge and interact with visual representations and how these are embodied. We assumed that these players were a product and constituent feature of mediated culture and to a large extent they were; yet even across this relatively small sample there was variance in their levels of what we might call 'visual capital'.

For reasons of confidentiality, participants were asked to record their diaries individually and in their home/living environment. Whilst this elicited a generally positive response from the players it was (and is) understandably difficult to gage how participants respond to the camera and how useful and meaningful data will be. It was evident, for example, that the players had different levels of experience and confidence when handling and managing visual materials generally, seen in some of the camera-player relationships. For instance, some of the participants appeared to be talking *through* the camera as if it were a friend/known source of social interaction, whilst some seemed to treat it as a technological piece of machinery and were visibly less comfortable about talking to 'it'. Others still appeared to respond seeing the camera as what Brown *et al.* (2005) describe as a 'meta-researcher' hovering 'inconspicuously over the research scene'. The diversity of these relationships was notable and the difference in 'performances' inevitably affected the way in which the researchers watched and analysed the diaries. We would suggest therefore that future research needs to consider the different ways in which visual culture is embodied and visual capital displayed as a result. This could include, for example, watching diaries with participants and involving them in the analysis and interpretation more directly.

Video diary methods can be potentially inclusive (Pink 2007a) but they can also exclude potential, and already recruited, participants (Rose 2003). There are inevitably various challenges associated with using video diaries that emerge during the research process. One such issue, for example, was the researchers' normative

assumptions about players' abilities to record their video diaries, resulting largely from players' location in a visual culture. One of the players has a speech impediment and in a further interview with one of the researchers pointed out that being disabled was heightened by this visual data collection method. As Mauthner and Doucet (2003) warn, different methods are not always viewed positively by participants and there are a number of unresolved ethical issues in visual research methodologies (Prosser 2008). A useful safeguard is to embrace Pink's notion of a reflexive approach as suggested in our opening sections. However, as indicated by the above example and as detailed elsewhere, albeit in different contexts (Scraton and Watson 1998), stating that researchers aim to be reflexive does not prevent issues arising along route, particularly when research is understood as a dynamic process. Embracing visual methodology and employing visual methods do not necessarily resolve issues surrounding a crisis or a range of crises of representation; nonetheless we suggest they can be fruitful in addressing complex and changing social relations.

As discussed, one of the many benefits of using video diaries is that it allowed us to collect a variety of narratives and to some extent, the spontaneity of lived events (Buscher 2005). Whilst the 'openness' of the video diaries often lead to a deeper understanding of the participants lives, there remain questions about the 'absence' of the researcher (Gibson 2005). For instance, in the follow up interviews a number of the participants admitted to using the video diaries in order to 'get things off their chest', but what would happen if one of the players was upset or traumatised during recording? What, if one of the participants misunderstood the instructions and took the camera out into public? Video diaries are collected after they have been recorded and consequently, researcher 'interventions' are limited. This can be both beneficial and frustrating for researchers. On the one hand, video diaries are about giving free rein to participants, on the other, it can mean a lack of (researcher) control with varying ethical consequences (some of which are covered in this paper). Researchers might also wish participants had said more on a particular topic or aspect; using the diaries in conjunction with other methods is clearly useful here. We maintained some regular dialogue with the participants by attending practice sessions, games and social events.[5] During this time, we asked participants how they were getting on and encouraged them to talk about problems they had encountered.

For us, the video diaries are an integral part of the research findings that the wider project on basketball is discovering and creating. The diaries represent a dynamic interplay between first and second order narratives. Footage has already been used in conference presentations as it is the lived voices of the participants that we would argue it is important to maintain. This helps to avoid the videos becoming redundant once and if they have been turned into written texts, as Pink and others have stated, 'video has a special potential to represent the inevitably embodied and multi-sensory experience of ethnographic fieldwork and evoke other people's sensory experience to an audience/reader' (Pink 2007a, p. 175). Data included above would certainly seem to attest to this, although it is challenging to create text for a paper that is distanced from the visual materials:

> Ethnographers usually re-think the meanings of photographic and video materials discussed and/or produced during fieldwork in terms of academic discourses. They therefore give them new significance that diverges from the meanings invested in them by informants, and from meanings assumed by ethnographers themselves at other stages of the project. (Pink 2007, p. 124)

This remains an ongoing issue for researchers if and where we engage creative methodologies and particularly where visual (and audio) methodologies are employed. This is certainly a relatively new departure for sports research, yet one we claim offers numerous possibilities both inside and beyond social science analyses of sport. Researchers can and do act as facilitators, whereby participants are actively encouraged to be agents in the construction and interpretation of data and its related meanings (Carless and Douglas 2009, Enright and O'Sullivan 2009). Forms of data can also encompass a broader range of formats, including, for example, those that are multi-sensory (Sparkes 2009). We suggest that reflexive approaches in our research demonstrate how narrative data collection can be enriched when visual methodologies inform our research strategies, both on and off the court.

Notes

1. Please refer to the journal's website at http://www.informaworld.com/rqrs to view clips of these video diaries.
2. This player's name was removed for reasons of confidentiality.
3. The National Basketball Association in America. The biggest and most popular league in the world.
4. One of the diarists declined a request to interview him, and the other had left the country.
5. Which were part of a wider ethnography.

References

Bakhtin, M., 1984. *Rabelais and his world.* Manchester: Manchester University Press.
Banks, M., 2001. *Visual methods in social research.* London: Sage.
Barrett, D., 2004. Photo-documenting the needle exchange: methods and ethics. *Visual studies,* 19 (2), 145–149.
Baudrillard, J., 1983. *Simulations.* New York: Semiotext.
Baudrillard, J., 2002. *Symbolic exchange and death.* London: Sage.
Bauman, Z., 2007. *Consuming life.* Cambridge: Polity Press.
Brown, T., Shrum, W., and Duque, R., 2005. Digital video as research practice: methodology for the millennium. *Journal of research practice,* 1 (1), 1–19.
Bury, M., 1982. Chronic illness as biographical disruption. *Sociology of health and illness,* 4 (2), 167–182.
Buscher, M., 2005. Social life under the microscope? *Sociological research online,* 10 (1).
Butler, J., 1993. *Bodies that matter: on the discursive limits of sex.* New York: Routledge.
Butler, J., 1999. *Gender trouble.* London: Routledge.
Carless, D. and Douglas, K., 2009. 'We haven't got a seat on the bus for you' or 'all the seats are mine': narratives and career transition in professional golf. *Qualitative research in sport and exercise,* 1 (1), 51–56.
Carr, D., 1997. Narrative and the real world: an argument for continuity. *In:* L.P. Hinchman and S.K. Hinchman, eds. *Memory, identity, community: the idea of narrative in the human sciences.* New York: State University of New York, 7–25.
Clandinin, J. and Connelly, M., 2000. *Narrative Inquiry: experience and story in qualitative research.* San Francisco: Jossey-Bass.
Classen, C., 1993. *Worlds of sense: exploring the senses in history and across cultures.* London: Routledge.

Clifford, J., 1986. Partial truths. *In:* J. Clifford and G. Marcus, eds. *Writing culture: the poetics and politics of ethnography.* Berkeley: University of California Press, 1–29.

Collins, R., 1981. On the microfoundations of macrosociology. *American journal of sociology*, 86 (5), 984–1015.

Collinson, J.A. and Hockey, J., 2007. Working out identity: distance runners and the management of disrupted identity. *Leisure studies*, 26 (4), 381–398.

Deacon, S.A., 2006. Creativity within qualitative research on families: new ideas for old methods. *In:* S. Nagy Hesse-Biber and P. Leavy, eds. *Emergent methods in social research.* London: Sage, 95–109.

DeCerteau, M., 1984. *The practice of everyday life.* London: University of California Press.

Denzin, N.K. 1997. *Interpretive ethnography: ethnographic practices for the 21st Century.* Thousand Oaks, CA: Sage.

Elliot, J. 2005. *Using narrative in social research: qualitative and quantitative approaches.* London: Sage.

Enright, E. and O'Sullivan, M., 2009. Producing different knowledge and producing knowledge 'differently': rethinking physical education research and practice through participatory methods. *Participatory methods paper for AERA*, 1–18.

Featherstone, M., Hepworth, M., and Turner, B.S., 1991. *The body: social process and cultural theory.* London: Sage.

Felski, R., 2000. The invention of everyday life. *Foundations*, 39, 15–31.

Fitzgerald, H., 2007. Dramatizing physical education: using drama in research. *British journal of learning disabilities*, 35, 253–260.

Fitzgerald, H., forthcoming. 'Drawing' on disabled students experiences of physical education and stakeholder responses.

Foucault, M., 1978. *Discipline and punish: the birth of the prison.* New York: Pantheon.

Frank, A., 1995. *The wounded storyteller: body, illness, and ethics.* Chicago: University of Chicago Press.

Franklin, S., 1996. Postmodern body techniques: some anthopological considerations on natural and postnatural bodies. *Journal of sport and exercise psychology*, 18, 95–106.

Gardiner, M.E., 2000. *Critiques of everyday life.* London: Routledge.

Gauntlett, D., 1996. *Video critical: children, the environment and media power.* Luton: John Libbey Media.

Geertz, C., 1973. Thick description: toward an interpretive theory of culture. *In:* C. Geertz, ed. *The interpretation of cultures: selected essays.* New York: Basic Books, 3–30.

Gerson, K. and Horowitz, R., 2002. Observation and interviewing: options and choices in qualitative research. *In*: T. May, ed. *Qualitative research in action.* London: Sage, 199–224.

Gibson, B.E., 2005. Co-producing video diaries: the presence of the 'absent' researcher. *International journal of qualitative methods*, 4 (4), 34–43.

Gubrium, J.F. and Holstein, J.A., 1997. *The new language of qualitative method.* Oxford: Oxford University Press.

Halford, S. and Knowles, C., 2005. More than words: some reflections on working visually. *Sociological research online*, 10 (1).

Holliday, R., 2000. We've been framed: visualising methodology. *Sociological review*, 48 (4), 503–521.

Holliday, R., 2004. Filming the closet. *American behavioural scientist*, 47 (12), 1597–1616.

Holstein, J. and Gubrium, J.F., 2000. *The self we live by: narrative identity in a postmodern world.* New York: Oxford University Press.

Johns, D.P. and Johns, J.S., 2000. Surveillance, subjectivism and technologies of power: an analysis of the discursive practice of high-performance sport. *International review for the sociology of sport*, 35 (2), 219–234.

Leder, D., 1990. *The absent body.* Chicago: University of Chicago Press.

Lefebvre, H., 1984. *Everyday life in the modern world.* London: Continuum.

Lefebvre, H., 1992/2004. *Rhythm analysis: space, time and everyday life.* London: Continuum.

Lysaker, J.T. and Lysaker, P.H., 2002. Being interupted: the self and schizophrenia. *Journal of speculative philosophy*, 19 (1), 1–21.

Maffesoli, M., 1996. *The time of the tribes: the decline of individualism in mass society.* London: Sage.

Markula, P. and Denison, J., 2005. Sport and the personal narrative. *In:* D. Andrews, D. Mason, and M. Silk, eds. *Qualitative methods in sports studies.* Oxford: Berg, 165–185.

Markula, P. and Pringle, R., 2005. No pain is sane after all: a Foucauldian analysis of masculinities and men's experiences in rugby. *Sociology of sport journal*, 22 (22), 472–497.

Mauthner, N.S. and Doucet, A., 2003. Reflexive accounts and accounts of reflexivity in qualitative data analysis. *Sociology*, 37 (3), 413–431.

Myrvang Brown, K., Dilley, R., and Marshall, K., 2008. Using a head: mounted video camera to understand social worlds and experiences. *Sociological research online*, 13 (6).

Pink, S., 2007a. *Doing visual ethnography.* 2nd ed. London: Sage.

Pink, S., 2007b. Walking with Video. *Visual studies*, 22 (3), 240–252.

Pronger, B., 1998. Post-sport: transgressing boundaries in physical culture. *In:* G. Rail, ed. *Sport and postmodern times.* Albany: State University of New York Press, 277–301.

Prosser, J., 2008. Visual ethics. Paper presented at the international visual methods conference, September 2007 Leeds: Leeds University.

Randall, W. and Phoenix, C., 2009. The problem with truth in qualitative interviews: reflections from a narrative perspective. *Qualitative research in sport and exercise*, 1 (2), 125–140.

Rojek, C., 1999. *Decentering leisure: Rethinking leisure theory.* London: Sage.

Rose, G., 2003. *Visual methodologies: an introduction to the interpretation of visual methodologies.* London: Sage.

Scraton, S. and Watson, B., 1998. Gendered cities: women and public leisure space in the 'postmodern city'. *Leisure studies*, 17, 123–137.

Seigworth, G., 2000. Banality for cultural studies. *Cultural studies*, 14 (2), 227–268.

Shilling, C., 1993. *The body and social theory.* London: Sage.

Silk, M., 2005. Sporting ethnography: philosophy, methodology, and reflection. *In:* D. Andrews, D. Mason, and M. Silk, eds. *Qualitative methods in sports studies.* Oxford: Berg, 65–104.

Smith, B. and Sparkes, A., 2002. Sport, spinal cord injury, embodied masculinities, and the dilemmas of narrative identity. *Men and masculinities*, 4 (3), 258–285.

Sparkes, A., 1996. The fatal flaw: a narrative of the fragile body: Self. *Qualitative inquiry*, 2 (4): 463–494.

Sparkes, A., 1997. Reflections on the socially constructed physical self. *In:* K. Fox, ed. *The physical self: from motivation to well being.* Champaign, IL, Human Kinetics, 83–110.

Sparkes, A., 1998. Athletic identity: An Achilles' heel to the survival of self. *Qualitative health research*, 8 (5), 644–664.

Sparkes, A., 1999. Exploring body narratives. *Sport, education and society*, 4 (1), 17–30.

Sparkes, A., 2004. Bodies, narratives, selves, and autobiography: the example of Lance Armstrong. *Journal of sport and social issues*, 28 (4), 397–428.

Sparkes, A. and Smith, B., 2002. Sport, spinal cord injury, embodied masculinities, and the dilemmas of narrative identity. *Men and masculinities*, 4 (3), 258–285.

Sparkes, A. and Smith, B., 2008. Men, spinal cord injury, memories and the narrative performance of pain. *Disability and society*, 23 (7), 679–690.

Spiro, H.M., *et al.,* eds., 1993. *Empathy and the practice of medicine: beyond pills and the scalpel.* London: Yale University Press.

Stone, C., 2007. The role of football in everyday life. *Soccer & society*, 8 (2/3), 169–184.

Thrift, N. and Dewsbury, J.D., 2000. Dead geographies and how to make them live. *Environment and planning D: Society and space*, 18, 411–432.

Turner, B., 1984. *The body and society: explorations in social theory.* London: Blackwell.

Weeks, J., 1990. The value of difference. *In:* J. Rutherford, ed. *Identity, community, culture, difference.* London: Laurence and Wishart, 88–101.

Weiss, O., 2001. Identity reinforcement in sport: revisiting the symbolic interactionist legacy. *International review for the sociology of sport*, 36 (4), 393–405.

Wiles, R., *et al.,* 2008. Visual ethics: ethical issues in visual research. ESRC review paper. NCRM/011. National Centre for Research Method.

Seeing is believing: telling the 'inside' story of a beginning masters athlete through film

Mary Ann Kluge[a], Bevan C. Grant[b], Lorraine Friend[b] and Linda Glick[a]

[a]University of Colorado at Colorado Springs, USA; [b]The University of Waikato, Hamilton, New Zealand

Readers should also refer to the journal's website at http://www.informaworld.com/rqrs and check volume 2, issue 2 to view the accompanying video clips. This will appear as 'Supplementary Content' to this article.

This paper is about how a previously inactive woman with little or no experience of playing sports became a masters athlete at 65 years of age. The authors explore how visual methods as a different way of knowing can be used to enhance our current theories and practical knowledge about older adults' experiences with sport and exercise. How data were gathered and analysed through film and how film was used to represent experience are described. Additionally, the authors offer their perspective on some challenges and/or ethical issues researchers may face when visual methods are used.

Introduction

When Linda turned 65 and received her Medicare card from the US government, she had an inspiration to do something different, embark on a new experience. Prior to this, she had never, even at school, been the *sporty type* or been one to exercise for the sake of keeping fit. 'Exercise' was something Linda did to satisfy everyday needs or to be socially engaged, like going skiing with her family once or twice a year. It was, therefore, a great surprise to her family, friends and professional colleagues when Linda announced one day, 'I want to compete in the Rocky Mountain Senior Games!'

Linda called her new programme *Shape-up* or *Ship-out* and asked Mary Ann (first author and friend) if she would be her personal trainer/coach. We (co-authors) were certainly intrigued by Linda's decision to become a first-time athlete at 65 and agreed that her story needed to be told as *she* experienced it. What would 'shaping up' entail? Would Linda become an 'athlete'? We anticipated a real adventure as it defied what we know about the socially prescribed norms of becoming physically active – particularly in later life.

As Linda's story began to unfold we asked, 'How could we best capture and present what might occur over the next year as Linda engaged in her Shape-up programme?' It was clear that Linda's experience would be rich in meaning at the conscious, feeling, thinking and reflective levels. Being encouraged by the work of others who have used film to gather data and represent research findings (e.g. Belk

and Kozinets 2005, Harper 2005, Wagner 2006), we set out on a mission, with some trepidation, to uncover the everyday experiences of Linda becoming an athlete. And, we decided that film would be the medium through which we would collect our data and report the findings.

The purpose of this paper is to focus on Linda's becoming an athlete and how we used film to represent her experience.[1] We explore how film as a different way of knowing can be used to enhance our current theories and practical knowledge about older adults' experience with sport and exercise. Additionally, we offer our perspective on some challenges and/or ethical issues researchers may face when visual methods are used.

Masters athletes

Irrespective of the label (Masters, Seniors, Veterans) or the eligibility requirements (30+ years, 50+ years), there are now more people than ever participating in sport, a phenomenon noted by entries in regional, national and international events. The growth in participation is paralleled by an increasing number of organisations promoting healthy living in communities (Cardenas *et al.* 2009). These organisations sponsor sporting events with stated missions such as 'to improve the quality of life for adults age 50+ by providing athletic competition and social opportunities that promote healthy, active lifestyles' (Rocky Mountain Senior Games, www.rmseniorgames.com). The World Masters Games, a bi-annual event with eligibility starting at 30 years of age, were recently held in Sydney, Australia. Competitions were offered in 28 sports and used the following motto to represent the essence of this form of physical activity: *ordinary people – extraordinary experiences.*

A better understanding of the myriad meanings associated with participating in sport in later life has been undertaken by a few scholars. In a study of masters athletes over 70 years of age, Grant (2001) reported that although much is to be gained by regularly partaking in deliberate physical activity during later life, this is not always as easy as it sounds. At a personal level, changes in functional capacity and dealing with the sometimes ailing body can serve as a deterrent. From a broader perspective, the stigma associated with being older poses a significant physical, sociological and psychological challenge, particularly during the initial phases. Despite challenges, however, Dionigi (2006) found that competitive sport provides a way for older adults (60–89 years of age) to express youthfulness and negotiate the multiple meanings of older age. After exploring the complexities and contradictions of performance discourses of masters athletes, she concluded that friendship, fitness and 'serious fun,' namely competing-to-win, were all potent reasons for participation.

In their analysis of personal narratives of experiences with sport and physical activity, Partington *et al.* (2005) discovered three different narratives, or 'maps', that individuals at mid-life (ages 35–55) used: (1) 'age is a state of mind' (the resistance narrative); (2) 'life begins at forty' (the rejuvenation narrative); and (3) 'growing old gracefully (the acceptance narrative). This group of athletes, who participated in badminton, distance running and a variety of outdoor activities, by far used the resistance narrative most often to make meaning of their experiences. They told about the problems, difficulties and obstacles of ageing and how they fought the ageing process by disciplining themselves to stay involved with the sports they engaged in as youth.

A narrative approach to understanding athletes' experiences was also undertaken by Tulle (2007). Tulle's study gathered life histories from a group of masters runners

(48–86 years of age). Findings indicated that in spite of an exuberance to engage in their sport, the broader discourses these athletes confronted tended to constrain agency and affect disposition. Furthermore, many of these runners' experiences were flavoured with 'forms of knowledge and practices informed by the medicalization of old age and its correlate, the narrative of decline' (p. 342).

When thinking about participants in masters sport, it is impossible to ignore the older body's biological reality. There are to be expected changes in the body as it ages. Older athletes, however, are not bodies without stories. They are, rather, individuals whose stories are as mysterious as their bodies and whose bio-*graphical* ageing is as intricate as their biological ageing, and as worthy of study. A special issue of the *Journal of Aging and Physical Activity* was devoted to qualitative research (see Markula *et al.* 2001). Drawing readers into the vicarious experience of the lives being described and circumstances that surround those lives was encouraged by contributors to this special issue and continues to be advocated (e.g. Grant and Kluge 2007, Hockey and Allen Collinson 2007; Paulson and Willig 2008; Phoenix and Grant 2009; Roper *et al.* 2003). After all, growing old cannot be understood apart from its subjective experience.

To date, research on older adult athletes has primarily involved individuals who have participated in physical activity for a lifetime or those who have had previous experiences with sports activities they are returning to in their later years (Dionigi and O'Flynn 2007). Less is known, however, about what it is like for older adults who have *never* participated in sports, but are interested in trying something new. So how does one *become* a masters athlete? And, how do we as researchers capture and convey lived experience through film?

A perspective on visual research

Our reasons for using film were both theoretical and methodological. Film is often subsumed within the field of video-ethnography (Pink 2007) and sometimes referred to as videographic research (Kozinets and Belk 2006). Similar to other scholars' points of view on the value of visual methodologies (Rose 2007; Shrum *et al.* 2005, Wagner, 2006), we contend that film offers an appropriate alternative to represent and tell a tale of people's physical activity endeavours. It is an appropriate way to examine and enrich what is visible about culture and social life. Even in clinical arenas, there is an increasing acceptance of visual methodologies in the study of health, illness and health care (Harrison 2002). The visual provides a way *for participants themselves* to give meaning to and represent their experiences. The visual allows direct entry into participants' points of view as well as capturing some of *what they do* rather than only what they say they do (Radley and Taylor 2003).

Film might make more visible aspects of the lived experience that we might not otherwise be able to understand, but as Wagner (2006) contends that it is only one form of representing that is being studied. Dennison and Markula (2003) contend that it is unlikely, irrespective of medium, that we will ever be able to produce truly embodied accounts of people's experiences. While different types of knowledge may be experienced and represented in a range of different textual, visual and other sensory ways, there is no way to present a truly 'untainted reality' about that being studied (Pink 2007, p. 103). Fundamentally, visual research provides 'an experiential dimension in which the viewer vicariously learns what it [the phenomenon being studied] is like for the participant' (Belk and Kozinets 2005, p. 138). In deciding on film, we were conscious that 'how research is presented is at least as important as what is presented'

(Sparkes 2002a, p. 12); and it need not always be in the written form (Harrison 2002; Markula and Denison 2000).

Within our field of enquiry (sport and exercise), it is appropriate to report research through mediums such as film given that meaning and movement are inextricably bound (Kerry and Armour 2000). Just as 'readers must plan to make meaning as they read' (Sparkes 2002b, p. 220), seeing a story via film provides 'connection, empathy, solidarity and emancipatory moments which provides powerful insights into the lived experiences of others (Sparkes 2002b, p. 221). The medium of film brings visual and oral dimensions to the research process. It enables researchers to record interviews and events reducing their reliance on pictures painted by words (Banks 2007). Actual visual footage of participants can depict their thinking and actions as well as the events in which the meaning is infused, thus enriching the research by making the findings and the story told a living document.

Seeing and recording: gathering 'data'

Film is also a process in that it organises the participants (researchers, technicians and actors), collects information and follows strategies that take into account the purpose for the research, subject matter, participants, location and environmental constraints (Banks 2007; Kozinets and Belk 2006; Rose 2007). In our case, we used the visual medium to make visible a social life otherwise invisible (Rose 2007); an experience lived *for the first time* by an *ordinary* person. It was important to us to gather visual and sensory knowledge that provided an account of physical, emotional and social aspects of the experience. Linda not only became an athlete; she became a different (older) person.

Many hours of video footage – from her first training session to her competing in and winning the 100 metres at the Rocky Mountain Senior Games – was collected, reviewed and edited for this project. In addition, Linda also kept a journal of her thoughts and feelings related to the numerous experiences. This ultimately led to producing a 23-minute long film titled *The Starting Line: Becoming a Senior Athlete.*[2]

There were several advantages of having data video-recorded and archived for this project. It was an efficient way to record information within the theoretical framework we chose to apply (phenomenology), and, arguably, more 'accurate' than other forms such as audio recording interviews. Further, the video camera was less obtrusive means than other forms of data collection would have been (Radley and Taylor 2003). Much of the time that Linda and Mary Ann spent together was in active settings where Linda and Mary Ann both were *doing something* physical. There were few opportunities to take observational notes. Moreover, audiotaped conversations would have felt contrived and much valuable data captured via the video would have been lost if there was a reliance on verbal accounts alone.

In addition to providing a visual and verbal accounting of these training sessions, the data saved via video recording provided an opportunity to later view changes in Linda's physical features and abilities – the 'before and after,' so to speak. The video-taped footage also enabled the capturing and viewing of her non-verbal behaviour (e.g. training sessions), thus providing a more complete and potent sense of the 'becoming an athlete' experience. For example, during her Shape-up programme, Linda had several 'rants' (as we called them), whereby the circumstances she faced created strong emotional responses in her that she 'vented'. Those rants were captured on camera, in real time. Without the videotaped footage of these instances, we neither

would be able to accurately remember nor would have been able to, at a later date, accurately recall these events in order to make meaning of them. Participant response to visual images, Harper (2002) argues, evokes 'deeper elements of human consciousness' than do words alone (p. 13). As such we argue that the videotaped footage we collected about her everyday experiences of becoming an athlete enhanced the accuracy of the data collected and meaning made of it. Filming allowed the researchers to capture how Linda experienced becoming an athlete through performance and voice.

Formulating the visual

Wolcott (1994) indicated that 'the real mystique of qualitative inquiry lies in the process of using the data rather than gathering and collecting it' (p. 1). He contends that 'nothing becomes data until a researcher intervenes and takes note' (p. 3–4). During the production phase, our data were *transformed* into an intelligible account of a 'real' sequence of events about Linda's Shape-up experience. Using video as a research method is not merely about recording what people do to generate data, but 'engaging in a process through which knowledge is produced' (Pink 2007, p. 105). We were however reminded by Rose (2007) that imagery is never innocent and that there is 'no such thing as a neutral image' (Belk and Kozinets 2005, p. 134).

In order to make the transformation of raw data into selected visual images that told her story of becoming an athlete, Linda's journal was read several times. Code words were identified and meaning statements that appeared to represent her experience were labelled. Themes that emerged were labelled consistent with the narrative interpretive tradition (McQueen and Zimmerman 2006). This classic qualitative data analysis, whereby the participants' words are used to represent meaning, helped ensure that the theoretical perspective influencing the analysis (phenomenology) was adhered to.

The videotaped footage was also reviewed several times by researchers and participants together. As such, videotaped footage has the benefit of being a memory aid (Radley and Taylor 2003), but as in other forms of research, there can be varying portrayals of a particular truth(s) (Belk and Kozinets 2005). The key point is to recognise what visible material is visually significant and how to use it to best reflect the associated narrative. Trying to explicate situational interfaces between text, image, activities, varied settings and meanings poses a considerable theoretical and methodological challenge (Wagner 2006).

During the editing stage, Linda was a full participant in the process that took many more hours than anticipated. As Radley and Taylor (2003) explain, the value of this time together helps ensure footage that matters to the participant is considered and possibly included in the finished version. It was a collaborative process and afforded Linda had the opportunity to decide whether or not the footage being chosen for the film best represented her becoming and being an athlete. In essence, this is a form of member checking, whereby the research participant has the opportunity to read, or in this case view, the themes identified as potent to the researcher and verify them as 'believable, accurate and right' (Creswell 1998, p. 193). The participant's view has to be balanced by considering what story the movie is endeavouring to tell (Rose 2007), for it is the researchers' responsibility to craft a plausible account (i.e. film) of that being represented (Willig 2001).

We decided that Linda should narrate the story, as her voice would provide a greater sense of authenticity and credibility to that being represented via the film.

Having Linda talk about 'herself' also helped to ensure the inevitably embodied and multisensory experiences (of becoming an athlete) and would entice the viewers to look beyond the images (Pink 2007). In the beginning, Linda recounted almost verbatim snippets from her initial journal entries that resonated with *Getting-into-Shape* and *Gearing Up* (both themes that emerged) for being a physically active person. For much of the commentary, the researchers constructed narratives that were meaningful as well as representative of the images being shown (Pink 2007; Wagner 2006). To enhance the emotive energy in places throughout this film, several live accounts of Linda's experiences were incorporated rather than using a voice-over. These moments were selected primarily for their visceral value and in each case Linda was sharing heartfelt concerns and/or epiphanies. The quality of the sound during these live accounts may not be as good as when we had Linda voice-over footage, but her passion comes through.

Dissemination for others

Once the film was completed, we had decisions to make regarding dissemination. Because this film represented findings from our research, we did not purposefully identify a specific target audience for our film while making it. In hindsight, this may have been a mistake, but our goal was to get the story out to a broad audience in our academic *and* lay communities. We were conscious that the use of film in the research process is advocated (although rare in sport and exercise) as a means to accessing a wider audience (Belk and Kozinets 2005) and contributes to our knowing and to our being known (Witherell and Noddings 1991). Much like Schratz (1993) describes when she discusses the powerful impact of 'situated cognition', our film seemed to invoke a connection by many to what viewers described as the inspiration of Linda's story. Table 1 shows the list of the settings in which the film has been shown, the context of examples of common comments made, and who made the comments. As illustrated, there were various aspects of the story that people of various ages, interests, gender etc. connected to.

Challenges with using visual methods

As in any form of inquiry, numerous decisions are made and practicalities considered about the theoretical position, methods, ethical considerations, analysis of information, and how and where to disseminate the findings (Banks 2007; Harper 2005; Pink 2007). In this case, the researcher must give attention to image and sound as well as the accompanying narration. All three are equally important in creating meaning, although they can only present a version, an incomplete picture and tell part of the story. In this research, the information collected was in accordance with a phenomenology; *What was it like to become a masters athlete?* Linda was filmed on numerous occasions in a range of everyday activities mostly associated with her becoming an athlete. Visual representation focused on the lived experience of Linda becoming an athlete rather than visual facts. Although the footage was a form of diary, it was not possible to capture an entire or completely authentic record of every event or process on film. Pink (2005) argues that one of the reasons for not being able to record a fully accurate, authentic record on film is that 'reality is not always visible, observable and recordable in video' (p. 23). Moreover, 'images allow only one way to interpret that which is visible' (p. 24).

Table 1. Representative audience member responses.

Place	Context	Person	Comment
Linda's youngest son's wedding reception	Shown to those in attendance who were interested (mostly in their 30s and 40s)	A woman in her 20s who is in military service caught up with Linda afterward.	Was inspired to run again; saw doing so as reconnecting with who she is, biographically.
University venue	Shown to faculty, staff, students, and community partners (18–80+ years)	A 60+ age man who is owner of a senior residential facility	Was moved to tears by the connection Linda had made with her grandchildren.
Linda's Book Club	Shown to women members who are 50 years of age and older	Four members attended the state competition to watch Linda compete.	All were 'inspired'; one is now a member of the volleyball team; another has taken up Yoga.
National Senior Games where Linda was competing	Linda's girlfriends from the 7th grade	Four women 65+ not regularly physically active	Two women joined the senior volleyball team.
Public library in town	Shown to community members (over 50 years of age–men and women)	Man in 60s who used to play basketball	'Where can I find out about these Senior Games?' he said. 'I used to play and coach and its been a while but it looks like fun!'
Graduate Research Class	Shown to graduate students (30+ years of age) to start a discussion about research methods and alternative was of representation	The graduate students were 'inspired', 'curious' and were 'eager' for more	It 'offered a new way of understanding' and an example of how film 'could bring meaning to scientific research'.
7th World Congress on Ageing and Physical Activity	Shown to delegates, male and female, from around the world; both researchers and practitioners were in the audience.	A delegate in his 50s said, 'The film was an enjoyable, wonderful story, but where's the data?' Another delegate (a male in his 30s) bowed to Linda and said, 'You are my role model'.	Stimulated a discussion about how we come to know about ageing and physical activity through qualitative research methods and alternative forms of representation.
Retirement Community	Residents (75 years and older) and staff (20+ years)	A woman in her mid-80s	Watching the film 'helps me realise my own potential, some of which I am not using'.

Searching for accuracy and authenticity in this project echoed Denison and Markula's (2003) thoughts about writing narratives; 'it seems unlikely that we will ever be able to produce *truly* embodied accounts of people's experiences' (p. 18). The images should be informed, however, by the subjectivities of the character(s) and meanings the character(s) gives to the images (Pink 2005). In other words, the research has to be more than a chronological portrayal of a person's life and/or an event, created by researcher alone. In the film, *The Starting Line: Becoming a Senior Athlete* Linda was a co-researcher and involved in the editing and analysis, a means through which credibility was attained.

As visual methods grow in popularity, so do 'audience studies' (Rose 2007). This area of study suggests that there is 'no single or correct answer to the question: What does this image mean?' (p. xiv). *Things* have more than one meaning, and meaning changes over time. Following is an example. Upon first seeing *The Starting Line*, several members of Linda's Book Club (a group of six women who meet regularly to discuss selected readings) and a few neighbours were moved to become more physically active. Two of them even joined the volleyball team that Linda and Mary Ann subsequently formed. Their impressions of the film as well as the themes they most related to the *first* time they viewed the film, before their own involvement in masters sport, changed significantly *the next time* they viewed the film as athletes themselves. At first viewing they were inspired to get involved. Subsequently, once they were involved, themes such as what it was like to prepare for competition and actually compete took on more meaning for them. Similar to the experience of reading a written text, viewers interpret and diversely value the story according to *their* experiences, knowledge and the paradigmatic lens through which they view the film.

Adopting alternative ways of knowing and representing the nature and meaning of physical activity in later life through alternative methods is not without its challenges as well during dissemination. Representation through film can be theory rich, leading to better understanding or explaining a phenomenon and can thus guide practice. The theoretical contribution via film, however, may be less obvious than the written text. This was evident during a symposium we did at the 7th World Congress on Ageing and Physical Activity held in Japan, July 2008, called Masters Sport: An Inside View. The symposium included a broad perspective about masters games, examples of qualitative research with masters athletes, and a brief section about various forms of representation. Showing *The Starting Line* was one example of an alternative way to represent lived experience. We anticipated that following the film there would be a lively discussion about the worthiness of representing the older active person in this way. Instead, we were greeted with an *unearthly silence*. Perhaps the audience was trying to determine whether this was entertainment or scholarship. The lesson learned was that it pays not to have preconceived expectations of what might be achieved by using an alternative form of representation, in this case film. We expected the audience in this research forum to 'suspend (its) disbelief in the reality of what is shown and to absorb the story being presented' (Belk and Kozinets 2005, p. 134). Perhaps we needed to introduce the 'why' and 'how' of using the film first; then describe some aspects of the data collection process, production issues, and goals for dissemination *prior to* showing the film. One thing this conference experience did, as Sparkes (2002a) indicates, is illustrate that moving into unknown territory using alternative forms of representation can be both frightening and exhilarating. Members of our symposium panel certainly experienced both emotions that day.

Conclusion

Through this experience we need no convincing that film has the potential to add a whole new dimension to our understanding about all facets of movement culture. In line with other ways of knowing, film provides 'a more visually oriented science that starts and ends with seeing and making sense of what we see within the theoretical framework we chose to apply' (Pauwels 2000, p. 8). New ways of knowing using visual methods are welcome given that images – visual and static – are ubiquitous in contemporary society and used in multiple ways. As Pink (2007) suggests, the written word need not always be superior. Taking a similar position, Belk and Kozinets (2005) argue that 'if our written papers invoke the mantle of science, our videographic productions may be as likely to invoke the mantle of art' (p. 138).

In spite of being novices 'playing around' with representing our research in a different way, we believe that this film captured *the essence* of Linda's experience in making a transition from a self-proclaimed 'non-exerciser' to athlete, competing in the masters games – sprints and jumps at a state-held competition. Furthermore, we contend that this film enhances our understanding about the struggles, dilemmas and excitement of embracing such a lifestyle in later life and provides an example for others to 'get out of the starting blocks'. It's never too late!

Notes

1. Please refer to the journal's website at http://www.informaworld.com/rqrs to view footage of this film.
2. Copies of the book and the film are available at: http://glamcomm.com/

References

Banks, M., 2007. *Using visual data in qualitative research.* London: Sage.

Belk, R. and Kozinets, R., 2005. Videography in marketing and consumer research. *Qualitative market research*, 8 (2), 128–141.

Cardenas, D., Henderson, K., and Wilson, B.E., 2009. Physical activity and senior games participation: benefits, constraints, and behavior. *Journal of aging and physical activity*, 17 (2), 135–153.

Creswell, J.W., 1998. *Qualitative inquiry and research design: choosing among five traditions.* Thousand Oaks, CA: Sage.

Denison, J. and Markula, P., 2003. Introduction: moving writing. *In:* J. Denison and P. Markula, eds. *Moving writing: crafting writing in sport research.* New York: Peter Lang, 1–24.

Dionigi, R., 2006. Competitive sport as leisure in later life: negotiations, discourse, and aging. *Leisure sciences*, 28, 181–196.

Dionigi, R. and O'Flynn, G., 2007. Performance discourses and old age: what does it mean to be an older athlete? *Sociology of sport journal*, 24, 359–377.

Grant, B.C., 2001. 'You're never too old': beliefs about physical activity and playing sport in later life. *Ageing and society*, 21, 777–798.

Grant, B. and Kluge, M., 2007. Exploring 'other body(s)' of knowledge: getting to the heart of the story about aging and physical activity. *Quest*, 59, 398–414.

Harper, D., 2002. Talking about pictures: a case for photo elicitation. *Visual studies*, 17 (1), 13–26.

Harper, D., 2005. What's new visually? *In*: N. Denzin and Y. Lincoln, eds. *The Sage handbook of qualitative research.* Thousand Oaks, CA: Sage, 747–762.

Harrison, B., 2002. Seeing health and illness worlds – using visual methodologies in a sociology of health and illness: a methodological review. *Sociology of health and illness*, 24 (6), 856–872.

Hockey, J. and Allen Collinson, J., 2007. Grasping the phenomenology of sporting bodies. *International review for the sociology of sport*, 42 (2), 115–131.

Kerry, D. and Armour, K., 2000. Sport sciences and the promise of phenomenology: philosophy, method and insight. *Quest*, 52, 1–17.

Kozinets, R. and Belk, R., 2006. Camcorder society: quality videography in consumer and marketing research. *In*: R. Belk, ed. *Handbook of qualitative research methods in marketing*. Northampton, MA: Edward Elgar, 335–344.

Markula, P. and Denison, J., 2000. See Spot run: movement as an object of textual analysis. *Qualitative inquiry*, 6, 406–431.

Markula, P., Grant, B., and Denison, J., 2001. Qualitative research and aging and physical activity: multiple ways of knowing. *Journal of aging and physical activity*, 9 (3), 245–264.

McQueen, L. and Zimmerman, L., 2006. Using the interpretive narrative research method in interdisciplinary research projects. *Journal of nursing education*, 45 (11), 475–478.

Partington, E., Partington, S., Fishwick, L., and Allin, L., 2005. Mid-life nuances and negotiations: narrative maps and the social construction of mid-life in sport and physical activity. *Sport, education, and society*, 10 (1), 85–99.

Paulson, S. and Willig, C., 2008. Older women and everyday talk about the ageing body. *Journal of health psychology*, 13 (1), 106–120.

Pauwels, L., 2000. Taking the visual turn in research and scholarly communication key issues in developing a more visually literate (social) science. *Visual studies*, 15 (1), 7–14.

Phoenix, C. and Grant, B., 2009. Expanding the research agenda on the physically active aging body. *Journal of aging and physical activity*, 17 (3), 362–380.

Pink, S., 2005. *Doing visual ethnography*. London: Sage.

Pink, S., 2007. *Doing visual ethnography: Images, media and representation in research,* 2nd ed. London: Sage.

Radley, A. and Taylor, D., 2003. Images of recovery: a photo-elicitation study on the hospital ward. *Qualitative health research*, 13 (1), 77–99.

Roper, E.A., Molnar, D.J., and Wrisberg, C.A., 2003. No 'old fool': 88 years old and still running. *Journal of aging and physical activity*, 11 (3), 370–387.

Rose, G., 2007. *Visual methodologies: an introduction to the interpretation of visual material.* 2nd ed. London: Sage.

Schratz, M., 1993. Voices in educational research: an introduction. *In*: M. Schratz, ed. *Qualitative voices in educational research.* London: Falmer Press, 1–6.

Shrum, W., Duque, R., and Brown, T., 2005. Digital video as research practice: methodology for the millennium. *Journal of research practice*, 1 (1), 43–56.

Sparkes, A.C., 2002a. *Telling tales in sport and physical activity: a qualitative journey.* Champaign, IL: Human Kinetics.

Sparkes, A.C., 2002b. Autoethnography: self-indulgence or something more? *In:* A. Bocher and C. Ellis, eds. *Ethnographically speaking: autoethnography, literature, and aesthetics.* New York: Rowman & Littlefield, 209–232.

Tulle, E., 2007. Running to run: embodiment, structure and agency amongst veteran elite runners. *Sociology*, 41 (2), 329–346.

Wagner, J., 2006. Visible materials, visualized theory and images of social research. *Visual studies*, 21 (1), 55–69.

Willig, C., 2001. *Introducing qualitative research in psychology: adventures in theory and method.* Buckingham: Open University Press.

Witherell, C. and Noddings, N., eds., 1991. *Stories lives tell: narrative and dialogue in education.* New York: Teachers College Press.

Wolcott, H., 1994. *Transforming qualitative data: description, analysis, and interpretation.* Thousand Oaks, CA: Sage.

Index